MAR — 1999

**LIFE**
Photographers

# What They Saw

# We were all individualists
—Alfred Eisenstaedt

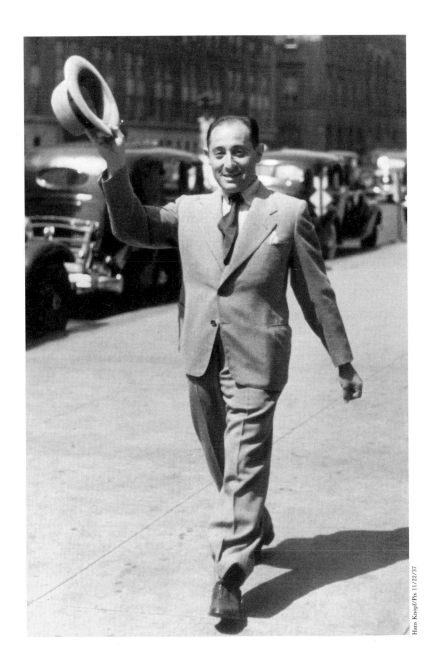

**LIFE**

Photographers

# What They Saw

John Loengard

A BULFINCH PRESS BOOK
LITTLE, BROWN AND COMPANY
BOSTON NEW YORK TORONTO LONDON

This book is dedicated to Carl Mydans.

For more than 60 years his instinct for the right picture and the right word, his unflagging curiosity and unfailing courtesy, have set the highest possible standard for the photojournalist—and everyone else.

## ACKNOWLEDGMENTS

I am indebted to the photographers and to Shelley Mydans for their willingness to give their time and their memories to this oral history. / James R. Gaines proposed the project when he was managing editor of *Life,* and Jason McManus, then editor-in-chief of Time Inc., enthusiastically underwrote the cost. Peter V. Bonventre, Sheldon Czapnik, David M. Friend, Daniel Okrent and Richard B. Stolley helped see it to completion. Doris G. Kinney's wish to have transcriptions of the questions and answers, as research for *Life's* 60th anniversary issue, led directly to this book. / I am also grateful for the contributions of Susan Bolotin, Mary Beth Brewer, Barbara Baker Burrows, Debra A. Cohen, June Omura Goldberg, Murray Goldwaser, Maryann Kornely, Marthe Smith and Steve Walkowiak. / Bill Hooper energetically provided biographical material and rare photographs from Time Inc.'s archives. / Beth Bencini Zarcone and Joan Shweky organized the extensive research performed in the picture collection by Philip A. Brito, Robert Brow, Liz Brown, George Hogan, Amy Holderness and Amanda Schuster. / Thomas Hubbard, Eric Valdman, Ismael Reina and Tom Stone coordinated the color lab work of Rocco R. Bueti, Daniel Chui and George Jinks. John Downey took extraordinary care to see that the best possible black and white prints were produced by Victor Echevarria, Patrick McBride, Hieke Hinsch, Betty Lazar, Lutgardo O. Rodriguez, Eugene Merinov and Tyrone C. Rasheed. / Janet Swan Bush at Bulfinch Press provided wise and valuable counsel. / Elizabeth Kalkhurst read these interviews as I edited them, and her comments helped shape their final form.

### A BOB ADELMAN BOOK

*Copyeditor:* Amelia Weiss    *Art Director:* Samuel N. Antupit    *Designer:* Arlene Lee

First edition

Library of Congress Cataloging-in-Publication Data
Loengard, John.
Life photographers : what they saw / John Loengard.
p.    cm.
"A Bulfinch Press book."
Includes bibliographical references and index.
ISBN 0-8212-2518-9.
1. News photographers—United States—Interviews.
2. Photojournalism—United States. 3. Life (Chicago, Ill.).
I. Title
TR139. L64    1998
070. 4 ' 9 ' 0922—dc21                            98-14442

Bulfinch Press is an imprint and trademark of Little, Brown and Company (Inc.)
Published simultaneously in Canada by Little, Brown & Company (Canada) Limited

Printed in the United States

*Page 2:* Alfred Eisenstaedt on Park Avenue. New York City. ca. 1936

# CONTENTS

# "Photography is more than an art,"

Alfred Eisenstaedt's photographs taken on assignment in the southern United States convinced Henry Robinson Luce, who was planning to start a picture magazine in 1936, that photographs could tell a story, not merely illustrate one. That conviction has attracted photographic talent to *Life* magazine for more than 60 years.

Early in the 1990s, I interviewed nearly half the 88 photographers who had, like Eisenstaedt and myself, been on the staff of *Life* magazine before it stopped weekly publication in 1972. It's hard to say what we had in common. Seven of us were born in Germany, two in Russia, one in Holland and another in Algeria. Another seven graduated from the same high school in Los Angeles. Some of us were bold. Some were shy. Some had a sense of humor; some had none. The tallest measured almost six-and-a-half feet with his shoes off, and the smallest barely five. Four were women. The one characteristic we all shared, I suppose, is that each of us liked to photograph the world around us, especially people and what people do, and each of us thought we did it better than anyone else.

*Life* editors used an awkward phrase—*the mind-guided camera*—to explain what we were about. Earlier picture magazines in Europe sent photographers out to record the celebrated and the picturesque—printing portfolios showing vacationers having fun on Baltic beaches or Benito Mussolini, the Italian dictator, in his office. But the story on the cover of *Life's* first issue was more complex. The cover itself showed the spillway of a dam under construction on the Missouri River near Fort Peck, Montana. Margaret Bourke-White, a New York–based advertising and industrial photographer who had often worked for Luce's *Fortune* magazine, photographed the spillway for a story showing projects under construction by the government's Public Works Administration. But she also photographed how workers spent Saturday night in the boomtown shanties surrounding the dam site. Indeed, until her film was developed, Bourke-White presumed she was doing two stories. One was on construction. The other was a candidate for the magazine's "*Life* Goes to a Party" department. Editors in New York put the two sets of pictures together to make the issue's lead story. With her reportorial purpose, Bourke-White recorded scenes that a purely pictorial photographer might never have witnessed. Her photographs are informative and interesting. When placed together on the page, they form an incisive and broadly encompassing

# said Ralph Morse. "It's knowledge."

story; and although none were taken solely to please the eye, the story's opening picture—a tableau of dancers in a bar of dubious reputation—is widely considered to be a classic of modern photography.

In the 1930s and '40s, before radio got pictures and became television, *Life* had a symbiotic relationship to broadcasting; that is, radio networks brought news to large audiences, stimulating their desire to see the events described. Through the 1950s, news photographs mixed well with less timely stories in the weekly *Life*. Essays on the world's great religions, for example, were pictorially rich, and "the news in pictures" still had urgency. Newspapers at the time reproduced photographs poorly in letterpress, and the rotogravure sections some papers printed required too much preparation time to handle daily news. To compensate for poor reproduction, newspaper photographers relied on the high definition of the large 4x5 inch negatives produced by their Speed Graphic cameras, especially when they were exposed with flashbulbs. The flash, synchronized to fire as the shutter opened, would highlight foreground subjects and isolate them visually from less exposed, hence darker, backgrounds. This vivid contrast between light and dark helped pictures reproduce with some clarity on newsprint. But the need for maximum clarity meant newspaper photographers could not use the small precision-made cameras manufactured in Germany, the Leica and the Contax (or the Japanese equivalents turned out by Nikon and Canon in the 1950s). These 35-millimeter cameras produced negatives less than a tenth the size of a Speed Graphic's, and their shutters synchronized poorly with flashbulbs. However, with their fast lenses and especially when used with high-speed films that came on the market in the 1930s, these "miniature" cameras (as they were called at the time) allowed photographers for the first time to record people in a wide range of behavior in ordinary room light.

To ensure a supply of such intimate, natural-looking pictures, *Life* hired 13 photographers onto its staff during the magazine's first 12 months of publishing. Seven of them are interviewed here: Alfred Eisenstaedt, then 38, had worked for the Associated Press in Germany and contributed to picture magazines in Europe before immigrating to New York in 1935. Peter Stackpole, 23, was busy photographing the construction of the Golden Gate Bridge in San Francisco. Carl Mydans, 29, had been taking pictures for the Federal Government's Farm

Security Administration; and Hansel Mieth, 27, was working on a W.P.A. project in San Francisco. John Phillips, 22, was a young man about town in London. Rex Hardy, 21, had just graduated from Stanford University; and Horace Bristol, 28, had just opened his studio in San Francisco. To ride herd on this group and expand the staff, Wilson Hicks was brought in from the Associated Press's picture service. He hired most of the next 40 staff photographers and was, until he retired in 1952, the Time Inc. executive that photographers dealt with most directly.

In November 1936, when its first issue appeared, the magazine's masthead listed only four photographers. Bourke-White, Eisenstaedt and Stackpole were based in New York; and Thomas McAvoy lived in Washington, D.C. In 1960 there were 37 photographers on the staff, which still included those original four. By 1972—the weekly *Life's* final year—33 of these 37 had left the staff, for a variety of reasons, and been replaced by nine others. The final staff of 13 reflected the fewer editorial pages in each issue, which, of course, reflected the fewer advertisements. It also reflected the ubiquity and reliability of jet aircraft, which allowed photographers to reach most places on the globe within 24 hours, and meant that free-lance talent, concentrated in New York and Paris, could move anywhere with ease and speed. Revived as a monthly in 1978, *Life* had no full-time staff photographers until 1994, when Joe McNally became a staff of one.

I should point out that many distinguished photographers not on the staff of the magazine have worked for *Life* on assignment, photographing under contract or as free-lance. For example, Gjon Mili, who first applied the strobe light to journalism, and Philippe Halsman, who concentrated on photographing show-business personalities, preferred to be free to do commercial work and were unwilling to join the staff. They, and a few others like Lennart Nilsson, who specializes in medical photography, fashion photographer Milton Greene and portraitist Arnold Newman, were listed on *Life's* masthead at one time or another but were not on the staff.

Nina Leen was an anomaly. A contract photographer, she was included in a photograph taken of the staff photographers in 1960, on the one occasion when they were gathered together from around the globe. Presumably everyone thought Leen *was* one of them. "Nina is under the impression that she was a staff member and got profit sharing and all that, but we had to tell her last year that this is simply not true," said Richard O. Pollard, the director of photography, in 1970. "She had a contract with Wilson Hicks, when he was executive editor, that didn't make any sense at all . . . I think she had some hang-up about taking the physical." Last to face that not-so-daunting examination was a Scottish photographer, Harry Benson. He was to join the staff officially on January 1, 1973, but *Life* suddenly suspended publication with the issue dated December 29, 1972. Benson has since become a major contributor to the monthly *Life*. Both Leen and Benson are included here.

Interviewing the former staff photographers had been suggested from time to time. Finally, in 1991, James R. Gaines, then the monthly *Life's* managing editor, asked me to do it. I felt that the interviews should be taped for future use on television; and Kathy Sulkes, a former *CBS News Sunday Morning* producer, joined the project. She chose Greg Andracke as cameraman, and he asked Duncan Forbes and Dean Sarjeant to record the sound. In television, logistics are complicated, but of 50 photographers who could be interviewed, we missed only six. One of these had closed the book on his career long ago, and dredging up the past upsets him. Another steadfastly avoids group projects. A broken ankle and a daughter's wedding prevented a third . . . and so on. The tapes have not yet been aired.

"*Life* magazine for me was like the American flag," says Eisenstaedt. "We felt a great responsibility . . . to be honest." As the interviews progressed, I noted that whereas writers interview people, photographers interact with them. Either the subject performs before the camera or there's no story. Luck is important, but photographers must know what to bring out in a subject; and to know that, they must have their own point of view. For 36 years, from their own points of view, *Life* photographers showed Americans what the world looked like, and they showed the world what America looked like. Some of them continue to do so in the pages of the monthly *Life*.

What experiences help shape a photographer's point of view? Surprisingly, Cornell Capa cites the effect of a high school teacher in Budapest who gave him a love of the English language. Benson traces his desire to cover the drama of events to listening to Winston Churchill's wartime speeches as a boy in Glasgow. George Silk felt compelled to match exploits with his New Zealand buddies who flew fighter planes and commanded PT boats during World War II. John Shearer simply found that photography is magic. I did too.

In 1956, when I started taking pictures for the magazine, I had glimpses of the celebrity that still surrounded *Life* photographers. I am sure some of them used the glamour of the job to enrich their social life, but the apocryphal starlet who succumbed to a photographer's line, "Baby, I can get you on the cover of *Life*," was probably not talking to a real staff photographer. Of course, constant travel battered marriages, as three of my colleagues recall. Certainly it did mine. So perhaps it's surprising that half those I interviewed had marriages lasting 25 years and more. At any rate, I know we had a glamorous job because when I started, people asked for my autograph. Then they inquired, "Will the pictures be in next week?" By 1960 that was over. Filmed by the local TV crew, people preferred to know, "Will we be on at 5 or at 11?"

The cooperation that subjects give *Life* photographers remains extraordinary even today. "No one wants to pass this way unnoticed," observes Benson, and photographers have made the most of this feeling. By 1960 it seemed that almost everyone in the United States had been photographed by *Life* at least once.

Anyone at that time might know somebody who knew somebody else—whose face had actually appeared in the magazine. *Life* used to do four or five stories for every one that ran. "They shot much, much more material than they could use and then culled from it the best," says Shelley Mydans. Failures were anticipated under this system and accepted. As a result, stories on the complexities of ordinary life—an especially difficult subject to photograph in a telling fashion— were regularly attempted. Mark Kauffman documented the week of a housewife. Grey Villet chronicled the pressured life of a furniture salesman, and Capa watched as an aging grandmother tried to fit herself into her son's household. *Life* photographers invented the photographic essay (Luce coined the term in 1937 to describe their more comprehensive pieces) and brought new sophistication to the picture story. At no time since has anybody placed such expectations on pictures.

What might seem a scattershot approach to coverage was more organized than it appears. Until the 1960s, department editors routinely wrote outlines for picture stories—beginning, middle and end—and itemized photographs that might be taken. The purpose of these scripts was to persuade the picture editor that a story idea which sounded interesting would look interesting and be worth assigning to a photographer. All along the way, those involved in a story thought of it in terms of pictures. No text was normally written until a layout had been made and the photographs sent to the engravers. Naturally, an inspired idea in a script was not ignored (neither was a good idea from a reporter working with a photographer in the field), but many photographers did not want suggestions and felt that their best pictures depended on a spontaneity that no one could predict. If they read a script, most *Life* photographers said, it was only to note the factual information and travel arrangements it contained—names, addresses and dates. The magazine accepted this. The reasoning was simple. In the end, only a photographer could create a memorable image. If a photograph surprised the editors, it should also surprise readers.

By the 1960s, however, television had become the most effective way to advertise items that people of any income and education might want to buy. General-interest magazines of the sort that had developed national advertising at the end of the 19th century were no longer profitable. *Collier's* ceased publishing in 1956. The *Saturday Evening Post* was sold off in 1969. In 1971 *Look* magazine closed.

When *Life* stopped publishing as a weekly, 25 years ago last December, university art departments were just beginning to offer courses in photography. Since then—a bit like Adam and Eve after eating the apple and being expelled from the innocence of Eden—photography has become self-conscious. Most *Life* photographers assumed it was an art, but as Bill Ray modestly puts it, "I've never thought I was competing with Michelangelo or Rubens, or anyone like that." In the past two decades, self-expression has replaced exposition as the goal of many

a photographer, although one objective does not exclude the other. As Andreas Feininger points out, "To photograph something and get a picture that is exactly the way it looked to the eye is for the birds." Of course, Feininger's work is in museum collections today. As is that of many of his colleagues.

I confess that what makes these interviews so telling to me is not the vivid details of history they supply, but the individual voices of these men and women, in love with photography ever since they discovered it in their youth. These *amateurs* explain their ambitions, anxieties and accomplishments. Along the way, they have acquired special insight into their craft. "Suffering looks much better in pictures," says Eisenstaedt, who never photographed it. "It's much more dramatic than happiness."

"Photography is more than an art," says Ralph Morse. "In photojournalism, it's knowledge."

To interview them all, our crew traveled from New York to Los Angeles, San Francisco and Miami, carrying the camera, lights and a backdrop with us and transforming hotel rooms into TV studios. To put the interviews into print, I have edited nearly 800,000 words of transcript down to less than 200,000, and in doing so I've compressed some passages, moved or deleted others, and added a phrase here and there to guide the reader through. If I noticed a slip of the tongue or a misstated fact, I've corrected it. The normal hesitancy of speech is removed. If something important was not clear, I have asked the photographer to clarify it, but otherwise the interviews have not been revised. (Indeed, since they were taped, 13 of the photographers have died.) Each interview lasted one to three hours, without a break. The photographers talked without notes. They talked in earnest and for the record. Here is what they did. This is what they saw. This book is meant to be read.

This once, their photographs are subservient to their words.

— John Loengard
March 1, 1998

Unless otherwise credited, photographs printed with an interview were taken by the photographer interviewed. The date printed along the side of a photograph denotes the issue of *Life* magazine in which it first appeared.

If a man looked this way, and
I asked him to look the other way,
that's not a lie. I only wanted to
show the best of people

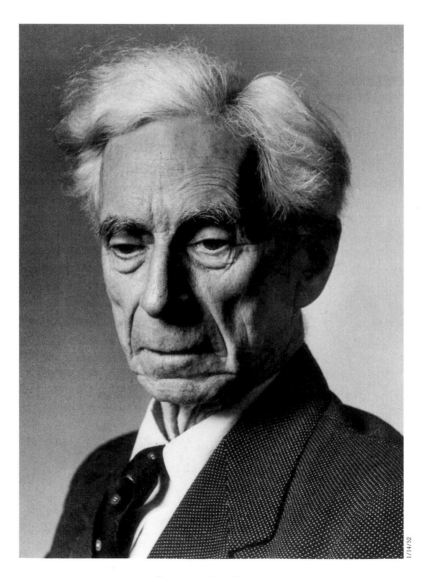

Bertrand Russell. 1951

# ALFRED EISENSTAEDT

**A**LFRED EISENSTAEDT: Whom have I photographed most in my life? I tell you: Sophia Loren. I was introduced to her in 1961. An editor phoned me and said, "We have a wonderful assignment for you. When is your story finished?" I was doing a commencement story on Harvard and Radcliffe, and I wanted to stretch it out a little bit, so I said, "Maybe tomorrow or day after tomorrow."

He said, "You have to go to Rome to photograph Sophia Loren."

"I am through in 15 minutes," I said. The next day, I was on my way to Rome. She was making a movie called *Madame Sans-Gêne*. I clicked with Sophia right away. I could do anything with Sophia. She was wonderful to me. About a year later, the *Life* reporter Dora Jane Hamblin asked Sophia, "Why do you click with Eisie so?"

She said, "Because he reminds me very much of my obstetrician."

When I started taking pictures, I had no idea it would be a profession. I got my first camera for my birthday in Berlin, from an uncle, when I was 11. It was an Eastman Kodak folding camera #3. I developed everything myself and photographed fountains, water, leaves, street scenes like any amateur does. I gave it up when I was drafted into the German army in 1916. I was a boy soldier. After the war, I did not photograph again until 1925 when I bought a Zeiss Ideal camera #3, with 9x12 centimeter glass plates. Again I took landscapes, cobwebs, forests and so on, but in September 1927 I went on vacation with my parents to Bohemia, and there I photographed a woman playing tennis on a sunken tennis court. It was four o'clock in the afternoon, and I was fascinated by her shadow. I took a picture that included other people and trees as well as the girl. When I came back to Berlin, I showed a print to a friend of mine who was always dab-

bling in photography. He said, "You can enlarge that picture."

I said, "What's an enlarger?" I'd never heard that word before. I went to his apartment, and he showed me a contraption on the wall, made of wood. He demonstrated for me how I could make a print that showed only the tennis player, without all that garbage around. This started my career. I saw possibilities. Before, I had only made contact prints, about 3x4 inches, on printout paper. Now I bought an enlarger, and I used the bathroom of my parents. Nobody else could go into the bathroom.

Somebody said, "You should show the picture to somebody at *Der Welt Spiegel*—that means *The Mirror of the World*. It's something like the Sunday magazine section of the New York *Times*. The editor there told me, "I like that picture very much." The caption under the picture when it was published was "Fall—Shadows Grow Long."

The editor said, "Bring me more pictures like this." Two weeks later I went to the Anhalter Bahnhof, a railroad station in Berlin, and I photographed an old lady passing through where four or five huge locomotives created steam. Sunlight fell on her head, and he liked that picture too. They paid me three or four dollars—12 marks. I didn't even know that you get paid for pictures. I was an amateur; I had no idea. At that time I was selling belts and buttons. I was always a very bad salesman. I was never interested in it. I was interested in art, theater, music and so on.

"If you want to do more, you should buy a camera like the one Dr. Erich Salomon uses," the editor told me. Dr. Salomon soon became a hero of mine. He caught all sorts of great statesmen off guard, in natural poses at international conferences. So I bought the camera, an Ermanox, and I photographed night scenes. I was in Bad Ganderscheim and photographed a street at night. I liked those type of pictures very much. I also photographed theater premieres.

I met people from the Associated Press, and I became a free-lance photographer. I got assignments to photograph cultural events and especially musicians. At that time I photographed all the great musicians of the world. Berlin was the music capital of the world like New York is today. I was still a belt salesman, and in November 1929 the boss told me, "You are a very bad salesman."

"I know this," I said.

"Make up your mind what you want to do," he said. "Let me know in a few days."

And on the 3rd of—I remember exactly—on the 3rd of December, 1929, I told the boss, "I'm switching over to photography." He looked at me as if I dug my own grave. I left.

Six days later I was in Stockholm to photograph Thomas Mann getting the Nobel Prize for Literature. At that time I could do anything. Nobody paid any attention. I had a little tripod between my legs, and a little camera was attached. You see, I had a very fast lens on the Ermanox camera. The lens opening was

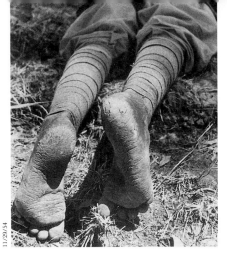

Ethiopian soldier. 1935
*Many people I photographed
were killed the first day.*

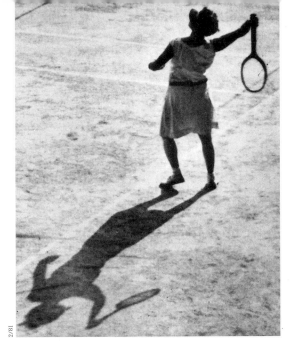

Bohemia. 1927
*I had no idea photography would be a profession.*

*Graf Zeppelin* in flight. 1934  *I just popped my head out the hatch and did this:* boom, bim, bim.

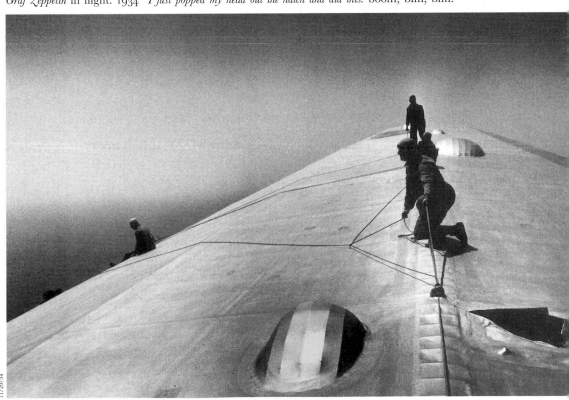

f/1.8, and it used Ilford glass plates, which I developed myself. I didn't even know what an exposure meter was. I guessed. And I bought a noiseless shutter, which I put in front of my camera. I attended many concerts, premieres and so on, and nobody paid any attention to me. I photographed all these great people. Furtwängler conducting Rachmaninoff with Bruno Walter. Nathan Milstein. Piatigorski. And so on. I photographed them all. Very often, I sat right with the orchestra when I photographed.

I was attached a little bit to the Associated Press, and I was there almost every day. They had other photographers around, but nobody had the Ermanox camera like me. I did very little in Germany. I was mostly out of the country. After I photographed the Nobel Prize in 1929, my second assignment was to go to Assisi, north of Rome, to photograph the wedding of Boris of Bulgaria to Sophia, the youngest daughter of the King of Italy. I went with exactly 240 pounds of equipment—large cameras, not the Ermanox camera. A Plaubel Makina, a Miroflex camera and so forth. When I arrived, I was fascinated by all the goings-on. There was so much pageantry. I saw Mussolini strutting by and King Ferdinand of Bulgaria—he had the longest royal nose in Europe. I was very happy. I photographed everything. When I came back to our office in Berlin, they said, "But where is the bride and groom?"

"What bride and groom?" I said. "I haven't even seen them." They thought probably I'm crazy. The man in charge of the AP in London said I had to be fired. But they couldn't fire me—I was a free-lancer.

In 1933 I took a zeppelin from Friedrickshafen, Germany, to Pernambuco, Brazil, where I stayed all night, and then to Rio de Janeiro, where we landed for only 18 minutes to take aboard one of the zeppelin company's executives. During the trip I was photographing the inside of the hull. The motors started running wild. Then there was quiet as the motors stopped, and everybody inside was running around. I asked, "What happened?"

"We have to repair the hull," they said. Some people went up a ladder to go out there on top, and I had great trouble to get permission for less than half a minute to photograph there, not even 10 seconds. I just popped my head out of the hatch and did this: *boom, bim, bim,* like this. Very fast. That's all. I did about 10 pictures, and then I went down and went to my cabin.

Everybody asks, "Wasn't it dangerous?" But it wasn't dangerous at all because we were drifting; there was no wind at all. It was like a balloon. It was a very airy picture.

It was absolutely wonderful flying in the zeppelin. We were 300 or 400 feet above the water. I had a Leica with me, but I photographed mostly with larger cameras: shipwrecks and shadows of palm trees and so on. After Rio, we flew back to Germany. It took two or three days. The speed was about 100 miles an hour, but you have no feeling you are in the air. The food was absolutely perfect. We had caviar and lobster and all kinds of things.

The next year, when I was photographing King Gustav V and his family in Sweden, I got a telegram to go to Venice. On the 13th and 14th of June, Hitler met Mussolini there. I photographed the handshake. Two months before, I had been in Italy to do society people for *Die Dame* magazine, and I photographed all kinds of ministers. They knew me, so I got permission to approach, 10 feet away, at the airfield. It was the first time I photographed Hitler. I knew what kind of man he was. People said to me at that time, "Why didn't you shoot him?"

I also photographed Joseph Goebbels in Geneva. He talked to about four or five reporters who were lined up with me in the garden of the Carlton Hotel. When they left, and I was alone, he looked at me. When I have a camera in my hand, I don't know fear—and I photographed him. I don't know whether that picture was published in Germany. Probably not, but I'm sure that the Associated Press sent it out overseas. There were also other pictures I'd taken that showed Goebbels arriving at the meeting surrounded by six or seven body-guards. Very elegant looking men with big swastikas in their lapels. (You could hardly see Goebbels. He was very small. He had a clubfoot.) About two or three weeks later, the doorbell rings, and I look through the peephole. I saw only the big swastika on the lapel. I thought, "My God, what happens? Are they going to arrest me?" But they were friendly; they came in. They wanted only pictures of themselves.

I wrote a letter to Goebbels, as the Minister of Culture and Propaganda, in 1935, telling him to take my name off the list of accredited correspondents. But, you know, when I left Germany in that year, I could take everything out. I still had permission to work there because I was in the First World War. My mother came about a year or two years later. The real trouble started there two-and-a-half years later.

I left at the end of November 1935, after I finished a very big essay in Ethiopia on the preparation for war against Mussolini. That was the first time I was in Ethiopia. In 1935, Ethiopia was very primitive and very easy to photograph. I photographed that famous picture of the feet of an Ethiopian soldier and many pictures of Haile Selassie and the Empress. I liked him very much. Mussolini attacked about six or seven months later, and many people I photographed were killed the first day.

I had stopped all payments from the Associated Press a year or so before, so when I came to America in 1935, I got all my money. But everything here was different. I found Germany was more advanced in everything than America. When I came to New York, for instance, I didn't like the window displays in the stores. Sixth Avenue had an elevated line. Everything was primitive compared to now, and it took me quite some time to get accustomed. I had lessons in English before I came, but I was better in French than English. I had to establish myself all over again here, and it was pretty difficult. With Léon Daniel, who had been with the Associated Press in Europe, I founded a picture agency called Pix. I was

Daniel Longwell. ca. 1938
*"The only thing I don't
want to see is blood."*

Henry and Clare Boothe Luce. 1943
*His idea about a new magazine
probably would be correct.*

Wilson Hicks. ca. 1938
*"Don't be afraid of all these
movie queens."*

Margaret Bourke-White. 1942
*Photographers are like spiders.
They don't come together often.*

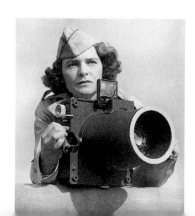

with Pix about 15 years. I left them in 1951 when I switched over full time to *Life* magazine.

Mr. Kurt Korff, who had been the editor of *Berliner Illustrirte*, brought me to Daniel Longwell and Henry R. Luce,[*] and they gave me an assignment for *Magazine X*. I was sent to photograph the Deep South. When he saw my pictures, Mr. Luce wrote later, he saw that his idea about a new magazine probably would be correct. You see, to me this was old hat. I did this for years in Europe. Magazine stories or series or photo essays. For me all this was not new, but here in America it was new.

At *Life* we were never told how to photograph. We were all individualists. We could do anything we wanted to do. Only once did an editor tell me what to take. It was in 1938 when Longwell[**] gave me an assignment to photograph Roosevelt Hospital in New York City. He said, "Alfred"—he didn't call me Eisie—"Alfred, you can do anything, but the only thing I don't want to see is blood." Longwell didn't like blood. Today, if an editor would give an assignment to a photographer, he would say, "I want to see blood one inch deep on the floor—and in color."

I was educated by a very famous editor, Wilson Hicks.[***] He gave me an assignment to go to Hollywood and photograph all these great movie queens there. He was smoking, with his legs crossed, and he said, "Don't be afraid of all these movie queens. You are a king in your profession." I've never forgotten that. Not that I feel like a king, but don't be afraid of people. The less you are afraid, the better.

The world changes every minute, every day. For instance, people ask me, "Do young photographers come to you and ask you for advice?"

"No," I say. "I ask them for advice. They know everything better." Naturally, they want to reach the pinnacle of their profession in six months. It took me a lifetime. They know more than I do about photography, about lighting equipment, but not about seeing. You know, it's not the camera which takes the picture; it's the eye. You could have the most modern cameras and not see picture possibilities. I see picture possibilities in many things. I could stay for hours and watch a raindrop. I see pictures all the time. I think like this.

In 1936 I was 38 years old. All the photographers were younger than I. All my life I was surrounded by younger people, and they treat me not as an old

[*] Luce started *Time* magazine in 1923 with Yale classmate Briton Hadden (who died in 1929). In addition to *Time* and *Life*, Luce founded *Fortune* magazine in 1930 and *Sports Illustrated* in 1954. Born in 1898 in Tengchow, China, the son of a Presbyterian missionary, Luce died in Phoenix in 1967.

[**] Longwell was hired by Luce as a special assistant in 1934. He was *Life's* first picture editor and became its executive editor in 1937 and managing editor in 1944. He retired from Time Inc. in 1954. Born in Omaha in 1899, he died in Neosho, Missouri, in 1968.

[***] Hicks was head of the Associated Press News Photo Service when *Life* hired him as picture editor in 1937. After his retirement from Time Inc. in 1952, he became a lecturer in photojournalism at the University of Miami. Born in Sedalia, Missouri, in 1897, he died in Homestead, Florida, in 1970.

man, but as their friend, brother and so on. That's the reason I'm still, in my spirit, a young man. I have friends, but not photographers too much. There was always some kind of rivalry going on, you know, with them. I found that photographers are like spiders; they are all alone. They don't come together often. I was friendly with all, but not close friends.

*John Loengard: But you became good friends with Margaret Bourke-White?*

Oh, Margaret Bourke-White! And I was often with Carl Mydans and with Peter Stackpole. Sure. But we were not socially together too much. That's what I mean.

*Were there any photographers from whom you learned especially?*

It's very difficult because nobody wants to imitate another photographer. For instance, Andreas Feininger did very different kind of work from me. The closest photographer to doing the type of photography I did is Harry Benson.

*If you were to tell me what it meant to be a Life photographer, what would you say?*

*Life* magazine for me was like the American flag. Something like this. We felt a great responsibility photographing for *Life*. We educated the world. We had a responsibility to be honest. When I staged a picture, let's say if a man looked this way, and I asked him to look the other way, that's not a lie. I only wanted to show the best of people. There are photographers today who show the other side, but I always like to do the best side of people. For instance, if I photographed the new ruler of Iran, Ali Akbar Hashemi Rafsanjani, I would show the best side of him. You see, if I have 30 pictures and some he sits like this, or like this, or smiles, or so and so, the editors can choose anything in 30 pictures what they want.

With Sophia Loren I could do anything I wanted. When *People* magazine decided they wanted to photograph her two little boys for a cover, Sophia said, "Absolutely impossible. No, on account of kidnapping, no pictures will be taken."

"But if we sent Lord Snowdon, would you do it?" they asked.

"I wouldn't do it for anybody," she said.

Then they said, "How about Eisie?"

"Eisie? Is he still working? For Eisie I would do it." Fifteen hours later I was on my way to Paris.

Sophia opened the door, and I said to her, "Sophia, how many pounds have you lost?"

She said, "Twenty-five pounds." She grabbed me by the arm, "Come right in and sit on my bed." I was sitting on her bed and looking at a TV program of Yves Montand. But this is how I am with her. When you are accepted by Sophia, you can do anything. You belong to the family. We had to cover every window with rugs and shawls to keep the daylight out because I used color film for artificial light.

When everything was finished, I wanted to clean up and said, "Sophia, when

any photographer photographs people, it always looks like a mess."

"But you are not a photographer," she said.

I said, "What am I?"

"You are a friend." She didn't permit me to do anything. This is how Sophia is.

When I have exhibitions, people ask me, Why don't you have color? I say that black and white is much, much better. Color never works very well with exhibitions. I don't know why. People look better in black and white. For instance, Sebastião Salgado photographs almost everything in black and white. If he photographed it in color, it wouldn't look good. People ask me all the time whether it's an art. I say, "I'm only a photographer. Let other people say whether it's art or not art."

*You like music very much. Has it affected the way you take pictures?*

I would say not. But it's very interesting. I am 93 years old. Lately, I always get up in the morning between 4 and 4:15 and do three different exercises. Between six and seven o'clock, I read the New York *Times.* From seven to eight, I sit in a dark room and listen to music, to tapes. Radio news and music. That's what I do in the morning. I feel very relaxed. But I listen only to classical music, not rock music.

*Have you been to a rock concert?*

No. And, you know, I still live.

*Can you talk a bit about your feelings in the early '30s, when you realized you had to leave Germany?*

No, see, it's very funny, my brain is blank; I don't remember too much. I was working all the time. I was traveling all the time. I was photographing very little in Germany. I photographed mostly in Switzerland, in the Netherlands, in France, in England, but never much in Germany.

*But you'd lived in Germany all your life.*

Until 1935, yes.

*As a teenager you were drafted, and then you were wounded.*

I was a cannoneer with the 55th Artillery Regiment, and I was wounded on the 9th of April, 1918, near Ypres in Flanders. Shrapnel exploded above me and went through this leg, in here. I'm very glad it went through, otherwise it would have split my leg open. They wanted to take my leg off first, but it did not happen.

*There were 10 of you with a gun?*

Yes, it was a 75-millimeter field gun. I was wounded at exactly 4 p.m. Everything was numb. I looked to see whether my legs are there. I thought they were shot off. They put me down. They cut my pants off and said, "Oh, my God, that's wonderful. You can go home now. This is a 'home shot' "—or whatever they called it.

Then everybody left because of machine-gun fire. I was lying on the ground,

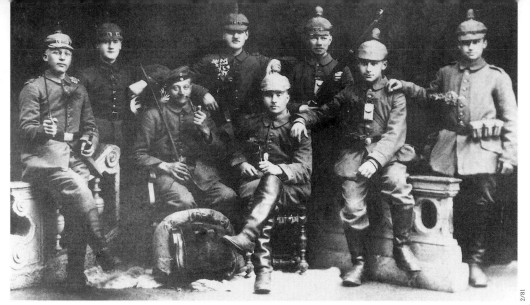

2/81

Private Alfred Eisenstaedt (second from right) in the 55th Artillery Regiment. 1916
*I looked to see whether my legs are there. I thought they were shot off.*

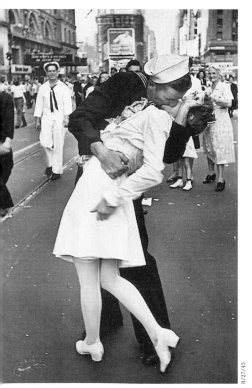

8/27/45

V-J day in Times Square. 1945
*It's a trademark. Like the picture
by Mr. Joe Rosenthal of the Iwo Jima
flag, the same thing.*

Adolf Hitler meets
Benito Mussolini. Venice. 1934
*People said to me at that time,
"Why didn't you shoot him?"*

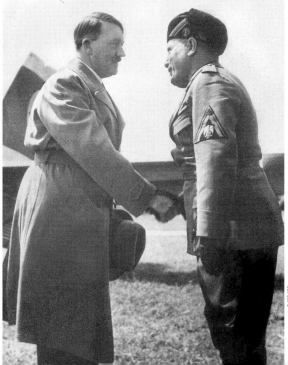

3/28/38

and I thought I will be killed. Two hours later people from the Red Cross came and put me into a wagon, brought me to near Lille in France. Three hours later they told me that everybody in my battery was killed. I was sent to Stettin in Germany for two months and walked on crutches, and later with a cane.

All my life I was always a health bug. I was never a vegetarian, just careful. I put myself on the scale every day, and when I'm a little over, I cut out, let's say, breakfast or something like this. My weight for 50 or 60 years is the same, 130 pounds. I say I'm 5'4" tall, but people say it's 5'3". I don't know. I have no idea. I don't care. I'm small. I'm a midget.

*Your family had been in Germany for a long time. You were comfortably off. Your father had a department store?*

Yes. But a long time ago. It was in Dirschau in west Prussia. In 1906 we went to Berlin, and I lived there from 1906 to 1935. My father had retired; he died in 1925. After the war, the inflation was unbelievable. One mark became a billion marks. What money my family had was gone. It was terrible.

*You got a job selling belts and sundries? Was that because of a family connection? The department store?*

No, it had nothing to do with it. I was a bad salesman. I was already interested in photography. I photographed all the time. I saved my money to buy photographic equipment, when other people went to breakfast or were drinking beer.

Today I can't even believe that I ever lived in Germany, I'm so assimilated to American culture. I understand German very well, but I don't know how to speak it fluently anymore. The first time I returned to Germany was in 1967 to photograph Mia Farrow making a movie in Berlin. At that time I didn't feel anything. But the second time I went back when I was the recipient of the Goethe Culture Prize. When I came to receive it, there were people who had been great Nazis, and they received me as if I were an old friend. Very, very funny. I did not feel too good, because the younger people are absolutely like Americans— wonderful  but the older people, they are still all really Nazis.

*You photographed Leni Riefenstahl.*

Oh, Leni Riefenstahl, yes. I had photographed her with Marlene Dietrich and Anna Mae Wong in 1928 and 1929, and I photographed her in Munich in 1980. She was at that time 72 years old. She was afraid that I might mention Hitler, because she photographed for Hitler very much. But I admired her. She was a wonderful lady. At that time, she did two books on African tribes and had started to photograph underwater. She wrote me twice.

*You have said that your best-known picture is of a sailor kissing a nurse on V-J day.*

Four or five different photographers got assignments to go to different places in New York to photograph the celebration, and I was assigned to Times Square. There were thousands of people milling around, in side streets and everywhere. Everybody was kissing each other, civilians, Marines, people, soldiers and so on. And there was also a Navy man running, grabbing anybody, you know, kissing.

I ran ahead of him because I had Leica cameras around my neck, focused from 10 feet to infinity. You had only to shoot; you don't have to fumble around. I ran ahead and looked back all the time. I didn't even know what was going on, until he grabbed something in white. And I stood there, and they kissed. And I snapped five times. A reporter was with me, but we were separated. I turned the film in at 8 p.m. at *Life* magazine. Next day they told me, What a great picture! I said, "Which picture?" I forgot already. Had no idea. Was a snapshot, an . . . accident.

*Do you think it's a good picture?*

I don't know, but I think it's the most successful picture Time Inc. has ever published.

*Do you like it?*

As a great picture? No, I don't.

*Why not?*

I don't know why. It's a very famous picture. They will remember whoever took that picture. It's a trademark. Like the picture by Mr. Joe Rosenthal of the Iwo Jima flag, the same thing.

*If you were going to do it again, would you do anything differently?*

No. The composition of their figures is excellent. She was up there [like this] and her arm [like this], and the man grabbed her. It couldn't be done better. That woman wrote me in 1980. She had seen a story in the Los Angeles *Times* that mentioned the picture. She remembered that she was the person. She wrote a letter, and I showed it to *Life,* and they investigated, and I met her for the first time. She wanted to invite me to lunch to a famous restaurant. I said, "I don't want a famous restaurant. But if you want to invite me to a restaurant where I have never eaten lunch, bring me to McDonald [sic]." They brought me to McDonald, and I liked it.

*What did you have?*

A hamburger and a milk shake. Exactly what I wouldn't do today. All the wrong food. Today I wouldn't do those things.

*You never got the sailor's name.*

Never, no. I remember only it was a mistake when *Life* published the story on the nurse and said, "Will the real sailor now come forward." I think 80 sailors came forward. One man even attempted to sue *Life,* but it was rejected in court. That man still says he is the sailor and the woman he married was the woman in the picture. It's not true.

*Who was the reporter who didn't get his name?*

I don't know. Most of my career has been working with reporters. Not all the time, but very often. Very few reporters were good. Many didn't understand pictures. In the first year or two *Life* published, we came to a farmer family. The farmer said, "Mr. Eisenstaedt, take my little doggie, and if you don't take my

little doggie, cancel my subscription to *Life*." I took that little doggie.

So when a reporter says, "Take that." You know what the best thing is? Photograph it. Wonderful. No trouble at all. But if you refuse, they're probably mad.

I remember once I worked with a reporter out West somewhere, and she was very difficult. She said to me, "Eisie, tell me what is wrong with me." Only this once in my life I did. I told her, and she started to scream and cry. Don't tell the truth when people ask you anything.

*Did Henry Luce have a good sense of pictures?*

No. Luce did not have any sense of pictures. But Luce said something very important, "I don't know very much about pictures, but I know what I like and don't like." I trusted the editors to pick the best pictures. I had to trust them, because at that time I was working so much that I never had time even to edit films. I'm rereading my diaries. I cannot believe that any photographer today works as much as I worked in the past. I worked day and night. I arrived sometimes at three o'clock in the morning in Washington. I finished up in the afternoon, and they'd tell me, Go to Detroit or somewhere. I slept on trains. I worked day and night.

*What did your wife think?*

Kathy said that *Life* comes 51% and 49% comes wife. When I told this to Mr. Luce, he said, "Eisie, you're absolutely right, but Clare [Boothe Luce] wouldn't like that." Kathy traveled with me sometimes. I took her along to do spring birds in the South a year after we were married. I took her to Sophia Loren twice.

*When you did that wicked cover of Sophia Loren?*

The cover where she is half nude? You know, we got about 2,500 letters when the story came out. Many, many mothers in America wrote to *Life* magazine that they had to tear the cover off the magazine because it is too risqué to send to their soldier boy in Vietnam. (They had no idea what's going on in Vietnam!) We got about 800 cancellations—how different it is today.

I photographed a dead body only once—in 1949 in Hollywood. There was an air crash, and I photographed a body. I never photographed a war, thank goodness. I can't look at blood, and I suffer when I see dirty people and misery. I just don't want to see it. However, suffering looks much better in pictures. It's much more dramatic than happiness.

*Is there anyone that you didn't photograph that you wished you had?*

I never photographed Indira Gandhi, and I wanted to photograph Mrs. Thatcher but couldn't get permission. I wanted to photograph Picasso. I couldn't photograph him, but somebody had an appointment with him, and I sent my autograph book and he signed it. (That's the only autograph I have I didn't photograph. I have nine autograph books. It was a hobby of mine.) I have been in every state except North Dakota. I have never been in Russia. I've never been

in China. The first time I went to Vienna was only several years ago. Never been in Hungary.

*Did you ever turn down an assignment?*

I don't think so. If it is bad assignments, I do it anyway. You know, on bad assignments sometimes the pictures come out nice, and on good assignments sometimes only poor pictures come out of it.

*Many think that your best story was on distinguished Englishmen.*

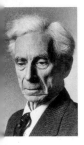

I suggested it. I was in London to do the campaign of Winston Churchill in 1951. I traveled with Churchill and photographed Clement Attlee, the Labour man, too. Everything was finished, and I wanted to come home, but Cornell Capa, who was a photographer in the London bureau at that time, went on vacation to the United States. So they asked me to stay longer. I said, sure, but only if I can do a story on distinguished Britons. I did 28 people in 11 days. I worked with three different reporters, by plane, train and automobile. Very fast. There was only one I wanted to photograph badly who refused—the composer Vaughn Williams. Some were chosen by me, but mostly by *Life* in London. Sometimes it took only three minutes. We could do the painter Augustus John only when we told him it wouldn't take more than 10 minutes. I photographed very fast. George Trevelyan was a very short time. The philosopher Bertrand Russell— when I commented that I have never seen such a stony, immovable face, he said to me, "A crocodile moves very slowly." I photographed Gilbert Murray, the great classicist who was 89 years old. It was November. He was sitting in Cambridge, warming in the sun. I was there a half an hour. Hugh Casson was a famous architect. Alexander Fleming was a great biologist, the man who was the discoverer of penicillin. I photographed him in the hospital. With the Very Reverend Martin Cyril D'Arcy, I spent some time. He had a very aesthetic face, wonderful face. The English people look very different, say, compared to Russian people. They are very drawn, you know, compared to Russians, who have the round faces.

*Suppose you were taking a picture of me. How many exposures would you make?*

I don't know. Let's say one roll of film. Sometimes I take only 10 pictures. I'm very different from Bourke-White. Bourke-White, for instance, if she had to photograph, she photographed 30 pictures the same pose. If I were to photograph you, after I go click, I change my position. I say look this way, look that way. Take your glasses off, do this. Raise your eyebrows, do that. Every picture is different. When I photograph 30 pictures, everything's a little different.

*What do you say to your subjects? What do you talk about?*

Oh, that's very funny. I just don't remember.

*What did you say to Marilyn Monroe?*

I didn't say too much, you know. I was on assignment to do a story on Lunch Hour, U.S.A., in 1953. I photographed John Foster Dulles, the White House

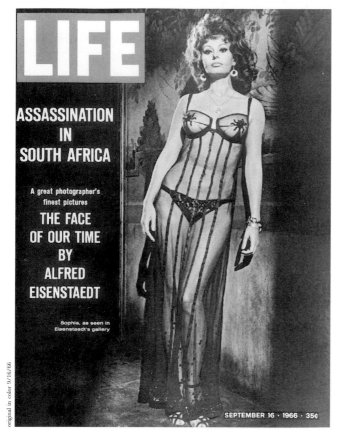

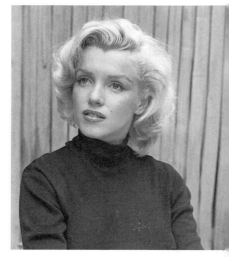

Marilyn Monroe. 1954
*She said, "Boys, come right over."*

Sophia Loren. 1966
*Mothers wrote that the cover is too risqué to send to their boy in
Vietnam. They had no idea what's going on in Vietnam!*

Gilbert Murray. 1951
*English people look
very different, compared
to Russian people.*

mess, and the Lions Club. All eating lunch. I went to Beverly Hills to photograph iron workers erecting buildings, eating lunch on beams. I asked the man in charge of our *Life* office in Beverly Hills whether he knows Marilyn Monroe, and he says yes.

"I'd like to photograph her," I said. "Can you make a call?"

She said, "Boys, come right over." It was very easy. I got along fine with her. I didn't know very much about her at that time, but she was very famous. She was a coming up actress. It was before she married Joe DiMaggio. I have pictures of where she sits on my lap too—and I sit on her lap. That type of thing. She said that I made her patio look like a palace.

I photographed John F. Kennedy—do you know why? It's a very funny story. In 1960 I went to New Hampshire to photograph frogs, and somebody said I'd find better frogs in Hyannis. So I went to Hyannis, and I photographed frogs and all kinds of things. At that time, the Democrats selected John F. Kennedy as their candidate. And Kennedy came back to Hyannisport. In his entourage was Don Wilson, who was an editor on leave from *Life*. Wilson asked me did I want to photograph Kennedy. "If you get an assignment from *Life*, you can do it." So, on account of the frogs in that pond, I photographed Kennedy.

Kennedy was great. He was very friendly. He came in, and I photographed him and his daughter Caroline, who was very small. I think she was four years old. She put chewing gum on his pants and on the legs of a table. I have a picture. He said, "Show me your mouth," and she opened her mouth, and he looked into her mouth. I photographed all this. Then I waited for Jacqueline. She let me wait a long time. I wanted to leave, but finally she came and was charming. And I can show you two letters I got from her when I sent her the pictures.

I followed up when Kennedy became President. I photographed his official portrait. He helped me close the curtains in the Oval Room. After, I showed him my autograph book. When he saw all these people I have photographed, he wrote in my book, "To Alfred Eisenstaedt, who has caught us all on the edge of the New Frontier. What will the passage of the next four years show on his revealing plate?"

*You also photographed Spiro Agnew?*

Oh, God. Vice President Spiro Agnew I photographed in 1971 during the Vietnam War. The appointment was for one o'clock at the building opposite the White House, the Executive Office Building. I was there already at 12 o'clock. And when I came up to his office, inside was an elderly lady, lovely lady, the secretary, and I asked her, "I would like to measure my light in the Vice President's office."

She said, "Come right in."

She went in with me. I thought nobody is there. I came upon an elevated dais, and there was sitting Spiro Agnew, and I was very surprised. I thought

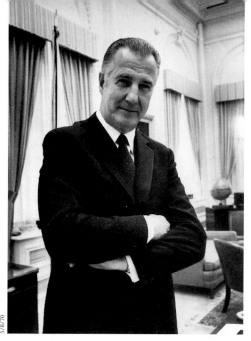

Spiro Agnew. Washington. 1971
*He looked at the little worm before him.*
*"Mr. Vice President," I said,*
*"let's chat a little bit."*

John and Caroline Kennedy. 1960
*"What will the passage of the next four years*
*show on his revealing plate?"*

Alfred Eisenstaedt. 1949
*He can change me into*
*anybody. Samson. Veronica Lake . . .*

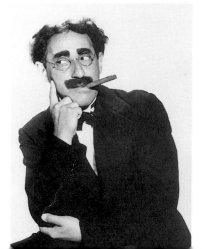

nobody was in there. I apologized. I grabbed my black exposure meter, and he flinched. I said, "It's only an exposure meter." I had it in his face, you know? He thought it's a gun. I apologized again. It was very hard to communicate with him. I said to him that I have an appointment at one o'clock with his secretary.

So I went out. I thought I can wait 45 minutes. But after five minutes he came out, "Mr. Eisenstaedt, you can come in."

So I photographed him on the dais, and I was there crawling like a little puppy, you know, because he was sitting high, and I was like this, crawling like a caterpillar close to him. I asked the Vice President—he looked at the little worm before him there—"Mr. Vice President," I said, "let's chat a little bit." Didn't say anything. I crawled a little further up. Didn't pay any attention to me. So when I was close to him like you and me, "Mr. Vice President, could you ask me some questions?" He looked up.

He said to me, "Are you a member of the silent majority?"

You know, when somebody asks you a question, you have to answer . . . You know what I did? It was at the time when they had the long-haired people, the yippies. I said, "Mr. Vice President, I don't have long hair." The press secretary had come in while I was there, and he stepped forward and whispered in Agnew's ear, "Mr. Vice President, he is a member of the silent majority." The Vice President got up and shook hands with me.

Somebody asked the Vice President later, "What is the silent majority?" You know what the silent majority was? Silent majority of people who eat dinner at Howard Johnson and line up at Christmastime before Radio City Music Hall to get a ticket. You know, every assignment I have something to tell. It's very funny, but, myself, I don't like to be photographed.

*You don't like to be photographed? Then why are there so many pictures of you?*

Sure, and they're all bad. There are very few I like. I did a story in Hollywood on Warner Bros. makeup man Wally Westmore. And I suggested to *Life* magazine, Do a story on me because he can change me into anybody. Samson. Veronica Lake . . .

*This is the man who says he doesn't like to be photographed.*

Yes, but you see, that time it didn't matter.

*Ernest Hemingway did not like being photographed either.*

He was the most difficult man I have ever photographed. He used only four-letter words, beginning and end. He told me that I have cost him 10 years of his life.

*Why did you annoy him?*

He felt pressured by me. I don't know. You see, he was an alcoholic. He was drinking from morning till evening. The second time I photographed, we photographed a deep-sea fishing contest in Havana. I visited Hemingway the night before, and he told me, "Don't come closer than 200 feet or else I will shoot at

you." This was a deep-sea fishing contest! We accompanied him in our speed-boat and kept at least 400 feet away from his boat. I saw him doing this: sig-naling to go away. That afternoon the Royal Yacht Club gave a cocktail party, and he came over, blue in his face from drinking and said, "Alfred, you came too close to my boat. I shot at you." With Hemingway, you had to think first before you answer, as he was an alcoholic. I'd forgotten that from the year before, and I said, "Papa, I don't believe it."

You know what he did? Dropped his glass. Foam came to his mouth. He grabbed me by the lapels and bent me backwards. My cameras flew all over. He almost killed me; he wanted to throw me into the water. To save myself, I pulled myself up close to him. He said to me, "Never say you don't believe Papa."

Thirty feet away was his wife Mary. An hour later she said to me, smiling, "Alfred, I didn't know that you liked men so much." She thought I wanted to kiss him.

<div style="text-align: right">

On the *Life* staff 1951-64
Interviewed in New York City on January 8, 1992

</div>

He was sensitive
about his baldness,
so he made a little crown of leaves
and put it on

Harpo Marx. 1937

# REX HARDY

**R**EX HARDY: When I got out of Stanford, I wanted some adventure. I had run across Peter Stackpole, and I wanted to be like him. A chap I had gone to school with was going to open an office for *Life*, the new magazine, and hired me to cover Hollywood at $30 a week. The first picture I took of any consequence was of a newcomer named Robert Taylor combing his hair. It was captioned "Beautiful Robert Taylor" in the first issue. That issue listed only four of the photographers on the masthead: Margaret Bourke-White, Peter Stackpole, Tom McAvoy and Alfred Eisenstaedt. The other four were myself, Bernard Hoffman and Bill Vandivert in Chicago, and Carl Mydans in New York. After I was in Hollywood for several months, I got summoned to New York. I took the TWA sleeper from Burbank, which was the airport for Los Angeles, and met Wilson Hicks, who had become the picture editor. He said, "You get a raise to $40 a week," so I was living pretty high. *Life's* offices were in the Chrysler Building, where we could keep our equipment and wait for a summons. The summons only came every so often, but we had to show up at the office every day.

My three covers were all surprises to me. Fred Astaire dancing with Ginger Rogers had been taken on a movie set where they were rehearsing. I was just snapping away and made 30 or 40 pictures. Months later the magazine came out with one of the photographs on the cover. I took Harpo Marx at a weekend party in Bucks County, Pennsylvania. He didn't have his wig and was sensitive about his baldness, so he made a little crown of leaves and put it on. I snapped his picture, and again to my surprise, there was Marx posing like a Roman emperor on *Life's* cover. The third was just as coincidental. Some editor suggested I go see Lucius Beebe, who was a well-known bon vivant at the time. We hit it off, and

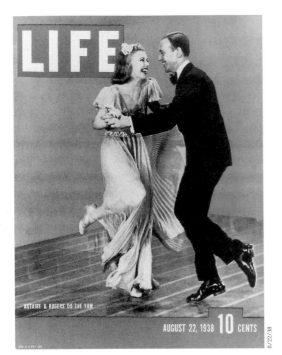

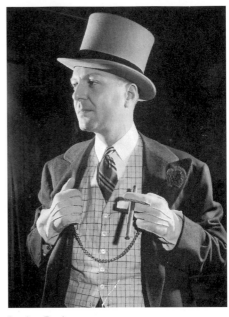

Fred Astaire and Ginger Rogers. 1938
*My three covers were all surprises to me.*

8/22/38

Lucius Beebe. 1939
*We hit it off . . . I thought that was
a very good picture.*

1/16/39

Border of Haiti and
the Dominican
Republic. 1937
*If I had been older and wiser,
I could have done more about
photographing the essential
Haiti. I'd try to get at the
heart of that very strange place.*

12/13/37

he put on a fancy vest and a top hat and wore a heavy watch chain across the vest. I thought that was a very good picture. Most of the time, I used a Leica, but here I used a 4x5 inch camera on a tripod. The photographer Otto Hagel suggested that I use flashbulbs located remotely, away from the camera. In those days, flashbulbs were the size of ordinary light bulbs, and you screwed them in and shot them off. I had bought some light fixtures, which I could carry around in a sort of suitcase. Otto was extremely good in technical matters. He had come from Germany with Hansel Mieth and photographed a lot for *Fortune*. He showed all of us how to arrange these lights and how to use the large cameras.

Henry Luce held court daily in a place called the Cloud Club, on the top floor of the Chrysler Building. I had the honor of having lunch with him there and looking around and seeing the likes of Juan Trippe, the founder of Pan American Airways, and other tycoons. Luce was aloof and fairly cool. I can't say I knew him, but I came to know his wife.[*] They were very kind to me. They had a big estate in Ridgefield, Connecticut, and they used to entertain on a grand scale on Sundays. Several times I was invited to lunch there. Later on, over the years, Mrs. Luce would pass through San Francisco and occasionally give me a telephone call. I've always thought extremely highly of her for her kindness to a very young man. I was 22.

*Life* had a picture of a different photographer in the back of the magazine every week, and whenever they had occasion to use me, they always referred to me as "*Life's* youngest photographer." I wasn't much younger than anybody else, but at the time it seemed so, and I was embarrassed by this tag. Peter Stackpole was the next youngest, and he's only a couple of years older than I. Of course, Miss Bourke-White (none of us called her anything but Miss Bourke-White) was a veteran. She had an office of her own, with a secretary, and adjoining that was a larger room for the rest of us. You tiptoed around her, but she was away a good deal of the time, up in Alaska with the Eskimos or in Europe someplace. Her secretary, Margaret Smith, was very good to all of us and did quite a bit for us. On a couple of occasions, I would rent a car with Margaret and go out to Newark, which was the airport for New York in those days, and pick Miss Bourke-White up from one of her trips. She always used a large camera on a tripod and had a collection of cameras which were absolutely beautiful, made of rosewood, with red leather bellows. She carried big suitcases around and had people following her, carrying—well, she was so imperious that she could get a bank president to carry her lights for her, that sort of a thing. She wasn't like the rest of us at all.

And we didn't see much of Eisenstaedt. He used to come to the office occasionally, but in the office were mostly Mydans and Stackpole and myself. Mydans

---

[*] Clare Boothe Luce's play *The Women* opened on Broadway in December 1936 and ran for 657 performances. She was elected to Congress as a Representative from Connecticut in 1942 and 1944 and served as ambassador to Italy from 1953 to 1957. Born in New York City in 1903, she died in Washington, D.C., in 1987.

and I had an apartment in New York together. At one point, I had run into a girl I had known at Stanford who was then a researcher at *Life*, and I introduced her to Carl. At the end of 1937 I was sent back to the Coast to do another Hollywood stint, and Carl wrote me to say I might be surprised to know that he was marrying my friend Shelley Smith.

Carl was very nice to me. He was a little bit older than we were. He was helpful and cooperative, but Carl was primarily a journalist from the very beginning. The pictures he took were coincidental with him. Some of the photographers were more concerned with the artistic end of things. I was neither artistic nor journalistically inclined, really. I was inclined toward adventure and experience. I was doing what Mr. Hicks told me to do. I was sort of typed to be the "Life Goes to a Party" man, which I didn't much care about, but I did do a story on Haiti with a man named Alexander King, who was one of Mrs. Luce's friends.

King was mostly involved with theatrical people, and he became a *Life* editor, with a sort of roving commission. He wasn't a magazine type. He was a very eccentric but a very likable man—a wild-haired fellow and a Hungarian. For some reason he got very interested in Haiti, which was having a war with its neighbor on the same island, Santo Domingo. He asked for me to come with him, and we sailed to Haiti on a ship, which was really the only way to get there at that time, although Pan American had a weekly flight.

We stayed in Haiti several weeks, taking various pictures around the place. We took some pictures of the President's inauguration. But what we really wanted to see was this war with the neighboring country, so we hired a car and driver and drove up into the mountains on a bad road, and took two or three pictures on the border and so on. Then we came back, and through some anthropologist King knew, we got involved in this voodoo thing. It took up several pages in *Life*, and I was very disappointed. It was simply a ceremony in the jungle. They massacred a chicken, did a lot of dancing around and beating of the drums, and I set off a jillion flashbulbs (which I threw in the jungle), but I didn't think the pictures showed very much. There's a double-page spread, as I recall it now, of various aspects of the chicken massacre, that sort of thing. Although it didn't seem to me that we accomplished a great deal, there were two or three dramatic pictures that came from it. We did go up to King Christophe's citadel, a really extraordinary place up in the mountains, but I didn't do much with the people themselves. If I had been older and wiser, I think I could have done more about photographing the essential Haiti. The squalor. I'd try to get at the heart of that very strange place.

*John Loengard: When did you feel that you did get to the heart of things?*

I don't know that I ever did. Maybe that's why I was glad to get out of it.

I guess I lost my girlish laughter early. Partly due to Hicks.

*You didn't like him?*

He was oppressive to me. He was a very cold man, and I was a very young man on my first job. I don't think we ever got a commendation. He'd look at the stack of pictures and flip through them and say, "Where's your overall shot?" And that was the end of it. I don't know when Hicks came, but I think my summons to New York after a few months in Hollywood at the beginning was initiated by Hicks. I had taken some pictures of some aerial maneuvers that the Air Corps was doing at that time. They turned out quite well, and on the strength of those pictures, I think, Hicks ordered me to New York. He kind of let on that it was a good job, but I don't know that *Life* ever used it. That was the most discouraging thing. We never found out what was going to happen to our pictures. We would work hard on a particular job, and wait and wait and wait and wait, and the pictures either turned up or they didn't. I don't suppose a tenth of the pictures I took were used, or a tenth of the stories I did were used. This got kind of discouraging after a bit.

When I came back from Hollywood the second time, *Life* had moved from the Chrysler Building to the Time & Life Building—not the present one, a smaller one nearby. Apparently, they had forgotten about the photographers, so we had offices around the corner. If we were summoned to Mr. Hicks' presence, we had to walk out the building and up the street to the Time & Life Building, and it wasn't nearly as homey as it had been in the Chrysler Building. In 1939 Mr. Hicks and I became discontented with one another. I missed California very badly, so I left and went back there as a free-lance. The Navy came along, and that was the end of it for me. I lacked the talent that the rest of these people had, as well as the temperament.

*What kind of temperament?*

I guess I lacked the ego of the performer. Others liked publicity more than I, and frequently there was jealousy about it. It was a kind of world that I didn't feel comfortable in. I was offered a commission as an officer in the Navy. I believed we were going to get in the war and should get in it. The Navy sent me to flight school, and from that I went to the Solomon Islands as the commander of a big B-24 bomber, which had one of the four bomb bays converted to mapping cameras. I spent the war years doing that kind of work, and I felt that I got the best education in the world in aviation. I got along with the aviation people. I felt more at home with them than I had ever felt with the photographic and publishing people, so I simply stayed in aviation the rest of my life.[*]

On the *Life* staff 1936-39
Interviewed in San Francisco on August 15, 1993

---

[*] After the war, Hardy tested versions of the Flying Wing bomber for Northrop Aircraft Co., and in 1954 became chief pilot for Lockheed Missiles & Space Co.

# We all went "Oh!"
## Because this poor invalid was suddenly
## Franklin D. Roosevelt

Teheran Conference. 1943

# JOHN PHILLIPS

JOHN PHILLIPS: I was born on Friday, November 13, 1914, in a place called Bouira in the Djurdjura Mountains in Algeria, which was then part of France. My father called himself a British subject. His family came from north Wales, very close to the English border—not far from Liverpool. They were there since God knows when. In 1400-something, when there was a Welsh rebellion, the family stuck with the British, which explains why they had so much property afterward. Nobody did much of anything until I came along. They were county gentry, and in those days, if you had farmland, it was sufficient. That's how I inherited 150 cottages and several hundred acres.

My grandmother was a very devout feminist, which at that time in England was extraordinary. For instance, she divorced my grandfather, and she never mentioned him to my father, except to quote him saying, "You must not eat oysters and Camembert cheese because it's wicked." She sent my father to Dover public school, which as you know in England is very private. My father was a rebel, and he got fired from there because he refused to sing. My grandmother didn't know what to do. The only one answer was to send him to the Siberia for the well-to-do, which was Switzerland. That's how he wound up in Lausanne studying with a professor who became my godfather. When my father finished his studies, he went to England to study medicine, but he used to go to Germany for holidays, and there he met my mother, who was from Troy, New York. Her family was, thankfully, wealthy. They had invented a way to make paper with rags. My mother and her two sisters and her mother were touring Europe in 1903, and my father met them in Munich.

So in 1904 my father dropped his studies five months before his finals and

went to the States with a camera and married my mother. When they asked him, "What do you plan to do?" he said he was going to the St. Louis World's Fair.

Then they went back to Switzerland, where his professor said to my father, "Why don't you go to Algeria for a couple of weeks? You like to take pictures. They say it's pretty colorful." My father bought a farm there and made very good wine and stayed until 1925.

Being a romantic, he enlisted in the French army when the First World War came and moved my mother and me to Algiers, where I had a little Arab girl who took care of me. She talked in Kabyle, which is an Arab dialect. I answered. They were the first sounds I heard, which explains the guttural accent I have. I sound like a wog. This is not very nice. If you're a Wasp, you should sound like a Wasp and benefit. When I got to the States, I said to Carl Mydans, "It's marvelous. Nobody has asked me about my accent."

Carl said, "Sure, you can speak with a Polish accent, and nobody cares."

I took my first pictures for *Life* when I was 21 and living in London. I had helped a fellow who was auctioning off his mother's house. There was a stack of magazines I never heard of, called *Time*. It was so beautifully printed I didn't mind it was four or five years old—it was nice reading. I sent them a picture I'd taken of a sculptor who was in the news, and I got this beautiful envelope back from the States with a letter on nice, solid paper, saying, "We apologize for not answering before."

That impressed me because English editors kept you waiting outside their office all day and then said, "Come back tomorrow."

*Time* said, "We are not using your picture, but as we're keeping it for the files, here's a check for $14." I realized I earned much more money not being published in the States than being published in England. They also said, "We are starting a new magazine. Our office is at number 2 Dean Street. Why don't you drop by?" An hour later I was in number 2 Dean Street, which was the *March of Time* office.

I met A.K. Mills, who was a *Life* editor, and he said, "We'll take your name. Don't call us; we'll call you." I got a call the next day. He said, "Parliament is opening tomorrow. The agencies will photograph King Edward, but we'd like you to get crowd scenes. We want them to be original, you understand? It's a new magazine. Don't forget: be original."

I knew my whole future with this magazine depended on these pictures, but in those days I was so darn shy, which is a very bad thing for a photographer. I couldn't photograph people face on. So I did 44 backs. Standing, seated, crouching, on walking sticks, etc., in the streets outside Parliament. The morning after, I arrived with 44 backs, and Mills said, "Well, by God, I asked for something different, and I got it. You're either an imbecile or very intelligent. I don't know which." After that, they kept on assigning, until Mills said, "John, we'll put you on staff. You'll like it because it will give you a sense of security." They put me

on staff for $36 a week. When I was arrested by the Nazis in Vienna, I thought, "Yeah, it gives me a nice sense of security."

In 1938, New York cabled, "Send John to Vienna. Something seems to be happening." I took a very nice suite at the New Bristol Hotel. I looked down from my balcony on the Ring and the Kärtnerstrasse. I was with Bob Best, a United Press correspondent. On March 12th the Germans entered Austria.

"Have you got the press card?" Best asked me.

"No," I said.

"Well, that's lucky," he said, "because the Nazis loathe *Life* because of the *March of Time* on 'Inside Nazi Germany.' But if you have no press card, of course, you're in trouble because you need one. So you'll probably be in trouble either way."

Suddenly I had an idea. I rented the enormous Daimler automobile that the Duke of Windsor had used when he visited Vienna after abdicating the throne of England. I put two swastikas on it, and I had the same driver as the duke, in a black uniform. We went straight to the palace where Chancellor Kurt von Schuschnigg was held prisoner. They saw me get out and thought, "Obviously an official photographer." I took a couple of pictures of the young Austrian Nazis at the gate—the whole trick was take a couple of pictures, get back in the car before they asked to see my credentials—and I was off. I did this around the city for four days. Every day I sent my undeveloped film out on KLM Airlines, Vienna-Berlin, Berlin-London. I figured no one would try to censor film headed for Berlin.

Best suggested I hire a Jewish guy called Ernst Klein as a guide. Klein was a photographer, but I said, "Look, don't take a camera. I want you just to show me around. If they see a Jewish guy with a camera, we're all in an awful mess." On the day Hitler arrives, after the Anschluss, the Germans brought in huge trucks with troops to control the crowds. They stood along the avenues like a sea wall. I'm on my beautiful balcony. I invited the American military attaché and a number of other important people. I looked down, and to my horror I see Klein on the roof of my car with his camera, trying to force his way through the crowd. I thought, "Oh, my God, he is out of his mind, standing up there with a camera." I see he's pointing to our window, and by now he's arrested, and they're frog-marching him up to our room.

The American attaché says, "I'll speak to the consul general."

Everybody says, "We'll see what we can do." So, left in the room were Klein, myself, the *March of Time's* French cameraman Marcel Rebière and director Gilbert Comte. I ask, "Are we under arrest?"

The Germans call up someone, and I hear them say, *"Wir haben vier Juden."*

I say, "They said we're Jews."

The Frenchman is a genius. He opens his pants, pulls out his pecker and says, "You call that kosher." Well, that threw the Germans. Still, they held us there.

Now it's very funny. When you're arrested like that, you don't know how you'd react. I suddenly got mad—arrogant—because I had a British passport. The Nazis, on their day of triumph, would not knock the hell out of some English correspondent working for a large American publication, it seemed to me, so I was snotty. Four hours later they put us in a car and took us to an enormous building. Inside there are about 400 guys, naked, with their arms up in the air. I said to Rebière, "You think we'll catch pneumonia?" He had lost a finger at Verdun in the First World War and didn't think that was funny. They marched us to this German officer.

"Have you taken pictures?" he asked.

"No," I said. "I just took a couple of pictures of the Führer going by." I sounded fine.

"No other pictures?" he said. "Well, we're going to release you."

"And Klein?" I asked.

"Oh, no, we can't release him," the officer answered. "He is an Austrian, and we've got him."

We get out. I rush off a telegram to London to say pick up my film. *Life* held up the presses, and they used some of my pictures. I told Best about Klein, and Best told the Governor of Pennsylvania (who was touring Vienna), "There's this poor fellow who's in jail. He's an innocent man."

The Governor met with the Nazis, and the Nazis said, "All right, we'll release him." I decided it was time to get out of Austria.

*John Loengard: Did you get a reaction from New York to the pictures?*

We never really got responses. I remember I sent them a telegram after the Teheran Conference in 1943. I said, "Everybody's congratulating everybody, but I'm the only one who got there, and you don't send a word. Don't you love me anymore?"

New York had a rear-echelon attitude. Wilson Hicks first brought me through there for four days in December 1938. He wanted me to photograph the Nazis in Latin America. Before he got me off, he introduced me to the managing editor, John Shaw Billings. I also met the executive editor, Daniel Longwell, who said, "John, I want you to show how similar Latin America is to the United States."

I said. "Mr. Longwell, I've only been here two days."

"Well, look out of a plane window," he said.

At that time in New York, you arrived at a restaurant, and they gave you a big glass of water. You had a feeling of generosity. Things were done on a big scale. I mean, you ordered a sandwich, they'd give you free napkins with it and four pickles. There was a friendliness, an easygoing quality. Everybody had dinner about 5:30, six o'clock. I got there on December 18th, just before Christmas. The thing that startled me was that if the mailboxes in the street were full, people put packages on top of them. Nobody would touch the mail or the mailbox.

Ministry of the Interior. Vienna. 1938
*By now he's arrested, and they're*
*frog-marching him up to our room.*

Marshal Tito and Tigar. 1944
*"If the police are ever after you,"*
*Tito said, "have a dog. That*
*throws the police off more than any-*
*thing. But change dogs."*

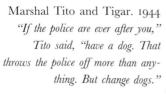

8/14/44

I mean this was sacred. That was the way it was in those days.

John Shaw Billings was a very great man. He didn't talk much, but if he liked you, he really liked you. Wilson Hicks, on the other hand, was unsure of himself. When Billings rang for him, Hicks would set a world record between his office and Billings'. God help you if you were in the way as he was whizzing by. He was that type of man. He reduced and reduced the photographers' office space to show to Henry Luce what he could do with little. Hicks was a budget man. Longwell, on the other hand, had practically the whole damn floor for writers. Luce wanted me to write in the early days. Longwell brought people in from California and gave Luce a dazzling luncheon of writing people. Then Luce asked Hicks to do the same. Hicks apparently sent everybody out of town. He kept only Alfred Eisenstaedt, who's no great conversationalist; Fritz Goro, who used to take scientific pictures; and another German, Walter Sanders, who did fashions. He would say to Luce, "See, Harry, that's what I have to work with." I could have killed him for that. Do you realize in those days there wasn't even a rest room for photographers? Hicks would say, "I should have a magazine with no staff photographers and make 'em work." If you hated Chicago, he sent you to Chicago. He dreamt of being managing editor. It was a bloody miracle that he ever made picture editor.

*Although Wilson Hicks didn't hire you, he built up quite an extraordinary staff.*

Yes, but you know, he was like Scrooge. He was really mean with the staff. Don't forget, the whole world wanted to work for *Life*. I think the genius behind it all must have been Harry Luce, because we really had one star, who was Margaret Bourke-White, whom Luce had brought in to work on *Fortune* in 1929. She was older than us. We were kids, and—face it—*Life* was making what? Half a billion a year? And we were making a hundred bucks a week.

*Did you ask for a raise?*

I got a raise. I said to Hicks, "I'm not a *native* anymore, so give me $100 a week." I knew that William Vandivert was making $150. One of the things about Vandivert was that he was 6'5", and he learned a trick about Hicks. He'd pace up and down a room, and Hicks would get very nervous and agree to anything. See, Hicks would sit—he had a part in the middle of his hair—and look out the window and turn around on you. I don't think he was fundamentally a bad man. He was a man in a job he really couldn't really cope with. Had he had more stuff, he would have been much nicer.

*Whom did you like?*

Carl Mydans was a good friend. I liked Thomas McAvoy, but I saw him very rarely. Goro was a remarkable man. Bourke-White was fantastic. But I said to her in Italy after her ship was sunk in the Mediterranean, "Gee, that torpedoing was something."

"John, it was a K-2 sky," she said. But that doesn't lead to much conversation, does it?

*"K-2" means?*

A K-2 yellow filter was used to darken the sky and bring out the clouds. She was an extraordinary woman. I mean, you just look at that picture of her standing out on a ledge on the edge of the Chrysler Building, and you want to throw up. No, no, she was a terrifically brave woman. She had Parkinson's disease. The last time I saw her was very moving. There was a dinner given in her honor at the Overseas Press Club in the late 1950s. She could still dance. She had a sort of crablike movement. Ray Mackland, the picture editor then, said to me, "Would you see Maggie home?"

She was staying on 42nd Street, and when we got there—she had a long white dress, evening dress; I in a dinner jacket. Suddenly she takes her shoes off and starts running, and she is running down toward where the United Nations is. I'm galloping, thinking, "Oh, my God! If she falls, I will throw my arms around her and hope for the best."

We get to where the light's green, and she goes across. She goes up to the United Nations building and gallops back. And when we get back, she says, "Would you like a drink?"

I said, "Would I like a drink? My God, yes!"

So we have a drink, and she has a Sunday paper, and I help her carry it up, and she said, "Could you do me a service? Could you unhook my dress?" So I unhooked her dress, kissed her goodbye, and I never saw her again. But she was extraordinary. The willpower. No sense of humor.

I once made a crack. I didn't mean to be nasty or funny, but I said, "If Maggie had more sense of humor, she wouldn't have been as successful a photographer." She was just driving. Just drive, drive, drive.

*You started to talk about the Teheran Conference. They didn't kiss you for getting in, but how did you get in?*

The British Ministry of Information tacked me onto the delegation to the Teheran Conference in 1943. If you look at the manifest, you have No. 1, the Honorable Winston S. Churchill, Prime Minister; No. 77, John Phillips, miscellaneous and advertising. I got a call, "We're leaving at dawn tomorrow. You'll be away four days. Destination unknown, but very cold." I learned where we were going, and I must say, it is an emotion I think the astronauts must have felt when they first went up—we were going to see Stalin!

We landed in Teheran and were driven down to the legation, and the foreign-office secretaries started turning everything into an office, and I was there to hang around. I talked to this guy, and he said, "I think six will do, don't you?"

"Why, if you say so, yeah, yeah, I guess so," I said. I mean it was a secret thing, so let's be secretive.

He said, "You know, my name is really Mr. Kram, *K-r-a-m*, but I'm here as Mr. Mark, *M-a-r-k*. You see, wherever I go, Hitler knows Mr. Churchill goes. I'm a chief petty officer of the Navy, and Mr. Churchill takes me to organize

dinners abroad, banquets, and take care of him."

So here I knew Mr. Mark. My whole story would turn around Mr. Mark. I finally discovered what six he was talking about. At the entrance to the British legation, there was a man selling turkeys, and he decided six were enough for the Teheran dinner. I asked, "You buy them yourself?"

He said, "Oh dear, no. No, no. They would have overcharged. I sent one of the local boys to buy them." I got the whole inside story of how the banquet would take place.

I'm sitting waiting for the official portrait session to start, and suddenly I look, and there's Stalin. Beautiful cap, uniform. Somebody said he got his beige uniform from Saks Fifth Avenue. Nobody could prove or disprove it. He walked around, and he looked to me like a Balkan peasant. You know, slow-footed but very sure. I could have touched him. No expression. His face was pockmarked, like a piece of granite. His right hand was shriveled like the Kaiser's. And then out comes Churchill in his air force uniform. He sits in a very comfortable armchair. He looked like a bad-tempered angel. Cupid, you know. The seat in the middle was for Mr. Roosevelt. Suddenly the two bodyguards came out carrying Mr. Roosevelt. Here's the President, the cigarette holder in his mouth, and his legs were flapping in the wind. A guy stood in front of me and said, "No pictures." Boy, if I'd taken one I would have had my head blown off. They put him in a chair, and his foot kept swinging back and forth. They blocked it. Then suddenly they moved back and we all went "Oh!" Because this poor invalid was suddenly Franklin D. Roosevelt. I mean, I have never seen anything like it. How he took over!

None of us had realized how crippled he really was because that was such a guarded secret. Stalin was sitting in a hardback chair—a bureaucrat's dream—awful. Roosevelt's was a mixture between an armchair like Mr. Churchill's and a bureaucrat's—comfortable but fairly rigid back. I took pictures. I remember Sarah Oliver, Churchill's daughter, came in. And Roosevelt said, "Oh, Mrs. Oliver, this is Marshal Stalin." Stalin kept looking at the photographers. Absolutely expressionless. Then we were shooed away.

There was a 69th birthday party for Mr. Churchill. I was told I could do nothing unless I was specifically told it was O.K. I'm there early, and I'm waiting in a yellow room, facing a dining room with 34 seats. The first man to walk in while I was waiting was Harry Hopkins' son Sergeant Robert Hopkins in battle gear. There was Randolph Churchill, Churchill's son, and Sarah Oliver. There was Mr. Roosevelt's family. His daughter-in-law and a married daughter. I mean, there was quite a family group. As I waited there, Mr. Churchill was moving around the seats, and he looked up, and he said, "Are you planning to photograph Marshal Stalin? I tell you what I'll do: when I go to meet him, I'll have a colonel with me, and I'll ask the marshal if you can take a picture. If you

can, the colonel will pull out his hanky from his cuff and wave it. That means you can take pictures."

I said to myself, "Fat chance." But he did remember.

Suddenly there's an uproar, and Stalin arrives. The colonel does his bit, so I'm ready. Stalin takes his coat off. He reluctantly takes his cap off and then walks into the yellow room, where I can't take pictures. Those pictures would have been wonderful. Roosevelt was seated mixing martinis. He gave one to Stalin, who sipped. One to Churchill, who knocked it back. Molotov was drinking a cocktail for a change, talking to Eden. It was unbelievable. It was like Madame Tussaud's waxworks.

*How did you feel about not being able to take pictures?*

In those days, you know, they gave orders and they meant it. You didn't fool around. At least I could watch it. I made notes. I wrote a piece and I sent it to *Life*, which they didn't use. Actually, I gave it to the *Time* correspondent, who filed it, and I'm quoted as a distinguished diplomat who said, "This is the greatest meal since the Last Supper."

*Why do people do things for you?*

Well, I had a great knack of getting in. You see, I did a very simple thing. I always photographed people the way they wanted to be, on the simple assumption that that's the way they are. For instance, when I started photographing King Farouk in Egypt, he showed me his throne room, and the throne looked like the inside of one of these raisin cookies, studded with all sorts of thing. I said, "Could I get a picture of you in your throne?"

"No, it's much too modest for me," he said. From that moment I knew he wanted to be seen as "the Great Farouk." When we photographed his cars, he would get out his *eight* favorite cars. I mean, I found if you follow people and anticipate the sort of thing they would like, and you ask them to do it, they will do it with pleasure because that is in keeping with their character.

I'd also bone up on a subject. If I'd go to Greece or Turkey, I would study the history. A photographer in those days had time to shoot a story. I went to a civil war in Greece. I had to get an idea of the people. They were all very eloquent. All a bunch of liars, I mean. One would say, "Every minute of the day, every second, we're fighting another Thermopylae." You know, that sort of stuff. I realized the whole story was about a bunch of crooks who were trying to talk the United States into giving aid. I discovered aid stashed away here and aid stashed away there.

*Did you ever photograph someone that you didn't like?*

Hitler.

*When did you photograph Hitler?*

That morning when he was going by in Vienna. You know, I wrote Hitler a letter. We were with Tito's partisans who went in to blow up a bridge in Greater

Germany. The great joke, we'd come into villages which were German held, and so you scribble things: The Führer, Germany, an insult, and leave it in a mailbox.

*That was after you photographed Tito, the Yugoslav guerrilla leader?*

Yes. I had moved on from Egypt to Italy, and in July of 1944 I went to see Tito in his cave on the island of Vis, which is very close to the Dalmatian coast. My first impression was that I'd come to see a revolutionary, and there instead was a chairman of the board. He was seated at a table. Everything was in meticulous order. He wore a uniform made out of a horse blanket. I didn't know it was the only uniform he had. It was a very hot day, but he looked cool. Tito said, "Look, take anything you like, but just don't ask me to pose. It looks more natural that way."

It went on to such a point that I followed him once, and I realized he was going to the latrine. With his face in repose he was a pretty cold fish, but when he'd laugh and smile, his face would light up. He had these extraordinary cobalt blue eyes. He once said to me, "Johnny, if the police are ever after you, have a dog. That throws the police off more than anything. But change dogs." The first thing he did when he became Secretary of the Communist Party was to refuse to take money from the Russians. He asked me, "Why should I be expected to love another country more than mine?" At that moment I realized that he might be a communist but he was not one of Russia's stooges. That's why I finally suggested *Life* publish Tito's memoirs, which we called *Tito Speaks*. With Tito I used five Rolleiflex rolls—60 exposures—I nursed my flashbulbs. I would do one shot of this. One of that. I mean everything got covered, but never repetitiously. As I went along, I had to calculate what would describe Tito. I got a general view, and then I got a close-up, but I didn't have to take 20 pictures of each. I saw he had his pencil, his lighter, a pencil sharpener and his army stamps. Next to him was an old weather-beaten leather case. I got close-ups of all that. I remember that the only time Tito was a little difficult he said, "You watch my dog. He jumps." He had Tigar belly-flop in the water. He said, "Maybe you better get another picture." That was the only time he worried. He was so proud of Tigar's jumping. Tigar had belonged to an SS colonel who had cut his ears and chopped off half his tail. He was always with Tito.

He adored the dog, and over the years, whenever I went back, I would always ask, "How's Tigar?"

In 1949 he told me, "He died." Every other German shepherd he had was called Tigar in memory of that dog. Tigar hated Russians. He used to nip a Russian general. That made Tito laugh. He would say to the general, "My dog doesn't like Russians."

After I'd first photographed Tito, I was supposed to parachute into Serbia to be with Tito's partisans. I waited in Bari, Italy. Twice a day I'd go call up the

British mission. At noon they'd say, "No movement." At 6 they'd say, "Call up tomorrow at noon." I waited six weeks.

One night at the OSS bar, a big, burly, drunken guy came up. His name was Captain Jim Goodwin, and he was an explosives expert. He said, "You want to see the war instead of hanging around the bar? I'll show you the war, if you've got the guts. I'm going into Germany. Want to come?"

I said, "Sure. Where are you staying?"

So he told me, and next morning I went and knocked on his door. Later he said, "I thought you were going to slug me. I'd been so insulting the night before, and all you asked was 'When do we leave?' "

Well, he went in, and I was to follow. So I waited and waited. You know, if something is inevitable, you think it'll never happen. Suddenly, I'm calling up at noon, and they say, "You're on."

I said, "You're kidding. I'm going swimming this afternoon."

They said, "You're going into Greater Germany. Be ready at 2:30." I did not have to parachute in because the plane was delivering ammunition to the guerrillas. We made the best landing I've ever made in a field, and I got out, and there was Jim. A group of partisans unloaded the plane, and we moved to headquarters. We were going in to blow up a bridge at Litija in Slovenia. We were a brigade, and at that same time, on the other side of the Sava River, another brigade was going through the same business. We spent 24 hours waiting for the explosives—this kind of plastic they packed in bags. It had a very sweet smell. When they fed us well, we knew a big action was happening.

At 7 that night, we moved and left what was called liberated territory. We moved one after the other in a column down into the valley and marched from 7 at night until 7 in the morning. As we walked, we kept saying one thing, *"Ali je veza?"* which means, Is there contact? From the first man to the 800th, we would answer, *"Je veza,"* there is contact. If suddenly there is no contact, we stopped. The whole column stopped. And then we'd check back to see who was missing. Twice we had a piece of artillery fall in a ravine, so it gave us 20 minutes to rest up.

We had to hurry because we had to pass German positions before dawn. At one point, I was holding the rifle strap of Goodwin and the partisan behind me seized my musette bag. We were running at night, bouncing up and down in the forest. And I remember dawn came suddenly, and I saw hills. Suddenly I thought, "My God! Nature can do things a photographer can't." I mean the sky was this green and orange mixed, which was beautiful to look at, but even if you painted it, it would have looked like hell.

We finally got near the spot where we could launch our attack. We slept until 2, had a meal, then we went up into position. We had brought 800 men to about a mile away from where the Germans' bridge was, and the Germans never knew

we were there. Same was happening on the other side. The bridges were forti-fied, and the reason you blew up a bridge was it could hold up traffic for two months. If you blew up a railroad, they could fix them in a few hours.

We were in the trees, sitting there waiting to get air support from five fight-ers. They finally came over, and I watched a bomb, which looked like a grape, coming down, down, down. Then the explosion. And then there were 800 men galloping, screaming at the top of their voices, "The Amerikanskys! The French! The Russkys are with us, you sons of bitches! We're coming after you!"

Well, you hear 800 men screaming like that, roaring down the road. I can tell you, you just get carried away. People are coming out of the German bunker to surrender. It was extraordinary because the first one who came out laughed, and we all laughed. One cried. We all cried. Another came with a weapon. He got bashed to pieces. Somebody threw a grenade, and Goodwin got wounded in the leg. The next thing I've got to do is to help carry him out. And, strangely enough, a wounded guy, a German, follows us. Greatest mistake he made in his life. So we're carrying Goodwin back to the hospital. By God, he was heavy. The "hospital" was a house in a nearby village, two rooms with one acetylene lamp, a doctor and straw. They had no real bandages. They had bits of shirts sewn together. When a man died, they took his shirt off and put it aside to wash. Goodwin had sulfanilamide, and the doctor spoke French, so I was the inter-preter. He said, "I've never used this. Let me do it the old-fashioned way and clean the wound, picking." Goodwin had taken something like 30 pieces of shrap-nel. Thank God it was an Italian grenade—a "red devil." If it had been a Mills grenade, the leg would have gone.

After picking out the bits of aluminum, Goodwin said, "I can't stand it in here. Take me outside." So I put him against the wall of a barn, on straw, and I got next to him to protect him. And we were lying there, and suddenly in the middle of the night we hear the explosions. Jim nudges me and says, "We got the bridge." There was a horse nibbling the hay around our feet.

At 4 in the morning we began our retreat, and at that moment in a battle, the doctor takes command. He says, "You've got to hold until I get my wound-ed." We buried our dead and got the wounded going, because the whole psy-chology of this war was that the Germans would be left with a destroyed bridge and nobody, no trace of anything. I remember a girl—we called her the Amazon—she'd been tough in the attack. She was standing up firing, and she had been shot through the heart. She looked quite tiny, you know. We put Goodwin in an ox cart and started to retreat. It was a little bit like *For Whom the Bell Tolls*—a battle for a bridge. So my story turned out not to be about attack-ing a bridge but getting out.

We were about to leave, and there's that wounded German. I gave Goodwin a cigarette, and Goodwin says, "What happens to the German?"

The doctor says, "We leave him here. His friends will take care of him."

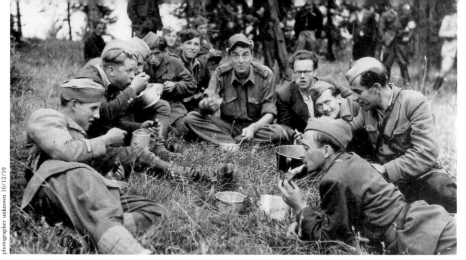

photographer unknown 10/12/59

Phillips (center) with partisans. 1944
*You scribble things: The Führer, Germany, an insult, and leave it in a mailbox.*

Major Jim Goodwin. 1944
*My story turned out not to be about*
*attacking a bridge but getting out.*

11/6/44

Bridge at Litija. Slovenia. 1944
*You have a high or a low threshold of*
*pain. I had a high threshold for fear.*

11/6/44

10/19/42

M. & Mme. Henri Bergeron. Saint-Fidele, Quebec. 1942
*The show had gone. I only saw it years later.*

"No, he's seen too much," Goodwin says. "Got to shoot him."

So I said to the doctor, "The captain says he has to be shot. He's seen too much." We're going out, and I hear a pistol shot. They killed him. They marched off. It took us two weeks to get out.

*I want to ask you about courage.*

You know, you have a high or a low threshold of pain. I had a high threshold for fear. For instance, I've watched people be scared when I wasn't scared at all because in my opinion there was no danger.

*When were you afraid?*

I was scared when I was under fire—you don't know who's around and there's shooting in all directions. When I got out of Greater Germany, *Life* sent me to Coney Island for a party with some café-society types, and they all wanted to get on the roller coaster. They said, "Would you like to come?"

I said, "Me? You're out of your goddamn mind. Pay 50¢ to be scared? I've been so scared in my life, I don't want to pay any money to have the experience."

*If you were to face St. Peter and could only bring one photograph, what would you bring?*

I have no idea. I suppose the most important one is Teheran. But it's not the most interesting as a picture. Tito in his cave is a historical document. In my book I wrote that I started off as a press photographer. I wound up as a historian.

*Why did you leave* Life?

I left because I got bored, in a sense. Don't forget, I started off at the top. At 21 where could I go higher than being a *Life* photographer? I had the big stories, maybe not because they got a big play, but I thought they were important stories. During the war, nobody could give us instructions because the movement orders were secret. You went along, dreaming up your stories on your own. After the war, I got in this fight with Hicks, who said I didn't understand Europe.

*He said you didn't understand Europe?*

Yes, he said, "Europe is not your meat." So I wrote him an 18-page letter, proving he was a damn fool, and that was all. Finally, I wrote to Edward K. Thompson, who had become the managing editor. I said, "Look, Ed, I'm going to resign. It really doesn't work out." Very friendly.

"I'll let you go, John," he replied, "because you really aren't suited for working at a large corporation." He was probably right. I like to go and dream up a story and suggest it to the editors and do it. Don't forget, all of us had done so many important things. It would be like suddenly asking a writer of some stature to go and write puffs.

*You talked earlier about photographers not having any offices or even a washroom. Did you feel as if you were a second-class citizen?*

We were second-class citizens, but I used to go around with all the writers when I was in town. I liked their company because they didn't tell me how the world looked through their typewriter. I mean if I talk with Carl Mydans, we can talk; but some of the others would talk photography, and that bored me. Maybe

about some technical thing you do it, but a general conversation I thought should be more general than photography. I didn't say, "I'm better than the photographers." I was a photographer. I remember a ridiculous story. We had to photograph a Halloween party, and there was a *Life* editor who was really a very silly guy. Pompous. We went together to this party out of town. A half an hour or so drive. It was at some actress's, but I've forgotten her name, and there I met another actress, June Havoc, who was a guest.

We took pictures, and June said, "Why don't you drive back with me?"

I said, "Sure." I thought it was more fun going with her.

You know, the *Life* photographers inspired legends—"Oh, this photographer did this or that." The story got around that I had an affair with June Havoc, which, I regret to say, I didn't.

But this pompous guy came roaring at me and says, "What is this I hear that you had an affair with June Havoc?"

I said, "I wished I had. I didn't."

He said, "Well, I knew it. I said it all the time, because if she'd gone to bed with anybody, it would have been with me, the editor."

That is an extreme case, but I'm bringing it up for the ridicule. Being a *Life* photographer was glamorous, but, you know, we were so damn busy during a war. There was nothing glamorous about that. When you came back, after you've been shot at, you feel as if you could fly over a building. Probably it's a compensation for having been so scared. But Carl Mydans and I, when we wrote, we eliminated that reality. We never really mentioned what we did. We didn't describe the life of a *Life* photographer—how stories are worked out.

A fellow wrote a big book, *The Great American Magazine*,[*] about *Life* magazine, but photographers don't come into it. When Dora Jane Hamblin wrote her book, *That Was the LIFE*,[**] it was all about researchers. We were really a word-oriented magazine because the people who ran it started by being word people.

*Did they use your material well?*

I would say in general yes. I would say Edward K. Thompson, when he became managing editor, learned to never use two pictures where one would do the job. That's really the greatest lesson. And if you look back, they got the essence. But a photographer being there would have done no harm. This again was Hicks. Keep 'em down. I mean, compare the salaries of writers and photographers. We were the best in the world at that point, and they didn't have the best writers in the world, but they paid them more. I'm not saying that out of bitterness. I'm just stating a fact. We all believed in what we did. That was the whole thing. When you are 23, 24, money hasn't got that fascination. But when doing a story you could sink your teeth in, we learned more about the subject than anybody.

[*] Loudon Wainwright, *The Great American Magazine, An Inside History of* Life, New York: Knopf, 1986
[**] Dora Jane Hamblin, *That Was the LIFE*, New York: Norton, ca. 1977

You put a writer and a photographer in an interview. After two hours, the writer will come out with lots of quotes. A photographer will come out with observations. In Tito's case, it was noting the way he would use a cigarette holder, how he'd hold it. You watched the gestures and the mannerisms. The reporter would watch what was said. I would pick up on what was said, but secondarily. My interest was watching him—how he reacted, how he behaved. You suddenly see something. When you do a portrait, you take a number of pictures and there's one that has an expression—"That's him!" That's what you want. You look for it. The perfect word to describe when you hit that perfect picture is *lightning*.

*Let me ask you about "The Family of Man" exhibition. You had one picture—*

Two. One was of two old Canadians: "We two are a multitude," Steichen captioned it. And one was a little Arab boy. I got $20 per picture. I got two free passes, but by the time I got back, the show had gone. I only saw it years later.

*How do you know when you have a good picture?*

You think it hits what you want it to say, and you go on. You try to get what is there, and it comes out better in some cases than in others. I took the Quebec couple because I thought it was an interesting picture.

*What has made you a good photographer?*

You say I'm a good photographer. I suppose if I was on *Life*, I must've been good. You asked me earlier what my favorite picture is. I wouldn't know. People said I had a very detached approach to photography. I had a guy write to me about my pictures saying things I never dreamt of. Were we press photographers? You have the title of who pays you. Fashion photographer—fashion pays you. Advertising photographer—advertising pays you. Michelangelo would have been a church photographer. When I started, press photographers were treated like mud in England. You stayed 12 hours outside of 10 Downing Street. They never even had a shelter. Nobody thought of having somewhere where you could keep out of the rain. That's what made the press photographers so damn tough, and that's what made them so damn good.

*Where did the term photojournalist come from?*

Photojournalist was a chichi version of photo-reporter. They called Alfred Eisenstaedt a photo-reporter, but he's not. He has a very gentle quality. I mean, if he's photographed a whore, he would get something nice. He'd photograph the most hard-boiled person, and he'd bring out something gentle in them. It's the way he is. Now he's an institution, but I remember him in the early days. You know what Alfred's genius is? Making himself look smaller than he is. This is why Sophia Loren can take him up in the arms like a baby panda and kiss him. I mean she couldn't do that with me. He makes himself look small, and everybody wants to help and protect him. When he takes a picture, he crouches down, he braces his whole body like a piece of granite, and he can hold his camera steady for half a second, which is incredible. He's a great magazine illus-

trator, but he never dreamt up a story. You set him up with the Pope, you'd get marvelous pictures of the Pope.

Today, everybody who wears leather straps and big telephoto lenses and dresses like a bushman is a photojournalist. But a photo-reporter is a man who knows what the story is. When I did "Canada at War" in 1939, an editor, Hubert Kay, said, "I've coined a word for you—reporter-photographer—because you send in written material with the pictures." Then the term got to be photo-reporter. Now they all call themselves photojournalists, but they aren't. Incidentally, Kay damn near got fired because of what I reported with my photographs. Daniel Longwell was more English than the British empire, and he had said, "In Canada everybody is running to enlist. They are very patriotic."

However, I found out that a lot of them were unemployed and enlisting just to get a job and some money. Hugh wrote the story from my research, and when it ran, Longwell was red in the face, telling Kay, "You can't say that about Canada. You can't say that about the British!" Of course, he never said anything to me. I couldn't be expected to know. I was just a goddamn photographer.

On the *Life* staff 1936-50
Interviewed in New York City on May 19, 1993

I wanted to get back to the
West Coast, and I did so by doing
every girl story I could

Carole Landis. Hollywood. 1939

# PETER
# STACKPOLE

**P**ETER STACKPOLE: My father was a sculptor. He had tried to make an artist out of me. He put a hammer and chisel in my hand once, and he gave me a little block of granite to work on. I lasted half an hour and decided I didn't want to be a sculptor. One was enough in the family.

I bought a used Leica. When my father saw me with this little camera at his stone yard, he said, "You don't need that thing." He reached in his pocket and took out a pencil and made a sketch of me in no time, and said, "This is all you need."

But my father took me down to Carmel, and I met Edward Weston. I was spellbound looking at his work because it was so clear and precise, with beautiful forms and beautiful values. I thought, "I can never do this with a 35-millimeter camera." But when I showed Weston some of the pictures I had taken of building the San Francisco–Oakland Bay Bridge, he encouraged me. Ansel Adams did too. They asked me to be a member of Group f/64.

On a weekend in 1936, Willard Van Dyke, another photographer, might call and say, "Pete, do you want to go down to Carmel and visit Edward?" Edward would put his prints on an easel lit with one floodlight. You'd sit there, and maybe you'd look at that print for five minutes. Edward would say nothing; he just wanted to hear what you had to say. We'd visit Ansel, who was still living in San Francisco and doing a certain amount of commercial photography. Of course, Imogen Cunningham was always fun to visit. It was not a card-carrying organization of any sort. There was an exchange of ideas and mutual appreciation. We didn't have a meeting place.

I was 23. I had been on a retainer in San Francisco for *Time* magazine. I got

a call one day from the bureau chief in San Francisco to go to Hollywood. When I got there, I met Joseph Thorndike, a junior editor on *Time*. He showed me this magazine, and on the front cover it said, "Rehearsal." This was before they discovered that *Life*, the old humor magazine, was about to fold and bought the name from them.

Thorndike and I followed Shirley Temple around and got her mother to make her behave and stop clowning every time she'd see me raise the camera. We all went to the head of publicity, Harry Brand's office, and the writer Nunnally Johnson came in. When Shirley and her mother left, Johnson came over and confided, "Actually, she's a 45-year-old midget." Which I thought was a very funny remark at the time.

Thorndike was about my age. Joe had a reverence for Henry Luce. He referred to him as "the founder," never as "Mr. Luce." We spent a week in Hollywood. Then Joe and I took a plane to New York. They put me up at the Commodore Hotel, across the street from the Chrysler Building. I was to meet Joe up in the Cloud Club, at the very top of it. I was still a kid from the sticks. I'd never been to the big city. I went up in that fast elevator, and the doors opened, and there was a huge restaurant with a view all around. I was so captivated by the view that I forgot the names of most of the people I was being introduced to. One was Luce and another was John Shaw Billings,[*] who became *Life's* first managing editor.

As it proved out, Billings had an instinct for looking through photographs and knowing what was mediocre and what had something to say and how to lay it out. Of course, *Life's* layout then wasn't anywhere near what it became later. At first they used all kinds of tricks.

I became aware of Margaret Bourke-White immediately, but stayed out of her way because she had a habit of looking on anybody as being available to help carry her bags. I helped her out a few times, and when she'd go on an assignment, believe me, there were numerous bags. She was the only photographer who had an office and a secretary. *Life* had a very small lab on the sixth floor, and Bourke-White had her own man who only did her work. Bernard Hoffman and I made our own prints.

Hoffman was a real New Yorker and showed me around. Alfred Eisenstaedt didn't hang around our quarters in the building. He came in and went directly upstairs to talk with editors. Only now and then would I meet Alfred. Once in a while I'd get up to the layout department and watch them put type under prints, and when they spread the issue around the wall, I'd get an idea of what

---

[*] John Shaw Billings, the 38-year-old managing editor of *Time* magazine, became managing editor of *Life* 17 days before the first issue went to press. He was made editorial director for Time Inc. eight years later and retired in 1955. Born at Redcliffe Plantation, his family's estate in Beech Island, South Carolina, he died in Albany, Georgia, in 1975.

was going to be in the magazine.

We all had great reverence for Mr. Billings. He'd spot you and ask you into his office and grill you about different things. He asked me a lot of questions about Hansel Mieth. He said, "I guess she's pretty left-wing, isn't she?"

I said, "I suppose so. She photographed the waterfront strike in San Francisco and the downtrodden."

He said, "I don't care as long as she takes good pictures." I admired him for that because her political beliefs didn't bother him a bit.

I had given the editors my photographs of the Golden Gate Bridge, which was just about finished being built, in case they wanted them for a story. I was not thinking in terms of photojournalism when I took them, because the term hadn't even come up yet. (I'm not aware that Eisenstaedt had heard of the term then either, even though the *Berliner Illustrirte* was considered the first to do picture layouts in the late 1920s.) I don't know who coined the word, but it's certainly stuck ever since. I had been doing a form of photojournalism when I photographed the building of the Oakland Bay and Golden Gate bridges. But if I did that today, I'd go home with those men and photograph them gambling after hours or going to a house of ill fame. All the facets of a bridgeman's life. But then I was so influenced by what I saw in the f/64 group, I was principally conscious of design and texture and structure.

They had sent Bourke-White to photograph the new dam at Fort Peck, Montana, and she had the better construction story. As we were preparing for the first issue, one afternoon, Bourke-White's lab man was taken ill. There were still prints to be made of Fort Peck, so I ended up printing them for the lead story in the first issue.

*John Loengard: Were they good prints?*

Well, *I* think so. I had a story in that first issue, but they credited somebody else with it. It was about a Chinese cemetery in south San Francisco, where they were digging up the bones and putting them in boxes to ship back to China.

I spent that first year in New York, but I wanted to get back to the West Coast, and I did so by doing every girl story I could. Once a writer named Paul Peters caught an item about the Allen Gilbert School of Undressing, where they show a wife the graceful way to undress for her husband. The whole thing was sort of a gag, but I went along with it and photographed this girl taking off garments (up to a point). Billings giggled when he saw the pictures and decided to use them. Next thing I heard, *Life* was banned in Boston, or wherever you'd get banned in those days.

*How did* Life *magazine decide a photographer of the Golden Gate Bridge was a girl photographer?*

That was just something I cultivated. After a year in New York, they sent me back to Hollywood, where I worked until 1951. It was easy for me to photograph

stars. I found them intelligent people. I think part of my job was that of good-will ambassador. By being diplomatic, sometimes I could talk people into things that at first they didn't want to do.

*What are you looking for when you take pictures?*

I very seldom preconceive what I think I want someone to do. If I go to somebody's house, I like to wander around and look for logical situations. Maybe the phone rings and an actress is in a long, flowing dress, and she's walking around with the phone. That's not bad. Or I ask if she does her own cooking. You do that. They all have to read scripts. So there's a chance to get her in bed reading a script. Situations present themselves. That's the way I like to work.

In the years that I covered the Academy Awards, they were done in places where people ate, like the Ambassador Hotel or the Coconut Grove or the Biltmore. The stars sat around at tables, and I could see the expressions on their faces. We were sort of table-hopping. They'd allow that then. People like Ginger Rogers would cry immediately when she heard her name. And their mothers would cry. Now the Oscars are big extravaganzas done in theaters, and all of that human touch is gone.

*In Hollywood you got involved with Errol Flynn?*

Oh, Lord, yes. One day the assignment came in, "Would Stackpole please go to Catalina Island and photograph Errol Flynn spearfishing." I came aboard, and suddenly I see this beautiful young girl pop her head up on deck. I was introduced to her as Peggy LaRue, and I thought I'd better keep her out of the pictures because Flynn was married to Lily Damita. Later Flynn got me aside and wanted to know if I would take some pictures of Peggy. I said, "Sure."

We went fishing—I had an underwater box made to put an old Leica in. In those days we had no face masks or flippers. I could only get pictures by diving and clicking one or two frames and then coming up for air. I managed to get part of a roll of film exposed before the camera flooded and was ruined.

Flynn had a beautiful ketch called *Sirocco*. That night we sailed back to Long Beach. I was on deck and steering some of the way. He would pop his head up on deck now and then. I never heard anybody scream or anything. When we got back to Long Beach, Flynn asked me if I'd mind taking Peggy home to Hollywood. He said his ears hurt from diving. I deposited her at her apartment.

That's the last I thought of it. Then I got a call from Flynn. "Meet me at the Beverly Hills Hotel," he said. We had a drink, and he wanted to know what she talked about on the way home. He said, "The girl's mother says she's underage. They're trying to shake me down for a lot of money."

The next thing I hear, I'm subpoenaed to be a witness for the district attorney's office in the famous Flynn trial, which made headlines all over the country. My testimony didn't hurt Flynn any. There was a pretty provocative picture someone had taken of the girl. The jury looked at it, and Flynn won the case. His films became bigger box-office hits than ever. Everybody wanted to meet

Managing editor
John Shaw Billings. ca. 1938
*Billings giggled when he saw the pictures
and decided to use them.*

How to undress. 1937
Life *was banned in Boston,
or wherever you'd get banned
in those days.*

Alfred Eisenstaedt

2/15/37

Joan Fontaine wins an
Oscar for *Suspicion*. 1942
*I could see the expressions on their faces.*

Errol Flynn. 1941
*I never heard anybody scream.*

Saipan. 1944   *I was denounced for doing it.*

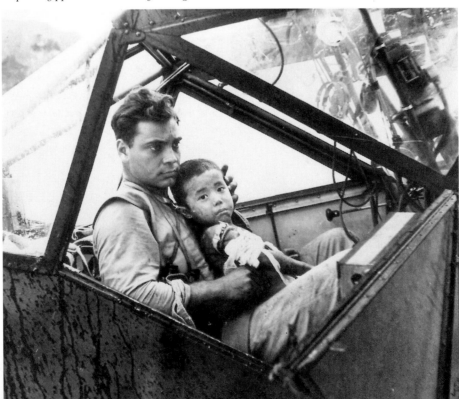

Flynn. Then he had to play the part of being a womanizer.

*Didn't that come naturally to him?*

No. It was tough on Flynn because wherever he'd go they expected him to be very flip about all the women he'd known. He wasn't actually like that at all. He was full of wit and dash and daring and adventure. I couldn't picture him doing anything but being on his yacht. That was his life. It drove him to try to take his life, and after that he became a real alcoholic.

*Why did you move from Hollywood to New York in 1951?*

The new managing editor, Edward K. Thompson, thought I'd had it too good out here, and maybe I had.

*That was when Wilson Hicks was leaving as picture editor?*

Yes, Hicks had come over to *Life* from the Associated Press within the first year. I had been a little leery of him because there was a rumor that all of *Life's* pictures were going to be printed in the AP Building. I thought one of the reasons *Life's* photographs looked so good was that the prints were carefully done, and I couldn't visualize this happening when they were batted out by the thousands over at a news service. The rumor wasn't true, and later on I got acquainted with Hicks. The distinctive thing that I remember about him was that he was strongly for the photographer. He got himself in trouble with the department heads at *Life* by saying, "Only look at the script[*] to know who you're going to work with and what's liable to happen. After you've read it, throw it away and make your own decisions. If you get out there and you find that the script has a lot of situations that don't exist, don't take your camera out of the bag. Come home." I liked him for that.

*Was he liked by other photographers?*

Hicks was roundly disliked during the war, and I had reason to dislike him then too. When I was sent to Saipan, I was led to believe I had the whole island to myself. The second day I was there, somebody says, "Who is this other *Life* photographer down the road?" I go and look the guy up. It turns out to be W. Eugene Smith. I had never heard of Smith before, because that was his first assignment for *Life*. Once I learned the nature of the fellow—that he took awful chances—I realized that Hicks was going to get better pictures by making two photographers compete.

I was going to take just so many chances and not needless ones. When we first met, I asked Smith, "What have you shot so far?" He said he had talked his way into the backseat of an artillery observation plane flying over enemy territory. When the plane landed, there was a hole, right behind Smith's head, where they'd been shot at. I thought, "Is this what you're supposed to do to be a good war correspondent?"

---

[*] Scripts were written primarily to persuade the picture editor there was a good reason to assign a photographer. Based on research, they itemized what photographs might be taken of a subject. Since the 1960s this has been done orally.

On Saipan I witnessed suicides during the very last of the fighting at the south end of the island. Japanese propaganda had told the native population that they ought to take their own lives because the Americans were going to torture anybody they captured. That wasn't the case at all, but I saw girls, all holding hands, jump off the reef in the ocean, trying to drown themselves.

In a truckload of civilians that the Marines had rounded up, I saw a little Japanese kid with his arm badly mangled and some makeshift bandages on it. The kid was about to be in a state of shock, and just then one of those observation planes landed on the road. I took the boy over to the plane and said to the pilot, "Is there any way you can take this kid back to the other end of the island where he can get medical treatment?" He didn't want to at first. Then he looked at the kid and said, "Sure." The kid sat on his lap, and I took one picture, and then the plane took off.

Hours later, when I got back to press headquarters, my colleagues from the Chicago *Tribune* and the Chicago *Daily News*—friends of mine—said, "You should have been here when that pilot brought that kid in. What a picture!"

"I know all about it," I said. And I was denounced for doing it.

*Denounced?*

Robert Sherrod, who was a *Time-Life* correspondent, let it be known that I had staged a phony and got it killed, I think. The picture never ran, but if I had it to do today, I would do it over again.

*What was phony about the picture?*

The fact that I was interfering with the war and made something happen. But I don't see it that way.

*Why did you leave the magazine in 1960?*

I thought a lot of my assignments were demeaning. Like having me be in New York at 7 in the morning to photograph a teachers' strike when New York City was full of photographers they could have asked. My spirit was being broken. I didn't cherish coming in on the train from Connecticut, an hour each way, every morning. And some of the three-martini lunches. And seeing colleagues fall by the wayside, healthwise. It was a pace I think people on the way up should experience. I think New York has a great deal to offer if you're young, but I don't recommend it as a lifelong experience. I had another reason to want to go west. My mother needed attention and help, and *Life* made it worth my while. They put me on a retainer, and I could free-lance all I wanted and build my own house. I guess once you're a Westerner, it gets in your blood.

*In 1991 your home in Oakland burned down.*

I had seen fires before that had come within a mile of the house, but they were always put out. I happened to be at a camera swap that Sunday morning, October 20th. Someone said, "Hey, come to the door. There's a lot of smoke around." The minute I got home, I found my wife on the road talking with neighbors. The flames were still three-quarters of a mile away. I thought we had

a good chance. We watered down the roof for a solid hour, and then the fire jumped one hill and was coming down the slope toward us. That gave us 20 minutes to load the cars. We saved a show of my life's work that I was preparing for the Oakland Museum. A friend who'd been at the swap with me knew where I was keeping things and brought out armloads of photographs. I saved all the negatives I'd shot on the bridges. I just happened to have them in the darkroom at the time. Then the lights went out in my darkroom, and I couldn't feel around for what I wanted to save anymore.

I lost the negatives of some of my key Hollywood pictures. But fortunately I had a lot of good prints in the hands of a publisher. I'm quite amazed at the quality I was able to preserve in some of the copies I've made of them.

Recently curators are discovering not only people who did photography as an art like Edward Weston and Ansel Adams, but people who photograph events and make memorable photographs. The museum crowd is catching onto this. They're recognizing the best of photojournalism as something to feature.

*Whose work do you particularly admire?*

I always admired Bourke-White. I know the lab couldn't stand her because she shot so many negatives. You'd have shoeboxes full of film come in. I don't think she trusted exposure meters. But, today, I think that Brazilian photographer is tremendous, Sebastião Salgado. He's taken the direction that I like to see. Very sensitive. He has an instant eye for composition. Instantly. I'd like to know how many pictures he shoots of one subject. Being a Depression kid, I was always a miser. I never photographed a subject more than one or two exposures. Then I'd go on to something else, because I was just trained that way. I don't admire photographers who use motors. It's like, "I'll look at this later and edit the one I like." It's not knowing that one instant.

I was looking at a copy of *Life* not long ago, and saw that they used Grey Villet to do a story on a town that was feeling a depression because big industry had moved out. I thought he did an excellent job, and I thought this is the kind of thing we should be doing more of. Wars get to look alike—people suffering, tanks and smoke. You've got to do them, but sometimes you feel you've seen one, you've seen them all. But things are happening in this country that touch every one of us. I would like to see more coverage of that.

*One last question. You have no fear of heights?*

No. I ran into a fellow named Joe Walton when they were building the Oakland bridge. I knew he was dying to get himself photographed on the tower. "Just follow me," he said. I started going up a ladder that would never quit. The ladder went up and up. He said, "It's easy. Just keep one hand and one foot on the ladder at all times, and don't let your mind wander." And that's what I've done ever since.

On the *Life* staff 1936-60
Interviewed in San Francisco on August 16, 1993

"It's too great a story for a
photographic book," Steinbeck said.
"I'm going to write it as a novel,"
And that was *The Grapes of Wrath*

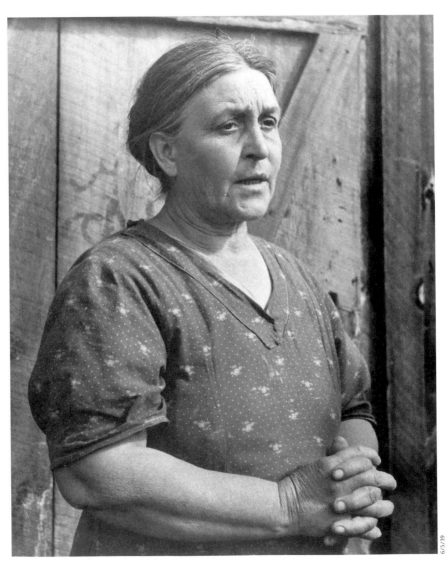

"Ma Joad." 1938

# HORACE BRISTOL

HORACE BRISTOL: My first wife committed suicide, after almost 30 years of marriage, and it was a terrible shock to me. I lived at the beach in Japan, and everything that I had connecting me with the past, I just wanted to get rid of. I destroyed the pictures and negatives that were there. Fortunately, my son had the bulk of my negatives at his place, and later he left them at my present wife's mother's house. One day my wife called me. Her mother had asked, "What should I do with all these things?"

"Throw them in the garbage," I said.

But her mother told my wife, "I can't do that with your husband's life work." So she sent me all the negatives.

*John Loengard: You have a good mother-in-law.*

I have a perfect mother-in-law, and I'm very grateful to her because, otherwise, I would have nothing of the past. Now the past has become the present, and to some extent the future. Particularly for my children. A lot of the things that I did have become historical documents, particularly *The Grapes of Wrath*.

I had been out with Dorothea Lange and her husband as they shot some pictures of migratory labor. I admired what Dorothea was doing, and I realized that this was an important story, so I wrote *Life* a letter describing migratory labor in California. Wilson Hicks, the picture editor, was less than enthusiastic. I was very disappointed that *Life* was not as enthusiastic as I was. It was an epochal story.

I thought I'd like to do a book on the subject. I had seen the book that Margaret Bourke-White had done with Erskine Caldwell titled *You Have Seen Their Faces*. I thought, *Life* can't complain if I do a similar book. I cast about for who

I could get to write the text and the captions. It would be essentially a photo-graphic book, and as I was living in San Francisco, I thought that John Steinbeck was the logical man. He wasn't as famous at that time as he became, but he'd written two books that I had particularly responded to—first *Tortilla Flat* and then *In Dubious Battle*, which covered laborers in the fields. I thought, "Here's a man who's going to be sympathetic to what I want to do." So I picked up a phone and asked the operator to give me his number. I called and asked him, "Would you be interested in working on a book like this?"

He said, "Sure. Come on down, and we'll have lunch, and we'll talk it over."

I went down the next day. He had a small, charming house near Stanford University, and we talked about the idea. Steinbeck was, I hesitate to use the word enthusiastic, but he was pleased with the idea of doing it. He said, "The only thing is that I'm engaged in editing"—I think it was *Of Mice and Men*—"so during the week I won't be able to do it. But I could do it on weekends."

"That's fine with me," I said. "*Life* magazine has me on call for the weekdays, but I feel that if I work weekends on a book project, I'd be perfectly justified."

*Working for* Life, *I would think that you'd be on call any day of the week.*

I was, but quite frankly I felt that if Margaret Bourke-White could find the time to do it, I could. I would load up my station wagon with cheap food—meats and whatnot—and we'd go down to the Central Valley. When we started seeing people camped along the roadside or wherever it might be, we would go to the nearest motel and check in. I would always register for us both using my name because Steinbeck was afraid that the Associated Farmers—the growers' repre-sentatives—would arrange to beat him up or even kill him. They hired people we called goons in those days. I tried to persuade Steinbeck that a writer of his stature, or even a man who worked for *Life* magazine, was in no danger.

We worked for seven weekends. Everyone I photographed was from Oklahoma. They were really displaced persons from the dust bowl. Very sincere farmers. Not terribly well educated, but by no means the undesirable characters the Associated Farmers tried to make them out to be. They were God-fearing and very sincere.

After two months of doing this, I called John and said, "I have enough pic-tures for the book now. Shall we get going on it?"

"I'm sorry to tell you this," he said. "It's too great a story for a photograph-ic book. I'm going to write it as a novel." And that was *The Grapes of Wrath*.

I was very disappointed, of course, but when I'd asked him to do it, I knew he was a novelist. I should have realized that he was going to write his own book. I didn't have any real interest in social issues. I had an interest in stories, and this was a really good story. Of course, I couldn't help but be sympathetic to the people, but when Steinbeck told me that he was going to do a novel, I just went on to my next *Life* assignment, without looking back. After *The Grapes of Wrath* was published and became a best seller, *Life* ran two pages of my pictures, show-

ing the actual people. Twentieth Century Fox used them to cast the movie.

*Did you like the movie?*

Oh, it was wonderful. Maybe I was overcritical of the book, in the sense of disappointment and jealousy and all that, but as time went on I saw the effect it had on the young people, who had no idea this world existed. The effect of the book and movie was just magnificent.

*How did you feel about being ignored in all this—or somewhat ignored?*

I've been asked that question a lot of times by interviewers. The first one that asked me said, "Did it ever occur to you that you were being used by Steinbeck?"

I said, "No, never." But years later I read a very thoroughly researched biography of Steinbeck, which made me realize that Steinbeck never mentioned my name at any time, under any circumstances. The closest he came was, writing to one of his agents, he said, "*Life* magazine is sending out a photographer to take pictures, so I know there'll be plenty of pictures."

Steinbeck was a copious writer of notes and workbooks, so I came to the conclusion that for some reason . . . well, I suppose because of ego: this was *his* book. I was there, and he resented it. He also resented the fact that his wife suggested the title, *The Grapes of Wrath*. But that was too good for him to pass up.

Working for *Life*, I dealt with other celebrities and some writers, and Steinbeck was just another writer as far as I was concerned. A photographer was a second-class citizen as far as he was concerned.

In the 1930s I had a studio a block from the St. Francis Hotel in San Francisco, and it was three doors down from a gallery that Ansel Adams had for his photographs. At that time he was showing his friends like Dorothea Lange, Edward Weston and Imogen Cunningham. I was lucky to become a part of that group that's erroneously been called f/64.

*But wasn't f/64 (the lens opening that produces an especially sharp image) the title they used?*

*They* didn't use it. The photographers themselves never said, "I'm a member of the f/64 group." At least Imogen and Dorothea were not interested in the aperture of their cameras. They were interested in the subject matter they were dealing with. The name was applied by critics and became accepted as describing a sort of West Coast philosophy of photography.

*Do you think photography is an art?*

I've always fought shy of using the word artist. Maybe it's an art, but *artist* I object to. I remember when I had just gotten the job with *Life*. Adams, Weston, Cunningham, Lange and I were having dinner in Chinatown. I was describing the fact that when I would do a story, I'd send the film in to New York and they would process it and make the prints. If they were going to use the story, they'd crop the pictures and do anything they wanted. Weston said to me, "You mean you let the editors crop your pictures?"

I said, "Of course. That's my job."

He said, "You're no artist. You're an artisan."

"That describes me exactly," I said. "I'm an artisan."

I like to think of myself as a photojournalist, but not as an artist. I come from four generations of newspaper owners, and in 1932 I was running a newspaper that I owned in Piru, a small town in Ventura County. I was trying to use photographs in the paper and thought I should learn something about photography. I'd drive down and go to the Art Center School in Los Angeles at night.

I became a photographer because it was journalism. I was interested basically in telling stories. I got a little diverted at the Art Center, but still whenever I did pictures, they were made with the basic story in mind. In 1933, when I just couldn't exist on the money my paper was making, I sold it and started taking pictures of children. That was great, but we were in Depression years, and I ran out of parents who could buy pictures of their children.

I thought I'd go up to San Francisco and try my luck at advertising photography. I was broke. I had two children, but I was also determined that I was going to tell stories with pictures. I did a little bit of work for *Time* magazine, and Luce was planning a new magazine. I did a story for the dummy, but it wasn't used. Obviously it was not sensationally good, in the sense that I didn't hear anything from them when *Life* started. But out of the clear sky, Daniel Longwell, the executive editor, came to San Francisco. He talked to the San Francisco office manager, who evidently recommended me, and Longwell just hired me. I never met him. This was March of 1937. My first cover was of a bullfrog. I'd run across a story about a frog-hunting party, and *Life* ran it as "*Life* Goes to a Frog Hunt."

I did various stories for *Life* that year and the next. One of my friends was a man whose brother was governor general of Java. I thought that what we called the Dutch East Indies would be a great story. I described it to Hicks, and he said, "It sounds very dull to me."

I said, "In Bali they do a lot of dancing, and the girls don't wear anything above the waist."

Hicks said, "There might be possibilities in that. We'll pay your salary as usual, but you have to pay all the expenses."

I was optimistic and foolish enough to say, "O.K., I'll do it."

So I went in the spring of 1939. The boat trip out took almost 30 days. There were no planes. I did the story, and it included a lot of Balinese dancing. I was gone at least four months. When I got back, I went to New York and I worked with the laboratory. They printed up 300 11x14 prints. It really was quite a nice story. I took the pictures up to Hicks' office very proudly and put them on his desk. He looked at the first eight or 10 and then flipped the rest as you would riffle through a deck of cards. He said, "Too many dance pictures," and shook his head.

I picked up the pictures, my overcoat and started out of Hicks' office. Hicks' assistant, Edward K. Thompson, said, "Where are you going?"

I said, "I'm going back home. I don't have to put up with this sort of thing."

I may have used a more vulgar term than that, but at any rate Thompson said, "Calm down." Thompson was not afraid to go up and see John Shaw Billings, the managing editor. Billings looked at the prints and laid out the cover and 12 pages, which was a huge essay in those days.

*What was Wilson Hicks' position if you and his assistant could go to his boss and lay out a story that you felt he was rejecting?*

I don't know anything about the office politics of that magazine, except occasionally as they affected me. Hicks was not terribly friendly to Longwell, and he always thought I was sort of Longwell's fair-haired boy. Evidently the photographers Hicks was most intimately associated with were the people that he had hired himself. The ones he hadn't chosen were sort of lesser people.

He was not always the easiest man to deal with. In 1940 I was no longer on staff but on contract, and Hicks decided that he wanted me in Chicago. I worked there for five terrible months away from my family and children. I was never in Chicago, anyway. I was always flying down to Alabama or Texas or wherever. Finally I said to Hicks, "I'd like to go back to the West Coast and be with my family. With airplanes, I can cover anything that you want just as well from there."

Hicks said, "We want you in Chicago."

And that was that. I was relatively young and naive. Perhaps I didn't really appreciate what a job at *Life* meant. I quit and moved back to San Francisco. After Pearl Harbor, Edward Steichen asked me if I would be interested in joining a unit that he was starting with five officers to do a story on naval aviation. We started out as sort of glorified propagandists to try to interest young people in joining the Navy and flying those planes. Gradually, it became very much wider in scope.

When the war was over, I settled in Japan. I was a free-lancer and kept doing stories for *Fortune, Paris Match, London Illustrated News,* the *National Geographic* and any other magazine that was interested.

I didn't give photography up because photography disappointed me or let me down. After my wife's suicide, I just started a different life. As a young man, I had studied architecture in school in California. After my first wife and I got married, we had gone to Europe, and I studied landscape architecture in Munich and Paris. I had been a frustrated architect, and after her death, I began building houses and made quite a good income from renting them.

*Do you find building buildings more satisfying than taking pictures?*

Buildings last a longer time, and you can look at them and live in them. And photography has an awful lot of inherent frustrations. In the first place, a picture is taken to be looked at, but how are you going to manage that? I tried to do it through *Life,* but that was limited. Now I'm trying to do it through galleries, but that's frustrating and very limited too.

Let me explain my relation to *Life* in a nutshell. I went into the San Francisco

Bullfrog. 1937
*I was broke. I had two children, but I was determined to tell stories with pictures.*

Mrs. F.M. Kendall.
Irrigation story. 1939
*They said, "Bourke-White's already taken my picture."*

Bali. 1939  *I may have used a more vulgar term than that.*

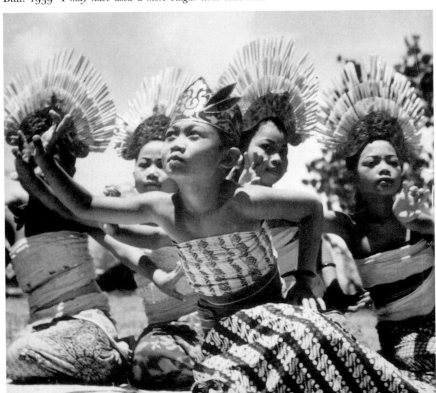

office one morning, and the manager said, "We have an interesting assignment for you." He handed me three blue memo pages detailing where to go, who to see, who to take pictures of and everything, much more elaborately than I'd ever had before. I was very happy to have all these instructions from the home office. Then I glanced up at the heading of the memo and it said, "For Margaret Bourke-White."

I said, "What's this mean? This is for Margaret Bourke-White, not for me."

He said, "Bourke-White has already done the story." I was scared because here I was asked to take a story that the greatest photographer on *Life* had already taken. It was really a frightening challenge. The only thing I could say when people would say, "Margaret Bourke-White's already taken my picture," was that the darkroom messed everything up and ruined the negatives, so I have to take them over. I don't know what really happened, but it was an excuse that everybody accepted and let everybody off the hook.

I started on the assignment, which was on irrigation, and I had to go all over the West. I sent my film into New York as I traveled, and for three weeks I heard nothing. I started sending telegrams asking, "Have my films arrived? Are they developed? How do the pictures look? Are you happy with them?" No answer. This was all addressed to Wilson Hicks. No answer at all. Another week went by. I was in the desert, and I went to town and bought a .22-caliber revolver. I put up a sign in the desert that said, "Wilson Hicks." I shot and shot until I ran out of ammunition. Somehow I had to relieve this feeling of frustration of not hearing anything—anything at all—from the magazine.

I finished the job, and I went back to San Francisco. My tail was really down. When I came into the office, the manager said, "How are you?"

I said, "Terrible. I failed." He said, "What do you mean you failed? A copy of the issue came by Air Express. Would you like to see it?" It had six double-truck pictures of mine and a lot of other stuff. And a column naming me the Photographer of the Week, but I never heard any of this from the office. Can you understand how frustrating that can be?

I have never been that frustrated again.

On the *Life* staff 1937-38
Interviewed in Los Angeles on August 13, 1993

73

One of the writers yanked
the monkey picture out and said,
"That's Henry Luce!"

1/16/39

Puerto Rico. 1938

# HANSEL MIETH

**H**ANSEL MIETH: You say that someone wrote about me and Otto Hagel that "He's strong; she loves animals"? Uh-uh. Is that kind of a crack about Otto or—

*John Loengard: It's an editor's note about your story on your farm.*

It sounds like some editor.

*Do you like editors?*

Some I do, and some, maybe I have a little difference with.

*How did you and Otto meet?*

We grew up together. When we were about 15 we decided that our little town in Germany was too tight for us. People had different ideas than we had, and we left.

*Well, what kind of ideas did you have?*

We were very young. You have high-flying ideas. You don't have ideas that can be put in a mold. We thought that people ought to get along together. We didn't need anything else but to find people who could be our friends and brothers. First, we went to Austria, and then to Yugoslavia. Then Hungary, Turkey and eventually, in 1926 and 1927, we were in Vienna. We lived with a group of teenagers under a bridge over the Danube River. We were about 15 kids with 15 different instruments. I had a guitar, and Otto had a violin. In the 1920s you could get along that way in Austria. We played our instruments in front of apartment houses, and people threw money down to us, wrapped up in paper.

We made a living, and as we went on, we took a few pictures of what we were doing and wrote small articles and sold them to newspapers. In Yugoslavia we stayed in a Cistercian monastery for about six weeks. I was dressed as a boy

in short leather pants, so they would think I was a male.

*Is that when you took the name Hansel?*

No. My father already called me Hansel often. But when I went with Otto, he called me Hansel too, and the name stuck. I'm really christened Johanna, but nobody ever called me Johanna. It's just my name for the banks and legal papers.

By then it was getting close to Hitler's time, and Otto said that he was going to America. I said, "You know nobody in America. How can you go there when you have no papers?" He said that I would see.

He got himself a job on a boat that carried canaries. It took about six weeks to make the voyage, and they landed at Baltimore. In Baltimore he walked off the boat like the other sailors, and with 25¢ in his pocket he was in America. He went to New York City and got a job as a window cleaner. He took a picture of himself as a window cleaner and sold it to the New York *Times'* "Midweek Pictorial" for $10.

I didn't want to come to America, really. I wanted to live in Yugoslavia, but Otto was over here and I wanted to be with him. So I came. I had an aunt in Philadelphia who sponsored me. (Otto was in California by that time.) I came off the boat in New York, and my aunt's daughter met me. It's a long story, but we quickly got into a fight. She went off to call my aunt, and while she did, I went out and got a taxi. The driver said, "Where do you want to go?"

"I'll tell you in a minute," I said.

I spoke Esperanto, and I had an international address book that had all the addresses of the Esperanto-speaking people in it. I could only find one address— out in Brooklyn—and the taxi driver said, "You want me to go to Brooklyn tonight? It will be two o'clock in the morning when we get there." So I told him my story, and he said, "If they don't accept you, I'll take you home to my wife and children."

We got to the address. I rang the doorbell, and a light eventually came on upstairs. A woman stuck her head out and wanted to know who it was. I said what it was, and she said, "Oh, you want my son." He came running down. Then 10 more people came down, and all of them welcomed me and welcomed my taxi driver. He stayed the rest of the night, and I stayed a week. We just had a very good time.

But finally I felt bad about my aunt. She was expecting me, so I went to Philadelphia, and my aunt welcomed me in a cast. She had gotten onto a chair, putting a Welcome sign up for me, and fell off the chair and broke her hip. So she didn't like me very much, but I didn't come to stay in Philadelphia to begin with. I had a ticket through the Panama Canal to San Francisco. Otto wrote, "Sell your ticket and come by Greyhound bus. That way we'll have a little money."

I turned the ship ticket back, and on the way home I saw a secondhand-automobile shop. For $50 I bought a not-too-bad-looking but broken-down Maxwell. I couldn't drive very well. I had no license or anything. In Germany

you needed one, but I didn't know about America. It took me $2^{1}/_{2}$ weeks. I had a terrible time. First the top flew off, and then the windshield fell down and I was frozen. It was Christmastime, and I saw all these nice houses with their Christmas trees lit up outside on porches. It was cold and snowy, and I went through Pittsburgh just freezing half to death. Some women came running out and gave me coats and shawls, and everybody was concerned about me.

I finally came to California, and the car was done for. I mean there was not much to save. Otto couldn't understand how that sardine can had made it across the country. In San Francisco I got a job for $6 a week doing piecework and sewing. The woman next to me got $12. I asked the boss if I couldn't make a few dollars more. He said, no, I was a greenhorn. So I quit. It was the beginning of the Depression. Otto was out of work too. He had an old red Ford, and we put our belongings into this and started out. We saw a lot of people in the same predicament as us, all going to the fields and ranches of Southern California to find jobs. We worked as field laborers for about three years.

When there was a slack season, with no crops coming up, we came back to San Francisco because we knew some men on the fishing boats. They were catching sardines, mainly for reduction plants that made fertilizers. We went out night after night with these sardine boats. Most of the fishermen were Italian, Yugoslav or, anyhow, foreigners, as we were. There were very few American-born fishermen.

On the docks the stevedores were not organized. They were fighting with each other—not physically fighting—fighting to get a job. There was one place, called the slave market, where they'd all stretch out their hands for a pass for a day's work. We took pictures in there.

*If you were to put a label on what you and Otto felt politically, what would it be?*

We didn't fit in any category. We never joined anything because we were not disciplined enough. We didn't fall into *that* class of people. We were idealistic liberals; that's about as much as I could say we were. And what happens to liberals? Nothing. They lose their shirt. So Otto finally got a job to take advertising pictures for an outfit called Hiller. Mr. Hiller invented a kind of helicopter and owned a big production plant out beyond the Golden Gate.

When he was doing that, I made an application to the Art Project of the Public Works Administration. They went through my photographs and said, "Girl, you are crazy. We are an art project here. What you have is propaganda." I had these photographs of workers, and they thought I had propaganda. But a young man who was head of the youth project of the Works Progress Administration in San Francisco had seen some of the photographs, and he called me up. I brought my portfolio to him, and he took me in his arms and said, "You are just what I am looking for. I don't have a photographic project, but we can make one. Get a few photographers together, and we will have a photographic project." We could do just about anything we decided to do. I photographed the neighborhoods in old San Francisco. I was there about three-

quarters of a year, doing fine. I got $94 a month, which was a royal sum at that time for somebody who had nothing.

In the meantime, we had made friends of the photographers in San Francisco, like Ansel Adams and Peter Stackpole and Imogen Cunningham. We lived with Dorothea Lange and Paul Taylor.

*How did a pair of liberal idealists—you and Otto—end up working for Henry Luce?*

At the end of 1936, while I was on the W.P.A. project, David Hulburd, the head of the Time Inc. office in San Francisco, asked me if I wanted to join his staff. Any magazine was beyond my aspirations. I thought they were making fun of me. I said, "You wouldn't like me. I don't think so."

So he said, "Would you do a few stories for us as a stringer?"

I said O.K. So they sent me out to do sheep raising in Red Bluff, California, which turned out very nicely and made the *Life* cover. Then there were all kinds of things. In April 1937 they asked me if I made up my mind. I must have been a little hungry or something, because I said O.K. and joined the staff of *Life*.

They sent me to Colorado Springs, Colorado, to open a bureau. The stories I did were all around a six-state area—Oklahoma, Kansas, Texas and so on. Otto stayed in California because he had that job with Hiller. About half a year later, *Life* said that I should come and work out of New York. Then Otto came from San Francisco.

In New York there was a nucleus of photographers who were our friends, like Stackpole, Carl Mydans, Rex Hardy and Charles Steinheimer, when he came later. I never met Nina Leen or Marie Hansen, but I wished I had. I like their pictures. Margaret Bourke-White and I got along fine. She often came to me and Otto about developing film. Once she admired a black velvet dress with red heart buttons that I was wearing. She came back a little later and handed me a package and said we should be friends together. When I unwrapped it, I found a nice red compact in a heart shape made of good leather, just like the buttons I had on my dress.

Wilson Hicks had a little bit of a personality problem. He didn't quite know how to treat people or how to even treat himself. He did some terrible stuff. When war was declared, he said his assistant, Peggy Matsui,[*] could not work any longer in the picture department because she was half Japanese. Hicks knew her for years and knew she was absolutely loyal, to the point where she would have given her life for everybody there. That he could fire her a few days after the war started, was awful.

[*] Peggy Matsui had married John Phillips in 1940. "Her Asian heritage added an exotic touch to her beauty. A few freckles made her look the delightful person she was," wrote Phillips in his 1996 autobiography (he does not mention her in his interview here). Right after the Japanese attack on Pearl Harbor, Wilson Hicks asked Matsui (whose Japanese father had practiced architecture in the U.S. since World War I) to transfer to another position on the magazine. "Peggy refused. Working with photographers had been her life. She resigned, came home, and never went out of the house after that," wrote Phillips. A few months later she died from septicemia when hospitalized for a fever.

10/7/40

Four generations of Roosevelts. Hyde Park, N.Y. 1940
*"I want to speak to my boy," Roosevelt said. I explained, "Your boy is not here."*

Wilson Hicks and Peggy Matsui. ca. 1938  *Hicks knew she was absolutely loyal.*

Carl Mydans

Otto and I were back in California, and he sent Otto, who was not an American citizen, a letter saying he had to turn in his cameras and forbidding him to take any pictures. Otto wrote back, "That's probably out of your jurisdiction, but I have been looking in the mirror, I have been looking in my files, I have been looking under my bed, and I could not find an enemy alien anywhere. It's probably just as well if I cannot photograph now because, what the heck, I couldn't photograph anything that would fit me and my beliefs."

I thought it was a little crummy to write Otto so coldly.

*Hicks didn't consider you to be an enemy alien?*

I wasn't. I was a citizen by then. But on occasion during the war, I had a hard time with my accent. For example, the Kaiser Shipyard in Portland, Oregon, was building a new nursery next to their shipyard, and *Life* assigned me to do a story. I had taken all the pictures I thought were necessary when I got a phone call from New York telling me that they needed an aerial shot. They wanted to see the layout of the whole complex. I looked around for a helicopter or a small plane. There was nothing to be had. Finally I saw a large tower. But that tower had no ladder going up, just its steel construction. I had my 4x5 inch camera in a knapsack, and I strapped my tripod to it and started climbing. It was sleeting and cold, and about the 10th bar up, my whole body was shaking because I was cold. It was very steep. Finally, I had pulled myself three-quarters of the way up when I noticed something above my head. It was a basket that had been built out, so I had to somehow get over that basket. I had to lean back to get around, and having that stuff strapped on my back, it pulled me down something awful. I finally made it up and found a platform.

In the meantime, the weather had closed in. It was sleeting like crazy. I set my tripod up, got the camera on it, and I saw one ray of sun come through the fog, but I didn't catch it. All of a sudden, a voice came up to me through a bullhorn. "You up there, come down here. You are arrested." So I hollered down, "Come and get me." I was waiting until I got another minute of sunlight. By the time it came, I was ready and snapped the shot.

I found going down was worse than coming up because I had less strength. They took me to the Coast Guard station, which was overheated. I got sick. I had all my papers. I had all the permits. Even so, they didn't believe me. They thought I was a German spy. My interrogator said, "Well, Fräulein, what are we going to do with you?" He called New York, Washington, every department he could possibly call. In the meantime I was so exhausted I just fell asleep. Finally, he shook me awake and said, "Wake up. Your papers are in order." He let me go, but when the pictures were developed, the censor took the pictures from the tower out.

*The pictures were censored because you were taking pictures of a defense factory?*

Yes. Just pictures that had to do with defense facilities were censored. In San Francisco I had a few censored because some sailors had cigarettes hanging out

of their mouths. It looked a little tacky. The Navy didn't want its sailors seen that way. The censor did very strange things sometimes.

*Was it Otto who wanted to buy the farm in California?*

No, it wasn't Otto who wanted to come back to San Francisco. It was me. By early 1941, life in New York was a little too—if not hectic, at least it didn't make a great deal of sense. I felt myself become a little hard-hearted. My better feelings receded, and I didn't like myself. I told Otto I just had to go back, but he said, "We worked so hard to get out of poverty, and now you want to go back into it. Isn't that crazy?"

I saw him in New York with all those nice girls making eyes at him, like the guys going after me. I had many opportunities for sex going out of town on a job, but I didn't give a damn. Most of the time I had my mind on something else. So when Otto was in Detroit doing a story I asked Wilson Hicks to transfer me from New York to California.

I threw my stuff in the car, and Hicks gave me a few jobs on the way to California. In Butte, Montana, I was photographing a one-room schoolteacher, and I felt something funny. I looked around, and Otto was beside me. "What the heck are you doing out here?" I said.

He said, "You thought you could get away from me, huh? Where you go, I go."

He went with me to California, but he had a much harder job. I was still employed by *Life*, but he had to start all over again. Otto never wished to go on the *Life* staff because he wanted to be able to work for other magazines or for advertising companies. He made about four or five times the money I made. I worked in the beginning for $75 a week, and the very most I ever made was $6,000 a year.

In California we lived with Dorothea Lange for half a year.

*Why didn't Lange work for* Life?

She would have liked to, but while she knew how to take a good picture, she had no essay sense. The same with Ansel Adams. Adams also wanted to work for *Life*, but it's an essay business.

*What does that mean?*

It means you put together a story with a beginning, a middle and an end. It leads to a height and then to a climax. If you can find that in a story, you are O.K. But if you just shoot pictures all at the same level, you don't have a story.

*When you were photographing, did you think of how the pictures would lay out in the magazine?*

The trouble with me is I didn't. Otto did. He could edit what he wanted from the very beginning of a story. But I just shot what I felt would make a good picture. They said at *Life* that Otto shot from his head and I shot with my heart.

Anyhow, we looked for a house to buy in Berkeley or San Francisco. But we saw an ad in Santa Rosa and went out and asked the real estate man if he had about five acres. He said, "No, but I have 500." We went out to look, and it was just like a paradise. It was in May.

# THE SIMPLE LIFE

*A couple of dreamers find farming to be anything but a romantic idyl*

Most city dwellers at one time or another have had the dream of escaping their hectic urban lives for the simple existence of the farm. The dream takes different forms but usually involves a rustic house, a garden, pigs, chickens and a cow—all that is needed to provide shelter and food in return for a minimum of work.

Nobody had the dream more strongly than two former LIFE photographers, Otto and Hansel Mieth Hagel, who had come to the U.S. from Germany 25 years ago—and had returned once to record what the years had done to the family in their home town of Feilbach (LIFE, June 26, 1950). Unlike most of the dreamers the Hagels put theirs to the test. In 1941 they bought 465 hilly acres near Santa Rosa, Calif. Otto, a strong-armed and strong-minded individual, built the farmhouse and barns with his own hands. Hansel, a gentle person who loves animals, gathered a barnyard of livestock and made pets of most of them. But the pair, who are now in their middle 40s, have never been able to sit back and enjoy their initial dream. "It is 365 days of work a year," they have found, "except leap years when there is an extra day of work." And the compassionate Hagels are continually faced "with killing a goose named Elmer or a pig named Oink, whose name and personality folks us as to the table."

But the Hagels have weathered their decade-and-a-half of the good life gracefully. Now, with warm humor—and a remote control device—they have photographed themselves and described realistically, in accompanying captions, their idyllic ordeal. They start at left with a half-satirical panorama of their original rosy dream and then show what happened when they woke up.

*We'll have a hill, to chop our wood, work up a real appetite and, when we're tired, stop and have a meal and a bottle of wine under a tree.*

Farm essay. 1955
*Otto said, "Where you go, I go."*

Dionne quintuplets. 1940
*The Hearst photographer lined the quints up: 1, 2, 3, 4, 5.*

Otto said, "Now that we've seen this place, let's look for something in the city because we cannot live out here and exist."

I said, "Let's try it." And somehow it worked.

*When you did the story on the farm, you called it "The Simple Life."*

With tongue in cheek. We used to take pictures of things that were going on. If a cow was pregnant and had a hard time in labor, Otto might have pulled the calf, and I took pictures of it. Everything was new to us, never having lived on a farm really—or being on a German farm—and it's so different here. I have hundreds and hundreds of farm pictures. There were just a few in *Life*.

When we first came there, we were out fixing fences, and I said to Otto, "Hey! There are some Gypsies picking walnuts." But as we came close, we realized they were Indians. One of that group was an old, old man who was born on our ranch. He was about 88. We told him he could live here if he wanted to move back. He did, and many a morning he sat on the hilltop and let the wind go through his hair. He just sat there, enjoying life, while Otto and I sat next to him. He was talking about the land. This sweet land. Sweet land. He stayed there till he died.

*You and Otto had no children?*

No, but life here was exciting at times, if you are excited by certain things. We had made a lake, and there in the evenings you could see all kinds of animals. You might have 30 wild pigs around you snuppling up on your leg so you couldn't walk. Or I was counting the calves one evening, and I counted one more than we should have. I took a flashlight and found a mountain lion among the cattle. He saw me and moved away, wandering up the hillside; and when he was half up the hill, he let out a scream. You never heard anything like it.

Otto died in 1973. It was a rough paradise. Rocky and canyon-y. But I couldn't move away from it, even after 50 years.

*I heard that Robert Capa got married on the farm.*

No, you heard wrong. But it was a strange wedding day for me too. That was in 1940, when we were still in New York. Otto and I had been living in sin for many years because we didn't feel that marriage was the most important thing in the world. But the editors wanted to save the clean name of *Life* magazine and asked us if we were contemplating getting married. We said, "O.K. If everybody wants us to get married, let's get married." So we had applied for a marriage license.

In New York you had to wait three days. We were on the second day when Capa came up to the photographers' cubbyhole office on 48th Street and said that his visa was canceled. He had to leave the country—or marry a citizen. I asked if he had a person to marry. He said, "Yes. We met the other night. She is marrying me for a year's dancing lessons."

"Are you in love?" I asked.

"Well, that's another question," he said. "I don't want to discuss it."

So I said, "Bob, I don't have time to help you. I have to go to Montana tomorrow."

But Otto said to me, "Get off your high horse. If you can help anybody to stay out of Hitler's grasp, you do so." Capa and Toni needed someone to take them to Elkton, Maryland, where there was no waiting period to marry. It was a drizzling day, and we started late. When we got there, the officials told us, "We have a three-day waiting period now. You cannot get married in one day." We started back, but a car stopped us. Two sharpies in it wanted to talk to the men.

When Otto and Bob came back, Otto said, "It's just some cheap gimmick. They want you girls to go to a doctor. If he declares you pregnant, you can get married the same day."

I said, "I'm not going to do it."

Toni said the same, but Capa begged, "I need to get married today."

So we went up to the doctor. He didn't look at us. He slipped on his white coat, went over to a desk, and wrote out a paper and handed it to us—for a certain price. Otto wouldn't tell me how much it was, but I saw him reach in his back pocket and take his wallet out and pay. Nobody took checks down there.

Those two guys who were with us said, "Now, you've got to go to a minister and have it sanctioned."

Otto said, "I am not going to any priest. You cannot drag me there."

Again, Bob said, "I know how you feel, but please let's get it over with."

So we went to that minister, who was an old, old man living with his old sister, who became the witness. He said a few words, which was supposed to be a marriage ceremony. I saw Otto reach in his back pocket again and pay him whatever he had to.

We phoned ahead to the marriage bureau to keep it open. When we came there, they were angry that they were kept late and in a very bad mood, but they wrote out our marriage certificate. Otto pulled out some money, but he didn't have enough left. Bob was out of money to begin with, so Toni and I emptied our purses, and we just had it down to the penny. When we walked out, Bob said, "That calls for a drink."

"We have no money," Otto said. "You just have to suck your thumb."

So we started driving back, and it was dark, and it was raining. Otto was driving not to my liking. He was going over the white line a little bit, and I became concerned and finally angry and said, "Otto, you are not driving well."

He kept on driving, and I said, "You just did it again."

He got angry. "You know how to drive so well, you drive," he said and stopped the car. While he was coming around to the passenger side, I drove off and left him standing in the rain.

I had gone a quarter mile when Capa screamed, "You so-and-so. Otto is back there. What do you think you are doing?" He was very, very angry. About a mile later I turned around and went back and found Otto sloshing along the side of

the road. Without saying a word, he got into the car, on the passenger side, and after a while fell asleep leaning against the car window.

Then, in the back, there was a commotion. Bob had tried to kiss Toni, and she was angry because—I don't know if you knew Bob—he was a little funny at times. He made, maybe, a little love to her. She got angry and slapped him. And he got angry and slapped her back, and before we knew it, there was a fight going on.

Otto woke up, and I stopped the car, and we got them apart. One was sitting on one side and one on the other. Pretty soon everybody fell asleep but me. I drove to Greenwich Village, where Toni said, "Let me out here. I'll go stay with my mother." She got out, and I don't know if Bob was awake or not. She said goodnight, and that's the last time I saw her. Otto and I went to *Life*, and I got my stuff packed for Montana. That was my wedding night.

*You're known as a slugger.*

So they tell me.

*You had an altercation in Albany, Georgia, at the opening of a movie called* The Biscuit Eater, *which* Life *described as "the story of the life and death of a bird dog."*

Well, that wasn't my fault. They invited the press of the whole darn nation. The society gentlemen and their hounds were dressed up. The dogs had white tie and cutaway suits on, and so did the men. There were many photographers there because the food and drink were free and plentiful. I don't drink, but everybody was a little bit inebriated when the photographing started. We lined up, and the photographer to my left kept jostling me, or putting his elbow in front of my lens, so that I would miss the picture. I told him to desist. He didn't say anything, but he kept it up even worse.

I couldn't take it anymore. I had a Contax camera with a flashgun, and I knocked him over the head with it. I didn't know what else to do. He kicked me in the shins, and pretty soon there was some kind of a scrambling going on. They pulled us apart. But then this guy was on the same train going back to New York. He attacked me again. He really let me have it in the teeth. So I kicked him, and again we were scrambling. The conductor had to take us apart. He put him way in the back of the train, and he put me way in front on the train, and kept an eye out that we would not meet anymore, for which I was thankful.

If you happen to be a woman, you run into this. Another time, I was sent by Hicks to do a party in the Waldorf-Astoria Hotel. I hated these "*Life* Goes to a Party" stories. When you are doing a sensitive job, who wants to photograph some drunks rolling around? It turned out to be a stag party, and the lights went out in the hall and went on on the stage, and all I could see was some nude female rising out of a cake. I photographed it, but what kind of a picture is that?

Every time I walked down an aisle, some weasel put out his foot and tried to catch me when I tripped. The last time that happened, I took a really bad fall, and I got mad. I had a 4x5 inch Speed Graphic with a flashgun, and I hit him over the head. He passed out. He didn't get up for a long time, and the lights

went on, and people went over to him, and they said, "He isn't breathing. You killed him." I got worried.

The people there called for a doctor, and after a while the doctor said, "He's breathing." But that is my slugging career.

*You're pretty strong with a flashgun.*

A three-battery flashgun is pretty heavy. It's also pretty sturdy. Well, in Georgia, the synchronizer part had to be adjusted. But nothing was kaput on the camera.

When I started, some of the press were jealous of the *Life* photographers, and if you are a female, they are doubly jealous. I remember on a story at Hyde Park. It was President Roosevelt's mother, Sarah Roosevelt's, 86th birthday. The press photographers tried to trick me when they got word that something was going on. They left the hotel where the press stayed without telling me. I only noticed it when I looked and they were no longer there.

So I got a taxi to the Roosevelt mansion, and they were just about finished photographing. I went up to Sarah and President Roosevelt and asked them if they wouldn't sit a minute longer for me until I had my camera out. They said they would. So I got better pictures than the press got by being late.

*Why were they better?*

Maybe because I begged them specially for it, and told them that I was left behind. Maybe they wanted to teach the press a thing or two. Also, because of being late, I made a different arrangement of the four Roosevelt generations.

*I would imagine you charmed his mother.*

That was very hard to do, but Sarah could be very gracious at times. I was a little worried because you could see the lower part of the President's leg. It was emaciated.

*They liked the picture and especially commented on it?*

Yes.

*Did you spend much time at Hyde Park?*

Well, the President had a kind of a friendship with Otto. In 1940 when Otto was in Cuba, the telephone rang and it was Steve Early, Roosevelt's press secretary. He said the President wants to speak to Otto. I said Otto is not here. *Life* had sent him to Cuba on assignment, and Otto was having trouble getting his American visa to return. Five minutes later the phone rang again, and it was Roosevelt himself, and he said, "I want to speak to my boy."

"Your boy is not here," I explained again.

The President was running for his third term. He said, "He promised me he would take some shots." Two days later Otto was home with his visa.

*You photographed a monkey in Puerto Rico.*

I call him the monkey on my back. It was a story on a Harvard Medical School project to study monkeys they set free. One afternoon all the doctors were away, and a little kid came running to me and said, "A monkey's in the water."

I came down, and that monkey was really going hell-bent for something. "He

is not coming back," I said. "I better go in and get him." I don't know why I was such a policeman, but I threw my Rolleiflex on my back and swam out.

I'd stand on the coral reef every so often and then swim again. Finally, I was facing the monkey. I don't think he liked me, but he sat on that coral reef there, and I took about a dozen shots.

I'd taken a lot of pictures of things besides the monkeys, but when I brought the pictures to Hicks, one of the writers stopped me in the hall and went through the pictures. He yanked the monkey out and said, "That's Henry Luce!" I did not know what the heck he meant, but it became the joke around the office, on the 32nd floor, that I had a picture of Harry Luce.

*Do you think it looks like Henry Luce?*

I didn't see Luce that much. He had lots of other things to do rather than talk with photographers. The photographers were a low group of animals then. But I suppose it does in a way. It all depends on what kind of a mood you are in. To me it looks like the monkey's depicting the state of the world at the time. It was dark and somber and angry. There were a lot of dark clouds swirling around. I heard from many people that they were scared when they looked at it. I have given a number of prints away. Somebody bought one in a Sotheby's auction. It sold for $6,400.

*Do you think photography is an art?*

It is a number of things. If you are an Ansel Adams or an Edward Weston, it's an art. But *only* that. *End.* But if you work with people, it has to be much more than art, and practically the only thing I work in is people.

You have to know how to read things in what's happening. When something comes into the face, into the eyes, you have to snap it very fast, otherwise you've lost it. But when you talk about it being art, actually I don't agree with that. Whether or not it is art, it's photography. You observe and decide what will make a picture. There are many things that I look for. Every story is a little different.

*Take the Dionne quintuplets, for example.*

Oh, I thought that would come up. [*Laughs*]

*Do you mind?*

What is it for me to mind or not to mind? The Hearst photographer was there at the same time, and he lined the quints up, 1, 2, 3, 4, 5, on the steps for the daily papers. I thought it was kind of corny, but I stood next to him and asked him to let me take that picture too. I just wondered what our editors will do with a thing such as that. By God, they ran it on the cover.

On the *Life* staff 1937-44
Interviewed in San Francisco on August 15, 1993

# "My cameras are upstairs, and I'm going in to get them"

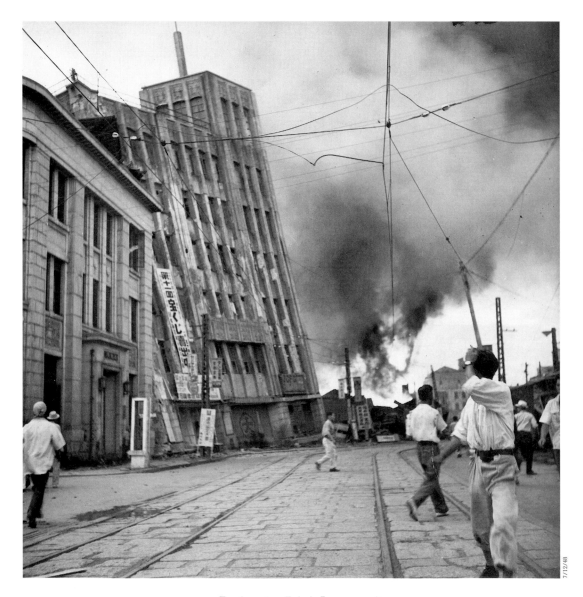

Earthquake. Fukui, Japan. 1948

# CARL AND
# SHELLEY MYDANS

CARL MYDANS: It may not be commonly known how often photographers see pictures that they very much want, that they cannot get, and that those lost images seem to cling to them forever. The kinds of things that you see out of a car or taxi or train for an instant, in circumstances when you couldn't get out with your camera and take pictures and yet the image that you lost stays with you. And sometimes it grows and gets better and better, and there's nothing you can do about it. I always thought that was a fate characteristic of the photographer.

But, then, someone in recent years who was not a photographer, told me exactly the same story. Barbara Tuchman, the historian, had just come back from China, where she was one of the few Americans who were allowed to enter China at the time when the conflict between communist China and the U.S.A. was at its peak. She had one of those little cameras with her, and every now and then she would point and hope to get pictures. One day she was in a big black limousine with a driver, a guard sitting beside the driver, and two notable Chinese gentlemen, who were conducting her through China. That morning when they started out, the car came alongside a small lotus pond. As her car passed, Barbara Tuchman saw one woman standing in the pond with long, wet black hair, the water up to her armpits, reaching out for a lotus. Barbara Tuchman surprised herself by saying, "Stop, please. I want to take that picture." Still the car continued. Barbara Tuchman then raised her voice and said, "Please, oh, please, stop. I want to take that picture." But the car kept rolling. And after a while, of course, the pond had gone, and the woman with the long black hair and that wonderful scene had disappeared. Barbara Tuchman repeated to a sedate man in the backseat with her, "Oh, dear, I so wanted to take that picture."

And the gentleman said to her, "Oh, please, Mrs. Tuchman, don't worry. There are many lotus ponds in China, and I'm sure we'll pass another one."

Then Barbara Tuchman said to me, "Do you know, I've never forgotten that picture. It keeps coming back to me. I don't know why it is." And I was so impressed. I thought only photographers felt that way about the loss of an image. They see images lost before them and around them all the time. I thought this was one of our unfortunate fates. But, no, here is a woman who hardly uses a camera, who felt the very same.

Of course, I may add to this too: it's common to have nonphotographers say to photographers, "Oh, well, never mind that," when you've exclaimed, "I wanted that picture!"

"There's lots of them," they say. Or, "We're coming right back by here this afternoon. We'll have a chance then." People who say that don't know what's in a picture. They don't know that a picture is never the same. That it's always changing. The light is changing, the background is changing, the feeling is changing—and if you don't get it when you see it that time, chances are you will never again get it.

Many photographers have gone back to redo a picture that they either did not get right the first time or were unable to get, and have never been able to redo it. What is in a picture is more than what a photographer sees. It's what he sees and he feels.

Other photographers have influenced me greatly, but I never felt them competition. Tom McAvoy was a very big influence in my life. Otto Hagel and Hansel Mieth were others. So was Bernard Hoffman, one of the funniest people we had on staff. I was very close to Peter Stackpole. Rex Hardy and I shared an apartment and often went out on stories together. He'd say, "I'll hold your lights," and I'd say, "I'll hold your lights." Rex went to Stanford with my wife Shelley and knew her long before he knew me.

I don't respect all the things W. Eugene Smith *said*, but I respect his eye. I respect both what Alfred Eisenstaedt shoots and what he says. Margaret Bourke-White was a great photographer. Just a great photographer. She had very good ideas. I knew her very well.

There's something about *Life* photographers working together that I should mention. There was an unwritten law, though I never heard anyone state it, that if two *Life* photographers, especially in combat, found themselves at the same place, they'd shake hands, share a cigarette, wish each other well and go in different directions. That's what I've always done. When David Douglas Duncan and I were covering the Korean War, we were forever coming together, and we always had the best of relations. We would sit down somewhere and say hi and talk about a few things. And then we'd get up and walk off. George Silk and I worked together in Italy. We were very good together, but I remember him as a very nervous combat photographer.

*John Loengard: Is that a good thing to be?*

No, I don't think so.

*What is good to be, as a combat photographer?*

Convinced that what you're doing is important. If I had ever reached a point in combat that I felt that what I was doing wasn't important, I would have gotten out of there.

*Did a feeling of importance make you feel safe?*

In combat, two things, I think, made me feel safe: the fact that what I was doing was important and the fact that I had that great protective instrument in front of me—a camera. The camera was my reason for being there. It was a justification against personal fear. Fear takes place mostly when you are uncertain of what you're doing, uncertain as to why you're there, and you wish you could get out.

We all had fear. I had fear over and over. I don't think I knew anybody who didn't have it. And sometimes fear was worse than other times. Sometimes you got up in the morning and you felt that no matter what you did, you couldn't get hurt. And sometimes you got up in the morning and you felt that whatever you did, you *would* get hurt.

*Did that stop you?*

No, it just made me all the more scared.

You know, in the Second World War, the military made a carrying bag called a Val Pack. When we were being briefed for the next operation, they would say, "Who are you going in with?" I never knew anybody who went in on a first-wave assault because he was asked to go. Everybody went in because he felt that he must. He raised his right hand.

Before the landing, everything except what you were taking across the beach with you was put into your Val Pack. The Val Packs were then collected, and after the landing, the word would be passed on D-day +2 or +3, or whenever the fighting allowed, "The Val Packs have come." You found your way to the beach and collected your Val Pack and put it in a jeep.

We correspondents were always sensitive and critical about our colleagues. The more battle wisdom someone had and the better their copy or their pictures, the better we respected them. But there were some among us who for any number of reasons didn't go in on the assaults. If you were going in over the beach, you were aware that so-and-so of such-and-such a newspaper or magazine was not going in with you. And we talked quietly about them. I don't remember anyone saying they didn't have the guts or whatever. They simply said, "Oh, John Jones, he's coming in with the Val Packs."

*Do you think that television has taken over what you were doing?*

Television's strength of reporting is fabulous. But it would be a mistake to think that the moving picture or TV will replace the still picture. There's a difference between what the still picture does and the picture that TV film gives.

On television it's wonderfully dramatic to see it as it goes by you. But it *does* go by you. With the still picture, it stays with you. You can hold it in front and look at it as long as you want and, like so many of us, go back to it and look again.

SHELLEY MYDANS: My father started the journalism department at Stanford. I went to Stanford, but I didn't study journalism. I came to New York nearly a year before I went to work for *Life*. I worked on the *Literary Digest*, which predicted a landslide for Alf Landon over Franklin Roosevelt in the 1936 election. Soon after that, it folded. I came to work on *Life* in September 1937. *Life* hit the world like a blossom. When I came, Mary Fraser, who was the head of research, said, "What do you know about pictures?"

I said, "Nothing," but it didn't seem to matter. I worked for the national affairs department, and so there was a lot of ordinary research and phoning and maybe going out on interviews, but not necessarily with a photographer. I met Carl at the Christmas party that year, which was one of those old-fashioned Christmas parties, a really good party. Everybody got drunk. We had done a story on Louisiana rice, and somebody had sent a gift of a big sack of rice to the writer or researcher. It had popped open while we'd been trying to close the issue of the magazine, and it was in all the different typewriters, and there was a gay time. That's where I met Carl. That was December of 1937.

We were married in June 1938 because we got the same weekend off, which was rare. We had been preparing all along, getting our license and the Wassermann test and the ring and all that, and suddenly we had a weekend together, so we went and got married. We drove up to a place that a number of photographers shared at Lost Lake, New York—a weekend place—and when we drove through Brewster, there was a lovely church with a white steeple, and we decided that was a good church. It was breakfast time, and Carl went in and got the reverend up. The poor man was shaking. But nevertheless he went through with it, and we got married. Then we had that weekend at Lost Lake and came back, and Carl went off immediately to do a story on a transcontinental airline— United Airlines—with my best friend, who was also a researcher. That's how our marriage started. Shrifty—Bernice Shrifte—became the head of research later, and she lives very near here.

*Life* editors thought a researcher who knew how *Life* operated and a photographer—if they were married—would make a very good team to send abroad when the war started. When the Nazis attacked Poland in September of 1939, we'd been married a little more than a year. We were to go to France, but nothing was happening there, so we went to England, and we did an essay on the Port of London: on all the docks and docksides and warehouses. That was the lifeblood of the empire, what was coming in and out of the Port of London. By now I had experience as a reporter for what *Life* wanted, and Carl was one of their best photographers.

*What did* Life *want?*

SM: *Life* wanted a story that could be told in pictures, and the role of the researcher was to get the background of the story and arrange for a photographer to shoot it. We were called researchers in those days, until you went overseas, and then you were glorified by being called a reporter, but it was the same work. The researcher got all the background, did all the phoning, and got an idea of what might be photographically interesting. Sometimes there was tension between what the researcher wanted and what the photographer wanted, because researchers got carried away a little bit. They went out in the field and talked to the people and came back and—sometimes, which they should not have done—they wrote a long list including this picture and that picture and the other picture that should be taken.

Alfred Eisenstaedt was quite noted for photographing only what he found picture-worthy. Sometimes some poor researcher would inconvenience a lot of people, talking them into cooperating on a *Life* story and setting it up, and then Eisie would say, "I do not see a picture." It never happened to me—well, a little bit. But mostly the researcher-reporter was sensitive enough to know how to write an outline of what the story ought to cover, to contact the people involved and help the photographer set up, and then stand back.

I learned, sometimes painfully, that a photographer has an eye. If a researcher has an eye too, then she should or he should be a photographer. The eye of the photographer is something unique. I want to tell you of something that happened to me with Bernie Hoffman, who was one of the original *Life* photographers. I was in Lisbon to do an essay on Portugal, and Bernie was to join me and do the story. Those were the days of the Pan Am Clipper planes. His plane had to come down in the Azores, and he got caught there by weather for a long time, so I researched Portugal. I knew it back and forth. I studied the Portuguese government budget. [*Laughs*] I did all kinds of research, and so I felt I knew what was going on.

Bernie came in, and he was—it's the only time I've worked with a photographer who was in any way tentative. So I felt I could tell him, "There's a good picture," which I did at one point. It was a wonderful, very, very small chapel. Maybe six or seven peasants could get into it. I said, "Oh, Bernie, there's a picture. Take that picture." Well, he took something. And not until a long time later did I see a print of what he took. A marvelous picture of wooden shoes on the steps outside the chapel. It would have been impossible to take that picture of that little, dark chapel without going in and setting up all kinds of lights. But my feeling was, "Oh, doesn't that look wonderful!" Bernie knew what he could get and what he couldn't. What he did get was a very telling picture of those wooden shoes on the steps of the little chapel. It taught me.

*What if a story came back with bad pictures? Whom did New York harrumph at?*

SM: The photographer. That's the photographer's job. If it came back and

93

9/21/59

Shelley Mydans and troops returning from Mass. 1941   *The editors wept over it.*

Benito Mussolini. Rome. 1940   *"The elderly butcher boy of Fascism steps out."*

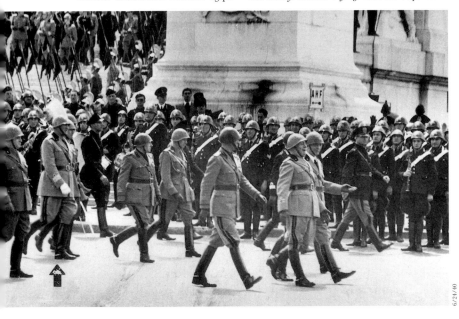

6/24/40

War in Finland. 1940
*I've never been sure whether it was*
*Life or the Finns that wouldn't allow*
*a woman correspondent in.*

2/26/40

some portion had not been covered, they might say to the researcher, "What happened here?" But photographers are not stupid. If they're on a story and you have forgotten to include some section, they're going to see that. Of all the photographers I worked with, besides Carl, the majority preferred to work alone. They preferred it if the researcher or reporter could set things up for them, and maybe accompany them, and then stand back. The only thing that they appreciated was your writing their captions.

When the editors were laying out a story in New York, a researcher was not supposed to say anything except to tell them what the pictures were about. They had a very good point. *Life's* executive editor Dan Longwell's feeling was, "I want the pictures to speak to me and to the reader."

Thorstein Veblen wrote about conspicuous consumption in his *The Theory of the Leisure Class,* and I always think that the early *Life* operated in this way. They shot much, much more material than they could use and covered things almost scattershot and then culled from it the best. I am guilty myself of suggesting three stories because there was one I wanted very much to get in the magazine. So somewhere around the United States some photographer was shooting a story that already, in the mind of the originator, was a reject. There's a possibility it could have been used, but that was kind of profligate. Shoot everything, and we'll get the best. It worked in those early days of *Life*.

CM: There's a point I would like to make here. One of the reasons that some of these stories were never used was that somebody may have thought the story did not meet standards. One of the reasons why *Life* magazine is the great magazine it is, is that no matter what was spent on the story, the pictures had to be worthy to be used in the magazine.

SM: After England, we did an essay on Sweden. While we were doing it, the Russians attacked Finland and Carl went into Finland. They wouldn't allow a woman—I've never been sure whether it was that *Life* wouldn't send a woman or the Finns wouldn't allow a woman correspondent in. I think it was *Life* that didn't want a woman endangered. So I stayed in Sweden to finish the Swedish story. While I was finishing that story, the opportunity to work in Italy came up, and Tom McAvoy and Carl went there for the essay on Fascist Italy in 1940.

CM: Tom and I were arrested continually, wherever we raised a camera, wherever the Black Shirts saw us attempting to work. For example, Benito Mussolini had just pinned medals on the wives and mothers and children of Italian soldiers who had died in the fighting in Abyssinia. He came down the steps of the Victor Emmanuel Monument in Rome. As Mussolini marched past me, the Black Shirts had to turn around and salute. Between their shoulders I was able to shoot a quick frame or two. When those pictures appeared in *Life* with the caption "The elderly butcher boy of Fascism steps out," our entire bureau of *Time* and *Life* and *March of Time* was expelled from Italy. None of us were allowed back in until we returned with Mark Clark's Fifth Army.

SM: While they were in Italy, *Life* sent me to Portugal; and when the Germans came through the Maginot Line, Carl went to Paris from Italy. Then when all of Paris fled the Germans, Time Inc.'s whole bureau fled south. Carl went with them, and there I was in Portugal trying to get places for them to stay. It wasn't easy. They called Portugal the balcony of Europe, and it was really tipping into the sea at that point. Then *Life* decided to send us to China in December 1940.

CM: When we worked in China, I did virtually everything with Shelley. She says that she didn't work as steadily with many of the other photographers. It was their loss. It's a sheer pleasure for a photojournalist to be able to work and not have to stop after every frame or two and write captions in a notebook. Shelley, behind me, would know what camera I was using and what picture I was getting. I had the complete comfort of not having to stop and talk to people and say, "What's your name? What's that place?" The captions that Shelley made in the years that she worked with me are still in *Life's* files. They're great captions.

*Carl says that when he was at war, because he had a camera, it made him feel less afraid. How about you?*

SM: I didn't have that crutch. And not having it, I didn't miss it. I hesitate to say it, but there's a certain trust in God. I don't mean to sound very religious, but if you've lived your life in God's hands, then the bad times and the good times smooth out a little bit. And we were very young. I was 26. That has something to do with it. It was so extraordinarily exciting. It was going into a totally new and ancient culture, under great stress. Everything you saw and heard in China in 1940 was extraordinarily new and exciting. During air raids everyone went down into the air raid shelters—long caves that they dug into the sides of Chungking's rock. One thing that struck me, and I always like to bring it up: it didn't smell bad. Packed with Chinese who didn't eat meat. [*Laughs*] The smell was perfectly O.K. You'd sit there for hours. Hours. All day on and off. But it didn't ever smell bad.

CM: One of the charges against Westerners and Americans when we first entered Japan in 1945 was that we were meat eaters and we smelled bad.

SM: In 1941 we went to the Philippines. General Douglas MacArthur was building up the Philippine army in case of a Japanese attack. Carl made a picture there that people talk about. I used a large notebook for captions, and I was marching back from Mass in the fields with some young, raw Filipino troops. Carl told me to walk next to the flag at the front of the Filipino soldiers, and I did. We thought it was a joke. By the time the picture got to New York we were already captured and in a prison camp, and the editors thought my notebook was a Bible. They all wept over it. The managing editor, John Shaw Billings, hung it in his office. And we thought the picture was a joke, I'm sorry to say.

CM: It was a personal picture. Normally I'd get contact prints sent back to

me in the Philippines, but by then the war put us out of reach and New York had no way of knowing that this was a personal picture. Normally it would have been identified as such in the caption material, but in this case we had no time. The story and some others taken just before the Japanese invasion were sent in great haste on the last Clipper to get out of Manila.

*Tell me about the day you were captured.*

SM: We were in a hotel in Manila. The Japanese had ringed the city. They came in from the north and the south and had it in a vise. Our army had pulled out in retreat and gone to Bataan. The word came from the Japanese commander, "Stay in your houses." So we stayed in the houses—this is very tame, really, I'm sorry to tell you. Then they came into the hotel, and they sent Japanese civilians up to each room to check on our belongings and whatnot. Carl had gotten rid of his cameras—hidden them. The Japanese were very, very correct when they came into Manila, at least as far as the foreigners were concerned. I think that was because they were aware of their reputation from when they went into Nanking. Later on they lost their cool and were horrible to American soldiers. And at the end of the war, when they were losing, they turned into beasts.

CM: The Japanese were watching very carefully what the Germans, their Axis partners, were doing in Paris. You may remember that when the Germans took Paris, at first they took it with gloved hands. The Japanese tried to emulate what the Germans were doing in Paris.

SM: They weren't so very good to the Filipinos, but they were very careful with us. They had the Filipino hotel staff clear out. We took care of ourselves in the hotel for a couple of days. Then the Japanese brought trucks up and said to come down and get into the trucks. They surrounded us with fixed bayonets, but they didn't look very fierce. When they said, "Get in the truck," we got into the truck.

*How long did you think you'd be prisoners?*

SM: Two years. A lot of people said, "MacArthur's coming over the seawall tomorrow and we'll be free on Wednesday," and then they would be a little more realistic: "It will be six months." I wrote a book about the first year in the Santo Tomas prison. It was fiction. One of my characters said what I believed at that time, "Two years." Carl and I could see each other all day long, but at nighttime we were in separate rooms. They didn't feed us, so we were very hungry, and we were sick sometimes, but not physically hurt. At first the Filipinos threw food to us over the prison fence, and later the Philippine Red Cross brought rice and cereal into the camp. The Japanese, I have to say, from my own personal experience, were all extremely correct and decent to me.

*Were you treated in any way differently because you were journalists?*

SM: They discovered that Carl was a photographer some months after we were interned, and they asked him to come out and photograph the American prisoners that were taken—not the Bataan death march, but a little later when

Corregidor fell. They marched the American prisoners through Manila. The commandant by that time was a foreign service officer and had been a Japanese consul in Vancouver. He asked Carl to go out and take pictures. Carl said he couldn't do it—What would the commandant think of a Japanese in America who took propaganda pictures for the Americans? And the commandant said, "Ah so." And no more pressure.

*Carl, did you feel that history was passing you by?*

CM: I felt two things. I felt that I was living in history and that the history I would like to have covered was passing me by. Remember that we were in a prison camp in Santo Tomas, the university in Manila, and that was within bombing sounds of the war on Corregidor and Bataan. We had spent our lives as journalists actively covering what was happening around us, and here, suddenly, because of our capture, we found ourselves sitting in a barbed-wire compound, listless, with nothing to do, listening to the battle that was going on. That was maybe the most terrible period in my life.

SM: I think Carl felt it much more than I did. As a matter of fact, the whole thing of being taken prisoner, I think, was much worse for the men than the women. In those days women—we didn't think of ourselves as subservient at all, but it wasn't demeaning to our ego as much as it was to a man's. Especially as the Japanese in those days were very small people. They've grown a lot physically since then. They were very small, little soldiers who took us. It was demeaning for the men.

Then the opportunity came for us to go to Shanghai on a Japanese troop ship. Several journalists seized it. One of the reasons we went was that the idea of escape in the Philippines was really out of the question. We hadn't been there long enough to know anybody. And it's an island. There was a dreamy feeling that maybe in Shanghai we could get through the Japanese lines to free China. When we got to Shanghai, almost immediately an American bishop who had been in Shanghai many years, and two other people who spoke Chinese well, had tried to escape. They had been brought back and put into Ward Road Jail, which was a terrible place where people got tortured. That greeted us when we arrived.

The other reason you couldn't escape from the camp and from Shanghai was that there's this network thing that the Chinese have—and the Japanese also have—of interlocked responsibilities. You had to name a friend in Shanghai before you ever got there, and then he had a friend and so forth. If you escaped, then that man would be killed. That was how they stopped escapes from Santo Tomas. The first escape we had there, three young men got out. They were captured and brought back into the camp. There they beat them, and each room, under Japanese orders, had to select a monitor—sort of the responsible person— and the Japanese took the room monitors to the cemetery to witness the shooting of the men. And the Japanese said, "From now on, anyone who tries to

escape, the room monitor will be shot." Well, you're not going to—this poor guy or woman who's the monitor is, willy-nilly, your anchor to stay in camp. And the same thing happened in Shanghai.

The other reason we went was that we should have been in the very first exchange of correspondents and State Department people and Red Cross people who were supposed to be exchanged immediately. But the Japanese didn't recognize the Philippines as foreign territory to the United States, and we thought an exchange might be more feasible in Shanghai. So we had a fascinating trip on a Japanese troop ship from Manila to Shanghai in September 1942. We were bedded down in the hold along with several platoons of Japanese soldiers with some of their "comfort women" and two unhappy neutrals, who had booked passage thinking they would have cabins on deck.

After a few months of relative freedom in Shanghai, we were interned again, and one year later were included in an exchange of Americans in China for Japanese civilians in the United States. We were very thin, of course, when the exchange took place on the west coast of India. But then we had a long trip on a Swedish ship, the *Gripsholm*. Eating, eating, eating, and writing about Japan and the Philippines and China the whole time.

CM: I was a week late in registering with the draft board after I got back to New York and was back again in my office. Wilson Hicks, the picture editor, said that he'd just gotten a call about me. Had I been to my draft board?

I said I hadn't. I'd forgotten about it. He said, "You'd better go right over to them now," and he wrote out the address for me. When I came into the room, it was empty. One old man was sitting at the table way down the end of the room with a single bulb hanging over him, reading the newspaper. I walked all the way down to the end of the room, and he looked up at me and he said, "What's your need, Son?"

I said, "I've come to register for the draft. And he reached over and took a form and handed it to me. I said, you know, I've been away. I've been a prisoner of war, and I've just come back on the *Gripsholm*.

He said, "Put it all down there." And I did. I wrote it all out and handed him the slip, and he looked at it under that one bulb and raised his head to me and said, "Son, where you been all this while?"

I said, "I've just told you. I've been a prisoner of the Japanese, and I only got in on the *Gripsholm* last week, December 1st."

He said, "Yes, yes. I understand that, Son. I can read. But you've been here a *week* since you've come back. Where you been all this while?"

SM: Carl then went to cover the war in Europe. I took a leave of absence to write a book about Americans interned by the Japanese called *The Open City*.

CM: I went to France, and in every town, the moment it was liberated, the French sought out the unfaithful French. Some they dealt with by insulting them, by shaving their heads, by ridiculing. Some they hanged. Some they shot. In

Firing squad. France. 1944

*I have never been able to make a sharp picture of executions.*

10/2/44

3/5/45

Former prisoners. Manila. 1945

*"It is Carl Mydans!" somebody yelled,*
*and I fell into the arms of friends.*

General Douglas MacArthur landing on Luzon. The Philippines. 1945

*"How many times did he do that for you, Mr. Mydans?" The answer is always: "He did it once."*

2/19/45

Grenoble I photographed the shooting of six young Frenchmen who had been persuaded by the Germans to do things for them. It was quick justice. I photographed a number of such rifle volleys against human beings during the war. I had just photographed the execution of Pietro Caruso, who was the police chief in Rome under the Germans. I photographed some others, but I have never been able to make a sharp picture of executions. It has nothing to do with the imperfections of my camera or my own failure as a photographer. It has to do, I now understand, with an inward revolt, a self-revolt against my taking such pictures.

I was in France when I got a coded message from my office that spelled out in bright letters to me: MacArthur was returning to the Philippines. By the time I got to Leyte, though, the landing was over and a picture of MacArthur coming ashore there had already been made and published. While the last of the battle for Leyte was still being fought, MacArthur's public information officer called us together and said, "MacArthur will go to the Luzon assault on the U.S.S. *Boise*. Six of you will go in with him. You'll draw lots out of a helmet." A captain tore up paper, and everybody put his hand in and took out a piece. In the helmet for photographers, the slip of paper I found in my hand had the one word "Stills." I was the only still photographer, except for the military, on the U.S.S. *Boise*. I was loaded into the same landing craft with MacArthur, and I went ashore with him.

The story of what happened there has been told and retold many times, incorrectly. I've just come from a photo exhibit in San Francisco. One of my pictures hanging there was of MacArthur coming ashore. So many visitors there came up to me and asked the same old question: "How many times did he do that for you, Mr. Mydans?" And the answer is always the same: "He did it once." I now realize that the question will go on forever. These are stories that once created will keep being told, and each new generation will find, if they're interested in the subject, some reason for telling it. Usually it's with delight.

Well, I went ashore with MacArthur in that LCVP landing craft, and not until we neared the shore could we see that the Seabees had gotten there ahead of us. They'd laid a series of square steel pontoons that were joined together to make a landing platform for MacArthur to walk ashore. When I saw that we were heading for the pontoons, I climbed up on the top of a landing-craft ramp to prepare to jump ashore and photograph him stepping onto the Philippines. I heard the motors reversing, but I was poised over the dock, so I jumped onto the pontoons. When I swung around, the LCVP was already backing out, away. Having spent a lot of time with MacArthur, it flashed on me what was happening. He was avoiding the pontoons and was going to land in the water further down the beach. So I ran up those pontoons with cameras hanging on me and saw the LCVP straighten out and proceed parallel with the shoreline. I followed it, running along the shoreline, until, as I expected, the boat turned and headed in, and there I was standing in my dry shoes waiting for MacArthur to come

ashore wading in the knee-deep water. I photographed him, and that's my picture of MacArthur returning to the Philippines.

As I have often said, anybody who asks, "How many times did General MacArthur do that for you?" doesn't know much about MacArthur's behavior toward photographers. One thing had been not to do what a photographer asked him to do. If the general was in a crowd, and photographers were desperately trying to photograph his face, and one of us called out, "Will you turn this way please, General?" He just would not turn. We've all got bugs, and one of his was never to give a photographer what he asks for. I've spent years with MacArthur, and he was very good to me in many things, but he always treated me as though it was up to me to photograph him without his help. Just as it was up to him to land on Luzon, it was up to me to photograph him coming ashore. He did it once, and that's how I caught him.

I had many friends in MacArthur's command who knew my history, and because of that I was the only photographer to take part in the liberation of Santo Tomas. That was the most important story in my life. We burst into the main gate at night. I rode on the back of a tank up through the big blacktop road into the prison camp, and came into what we had learned to call the Big House.

In the dark, somebody had cried out, "They're Japs!"

I called back, "No, we're Americans. I'm Carl Mydans."

"It is Carl Mydans!" somebody yelled, and I fell into the arms of friends.

I began making pictures all over the place with first light. There were 32 men in my room in Santo Tomas, and I photographed them all. All were very ill. The most common disease was beriberi, a deficiency disease which results in large legs and ankles and wrists. They thought that the Americans who liberated them were the most handsome people in the world.

SM: While Carl was going on up from Leyte to Luzon and then into the fighting for Manila, I was not allowed to go to Manila until it was pretty well secured. I worked with Gene Smith on a story on the refurbishing of the damaged machinery in Pearl Harbor. Gene is the first person I'd ever known who lived on uppers, downers and chocolate bars. That's it. But a very gentle person, you know. When Admiral Chester Nimitz, who was Commander-in-Chief, Pacific, moved his headquarters from Hawaii to Guam, I went with him. B-29s were making fire raids on Tokyo. It was very dramatic the way they took off from Tinian in great sweeps. Tinian had a cliff at the end of the runways. These big, heavy planes would trundle down, and then they'd go off the edge of this cliff and sink down almost to the water and then rise again. Formation after formation after formation. But burning down a city was really—it really hurt your heart knowing what was coming for the Japanese. Daily we could get the Japanese internal propaganda through the Navy. The phrase that sticks in my mind—and I use sometimes—was when the Japanese, knowing that these B-29s

were coming, would say, "Fill your teakettles, and prepare your mental attitude." Thousands were then killed. Burned up—oh, it is horrible to think of what we all did then.

Gene Smith came to me on Guam and said, "Would you arrange for me to be with the first flight of planes over Tokyo, and then, on their way back, would they drop me off in the first wave that's going to land in Okinawa?" Everybody got a very good laugh, but Gene meant it. He didn't get to go on the plane, but he did go into Okinawa on the initial assault. He always wanted to be in front of the first soldier in combat. He often was, and he stood up with his camera on Okinawa and got shot in the mouth. He came back to Guam with his mouth wounds and his face shot to death. We got him back to the States.

At any rate, when MacArthur finally said I could come to the Philippines, I went and joined Carl in Manila, and we did one story there together. Then the war ended. Carl went up to cover the surrender on the battleship *Missouri*, and I got stuck behind, to cover the surrender of General Tomoyuki Yamashita in the Philippines.

CM: On the *Missouri* I made pictures of the surrendering Japanese officials. The ceremony was interrupted when the Canadian representative signed the surrender document in the wrong place and threw the smooth working of the ceremonies into confusion. During that upset, I was standing in my position on a planked-over 40-millimeter gun tub. We all were to hold our positions and not move, but in the moment of that great mistake, I jumped off of the gun tub down to the deck and made three or four frames of the Japanese delegation and the faces of the MacArthur team, concerned about where the correction should be made.

A Marine, who I remember as very big, came up behind me and picked me up, cameras and camera bag on my shoulder and all, and carried me back across the deck and put me back onto the 40-millimeter gun tub. As I was being carried past the general, there was just a moment's glance between MacArthur and me, and I caught what I remember was a very small twinkle in his eyes.

In Tokyo, months later, I was meeting General Robert Eichelberger, commander of the Eighth Army in the occupation of Japan, in his office when a telephone call came reporting that Prime Minister Hideki Tojo had shot himself at his home in Tokyo and was being rushed to an Army dispensary in Yokohama. I rushed there in a convoy of jockeying, competing jeeps with other correspondents. There General Eichelberger spotted me and invited me into the dispensary with him. Inside, I saw two American medics giving General Tojo blood— American blood. Tojo had not, at that instant, regained consciousness, but in a moment or two, we could see color coming into his face and he opened his eyes. The U.S. Army interpreter bent down to Tojo and said, "General Tojo, this is General Eichelberger standing beside you." And Tojo's face turned a little and looked up toward Eichelberger. Then he muttered something, and the interpreter

reported, "Tojo said, 'I'm sorry to have caused you all this trouble.'"

"Ask him if he's talking about the trouble he's caused today," Eichelberger said, "or the trouble he's caused the past four years."

SM: After the surrender, two things happened. One, I had a baby, and, two, Carl got to be the Time-Life bureau chief in Tokyo. So the bureau was a man and a half. I was the half man–half mother.

CM: It was my custom to take a long drive through the Japanese islands every two weeks to look at what was happening as the occupation was developing. I was standing in our office with my assistant Kay Tateishi about to leave again for another trip, and we were undecided where we were going. Shelley was sitting nearby at her desk. I said, "Shelley, we're about to leave. Do you have any ideas where we should go this week?"

She said, "Yes, I've just been reading the military government report on a town called Fukui. It says it has one of the best records of rebuilding since the end of the war."

So I said to Kay, "Let's look at it on the map." And we found it and said, "Let's go there."

It took us two days to drive there because we were making pictures all along the way, particularly the scenes of harvesting of rice. When we got to Fukui, we checked in with the military governor, who told us what was happening in the city and said, "Let me send somebody around with you to show you what the Japanese have done." Having worked half a day on the town of Fukui, we were having dinner in the makeshift dining room of the military government and were just beginning our dessert and coffee when suddenly the floor blew up under us.

I remember someone shouting, "Earthquake!"

We all got up from our chairs and tried to get to the door. We couldn't reach it because the floor was dancing so. Each time we took a step, we were pushed to this side or that of the doorway. Finally I got through and out of it, and Kay Tateishi came with me.

Outside the building there were all kinds of injured people already being gathered there, and then I realized that all my cameras were upstairs. The ground was still opening up and jumping around us. I said to Kay, "My cameras are upstairs, and I'm going in to get them."

He said, "Don't go in that building." But I went in, and at first I couldn't find myself in it because everything had changed. All the fire extinguishers had been thrown on the floor and were foaming white over everything. When I got upstairs in some way, I couldn't find the room where my cameras were because everything had been shifted and thrown around. Finally I found the cameras and came down, and Kay and I began to work at once, covering the earthquake. Very nearly everything we saw was a picture.

By daybreak we had made all the pictures that we could. Some were made with the light of the burning town. The earthquake came not only at dinnertime

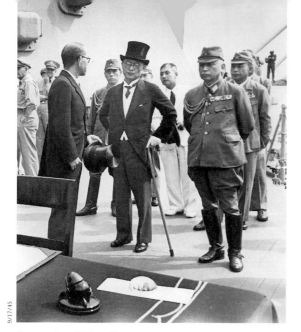

Surrender, Tokyo Bay. 1945
*The Canadian threw the ceremonies into confusion.*

Winston Churchill. Sicily. 1955
*Sir Winston hid his glass and said,*
*"I'm not eager to be photographed."*

J.F.K. is dead. New York City. 1963
*One of my pictures of that scene is one of mine most often asked for.*

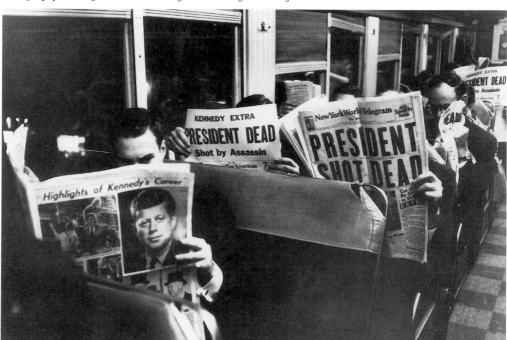

for us, but at dinnertime for the Japanese, which means they were cooking their dinners all through the town on little open charcoal hibachis. The timbers of the buildings fell on the charcoal burners and began to burn as we stood there and watched. In a few minutes we could see smoke beginning to come from every part of the city. And pretty soon the entire city was burning. Mine was perhaps the only picture record made at the epicenter of a major earthquake by an experienced professional photographer.

*Let's talk about what you do when events aren't happening in front of you. When you photograph somebody, are there tricks you use to get the kind of picture you want?*

CM: I talk to them. One of the things I say is, "You know, I don't work very fast. I hope you're going to be patient with me. It may take some time, but I'm looking for a good picture of you, which I think you would like. I can make any other kind of picture quickly, so I hope you'll be patient with me."

When I was in Rome in 1940, I learned that Ezra Pound, the poet, was in Milan. For a long time we'd been wanting to photograph him, so I called him from Rome, and he said, "No, I will not allow anybody to photograph me." Then after a long talk, he said, "Well, I won't allow you to take my picture, but I will invite you to come to Milan and we'll have lunch together."

So I came to Milan to have lunch. A photographer is never sure of himself when a subject says, "I don't want you to photograph me." Sometimes they really don't want you to photograph them, and sometimes when they say they don't want their picture taken, they really do want to be photographed. This time I was convinced he really meant no. We had a long lunch in a small restaurant, and he talked, saying amazing things about Fascism, about world power, about the United States and about his broadcasting for the Fascist government. It was so good that early in the talk I did something a reporter is never sure he should do. I said, "I'm very much interested in what you're saying, Mr. Pound. Do you mind if I take some notes?"

He said, "No, not at all," and so I have notes of this visit with him that I think are historical gems. When we finished, we walked to the front door of the restaurant. I thanked him very much for giving me all that time. Then when I put out my hand to shake his, he took it very quickly, and straightening up said, "All right, now, where do you want me?"

That was the first indication I had that he was going to allow me to photograph after being with him all those hours. I took him across the street to a bench in a small park, and he sat waiting for me to act. I was not prepared. My cameras were still in my bag, and while I stood there taking them out, he was adjusting his Western sombrero with such eagerness that I had to say to him, "I'm not quite ready, Mr. Pound. Please relax. I'll tell you when I am." And he sat there with a hopeful look.

There is no assurance, as I have said, that when people say no to a picture, that they really mean no. But there are people who just hate to sit in front of a

camera. I'm one of them. William Faulkner is another. He proved to be one of the best and dearest subjects I ever had. Still, it was difficult to reach him. We had gone to his publisher and to many others. Nobody could get to him. Finally, his son-in-law invited me to go to West Point, where Faulkner was to lecture to English classes on the novel. There I was told that I would be put in a room with him, and I would have only three minutes by the watch. That I was not to speak to him. I agreed to all these things, and I got into the room before Faulkner, set up my lights and waited. I was shooting color. Then Faulkner came through the door and walked directly to me with his hand out and shaking hands said, "Mr. Mydans, how good of you to come all the way up here to photograph me." While I was photographing him, he broke the rule West Point had established that we would have no conversation, by speaking to me first, even though I didn't speak to him. My feelings for him are very warm. His portrait was on the cover and was already on the presses when the editors scrapped it for the hydrogen-bomb test in the Pacific. Someone at the office kindly saved a printed copy of the cover for me, which I still have among my favorite pictures. The picture was later used at his death, but it wasn't used as a cover.

In the 1950s, when I was based in London, Harry and Clare Luce met Winston Churchill in Sicily to persuade him to publish the *English Speaking World* in the Time publications. They asked me to come down to photograph them together. "Be prepared to come in tonight after dinner and photograph Sir Winston and Harry and me," she said. When I did and Sir Winston saw me coming with a camera, I got an unwelcoming look from him. Clare said, "Sir Winston, this is Carl Mydans. He's a friend of Harry's and mine, and he's come to photograph us." Sir Winston, who had a large glass of brandy in his hand, grumbled and hid the glass on the table behind him.

"I'm not eager to be photographed," he said.

"We would like very much to have the picture, Sir Winston," said Clare. "Carl is a friend and a notable photographer."

Sir Winston replied, "Photographers—I know them all. All they want is one more, one more, one more," and he stood there awkwardly beside the Luces, and I photographed them.

I never had much to do with the Kennedys. I was out of the country most of the time when John Kennedy was Senator and then President. The day he was shot, I had been out of New York, and when I got back late in the day, I found that our entire staff, both writers and photographers, had been sent in every direction, to get whatever they could. Somebody in the office said to me, "You're the last one."

I said, "What do you want from me?"

"We have no idea," they said. "Go out somewhere and bring something back." I went out and made pictures here and there, and finally I got to Grand Central Station and made some pictures, but nothing I felt was anything good.

Then on an impulse, as a train was about to leave, I followed the boarding crowd, and I got on the train. I didn't even know where it was going, but it was loaded with people, everybody sitting throughout the cars and reading about the murder of the President. It was in the days when there were many competing evening newspapers in New York City, and that's the scene I got. Just standing in the train and taking a picture of everybody reading. One of my pictures of that scene is one of mine most often asked for.

*Before you covered the world for* Life, *you covered the movies.*

CM: In 1937 I was the first *Life* photographer in Hollywood. In those days when they finished shooting a scene, someone would shout, "Stills!" and the studio still photographer would come with his 8x10 inch camera on a big wooden tripod, and he'd make a picture on a big negative and a very sharp contact print from it. I did not take pictures of these carefully produced, frozen scenes. I took pictures behind the production with my little 35-millimeter Contax, and that worried them. Word spread that this new man from *Life* has been sent out from New York to destroy the Hollywood illusions their papier-mâché scenes were creating.

There was a hostility to me on many of the lots. The word went out also that I was breaking the rules by making pictures without joining the union. I told New York about this, and they said, "Join the union." Some friends on the Paramount lot took me aside and said, "Look, Carl, you can't join the union until the books open."

I said, "The law says that the books must open once a year, so sometime I will have the chance to apply to join."

Another friend took me aside and said, "Let me tell you something. The books do open once a year, but they open in somebody's basement, somewhere in Hollywood. Try to find out where." Finally this was ironed out with an understanding. The union agreed to let *Life* make pictures on studio lots provided a union man was present. He might sit in the corner and smoke a cigar and read a newspaper, just so long as we paid for his presence. That rule began with me, and it's still the same rule today.

I had other problems in Hollywood. At first the actors and actresses there supported the union photographers. The first time I went to photograph Carole Lombard, she said, "I hope you understand my rule here. If anybody photographs me, all pictures must be shown to me. I will decide what can be used, and those pictures that I do not want used, I will tear the corners off."

I brought her my first batch of pictures. She received me rather coldly, and she sat with the pictures and looked at them. Then without raising her head to me, she tore the four corners off of each print. I went out of her studio office feeling awful. But some weeks later, I was invited to come back and photograph her again. I don't know what went on behind the scenes, but she received me

very nicely. I photographed her, and I brought back to her all the prints that I made. And she okayed all of them.

I don't think I had to bring any of my pictures to anybody for approval, except Carole Lombard. But, you know, there's a picture I made of General MacArthur in his plane, *The Bataan*, on a flight he was making to watch the dropping of U.S. paratroopers near Pyongyang late in the Korean War. There was only a handful of correspondents and photographers aboard, nested back at the tail end of the plane. The general was sitting up forward. We were not to talk to him or photograph him during the flight. But when I saw him sitting there with his hat off, I decided to take the chance. I had never photographed him with his hat off, and I don't know anybody else who did. He didn't want to be photographed showing his hair combed over a bald spot, as you see him in that picture. What motivated me was the rule he once laid down to me: "I will not allow you to come into my home or my office and photograph me in posed pictures," he said, "but if you get me doing my job in the field, you can do anything you want with me." This was a picture of him in the field, so I preset my camera, walked up quickly in the plane, made that picture and backed away quickly.

He turned around and looked at me. He never said anything. He never said anything later either. And we have that picture.

There's a thrill to see the picture form in front of you and to catch it. The world is in motion, and the photographer has to find some way to stop that motion for an instant. Sometimes it's not easy, but there's nothing that I have ever done that is more fun.

On the *Life* staff 1937-72
Interviewed in Larchmont, New York, on January 9, 1992

# It's probably the most memorable
# picture that I've ever taken

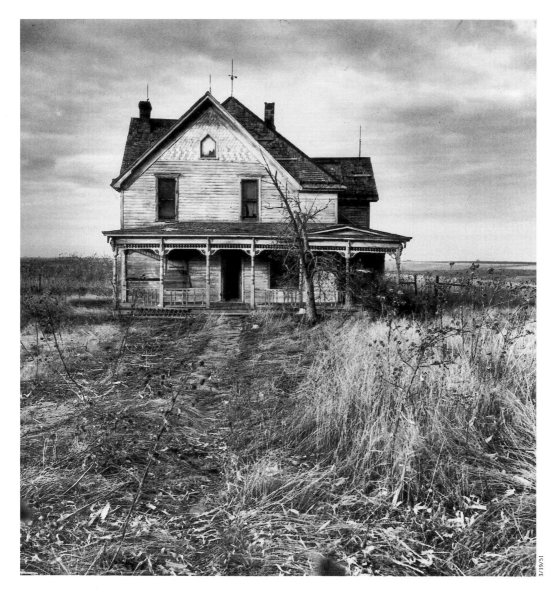

3/19/51

Willa Cather country. Nebraska. 1950

# DAVID E. SCHERMAN

**D**AVID E. SCHERMAN: There were a number of blessings in working for *Life:* permanent affluence, for one thing. I'm able to retire and live like a duke, if not a king, thanks to *Life's* open-handedness. For another, there's association with a wonderful bunch of people and working for the hottest publication—or the hottest medium—that existed until television came along.

The day the weekly *Life* folded—December 8, 1972—was a Friday. On Saturday I phoned the managing editor at home and said, "We ought to do a book called *The Best Pictures of* LIFE."

He said, "Go do it." Within six months I had produced a book called *The Best of* LIFE. Such was the popularity and importance of the magazine that this book sold 1.6 million copies in six months, which was the fastest-selling book in the history of publishing, including the Bible and *Gone with the Wind*.

*John Loengard: What did you look for when you chose pictures for* The Best of *LIFE?*

Pictorially astonishing pictures, because pictorialism is the hallmark of our business. Just as important is newsworthiness and immediacy—and emotional quality. By the time I did the book, I had gone through all the issues of *Life* three times.

*Who was the best* Life *photographer?*

Gjon Mili. He was technically brilliant. He was also artistically and emotionally brilliant. He started his career taking stroboscopic pictures of sports people, and of drops of water, and of bullets going. Everybody said, "That's as far as Mili's going. He's a hell of a scientist and a great technician." Then he fooled us all by becoming a fantastic artist.

Oddly enough, he was an expert dancer, so he became a ballet expert. His pictures of ballet in *Life* are unsurpassed. Then he started taking pictures of sculpture. Then, to fool everybody, Watergate came along, and Gjon, who was over 70, went to Washington with a 35-millimeter camera and took the most telling news picture of the Watergate hearings when John Dean was sworn in. So he was a news photographer, an artistic photographer and a great technician—and a sensational human being, which has nothing to do with photography. I think Alfred Eisenstaedt may be his equal, but I don't think Eisie has the technical facility that Gjon had. What makes Eisie distinguished is his sense of timing. Eisie has never, in his whole life, taken a bad picture, at least that I've seen. If you want the job done, you send Eisenstaedt to do it, and the job gets done.

*For 20 years you were an editor at* Life. *As an editor, for example, why did you ask Gordon Parks to photograph Ernest Hemingway's Paris?*

The purpose was to illustrate the posthumous publication of Hemingway's *A Moveable Feast*, which we bought for 100,000 bucks. It needed a genius to go there and re-create something which no longer existed. Gordon is a superimaginative person. He did exactly what we wanted him to do, and Mary Hemingway got along with him famously.

Mary Hemingway had been Mary Welsh, and she was a dear friend of mine. We were colleagues in the London office during World War II. I sweated out her romance with "Papa," which took place mostly in the Ritz Hotel in Paris during the war. Her colleagues on Fleet Street always said that Mary didn't behave like a gentleman. They thought that leaving her husband, who was a writer on the London *Daily Mail*, was an ungentlemanly, un-Fleet-Street-like thing to do. Needless to say, we all laughed uproariously at this.

*You were living with Lee Miller and her husband?*

Yes. I had been living with some other people in a flat in the West End. Lee had been the sort of reigning fashion photographer in Paris. She was invited to dinner one night and stayed—or, rather, I went back to her house and stayed—for six years. I lived with Lee and Roland Penrose, who later became her husband, from late 1941 until after the end of the war.

It was sort of a ménage à trois, but Roland was in the British army, and so the ménage à trois really became a ménage à deux. For two years after the liberation of Paris, Lee and I lived together in the Hotel Scribe in Paris. I had encouraged her to become a correspondent. She said, "For *Vogue?*"

I said, "Sure."

She applied to be a correspondent and got it within minutes. She became a frontline photographer—more so than Peggy Bourke-White, who admittedly was a war correspondent and saw an awful lot of action. But Lee became a G.I. *Vogue* printed her remarkably vivid, gory pictures of frontline activity. They had nothing else to print during the war, except women's volunteer services and fashion pictures. Along came these pictures from France and Germany, and they

were tickled to death, and printed them all.

During the war, Lee and I were mostly inseparable. We were together at the linkup with the Russians, and we were together at Dachau. We moved into Hitler's headquarters in Munich. Lee and I found an elderly gent who barely spoke English, and we gave him a carton of cigarettes and said, "Show us around Munich." He showed us Hitler's house, and I photographed Lee taking a bath in Hitler's bathtub, which is a fairly memorable picture in the book *The Lives of Lee Miller*. We found Eva Braun's house, and we moved in there and lived there for four or five days before the Americans discovered it. We got quite a few amusing souvenirs of Eva's and Adolf's.

*You also photographed Hitler's estate at Berchtesgaden.*

That was a few days later. We'd joined the 15th Infantry Regiment, where Lee was very well known. We went into Berchtesgaden with them. There were SS troops in the woods all around, and we were scared to death that we were going to get sniped by the SS. They started it burning. We didn't. We were looting as hard as we possibly could. I looted everything I could lay my hands on, including a complete set of Shakespeare with Hitler's initials, in gold, on the binding, which I sold a few months ago for 10,000 bucks. I took Shakespeare because I was interested in books. Roland Penrose still has a big gravy boat of silver, which Lee liberated.

After the war, Penrose was awarded a knighthood for his work on behalf of British art. Lee, a girl from Poughkeepsie, New York, became Lady Penrose, which delighted her.

*Had she photographed you in Hitler's bathtub?*

She did, but I don't know what became of the picture. We were continually swapping cameras. I used her camera for the photograph of her in the bathtub. Quite frequently, my pictures would come out in *Vogue* and her pictures would come out in *Life*. One of her pictures, *Paris in the Snow*—that's in her show which is traveling around the world—is my picture of Paris in the snow. There are a number of pictures that are hard to distinguish one from the other.

When the war ended, I came back to America and shortly afterward took a leave of absence. When I came back to work in 1953, the managing editor, Edward K. Thompson,[*] said, "You'll sit there."

I said, "What do you mean, sit there? How can I take pictures if I'm sitting down?"

He said, "I want you to become an editor and claw your way to the top. You weren't a very good photographer anyhow." So for the next 20 years I clawed my way, not to the top, but somewhere close to the top.

[*] Born in Minneapolis in 1907, Edward K. Thompson was the picture editor of the Milwaukee *Journal* before *Life* hired him as an assistant picture editor in 1937. Thompson became *Life's* managing editor in 1949 and its editor in 1961 before retiring from Time Inc. in 1967. In 1970 he became the founding publisher and editor of *Smithsonian* magazine. He retired for a second time in 1980 and died in 1996.

World's Fair puppet. New York City. 1939
*They were wonderful. I worked all night and*
*was established as a* Life *photographer.*

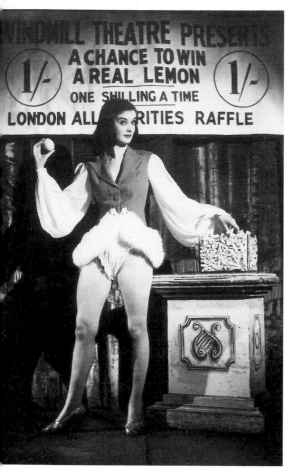

Lemon shortage. London. 1944
*I said, "Let's hold an auction."*

Edward K. Thompson (left)
and Scherman. ca. 1940
*How can I take pictures*
*if I'm sitting down?*

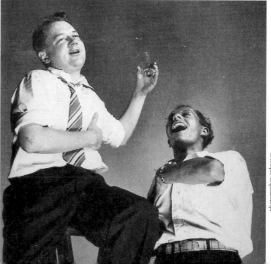

*It strikes me that during World War II, everybody on* Life *magazine was very young.*

I was really a squirt. The minute I got out of Dartmouth I got a job doing publicity for *Life, Fortune* and *Architectural Forum*. I hung around the photographers so much that my boss said, "I'm going to get you a week's trial as a photographer, and if you fail, you're out. You're no good to me." Wilson Hicks resented my having been forced upon him, and he was going to make it as hot for me as he possibly could. An old friend of his from the Associated Press came into his office—a kind of a dissolute chap who had become a press agent for a pharmaceutical exhibit of the 1939 World's Fair. He said, "Can you give me a photographer to take pictures of my exhibit?"

Hicks said, "I've got just the guy for you."

The pharmaceutical exhibit was a collection of 17-foot-high puppets created by a famous puppeteer, Remo Bufano. They were wonderful. I worked all night. The story instantly ran as a "Speaking of Pictures," and I was established as a *Life* photographer. I was sent to Washington. Since news was the thing that I did best, I bought a Speed Graphic, which was the standard news camera of the time. I began smoking cigars. I began to wear a hat with a press card stuck in the hatband, so that I had protective coloration among my fellow White House photographers. We were kept in a little gardener's cottage on the grounds, known as the doghouse. When anyone came to visit, we were called out to photograph the President on the porch of the White House. That was the closest we ever got to being inside the White House.

My concept of photojournalism is that it's pictorialism with a meaning. If you were lucky enough to get the exact instant of a guy being shot, as Robert Capa did during the Spanish Civil War, you couldn't beat that. But if you didn't get the picture at the exact instant, you kept the meaning in mind, and you faked the picture, or reframed it. This was considered bad poker by many of my colleagues, who were artistic types who hated that sort of thing and felt that if you missed, forget it, don't try to do anything about it. I was enough of a journalist to realize that you invent a good picture. I was the pioneer of the made-up picture. The faked, invented picture.

*Faked, invented picture?*

Well, it was not really a fake picture. It might be a picture that had happened, but it had happened 10 seconds before or 10 minutes before. I'd say, "Let's do it again." During the war I did nothing but fake pictures. For instance, in England there was a terrible shortage of lemons. We sat around the office in London and said, "How can we illustrate the shortage of lemons?" You can't photograph a shortage of something. So I said, "Let's hold an auction at the Windmill Theater, and let's have a seminude dancer auction off a lemon to the audience." It was an instantaneous "Picture of the Week."

Or, later, it was how could we demonstrate the shortage of oranges. There was the old song, "Oranges and lemons say the bells of St. Clement's." St.

Clement's had been bombed out and was nothing but a shell. So I got the rector to give out free oranges and lemons to schoolchildren. He stood at the altar of the bombed-out church in the Strand, and we had schoolchildren coming up and getting free oranges and lemons from the bells of St. Clement's. Another instantaneous "Picture of the Week." It was of no significance, but at the same time, it was a funny picture.

*I don't mean this badly, but these sound like some publicity man's stunts.*

Absolutely. I joined the firm as a publicity man. I was pretty hep to what constituted publicity. But a lot of these made-up things were fun. I've often kidded Henri Cartier-Bresson about his exact instant, and about us crooks who would fake the exact instant. He and I are still terribly good friends. It didn't upset him that much.

*Do you consider yourself an artist?*

Sure. And nothing but. I've been a builder and a contractor and a carpenter for the last 12 or 15 years. I think there's as much art to carpentry as there is to photography, or as there is to writing, or there is to music. I don't think I'm a very good artist. But I think I'm an artist, in as much as I can evoke emotion.

Toward the end of my career as a photographer, I went more and more into landscape photography. Not in order to avoid meeting people, but because it was fun to evoke emotion through a landscape. I did it first in England in 1943 with a story called "Literary England." I thought it would be a good idea to immortalize English literature by going out and shooting the scenes that the English authors wrote about. I also did a book called *Literary England*, which was a Book-of-the-Month in America during the war.

I did the same thing in France, at the request of the management, but it never ran in *Life*. It never ran anywhere, as a matter of fact. After the war, I came back and married, and my wife and I did *Literary America*. It was also a Book-of-the-Month.

*Literary America* tried to evoke the moods of America. Willa Cather wrote about Red Cloud, Nebraska. Heaven knows she evoked the mood of the early pioneer American people. I took a picture of an old, abandoned house in Red Cloud that was not the house that Willa Cather wrote about in *A Lost Lady*. But she described the Forrester mansion as an old house in the middle of the prairie, with wood lathe decorations, twisted and tortured, tortured and twisted, on the outside. I drove around and found an old, deserted house which most evoked the mood of this, and took a picture of it. It has become probably the most memorable picture that I've ever taken.

*As an editor, did you ever wish you could be photographing a story?*

No, but I really irritated the bejesus out of an awful lot of photographers by saying, "Do this, do this, do this and do this." I did second-guess a lot of photographers, I'm sorry to say. But when they did what I said, the story ran, without

fail. It was a set-up that I could envision. I simply wanted somebody else to do it.

In those days, an associate or assistant editor was really a writer. They just didn't call him that. I was also responsible for generating the story idea, for making sure that it got properly laid out by the art director, and then for sitting down and writing the captions and the text blocks under the aegis of the copy editor.

*How did you find working with art directors?*

I loved it. I've never met an art director I didn't like. I most respected Charlie Tudor, who was the art director under Ed Thompson. I never knew Howard Richmond, who was the original art director. Bernie Quint was one of the most imaginative and brilliant and erratic of art directors. I got along with him famously. We fought like cats and dogs, but we always resolved our differences. Bob Clive was a terribly good art director.

*What did Quint or Tudor or Clive bring to art direction?*

Tudor brought order and discipline to it. Bernie brought brilliance and change to it. Clive had great imagination, and was able to bring it up to date. Bernie was getting a little bit dated in the 1960s. He wasn't watching the other publications quite enough.

An art director only became involved in the story when you came to him with a bundle of pictures under your arm and said, "Let's lay this out." Then, for an essay, we might spend several days trying to evoke the meaning of the story as clearly, graphically and excitingly as possible. You took the best picture—one that had news significance and emotional Sturm und Drang—and made it big. That was what *Life* was all about.

Life *was about emotion?*

Well, not entirely about it, but it was largely about it. It was about intellect as well. We were intellectually trying to tell a story. We were journalists, after all. But we were pictorial and emotional journalists. I think that put journalism into a different category, the same way that television has put journalism, heaven forbid, into a still different category, i.e., the category of entertainment.

After you made your layouts, you and the art director went to the managing editor and showed the story. The managing editor said it's great or it's terrible. Let's do this. Let's do that. Let's kill that picture. Let's make it smaller. Let's make it larger. The top editors were pictorially minded, above all.

*Was the photographer involved in this?*

The photographer was sometimes involved. Different managing editors had different feelings about that. Sometimes they liked the photographer in the room; sometimes they didn't. A photographer in the room would frequently annoy the dickens out of the managing editor, because he would start squawking, "You've got to use this or that." The only one who got away with it effectively was W. Eugene Smith. Smith made himself impossible to the editor. He made himself impossible to the art director. Then, finally, having made himself impossible to

those two people, he went on to the top guy, and he made himself impossible to the top guy. He almost always won his case. *He* didn't think so, but he won his case an enormous number of times.

*How would you characterize him as a photographer?*

Magnificent. He had all of the requirements that we've been talking about. He evoked drama and emotion. He told what was going on. He was exciting. He was madly artistic, from a pure painterly point of view. He had those painterly characteristics of a good artist. He was impossible as a person, because he was so sure of himself and so indignant when anybody didn't allow him to do what he wanted. He was never impossible to me. We were good friends. But I was never involved with him editorially. I was movie editor when his Charlie Chaplin story ran, and I may have written it, but I had nothing to do with laying it out.

*What were the qualities of a good editor at* Life *magazine?*

A guy who could think up stories. Period. That's really what was in demand as an editor. I started a department called "Close-Ups." The subject had to be good looking or terribly famous or be terribly quotable, and the photographer had to be very good. Those were the four requirements to do a "Close-Up" on someone.

If any three of those requirements existed, the fourth did not have to exist. I got that idea from a guy who bankrolled movies. He said, "We have four qualifications: good director, good star, good story, low budget. Any three of those, we'll make the movie. If there's less than three, we will not make the movie." So I used that theory as the guide for doing "Close-Ups."

*But you didn't personally choose what photographers to assign?*

I did, against the rules, against the law. It just infuriated the picture editor. I would call up a guy and say, "I've got a good idea for a 'Close-Up.' Go to the picture editor, and give him this idea as coming from you, and say, "Since this is my idea, I would like to go out and shoot it."

*Why did you quit* Life *after the war?*

I was tired of pushing people around.

*Pushing people around?*

Well, when you're a *Life* photographer, you push people around. You say, "Stand there. Go there. Sit down and behave yourself." You have to assert yourself in order to get a picture, and I got a little tired of doing that. Also I was overcome with all of the psychological downers of World War II. I was tired, and I quit.

*Let me ask you about fear.*

Well, fear was a funny thing. Fear did not happen when I had a camera in my hand. For example, I'm terrified of heights, but one time I climbed the mast of a ship with a camera in my hand. Then I got stuck in the crow's nest on the top of the mast when I stopped taking pictures. It took me an hour to get up courage enough to come down. I've been in situations in which normally I would be petrified. I've been under fire. I was sunk at sea on the *Zamzam*.

The *Zamzam* was an Egyptian passenger ship. Charles J.V. Murphy of *Fortune* and I got onboard in Recife, Brazil. We thought it was a nonbelligerent vessel.

Our assignment was to go to Cape Town, South Africa, and take the Cape-to-Cairo railroad and do a story on it. Then we'd join the Eighth Army in Cairo and become war correspondents in North Africa.

None of this ever happened. The *Zamzam* left Recife on April 17, 1941. The city was such a hotbed of spies—we had been followed around and gotten many mysterious telephone calls—that I felt that I was waving goodbye to the entire German intelligence department when I waved goodbye to Brazil. Sure enough, about a week after, we were sunk at five o'clock in the morning.

Onboard were 140 missionaries and their families, 24 American ambulance drivers, young chaps—America was not yet in the war—six tobacco buyers from Wilson, North Carolina, and a half a dozen assorted other characters. A German raider spotted us, by full moon, at about three o'clock in the morning. The *Zamzam* had the silhouette of a British troop ship of World War I, which would have been fully armed, so the German captain thought he had every right to blast away. At about 5:30 he put 55 rounds of six-inch ammunition into the *Zamzam*, which was totally unarmed.

We all took to the lifeboats. Unfortunately, the German raider had destroyed most of the boats on the port side, the side from which we had been shelled. So people—women and children—were swimming around in life jackets.

I took a picture of the raider as it was looming toward us. Then I took the film out of my camera and rolled it up and put it in my pocket. We were taken aboard the raider. Charlie Murphy had not come down on the rope ladder into the lifeboats. He had burned both his hands badly, sliding down a greasy rope. He immediately went to the sick bay and had his hands bandaged. I took the film that I had shot of the sinking and put it inside Murphy's bandages. Later, of course, I was searched.

The welcoming committee of the raider was horrified when they discovered that there were 140 Americans, including women and children, onboard. They realized that they had made a terrible mistake, and they were desperately trying to figure out how to get out of it. They transferred us to a supply ship which had a planned rendezvous with them for the next day. The supply ship was a passenger-cargo liner called the *Dresden*. We lived onboard this horrible ship, below decks in a hold, for weeks. The 73 women and 35 children were crowded into half a dozen cabins on the upper decks.

The remarkable thing was that onboard the *Zamzam* there was nothing but hostility and anger. The missionaries hated the ambulance drivers. The tobacco buyers hated the missionaries. Everybody hated everybody, and when we were attacked, the missionaries thought that it was our sinning and drinking onboard the ship which had caused God to have the Germans come along and sink us.

The minute we were all prisoners together, however, this hostility totally dis-

Munich. 1945
*Lee Miller and I were mostly inseparable. I photographed her taking a bath in Hitler's bathtub.*

S.S. *Atlantis.* 1941
*The British navy posted it in the wardroom of every ship of the line.*

appeared. It was like *The Lord of the Flies* or *The Admirable Crichton,* by J.M. Barrie. Everybody became palsy-walsy. There was no more hostility. There was complete unanimity and harmony onboard this prison ship. For five weeks everyone assumed their jobs. The ambulance drivers cleaned the decks. The Germans assigned me to take pictures. They said, "You are the photographer. You must take the pictures of all this. Your pictures will be taken from you when you get off the ship, but we'll return them later on. It's simply a matter of censorship."[*]

I didn't believe that, and I took all of the sensitive pictures of the sinking, and I slit the bottom of a toothpaste tube and a shaving cream tube, took the paste and the cream out. I wrapped the rolls of film in black tape. I put dry, warmed-up rice inside the core of the rolls to absorb any moisture, and sealed them up. Then I sealed the bottom of the tubes. I had a 35-millimeter roll with some very sensitive pictures on it. I gave it to a missionary doctor. He opened a sterile bandage package, took the bandage out, put the roll of film in, sealed it again. The Germans, being correct, would never open anything which said, "Sterile. Do not open." So they didn't, and I was able to sneak the film out through an American diplomat after we were repatriated.

We ran through the British blockade to St.-Jean-de-Luz, in German-occupied France. We were interned in France for about two weeks. The BBC went on the air and said, "The *Zamzam* is 30 days overdue, and is therefore presumed to be lost with all hands aboard, including American women and children." They were hoping that this would be a second *Lusitania* and get America into the war in May of 1941.

Fifteen seconds after the BBC made this announcement, Germany got on the air and said, "Ha-ha. They're not lost at all. They're all alive, and we've got them all. They're living in Biarritz, in vacation hotels."

Which was sort of true. We were under house arrest. Then Murphy and I got out through Lisbon. I got the pictures out, and they ran in *Life* about two months after we were sunk.

The story included a two-page picture of the raider that sunk us. (It was one of the pictures hidden in the toothpaste tube.) The British navy bought copies of the June 23, 1941, issue of *Life,* cut out this picture and posted it in the wardroom of every British ship of the line. Eight months later, a plane from H.M.S. *Devonshire* spotted this ship, and she was sunk. The skipper of the raider wrote a book after the war, in which he said, "I was the skipper of the S.S. *Atlantis,* the German raider which was sunk by David E. Scherman of *Life* magazine."

On the *Life* staff 1939-47
Interviewed in New York City on May 20, 1993

---

[*] The German government returned these pictures to the American embassy in Berlin a few days before Pearl Harbor. *Life* used them in the issue dated December 15, 1941.

Management said we were the
best photographers in the world,
but actually I think they looked upon
us as very highly skilled clowns

Actress Gene Tierney with friend. Connecticut. 1940

# HART PRESTON

**H**ART PRESTON: I went to Stanford University and so did Charles Steinheimer. I was interested in drama, and I wanted to be a director, and Rex Hardy was the drama manager at Stanford. I directed a musical show under his aegis. The two fellows who helped me write it were Waldo Salt, who did *Midnight Cowboy* and got Oscars for two other screenplays, and Bill Rogers, the son of the humorist.

*John Loengard: If you were interested in theater and movies, why did you end up taking still pictures?*

When *Life* came on the scene in 1936, it was very, very exciting. Steinheimer and I were roommates in San Francisco. There was a fourth Stanford person, Jack Allen, who ran the Time-Life bureau there. We went in and showed him some photographs, and he gave us an assignment or two. I started working for *Life* in 1938 on a contract basis.

We brought America graphically to the public. We closed on Saturday, and the magazine was on the newsstands all over the country on Thursday. We were the Walter Cronkites of our day, you might say.

When I went on contract, I had never been to New York, and I couldn't think of an excuse to take me across. Carl Mydans had done a story on the United Airlines flight across the country, and Peter Stackpole had done one on the *Super Chief* railroad train from Chicago to Los Angeles, and somebody else had a bus trip. So I suggested a hitchhiking story, and they said all right. I had a student who was going to Bennington, and I put him out on the road and photographed him across the country. The story ran for seven pages.

When I came into New York, Wilson Hicks, the picture editor, said take the film across to our lab, which was on 48th Street above the 3-G's restaurant. I

was welcomed there by Dmitri Kessel and Bob Capa, and I can't remember who else, but the camaraderie was nice. The lab was on the third floor, and the bar was on the first floor, and it all kind of ran together.

They developed the film, and I made the selection to be printed. Of course, I had nothing to do with what ended up in the magazine. *Life* probably shot five stories for every one used, so there was a great competition to get your stuff into an issue.

*How would you describe the stories you did?*

Looking over my work recently in the scrapbook, I saw very few things that I was proud of as far as photography is concerned. I was a reporter, a photo-reporter, you might say, and I really can't think of much that was graphically exciting. They were *stories*. They had a beginning and a middle and an end, as you would have with written journalism, but I was doing it with photography. In those days *Life* often said, "A picture is worth a thousand words," which is a little dubious. One of the writers there would say, "A word is worth a thousand pictures."

Management said we were the best photographers in the world, but actually I think they looked upon us as very highly skilled clowns. That's one reason I wanted to move over to the written side. I opened Time-Life's first bureau in South America, and then I ran the bureau in Buenos Aires. I came over to *Time* as a writer after that.

One reason I switched to *Time* was that we were getting into using a lot of heavy lighting equipment. *Life* seemed to become more of an electrician's job than a photographer's job. Hansel Mieth and her husband, Otto Hagel, developed that multilight system, and we all copied them. I think we went in a pack, like pigeons, you know. I could get dramatic things using several lights, but it wasn't quite as real.

*What was your relationship with Wilson Hicks?*

It was a very good one. Some of the photographers didn't like him, but he gave me assignments and was more or less pleasant. His assistant at that time was Edward K. Thompson. We all loved Ed because he rapped with us well and was a very warm person. I won't say Wilson Hicks was a very warm man. He wasn't.

We were in awe of Henry Luce and what he had done. I suppose I had lunch with him or talked to him maybe half a dozen times. He was pleasant enough, but he was all business. I have been with captains of industry who could finish off the business and put their feet up on the desk and talk about old girlfriends. Henry Luce wouldn't, but we certainly respected his intellectual powers, which were considerable.

*Being a Californian, were you influenced by the f/64 school?*

You're thinking of Edward Weston and those people in Carmel. No, my kind of photography was not putting a big camera on a tripod and doing the f/64 bit,

cutting down the lens opening, which meant that maybe the exposure was two seconds or something like that. Mine was news photography, and I couldn't do it that way.

*Do you think photography is an art?*

Not in my hands, but in the hands of some people it's a great art. I think of Dmitri Kessel. I think of Henri Cartier-Bresson. Of course it's a kind of a static art in the case of Edward Weston. But, sure, sometimes a great picture just comes out from anybody. But there are a few who can do it time and time again.

Charles Steinheimer had a great technical knowledge of photography, and some of it rubbed off on me. He was very serious. He didn't want any fakery. And at times there is some fakery in photography. If you're doing a story and you think the story is a little dull, you might heighten it a little bit.

For example, the actress Gene Tierney was in a play called *The Male Animal,* and her mother got *Life* to do a story on her. Those were hard days for her family, which had lived in some luxury up in Greenwich, Connecticut, and was living in rather stringent circumstances in New York. But in the story she came out as this rich society girl. We would not have borrowed her old home in Greenwich and had her skating with her old social friends if it had been a more honest story. Things like that. The angle was a little off.

*Did you stop taking pictures when you went to* Time?

If I were doing a story and there was no good photographer around, sure I would take some pictures. But, no, that was the end of my photographic career. I left *Time* after the war and went on to the Marshall Plan and wrote the speeches for Paul G. Hoffman, who was in charge of it. Part of the deal was that he would send me to Paris to run a unit there that was involved in documenting what the Marshall Plan had done in Europe. I had some of my old friends doing assignments for me. That was wonderful.

My years with *Life* were fun years. I had a great time, but I think maybe the best time for that kind of running all around the world is when you're young. Some people may do it all their life, but it wasn't for me.

On the *Life* staff 1940-43
Interviewed in Los Angeles on August 13, 1993

I would bang on that door. I'd say,
"I've got to get in there."
He wouldn't unlock the door

Robert Capa. Washington. 1942

# MYRON DAVIS

**M**YRON DAVIS: I'd been in the Washington bureau about a year and a half when Wilson Hicks asked me to come up to New York. When I arrived in Hicks' office after a miserable all-night train ride, I saw that Daniel Longwell, the executive editor, was in the office. I was surprised, The word I heard in office gossip was that he was sort of a right-hand man to Henry Luce. When I saw him, I was glad I'd taken the time at Pennsylvania Station to get a professional shine on my shoes. It was office gossip—*Life* office gossip was pretty wonderful, whether it was true or not—that Clare Boothe Luce judged men by the quality of the shine on their shoes. So I noticed that Dan Longwell studied my shoes. I don't think he said anything after the introduction.

Hicks said, "Myron, we want you to cover the war, but your main responsibility is to make sure that the waters are not ruffled at MacArthur's headquarters. One of your predecessors' behavior when drinking caused some problems." He didn't name who it was. That was it. I don't think I was in Hicks' office 10 minutes. I had to turn around and take a miserable train ride back to Washington. Well, of course, I wasn't all that surprised because *Life* usually threw you into the furnace and you burnt up or you got out alive. I faced that situation.

I got out to the Pacific. On the landing at Lea in New Guinea, they used the new amphibious landing craft for the first time. I was on this LST* some distance away from the LCIs that had gone in ahead, but I was close enough that I saw three Japanese planes come right over the treetops. Two of them got direct

---

* The LST, a flat-bottomed landing ship, is large enough to carry tanks; the smaller LCI is a landing craft for infantry.

Lea, New Guinea. 1943  *I cannot photograph this.*

Landing on Negros Island. 1944  *I dropped my camera, took aim and fired.*

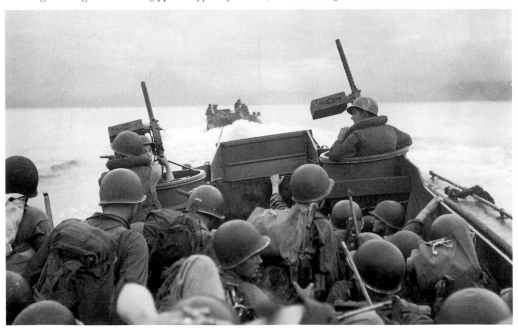

hits on the LCIs as they were unloading. I saw the flash, and when that bomb exploded in that metal hull, it reverberated like a cymbal.

As I got off the LST, I saw a body on a stretcher that had been brought down the ramp of the LCI and was lying on the beach there. I walked over and saw a head with the brains exposed. Parts of the face had been blown away. I was so shocked I turned away and said, "I cannot photograph this." Then I thought, "No, this is war. I've got to try to deal with this."

I was truly shocked. Fortunately I had the judgment to get down at a low angle and photograph from the feet so you could see that part of the boot had been blown away, and you could see that shrapnel had removed some of the clothing, but you couldn't see the top of the head. There was no way I would take a photograph of that. In the background I caught a guy charging down the front ramp of that LCI toward this corpse. *Life* ran it as a full page in an eight-page story on the Lea campaign. That was my first awareness of the reality of war.

*John Loengard: You've said that as a war correspondent you were issued a carbine and you used it.*

I was in the second-wave landing on Negros island in the Philippines. The first wave may get it, if the enemy is not caught by surprise, so you've got a little protection in the second. On the other hand (which was true of our case), if the Japanese were surprised by the first wave, we're the ones getting the first fire coming back. I saw tracer fire coming off from an angle. In the bow, our two machine gunners had their eyes focused ahead, ready to fire. Nobody else saw these tracers off to the side. I'd practiced firing that carbine only a couple of times. I dropped my camera, took aim and fired. The tracer fire stopped. Who knows? I don't. But they weren't firing again.

I took photographs of the people on my barge getting off. I made a decision in that moment based upon some rationale, but also maybe based on what some person might call cowardice. I'd learned that if you stayed too long on the landing, and your material got back to Washington too late, it might not get published.

I had made two landings that happened to coincide with the landing at Anzio and the battle at Casino when Europe was still the big war. The Pacific was still the small war. I risked my life twice, and not one picture appeared in *Life* magazine. So I'd learned the smart thing even journalistically, in a way, was to get what you could and get back safely with your film. On the other hand, I knew that I didn't have the guts to get off that barge then. I did not have the courage to get off then.

I may be here sitting talking because I didn't. Every combat man may not be willing to admit it later, but if you don't experience fear when strafing bullets are cracking all around you, when bombs are coming all around you, when you see tracer fire coming at you, you're not a human being. Your adrenaline begins to pump. The nearer you are to death, the more you feel alive, because your adrenaline is pumping to the level that you never experience in any other way. I think

a few guys got such a high out of that adrenaline rush that they might have later become combat junkies. They felt so alive in that situation of near death that nothing else could do that. They would voluntarily go back in to experience that.

I never really captured the essence of war because most of the time when the bullets were going by, I was trying to squeeze my whole body into that little tin helmet. W. Eugene Smith told a photographer I knew in Chicago that he was willing to die to get the pictures of the war. He came close to doing it. I wanted to live. So I didn't get the definitive war pictures.

*How did you get into this business?*

My younger brother came home one day in the 1930s with a little 39-cent plastic Univex camera that someone had given him. He shot a roll of film. I saw the results. Always curious, I went to my mother and asked, "Mom, what causes this to happen?" I was 11 years old.

She said, "I can tell you, Myron, because my father bought me a plate camera, and I developed those plates in a cellar on the farm in Kansas." She told me that you get some methyl and this, that and the other thing. I went to the drugstore, got the chemicals, and I came back to the apartment, put a blanket over the bathroom window, made a little red light out of some red cellophane, got some old pots and pans, and ran a roll through. I was bit from there on.

When I got to the University of Chicago, I had to make tuition money, and so I was taking photographs for a student publication that was a sort of an imitation of *Life*. My name got around, and before long I was doing photographs for the university alumni magazine and then for the university publicity office.

There was a Bernie Hoffman, a staff photographer at the *Life* bureau in Chicago, a fine guy. I showed him what I was doing. He was impressed. He said, "Wilson Hicks is the only one that can hire you."

He wrote a letter to Peggy Matsui, who was Hicks' secretary at the time, and I came to New York on an all-night coach. I sat at Peggy Matsui's desk. She said, "I don't know when I'll get you five minutes with Wilson." I sat at her desk for three days, morning till night, until finally on the third day she got me in to Hicks. I showed him my little portfolio of stuff, and he said, "Myron, I really don't see anything terribly impressive here."

I said, "Mr. Hicks, how would you expect to see anything impressive? You see all the best photographs coming in from all around the world. How do you expect me to match that with what I get on a campus." Then I said, "Other than that, how do you like what you see?"

He said, "Well, not bad for what it is. I'll tell you, Myron. You hang around 38 West 48th Street for a while, and we'll see what we can do."

I left the Time-Life office building—fairly fancy for those days—and went diagonally across the street to 38 West 48th Street, this dusty converted place with a locker room for the photographers. I'd seen better lockers in high school gyms than what was provided for the world-famous *Life* photographers—an old

beat-up wooden desk, and a chair and whatnot, and a big room with a stash of flashbulbs. I sat there for another three days.

Finally I get a phone call from Peggy. She said, "Mr. Hicks wants to see you."

I dash over there with my camera stuff thinking, "I'm going to get my first *Life* assignment." I enter his office, and the original art director was there, and they had a bunch of campaign buttons from the Willkie and the Roosevelt campaigns. "Myron, we want you to make a layout. Shoot some individual. Shoot some together. Make your own choices," he said. "I want prints on my desk at 9 tomorrow morning."

Well, I was a little disappointed when I went down in the elevator, but still it was an assignment. I went back across the street and set up my Speed Graphic on a tripod and used an old drafting board and started making close-ups. I spent quite a bit of time, and when I got through I went to the night darkroom man and I said, "Mr. Hicks says he wants prints on his desk 9 tomorrow morning."

The guy looked down and said, "I didn't get any rush order."

I said, "Mr. Hicks was definite."

He went into the lab chief's office and looked in the files, and he said, "There's no rush order."

I said, "O.K., I'll soup them myself."

He said, "I can't let you soup. I don't let Bourke-White or Eisenstaedt soup here."

I said, "Look, I'm certainly not gonna get any hypo in the developer or whatnot. This is important for me. It apparently is important to Mr. Hicks."

Finally he agreed, and I spent all night developing the negatives, waiting for them to dry and making a stack of prints. I had time for a cup of coffee, and I'm over at Peggy Matsui's office before 9. She didn't come in till about 9:20. She says, "Myron, what are you doing here so early? Mr. Hicks won't be in until 10:30."

He came in around 10:30 and asked Peggy for any international cables that had come in, and then sorts through them, and Peggy says, "You can go in."

I said, "Mr. Hicks, you said you wanted prints on your desk at 9 tomorrow morning. You didn't leave a work order for this to be processed. I spent all night developing and making prints, and you didn't come in until 10:30. If you'd told me the reality, I could have maybe got 20 minutes' sleep before I'm here."

He reared back, and I think he was about to toss me out of his office. Then he said, "Let's see." He looked at them and liked what he saw. He said, "Myron, tell Peggy where you're staying, and we'll get in touch with you."

I was staying at the YMCA hotel near Pennsylvania Station for 75¢ a night. I told Peggy, and they gave me six assignments while I was there. Five of them ran. I didn't know that that was unusual.

Wilson said, "Go on back to Chicago, Myron. We'll try to keep you busy." I started getting assignments. In two months they put me on contract. Most every-

thing I shot ran. Ultimately Hicks wanted to put me on staff. They needed somebody in Washington. Hicks had some recognition of what photographer would do the job best. I had a particular knack for making older top men feel comfortable in front of the camera.

Once, early in 1942, I was told to go to some remote office in the Pentagon and take this man I'd never heard of. I am certain that the editors knew that General George Marshall had picked Dwight Eisenhower to head the landing in North Africa.

His aide said, as aides do, "I'll give you 10 minutes with the general."

Fine. I got in there, and for some reason the word Kansas came up. I try to talk with my people while I'm shooting them. It's not always that easy to keep your mind on your job and keep a running conversation, but, in a sense, when we are in our prime we're like an athlete or a concert pianist. We know our tools and our instruments. We can almost work them intuitively. So the word Kansas came up.

When I was through, he said, "Sit down." We sat there, two guys, talked about Kansas, being farm boys, wheat fields and whatnot for 30 minutes.

When I got out of the office, the aide said, "I told you you could have 10 minutes."

I said, "If you got a problem, go talk to the general. I was there because the general wanted to talk to me about Kansas. Don't talk to me. You go talk to him."

*Why'd you resign from* Life?

I think some Time Inc. wives thrived on getting assigned to foreign bureaus and shifting from one place to another. My wife didn't. She wanted me to resign from *Life* magazine. To try to salvage the marriage, I did. I left knowing full well it was a bad decision career-wise, but because I had three children at that time, I didn't want a divorce. But another factor was I had become interested in motion picture photography. With motion we can convey a story line much better than we can jumping from one thing to another in stills.

I was assigned by RKO Pathé in New York to do a story on San Francisco. I'm vain enough to say I might have created the storyboard. I wrote the script and took pictures and juxtaposed my text description with my pictures. It startled and interested them. I originally wanted to be a cameraman until I learned that the controlling position was the director's. So they assigned me to direct a film documenting returning G.I.s going to colleges on the G.I. Bill.

They wanted me to come to New York, but my wife wouldn't move from the house we had in Chicago. I suppose if I'd have gone to the trenches with her, maybe she would have given in. That's not my nature. I think it was a huge mistake for my family, because when television started taking over the advertising dollar, as a free-lance photographer, the phone didn't ring. I ended up jumping the fence altogether. Having been an English major, I got a job as a cub reporter

for *Advertising Age*. Within four years, because of attrition—I never considered myself a great editor because I didn't care that much about the subject matter—I ended up, for a while, being the managing editor.

I think the craft of photography is unique in itself. When it's used well for what it does well, it is of value. If somebody wants to call me an artist, fine, but I never looked at myself that way at all. I think most journalistic photographers don't need that term either. They were happy to document reality and hope that what they produced was both entertaining and informational to people that saw it. We were conduits. We were middlemen. Hopefully we captured the moment of truth, which told the audience the reality of what was going on.

If you've seen the biography of Robert Capa, you've seen a picture of Bob in a bathtub reading. Bob came down to Washington to get his correspondent's credentials, and he asked if he could stay at my apartment there. I was married at the time, and I said, "Sure, Bob." In the morning, though, he would get into the bathroom ahead of me and sit soaking in the tub for an hour or two reading his books. To become the great war photographer which he was, he had transformed himself during the Spanish Civil War. He had manufactured his name. His real name was Endre Friedmann. I think he needed that period in the hot bathtub every morning to convert himself from a Friedmann into a Capa.

I would bang on that door. I'd say, "I've got to get in there." He wouldn't unlock the door. One morning he forgot to lock the door. He still wasn't going to get out, so I grabbed my Rolleiflex with a flashbulb and started taking pictures. I think I took two frames, one of which was one that I sent to Cornell [Capa] after Bob's death and wrote a letter of condolence. Cornell had that used in *Robert Capa, a Biography* by Richard Whelan, but the reason that picture exists is that's the only way I could get Bob out of my bathtub.

On the *Life* staff 1942-46
Interviewed in New York City on October 28, 1993

# It's a great picture to show people who want to go to war what war is like

Guadalcanal. 1942

# RALPH MORSE

**R**ALPH MORSE: In my high school in the Bronx, if you sold 10 rings for ring companies, you got your own graduation ring free. With my company, you had to carry a box of rings around school all day. The kids with every other company only had to carry a picture of each ring. I kept saying, "Boy, I should really do something about photography."

When I got out of high school, I got a job with a photographer named Paul Parker. I swept the floor. I delivered his pictures. I stayed with him only six months because *Harper's Bazaar* magazine had an opening for an assistant in their studio. I stayed there only three days because I decided I didn't like fashion, nohow. It was too boring. *Life* had started, and George Karger was working for a picture agency called Pix, and he needed an assistant. I was Karger's assistant for about seven months. I would deliver his pictures all the time over to Pix, where I met Alfred Eisenstaedt. Once I borrowed a Contax camera from Cornell Capa, who was working in their darkroom, and I went to Jones Beach on a Sunday. I bumped into a father who was throwing his kid up in the air. I just stood there and took a series of it. I walked in the next day and showed the pictures to Léon Daniel, the head of Pix. "You don't want to be working in a darkroom," he said. "Why don't you come take pictures for us?"

So I started free-lancing. I would read the papers and do stories, and they would sell them. Eisie kept telling *Life* magazine, "Hey, we got a young brat over there you should meet."

Wilson Hicks one day invited me over and said, "How would you like to do a test assignment for *Life*?"

Here I am 19 years old, and I said, "Sure." This is the end of 1939. He gave me an assignment to cover Thornton Wilder doing *Our Town* that night on

Broadway. The star was ill, and Wilder was taking the star's place.

I walked into Hicks the next day with it, and he says, "Not bad. How'd you like to try another one?" He gave me men's hats to do, somewhere in Connecticut. Then it was constant. Wilson Hicks was a genius as far as pushing, but at the same time, you know, he was a real sonofabitch. But he was a pretty great sonofabitch. The war started, and you could not be a war correspondent without being on salary, so Hicks said, "We're going to need you as a war correspondent. Why don't you join the staff?"

*John Loengard: Did that keep you out of the draft?*

Not at all. I had to go to my draft board in the Bronx and explain to them why I wanted to get shot at. There I am, the "little brat," explaining to these five businessmen that *Life* magazine has hired me to be a war correspondent and wants to send me to the Pacific, but I need their permission because I'm draft age. This went on for about a week. They have discussions. Finally one of them said, "Look, if someone wants to get shot at, why don't you let him go?" Remember that we were all going to be in it anyway. But what were the chances of my getting picked to cover the surrender of the German armies to Eisenhower if I was a G.I.? In May 1945 I had just driven back to Paris from doing a story on the first school to reopen in Germany—in Aachen. I walked into the Scribe Hotel to ship my film, and one of the public information officers came over and said, "I need you right away. I can't tell you what it's for."

We went to a red school building, which was Eisenhower's headquarters, in Reims, France. When we got there, they said the Germans were going to surrender in a couple of hours. We were brought into this room on the ground floor and told, "Get yourself ready." We needed all kinds of things. First of all, we needed some light in the room for the newsreel guy. We needed a short ladder so we could do an overall of the whole table. It was a big, oblong room, with this great big table and Eisenhower's big war map behind it. There was an alcove on one side, and they decided to put the 17 reporters in there and put a rope up to keep them behind so they wouldn't get in the way. The only people in the room (besides the military people involved) that were free to move around were the photographers: two Army and myself.

We tested our equipment. We loaded up the cameras, and suddenly they said, "It won't happen for another four hours." We sat around for a few hours, and finally they said, "We'll take you down to the cafeteria to get a hamburger." Then they brought us back and said, "You're going to be here all night." We slept underneath the table. There was no place else to go.

Suddenly lights came on. The Germans are coming. So we scrambled, got dressed, tested the cameras again and got more nervous. Then the Germans arrived, but they didn't have full permission. They couldn't make a total surrender, and the British general said, "We don't accept this. Go back and get per-

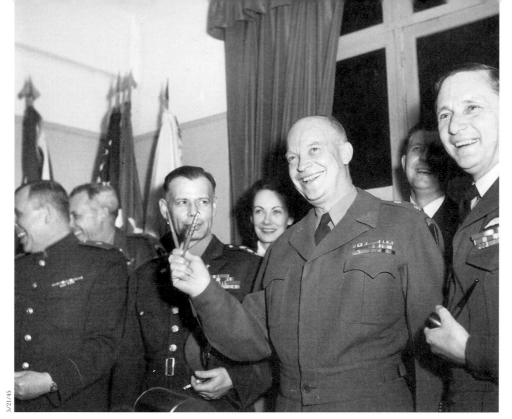

General Eisenhower. Rheims, France. 1945

*Holy cow! I just covered history!*

Hermann Göring.
Nuremberg. 1946
*You're young, and you can
hold your breath for a
half second.*

mission from your superiors to surrender totally." We had to wait another 24 hours until they came back and the surrender took place. When it happened, my only thought was, Will my flash work? I remember standing in back of General Walter Bedell Smith's chair, leaning over so that I could get the Germans signing, and taking other pictures by the Germans' chairs, and the Army staff all dying because what we're doing isn't protocol. But, you know, it was happening so fast, we just did what we had to do.

*What was said?*

I have no idea in the world. I was so busy shooting pictures. The feeling was very, very subdued. Very, very quiet. There was no smiling. I think the Russian and the British generals felt elated, but it was not a happy occasion. It was a very serious moment, and it showed in the pictures. Everyone was turning the pages, signing their names. It all happened in minutes. General Field Marshal Alfred Gustav Jodl walked in, sat down, and they told him what he had to do. The protocol guys had every pencil and every pad measured to where it had to be, and it went very, very quick and was suddenly over. In fact, when I started taking pictures, I thought, I've got to get to that ladder and get an overall of this. I remember running back, taking the ladder, and I took two pictures, and then I jumped down because the papers had already passed to the next guy. It really was over very, very quickly.

After it was over, they took Jodl up to see Eisenhower. That's when we got the picture of Ike talking to him and the two pens that were used for signing. Jodl was trying to plead to Eisenhower that it's over, it's not the soldier's fault— you know, it's not the G.I.'s fault—the German G.I., I'm talking about. We should be easy on them. Eisenhower said back to him, "This is our decision. This is not yours."

I don't think I felt anything until I heard from the lab back in Paris that everything had worked. Then I kept saying to myself, "Holy cow! I just covered history!" It's the same thing if I'm covering a prizefight and someone hits the other guy and knocks him out. I'm not even sure which guy hit which guy because my eye is glued to the camera. I know what they're doing, but I'm not following it, like *he's* hitting *him*. I'm just following the punches. It's the same kind of thing.

*How did your war begin?*

I got to Pearl Harbor in January 1942 and got on the aircraft carrier *Enterprise.* We went out into the Pacific and saw a second carrier coming up with Army planes on deck. The admiral got on the speaker to say that these planes are going to bomb Tokyo, and we were going to escort them to within 300 miles of the Jap coast. I remember taking pictures of General Jimmy Doolittle's planes taking off and circling and leaving. The pictures got to Washington, and President Franklin Roosevelt held them for 13 months before he released them. That was the longest hold I had of pictures that were in censorship during World

War II. He held them because they weren't sure how much the Japs knew about how we got there.

*You say that Roosevelt held them. It sounds awfully personal.*

Well, he was the President of the United States. It was his order, evidently, that nothing be released. The agreement was that the press would have to wait with their stories.

*When did you hear that the raid was successful?*

We listened to Japanese radios on the ship. Within two, three hours, we started hearing the Japanese talking about it. Some American planes had come over and bombed. So we knew they hit Tokyo.

*How'd it make you feel?*

We were the delivery task force, and we did it. It made us feel very good. It was only a token raid, but it was a pretty exciting kind of thing. Especially for my first war correspondence.

Then I was assigned to the cruiser *Vincennes.* We went to Pago Pago, where a lot of troop ships were sitting. The captain sent me over to a Marine general, who told me they were going to Guadalcanal. He said, "Have you been trained to go down rope ladders? Do you have equipment?"

I said, "Nope." (I'm with the Navy. I had a nice, clean, starched uniform. I had shoes. I had a hat.)

"We'll give you boots, and we'll give you canteens and all that stuff," he said. "You can pick your own wave when you want to go."

"I don't know anything about landings," I said.

"The first two waves usually get shot up really badly. In the third wave we bring in the radio equipment and the communications people. Why don't you go in the third wave with communications," he said.

I went back to my ship, got my film and cameras, and went back to the Marines. We took off for Guadalcanal. Well, I'd never been down a rope ladder in my life. If you ever went down a rope ladder, it is the most miserable thing in the world—plus you got a camera bag, you got drinking water, you got candy bars. All this weight on you. I found my feet didn't work. I just went down hand over hand, flopped into the thing. I just had no conception how to go down that ladder. You know, this is one of the great problems of being a war correspondent. Nobody tells you how to do anything. You just go.

The third wave goes to the beach, and all three waves hit at the same time. So the third wave didn't mean a thing. They just kept firing at us anyway. We got onto the beach. No major trouble. We got as far as the airport that day. Now what am I gonna do with the film? I knew the *Vincennes* had orders to go to San Francisco for an overhaul on her engines as soon as the beach was secured. I figured if I gave the chaplain the film, he could turn it in in California and send it on to Washington. I thumbed my way back and got onboard and put each roll of film in a condom that I got in the ship's store and sealed it. All the corre-

spondents sent their film back that way. It kept it dry. The chaplain said, "I'll put them in the ship's safe. The moment the ship arrives, I'll take them over to the censor for you."

The *Vincennes'* captain said, "We're not going to leave till tomorrow morning. As long as you're onboard, why don't you stay overnight and get a shower?" So I go down, get a shower, food and pack all my stuff I was going to take in the morning. At 1 in the morning they sound general quarters, and I roll out of bed and throw on my clothes, run out and get up on deck because we're being pounded.

Navy battles are very different from the Army. In the Army you hear a shell come. In the Navy you hear this whine. You don't know if it's for you or for another ship. We were in between islands in the Coral Sea, which was very, very deep water, full of sharks. The Marines were unloading troops all night to get them to shore, and suddenly you're in general quarters, and you're at battle stations. The next thing you know, shells are coming at you. You're so busy first taking pictures—I mean this is at night. It's jet black, but the sky is lit up because we're throwing flares up and the Japs are too. Boats are blowing up. There's a tremendous amount of light. Enough for pictures. Really, it was like a movie set. And you're busy working. As the ship is getting pounded, you hear screams, and you hear "Help me!" and all this. And people are taking over other people's jobs and running like mad, and suddenly you find that you're not working. You're helping people. In between trying to take a picture, you're trying to help someone. Pieces of the boat kept getting blown away, and you don't get scratched. It's amazing. You were talking to a guy and the next shell fell—you're standing there talking—and he's not there. The Japs came in from behind the island with a bunch of destroyers and they were firing at us point blank. Suddenly we were ordered to throw wounded men over, and you couldn't stand on deck there was so much blood. The deck was so slippery with blood that it was like an ice skating rink. You couldn't hardly walk. And then when the captain gave orders to get the wounded into the water. Well, at that point you're not taking pictures. You're throwing wounded. And you just keep throwing until you can hardly stand up. You're all covered with blood. Guys are screaming, "Throw me out! Get me offa here! Get me offa here!" And you just do it. And every now and then you pick up your camera and try and take some more pictures.

A Navy boat is a pretty horrible thing because it's all steel. When you try to walk, it's as hot as hell from the explosions. It's not like the Army, where you get hurt or you walk away. Where are you going to go on this piece of steel? We had 2,200 guys onboard, and maybe a thousand got hurt. You're in that other thousand that didn't get scratched. Why? I don't know. Your number wasn't up. We lost four heavy cruisers that night.

But it ends, and the battle got over, the light went down. Well, I had no flashbulbs. And the film's too slow. And it's the middle of the night. So at one point

I hung up my cameras very carefully. After they hit us enough times, they just sent torpedoes into us and we just rolled over. We kept throwing people over until orders came from the bridge to abandon ship. I went over the side with one of the ship's photographers. All you do is just jump. I left my cameras still hanging up on the bridge. What was I going to do with them in the middle of the Coral Sea? I had no plastic bags to put 'em in or anything.

We swam away from the ship. We were short one life preserver. We had five people and four life preservers. So we kept passing one around. You could float on your back for a while. And then, as we floated around, we met more and more groups. We used to play bridge, and two of my bridge partners floated by, so we spent the rest of the night floating by people asking if they played bridge— to keep from worrying about sharks.

We were very lucky that night because there was all that blood in the water, but we had no shark troubles, which is extremely unusual. With all the depth charge being thrown, I guess every shark in his right mind had got out of there. We were picked up around six hours later by destroyers.

All we had on was shorts. I was so busy trying to survive six hours in the water that I didn't think very much of cameras. Later, I thought, "We'll get it back. Someone will dive for it. Maybe the safe is waterproof." (When the *National Geographic* went there last year with divers, they never got my stuff off the *Vincennes*. I had drawn a picture for them exactly where I think I left the cameras and where the safe was on the ship for their divers to look. They didn't find it.)

We were taken to New Caledonia, and the military public relations office said, "Nobody is allowed to leave. We don't want anyone talking. We lost four heavy cruisers, and we don't want the Japs to know how well they made out."

Well, here I am sitting in New Caledonia with no cameras and no clothes. So I went out to the Air Force. I said, "You got planes going to Pearl Harbor?"

"Sure," they said. "A plane goes every day."

I said, "Can I get aboard?"

"No, you have to have orders," they said. So I went into an office and borrowed a typewriter and wrote myself a set of orders and signed them "General Morse." It'll take the military 25 years to find out who General Morse is. Went back to the desk and handed it.

"There's a plane going in an hour," the guy says. "Get aboard."

I got to Pearl Harbor. I get off the airplane, and two MPs meet me. "Admiral Nimitz wants to see you." I go to Admiral Nimitz's office.

He says, "You realize everyone's supposed to be kept in New Caledonia. You're the only person on this island who knows what happened that night."

"Yes, but what good am I if I have no cameras?" I said. "I can't even go back to Guadalcanal. I have to go to the United States and get equipment."

"We got to think about this," he says. He comes back a half hour later and says, "Look, you can go back to the United States on the condition that you don't

London lovers. 1944  *It became fairly famous later.*

George Lott. 1945  *The captain turns and says, "This is your man."*

talk about that raid. You don't say you went to Guadalcanal. You don't tell the editors of *Life* where you went."

I said, "Fine. I have to get equipment." I'm sworn to secrecy. They get me a plane to San Francisco. I get a plane to New York. I walked into Wilson Hicks' office and said, "I need clothing, and I need cameras."

He said, "Why?"

"I can't tell you," I said.

"How can we run a magazine if the people in the field won't tell us what's going on?" he said.

"Haven't you ever been sworn to secrecy?" I asked him. "I cannot tell you."

This went on for about three days. They didn't buy me any cameras. They were completely pissed off with me. They were screaming at me every time I walked in. I kept saying, "I can't tell you."

The fourth day it stopped dead. "What do you need? How long do you want to stay here, and how long will it take to get orders to go back?" Suddenly changed. I had no idea what happened. I didn't dare ask. I got new cameras. I got a bunch of clothing. I got myself a set of orders. I took a week off, got back, got a plane back to San Francisco. The Navy put me on a ship to Honolulu. I get off the ship, and two MPs were waiting for me. I said, "Oh, God, I didn't say a damn thing." I walk into Admiral Nimitz's office.

He has all the Navy high brass public relations with him, sitting there. Nimitz says, "Well, the first thing I want to say is congratulations. You didn't say a word."

"*I* know I didn't say a word," I said. "How do *you* know?"

"You were the only person in the United States besides the President and high command who knew what happened that night, and you kept your word," he said. "I want to introduce you to Commander Adams, Naval Intelligence. He has been trailing you. He's the one that stopped by *Life* and made them leave you alone." I almost died. I didn't even know I was being trailed by Naval Intelligence the whole time.

*Did you see your family when you were back in New York?*

Oh, sure, I went home, but I said I can't talk. Ruth, my wife, asked, "Where have you been?"

All I said was, "I've been in the war." I got back to Guadalcanal in time to spend Christmas with the first American troops in battle. We were on a patrol with the Army, and the brush was so thick that unless I kept my eye on the heel of the guy ahead of me, the jungle would close in around me, and I didn't know where I was. That's pretty scary when it's that thick.

We came to a little clearing. Here was this Jap tank with this skull on it. I didn't touch it because it stunk so. It might have been put there by a patrol before, or it might have been the Japs, to scare the Americans when they got there. I don't know. But here was this Jap skull on a tank, and it was just a great

picture. It's one of the atrocity pictures of the war, and it's used all the time. It's a great picture to show people who want to go to war what war is like.

If it had been an American skull, I would have taken the picture too, but it would never have gotten cleared through the censors. We didn't get a picture of American wounded cleared by censors until George Strock finally showed the beach in Buna with American dead in 1943.

I left Guadalcanal because I had malaria, and later I was assigned to Europe. *Life* had George Rodger, Robert Capa, David E. Scherman, Frank Scherschel, Bob Landry and myself covering D-day. We all knew each other in New York. During the period of waiting, we covered a lot of stories in England. I knew George Rodger very well. In fact, I was with him when he took his famous picture of carrying the body out of the rubble. We had been on the roof of the office watching the buzz bombs come over, and I said, "Hey, that looks fairly close. We can get there." So I drove him over.

*You also took pictures of lovers in Hyde Park.*

Yes, that was during this period. It became fairly famous later from the book *Family of Man.*

On D-day I was on a landing craft taking troops in. We took them in, then we went back and got more. I felt like getting off with the troops, but I figured if I got off, I'm not part of any unit. I'd be sitting on a beach by myself, and maybe that's not a good idea. After D-day I went across France with the Third Army. We were near the Rhine River when this telegram comes from Hicks saying, "We want to do a story of a man getting wounded badly enough to come back to the United States."

I showed this to the public relations guys. They said, "Boy, you're gonna need a hell of a set of orders to travel with a guy." *Life* went to the Pentagon and came back with a set of orders. I must have made 50 copies and carried them with me to give to everybody who wanted a copy. I went back to the front and down to this barn which had an advance medical team, and I spoke to the captain there, the doctor.

He said, "Fine," and we went out with the medics on patrol. We were pinned down by shellfire for a couple of hours along a wall. When it let up and they started to move, I was behind this medic named George Lott. We ran out, and mortar fire came in and hit a bunch of guys. Lott goes out to get this wounded guy, and I'm running a little further away because there was a whole field to cover, and Lott yells, "I'm hit!" I turn around—I was just talking to the guy. So I started taking pictures of him.

It didn't make any difference to me who my wounded man was because the captain had said, "You might have to go get 10 different guys before I say it's so bad he's gonna have to go back to the States." We put Lott on a stretcher and go back to the barn. They let him down in the straw, give him a cigarette, and the captain turns and says, "This is your man."

We moved from place to place, from ambulance to ambulance, from hospital to hospital for 30 days before we hit the United States. Penicillin had just come in, and being that I was with him 24 hours a day, sleeping on the floor next to him, I was putting the penicillin in his arm, to keep his arm from having to be taken off. He had been hit in both arms and the back. He couldn't feed himself, and everything had to be done for him. So for me to pour penicillin in him every hour was no big deal.

They didn't take his arm off until we got to the United States, when they decided he was better off with a false right arm than an arm that don't work. Lott was a truck driver, and he wanted to go back to being a truck driver for the A&P in Albany, New York. He couldn't go back to that very well with an arm he couldn't turn the wheel with. German prisoners carried him to an ambulance plane in Paris when we flew back to Long Island. I stayed with him in that hospital until he got his Purple Heart and was about to be moved to a hospital in Battle Creek, Michigan.

I was in the office in New York when the story hit the magazine, and Eliot Elisofon turned around and said to me, "This is the only story I've ever seen I wish my byline was on."

After the war, the Nuremberg trials started. I was covering Hermann Göring in the courtroom, and I asked, "Can I do him in his cell?" I didn't get much time. I was brought down to an interrogation room, and they said, "Go take it." I just shot it. No lights. No tripod. You're young, and you can hold your breath for a half second. The next day Göring committed suicide.

*You spent the 1960s with the astronauts.*

You've got to remember, we made heroes of the astronauts the day they were picked. In World War II, or even now, a guy gets a Medal of Honor because he does something great. We took seven men who were all good test pilots and terrific guys, but we were making heroes out of men who hadn't done anything yet. Normally you wait until Shepard makes a flight, comes down and then give him a Medal of Honor. We gave the Medal of Honor the day they announced the guys—not actually, but verbally. We made heroes before the fact, and *Life* magazine was as bad as all the rest of the press.

But if you look back at the *Life* coverage, it was the only written and photographed history of what the program was about. The government didn't have enough sense to do it. NASA was anti-press, so no one would ever tell you anything was going on. I would say we did a fantastic service because we told people what it was about. Of course, when the astronauts signed the contract with *Life,* the New York *Times* kept taking us apart for it, but I don't think the *Times* was as angry about us having it as the fact that *they* didn't get it. And NBC almost outbid *Life*. The contract had nothing to do with the NASA program. If the New York *Times* or NBC wanted to go out and stay with the guys and cover their training, they could've done it. During a flight, that was what the contract was

about. Then we could put a guy like Loudon Wainwright, a very sensitive writer, into the house of Annie Glenn. We didn't pose pictures. I mean maybe we used editorial license to bring two things together into a picture, but we did not pose pictures per se; we did not make news. We photographed news. There's a picture of the Scott Carpenters on a couch the night before he left. They were sitting talking about how he might not come back alive, but this is where they sat and talked every night when he talked about his training. They sat there and talked in the house. The same thing with Jan Armstrong sitting on the steps on a Sunday before the flight to the moon, and the director of training and the crew would sit in the corner of the living room talking about what they did that week, and she was left out. Yet she sat there listening because she wanted to know what was going on. It's not posed. That happened. It was there. You don't have to pose things when they're happening.

*Do you want to go to the moon?*

Oh, sure. I think every guy who covers the space program wants to go to the moon. They're proving that age doesn't mean anything, and health doesn't really mean a hell of a lot anymore. It did in the beginning when you first picked astronauts, but now it wouldn't really. So I think everyone wants to go. I would like to try riding in a spacecraft. I have a tremendous amount of weightless time. I flew weightless with the first 16 guys while they were being trained, but it's eight seconds at a time. I guess if you add up all the seconds I have 30 minutes of weightlessness. A training plane goes up, fast as it can, and when it reaches the top—like if you throw a ball in the air, it stops before it comes down. During that period you're weightless.

You've got to learn how to take pictures weightless. Suddenly you're floating, and you've got to get the camera aimed and get your own feet out of your own pictures. That's when the astronauts have to practice walking, floating, eating food without gravity. You've got eight seconds to work, and when the buzzer sounds you've got to get your cameras out from in front of you because the G force could push them right into your chest. You put the cameras over your shoulder. The plane starts pulling G forces as it dives, and it pulls about five Gs coming out of it. The moment you come out of the G forces, you put the cameras back and start over again. Do this for enough hours, you feel really terrible at the end. But in the weightless period, you actually float around in heaven.

*Is it like floating in water?*

Water is much more pressure on you than that. In water you know you're in water. Here, you don't know.

*Did you think the astronauts were heroes?*

No, I think they were a very lovable group of test pilots. Very, very intelligent, smart guys. But to me they're not heroes. You don't become a test pilot in the military unless you're a pretty damned good pilot. So I think there wasn't any question about them being great. They were all physically perfect. They all

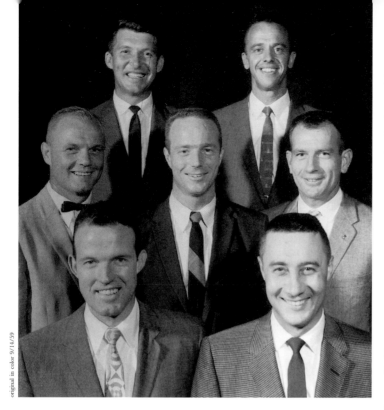

original in color 9/14/59

Mercury astronauts. 1959
*We gave the Medal of
Honor the day they
announced the guys—
not actually, but verbally.
We made heroes
before the fact.*

Scott and Rene
Carpenter. 1962
*They were sitting talking
about how he might not
come back alive.*

5/18/62

had to have kids. They all had a certain height and weight and all that. They were all perfect guys. Those who had experience talking to the press were much easier for us to get along with, of course. But also you've got to remember that I was the only news guy living with them all the time, going everywhere they went. And when it came to lift-off, we were with their families, so we were a hell of a lot closer as people to them and knew much more about it. When Glenn had the 10th anniversary of his flight and had dinner with his family and all his prize friends in Washington, my wife Ruth and I were the only outsiders from the press invited. When Shepard's daughter got married, we were invited. I'm just telling you it gets to be more than, "Hey, I'm covering you."

*Are there any pictures you didn't take?*

No. There are pictures NASA wouldn't let me take, but no pictures I didn't take. When Shepard came back from his flight, they were having a press conference, and seven astronauts were brought up on the stage. I'm standing in the wings taking pictures of seven guys which I'd taken 4,000 times. Shepard sees me and sticks his tongue out. I said, "Alan, that's the biggest mistake you ever made. It's in the middle of the roll of film. It's going to go to New York. How do you tell 'em not to run it?"

*How important is luck?*

Luck plays a big part in your being there. Luck doesn't play a part in what you take. I remember at the Republican Convention in 1952, Edward K. Thompson, the managing editor, said while we were sitting in the press room, "We need a closer for this story. Eisenhower's obviously gonna make it. Why don't you go look for a picture, and then we'll talk." I went out and wandered around, and found that way, way back from the last row I could line up a speaker at the podium with a portrait of Lincoln behind it, and using a very, very long lens, squash them together in the picture. Thompson said, "That's your assignment. When his acceptance speech comes, you have no other job." We ran it as a full page.

*Almost the only editor that staff photographers praise is Thompson.*

You have to remember, you don't get many geniuses in pictures. Pictures were new. Thompson had a flare for taking a stack of 75 prints and going through them and picking out seven and saying, "Lay these out." He had that intuition of absorbing the story and selecting what was right.

*Do you think photography is an art?*

I think photography is more than an art. In photojournalism, it's knowledge. I don't think you could be a very good photojournalist without being a very knowledgeable person about a lot of things.

*Did you find reporters helpful?*

Most times, yes. We walk into something cold. You've gotta make friends, you gotta get people to do what you want, and you have only two eyes. If you have a reporter, you've got four eyes—especially a reporter who could think in pic-

tures. I think the pairing was very good. But I remember once on a *Time* story, after the weekly *Life* folded, I had to go up to do the president of General Foods with one of their business reporters, and it was just the complete opposite of *Life* magazine. I'm trying to relax this guy, and because he's got a bad back, he can't stand. He can hardly move for pictures. I said to him, "I just did the president of Merrill Lynch, and he had a bad back too."

I was telling him what the other CEO did, and the reporter says, "No one's interested."

Now the president of General Foods is there, and the reporter turned around and says to me, "No one cares what photographers think." I just turned around and walked out. The hell with him. I'd already taken one picture. That was it.

I went back and said, "I'm not gonna work with that guy." I mean you can't. I'm breaking my neck to make a friend with the guy, and he's screwing it up. So I think it's according to the reporter.

*How did you feel when* Life *stopped as a weekly?*

I was down at Cocoa Beach covering Apollo 17. We had made a very special picture of everything you need to go to the moon. We shot it and went to bed. I called the color lab the next morning and said, "How did the color come out?"

They said, "Oh, the color is fine, but there's no magazine to put it in."

And that was the first I heard it. It was a very bad shock. First, because I'd been there for 30 years, and you sort of reach a point where it's your home. The shock was much worse than whether we could find jobs, because we were all pretty well known. That didn't bother me. I just went to work for *Time.* I didn't retire until April 1988. Then I sold every camera. I don't own a camera. I don't take a picture.

*You never take pictures for fun?*

If I had a camera, everybody and his brother would say, "Gee, would you take my wedding? Would you take my kid getting married? Would you do this for the condo?" I don't own a camera, so I can't do it.

On the *Life* staff 1942-72
Interviewed in Miami on September 30, 1994

He came up with his camera.
"Bingo," I said. "Hold it!"

Dennis Stock. New York City. 1951

# ANDREAS FEININGER

ANDREAS FEININGER: I was interested in everything that has to do with nature, and there were these crows in the snow. My mother had this little camera, so I tried to photograph them. Of course, I missed. What I got was two black dots on the solid white surface. I was 19, and I learned that photography is not as easy as it seemed. I also learned that you have to have a certain distance between your subject and the camera, and that it should not be too large. And I learned that you have to watch the contrast of your subject. You cannot shoot something that is solid black against something that is solid white. Well, you *can*, but you get a picture that you will not be happy with.

*John Loengard: Your father Lionel Feininger was a well known painter. What was the attitude in your family toward photography?*

My father photographed only the things he was really interested in, just like me. He was not interested in "photography," and neither am I. I want to get shots of the things I'm interested in. I use it as a means to an end. I think he did the same.

I learned the trade of a cabinetmaker at the Bauhaus in Weimar. After that, I finished my education—as an architect and structural engineer—at a technical school in Zerbst, which was a small town not too far away from Dessau. I graduated summa cum laude. I was very happy.

Then I thought, "What do I do now?" I went back to live with my parents in Dessau, where the Bauhaus had moved.

*The Bauhaus was noted for approaching the arts at a practical level, wasn't it? Was László Moholy-Nagy teaching there as well as your father?*

I never took any of Moholy's courses. Briefly, I took a course in photography from Walter Peterhans at the Bauhaus, but it was all about technique, which I knew. I heard from students who were my friends that what Moholy taught was—if you permit the expression—for the birds. He also stressed the technical part more than how something should be designed as a work of art. I felt that if you want to do something, whether photography or a drawing or designing a building, that's not what you need. The technical side, in all these fields, is so simple you can learn out of a little pamphlet. What you need is imagination and creativity. Moholy tried to tell students just how to create a work of art. In the Moholy manner, of course. There was a lot about straight lines. It didn't make sense to me.

*Marcel Breuer and Josef Albers were also teaching there.*

They were friends of my father's and came to our house quite frequently, and I met them there. All very nice people, but not for me.

I got a position as a draftsman with an architect in Dessau. I spent a year there. Then because he didn't have much work, he had to dismiss me. I got another position at a department store in Hamburg. They had their own architectural department, and I spent about a year there making drawings for their carpenters.

After a short while, I knew that I didn't want to be an architect at all because I would have to work with people who knew exactly what they wanted and would tell me to do it, even though I might disagree thoroughly. I couldn't do that.

Later I got to Sweden, and again I tried to get work with an architect, a very kind man. He showed me some pictures of his buildings and asked me, "How do you like them?" They were straightforward, honest, practical buildings. I liked them very much, but I also told him that "your photographs are terrible."

He said, "Do you think you can do better?"

I said, "Yes, of course." I made a series of photographs that he liked very much. He showed them to his colleagues, and I got assignments from them. It spread almost like wildfire. Within a short time I was a well-known architectural photographer and made a good living. That's how I got into photography.

*That photographs be simple was in line with the Bauhaus.*

Yes, it was. Practical and to the point, yes. Do not louse it up with things that don't belong there, like decorations that have no practical value, backgrounds that detract from the main subjects, or bad lighting, things like that.

Stockholm is surrounded by water, and big ships anchor there during the tourist season. I wanted to photograph those big liners in connection with the city. But if I came close to the ships, which you could at certain places, then you got the ship very big and the city very small in the background. The proportions were distorted, so to speak.

The only way of getting pictures that kept the correct proportion was from very far away. From that distance, a normal camera would have given me a pic-

ture that was a quarter of an inch high or less, so I designed a camera. I found a long lens in Paris that looked as if it were made in 1890. I think it probably was an old portrait lens. I built a camera to accommodate it.

The camera was the simplest thing you can imagine. It consisted of two long rectangular boxes, one sliding inside the other for focusing, a lens in front, and a cassette holder in the back. Using it, I could get pictures where the proportions between the city and the ships were more or less what they are in reality.

In 1941 I was visiting a camera store here in New York, and I saw an even longer lens in a case of used equipment. It was a Dallmeyer lens. I asked the salesman, "How much do you want for it?"

He said, "Two hundred dollars."

I said right away, "Are you kidding? I give you $50."

He said, "O.K., it's a deal." So I got it for $50. I built another camera for it. Same principle. Two boxes sliding inside each other. Then I had one problem. These long cameras are terribly sensitive to vibration. With vibrations I got an unsharp picture. So I designed a special tripod, which I called a "five-pod" because it has five legs. It consisted of a 2x3 inch piece of wood as long as the camera. At the rear end it was supported by an ordinary tripod. In front it was supported by two tripod legs which spread out from it to connect with the two front legs of the tripod.

The advantage of this is twofold: first, it keeps any camera rock steady because it supports it at the two ends. And, then, it touches the ground in only three points. If you have something that touches in four points, it always wobbles, but three points are always steady. The five-pod could be folded quite easily. It was no bigger than an ordinary tripod. I should have patented it, but, on the other hand, I think I'm the only one who ever used this kind of tripod.

*What did you use it on first?*

The skyline of New York. I came past Great Notch Mountain in New Jersey, and there is a little highway from which you get an absolutely magnificent view of the whole skyline of New York. Because you're high enough there, the skyline stands out against the sky. It is hopeless to photograph with any ordinary camera. This was the first picture I took with that camera. It was something that nobody had ever seen before.

It was a fairly clear day, but it could have been clearer. I used a filter to cut through the haze and improve the contrast. Some pictures need a clear day; others not. One of my best pictures is of the Brooklyn Bridge in the fog. I took that from the roof of an abandoned warehouse in Brooklyn. A horrible place where I wouldn't go today for anything. It was a hazy day when I got there, but then the fog came in. The Manhattan end of the bridge slowly disappeared until I couldn't see it. It is a very low-contrast picture. It has a very special mood.

When I had gotten up on the roof, there was another building between the bridge and me that I hadn't seen from the street. There was a plank connecting

the two that was eight feet long and 12 inches wide. I had to go over that damned thing, and I did, to get my picture. When the time came to go back, however, I got to that plank and turned to stone. I couldn't get over it. There was nobody around. There was no rail. I saw only the concrete six floors down. I stood there for 20 minutes, absolutely in a panic. Finally I decided I have to do it. I *can* do it. I took my two cases with me, one in each hand, balanced, and went straight on, without hesitating. I knew if I hesitated in the middle, I would fall. Step, step, step, I went across. That was the most unpleasant moment in my photographic career.

*You came to New York in January 1939, when you had just turned 32?*

Yes. My father was an American citizen. His family had come from Germany in 1848, when there was some kind of a revolution and a lot of people left the country. He was born here but went to Germany to study. I grew up in Germany, but I was an American citizen. Still, I spoke virtually no English. I learned it by speaking with people when I got here.

Black Star, the picture agency in New York, was run by people who had come recently from Berlin, and I had some connections with them. They had sold a few of my pictures. I visited them and talked to their director, Mr. Kurt Safranski. He said, "All right, we'll give you $20 a week." So I worked there for almost a year for $20 a week. And shot whatever they wanted me to shoot.

*That's $1,000 a year then, so it's about $10,000 now.*

Yes.

*They paid your expenses, and more if pictures were used?*

No. And I paid for everything. It was a very bad deal. Mostly they gave me assignments, but that time is very vague in my mind. Perhaps because I want to forget about it. It was not good. When my contract ran out, they said, "You have done well. We'd like you to work another year for us, and we'll give you a raise of $5 a week." I told them what I thought of them, but I cannot repeat it here. I left.

Safranski had introduced me to *Life* because if he produced picture stories for *Life,* he got paid. I met the picture editor, Wilson Hicks, who was a marvelous man. We got along splendidly. We spoke the same language. I am, by nature, a loner. I do my own things in my own way. I don't communicate very much with other people. I hardly ever go to photo or art exhibitions because I'm so filled with my own ideas and thoughts. I'm a terribly selfish person, and that's where it comes out. In regular social life, it's a bad quality, but there, I think, it might be a good quality.

*Your brother T. Lux is a painter, and your father was a painter. Did you ever want to be a painter?*

Never.

*Do you find any similarity between your father's pictures and your pictures?*

Yes. Even though it is difficult to see and more difficult to describe. There is a certain clarity in his pictures which I try to get in my photographs. There is a

similarity of attitude and philosophy. The way we approach a subject, and what we think is important, and how we can bring it out to best advantage in our work.

*There is a sense of motion in your father's work.*

Yes, that's right.

*Is it in yours?*

No, I can't say that. Not really. I deal almost exclusively with static subjects. Life *did a story on you and your brother and your father, and placed your photographs of New York from Weehawken, New Jersey, side by side with your father's painting of a city at night. You can't say that everything is still in that photograph.*

All I show is boats and buildings that are still, but I wanted to bring out the dynamic of New York. I did that through perspective and lighting. And luck. It was a very cold winter day, and there was a lot of steam in the air. On a warm day you wouldn't have seen it. I think it is the best picture I ever took. It's photographed in such a way that you cannot help feeling that dynamic.

I'm interested in everything man has produced, from machinery to buildings to airplanes. And, in particular, I'm interested in the city, but in a holistic manner. I want to show everything together: the cars and the street signs and the buildings and whatever there is.

*So you're an environmentalist.*

Oh, yes, very much so.

*Then there's a contradiction, in a sense. For example, the oil derricks you photographed in Long Beach, California, are very ugly, and yet there's something grand and dramatic about them in the picture.*

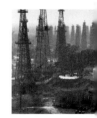

Yes. I did that deliberately because that way people remember what oil stands for, what this pursuit of oil does to the environment. I had to go pretty far back to find the perspective that puts all these derricks close together. That is how I got this feeling of their importance and their dynamic and their horror. They have totally ruined the whole landscape as far as you can see. There's not a tree, not a blade of grass there; there's not a bird there; there is nothing. It is dead, totally dead.

In modern oil fields there's virtually nothing to see. Every quarter mile or so there's a little pump, going up and down. Totally undramatic. People will say, O.K., so what? But when they see the Signal Hill in 1948, they see the whole horror that it involves. At the same time, the picture is beautiful. I know there's a contradiction. But I've found I have to dramatize—without falsifying anything or adding anything that doesn't belong.

I can dramatize a face with harsh light. It looks very dramatic, but it isn't the person anymore. But when I photographed Signal Hill, with the oil derricks filling the whole picture, it emphasizes pictorially what the thing is.

*Do you like New York City?*

Yes and no. It has marvelous qualities, and it is a horror in many ways. I like

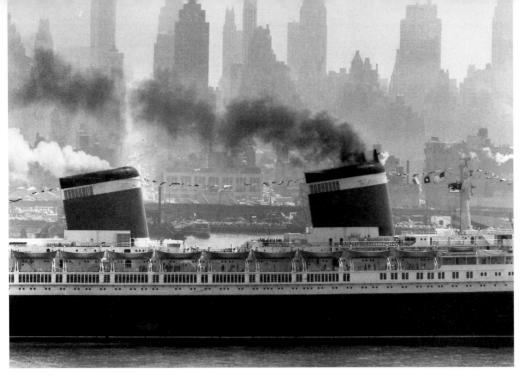

The S.S. *United States.* ca. 1952
*People lining the bridge are clear, but very small. That people
no bigger than these built that ship is almost unbelievable.*

View from Weehawken, N.J. ca. 1942
*I did that through perspective and lighting. And luck.*

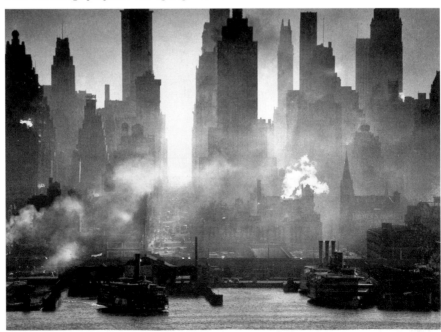

it now less than when I came first. But then it was new to me, something I had never seen before. That made it pictorially very dramatic.

In 1952 I took a picture of the ocean liner *United States* in front of Manhattan because I felt putting these two achievements together gives you a fantastic look at the achievements of man. Man has built this enormous city and this enormous ship. I don't know whether you noticed that there are tiny people lining the bridge of the ship. They are clear, but very small. To think that people no bigger than these have constructed and built that enormous ship. That is almost unbelievable.

It was a matter of luck that these people are there in the picture. It might just as well have been a windy day, and nobody would have been there. But, to me, that is a very important picture element. And there is one more element in it, and that is New York's 42nd Street, which is probably the liveliest and most typical street of New York, good or bad as it may be. So I tried to get them together. And I shot two pictures.

First, I found a viewpoint right opposite 42nd Street, so I could see along the entire length of the street. As a matter of fact, in this photograph you see the hills of Long Island in the background.

I waited exactly until the ship's two funnels were right and left of 42nd Street, with the street right in between. So I got it all together. Then since the opportunity was so marvelous, I quickly changed the film holder and shot another picture that got half of 42nd Street because the ship moved. *Life* has that good picture. I have the second negative. They are both pretty good pictures, I think. Very powerful.

*Did you make your own prints?*

It is terribly important. Every negative can be printed in 20 different ways in regard to cropping and in regard to contrast. You wouldn't believe what you can do with a film. Very good prints can come out of a negative and very awful ones.

*Do you crop often?*

I try to do it when I take the picture, so I crop in the darkroom very rarely. In Chicago I photographed a picture of a very decrepit tenement—absolutely, unspeakably awful. I shot it head on. You see every rotten detail in it. In the negative I have a little bit of sky above it and to one side. When I saw the print I realized that sky had to go. So I cut it all off. Now the whole frame is filled with this unspeakably horrible structure, and that makes it a very powerful picture.

Incidentally, there was another instance of luck. There were some children playing on one of the wooden galleries—you know, half rotten, half fallen down. Then a man came with a guitar in his hand. He walked into the picture and stood more or less in front of these children and held his guitar like this. He wanted something. That made the picture three times as powerful as if that man hadn't been there, or the children. More even. It gave it life and connection with today. Otherwise you could have thought, "Oh, that's an abandoned building.

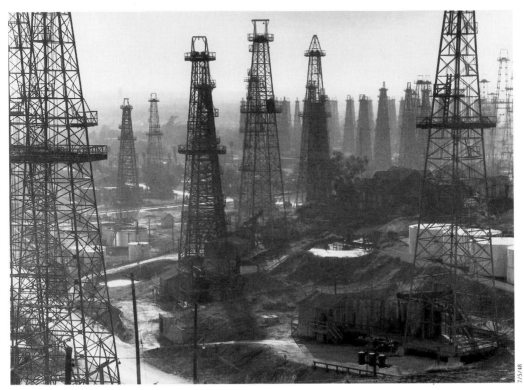

Signal Hill. Long Beach, Calif. 1948  *There's not a bird there; there is nothing.*

Chicago slum. 1948  *In the negative I have a little bit of sky above it and to one side. I cut it all off.*

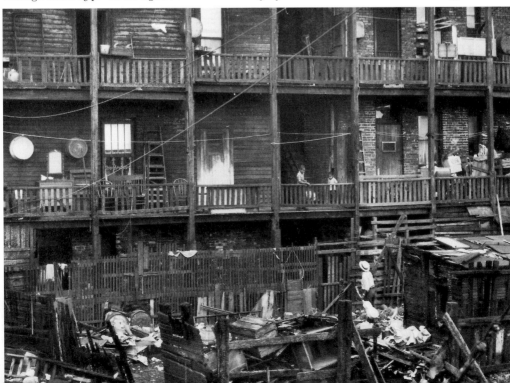

Nobody lives there anymore." But it was full up. People lived there, all over.

These are the little accents. You have to be able to see them. I had shot pictures without both the children and the guitar player. Then just when I was ready to pack up and go, the children came out and I shot a few more pictures. And then the man came with the guitar. I shot it, and so I got *the* picture.

*In your photographs, you rarely focus on a human being, but you photographed the photographer Dennis Stock.*

Yes. That was an assignment. He had won first prize in *Life's* 1951 contest for young photographers. Frankly, I didn't quite know what to do. We played around with lights, and he said, "Why don't you try just a spotlight?" So I got a spotlight. I focused it on him and immediately saw the power of this picture. He came up with his camera. "Bingo," I said. "Hold it. Hold it!" There it was. In a way, we worked together on getting this picture.

It should have made a cover. Some people at *Life* thought it would be the best cover ever, and others said, "It's gruesome! We can't have it." As usual, the wrong people won.

*Was it usual for the wrong people to win at* Life?

Very often, yes.

*Did you feel that your work wasn't used well?*

In the beginning I thought it was used very well, and they let me say a lot of things about layout or selection of pictures. That was because Hicks liked me and I liked him. As a matter of fact, he liked me so much he once said, "Why don't you write a book?" The result was this book, *Feininger on Photography.*

*Outside of Hicks, did you find many people on* Life *who understood pictures?*

I really don't know. When Hicks was picture editor, I hardly dealt with anybody else. Several stories on insects were my idea. Actually, they didn't really fit into *Life*, which is a people magazine. Hicks saw that occasionally you have to have something else. He said, "Do it," and I did it. I did a beautiful story on spiders that never ran. Somebody said, "Spiders, yuck!"

*You photographed a daddy longlegs.*

That is one of them. For instance, people have seen daddy longlegs, but they have no idea how they look really. To them, it's an ugly something suspended on the thin, ugly legs. But if you look at the structure and the construction of these legs, they are like ball joints. They turn in all directions. The insect is suspended on them. Most living things are supported by their legs, but this one is suspended from them. It hangs in the middle of these legs and moves in a rhythmic, swinging move that is beautiful to watch. The daddy longlegs' eyes are on the top of the body, which looks like a small pea. Its enemies come from above, so it has to see up. I see these things; I want to write about them and photograph them. But very often nobody's interested.

*Did you know the other photographers who were on* Life's *staff?*

Few very well. I kept myself to myself. I was friendly with everybody, but on

a rather cool level. Some of them I liked more than others. I liked Margaret Bourke-White very much. Whenever we met, we really understood each other.

*Do you consider yourself a journalist?*

A photojournalist. It means a person who tries to show other people something interesting. It is always based on something real. It is not like an abstract painting, which just exists in the painter's mind.

*Do you feel you have an obligation to bring the subject out?*

Yes. For instance, I did a story on a mosquito. The main picture was to show it biting. I looked around until I found a mosquito in our house on the wall, and I caught it with an ordinary water glass, which I placed above it, and it was inside. I used a thin piece of cardboard, which I shoved in between glass and wall. Then I could take the glass away with the mosquito inside because the cardboard kept it there. I got myself a human guinea pig—I forget who it was—and put the glass and the cardboard on his arm. Then I pulled the cardboard out. Now the mosquito was free inside the glass. It flew around a little bit and then settled down on the arm. Apparently it tasted good or it smelled good, because it began to sting. I had done all of this in front of the camera. I took away the glass. The mosquito didn't budge; it just kept on taking blood. And I got a beautiful picture of a biting mosquito.

*Since the 1970s, photography has become accepted as an art. How do you feel about this change in the attitude toward photography?*

Collectors buy my prints, and pay very good money for them. I'm represented in all the big museums. I have an archive at the Center for Creative Photography at the University of Arizona in Tucson. They have a complete collection of everything I ever wrote. They are marvelous people. They are my people, so to speak. We understand each other and like each other, because to us photography is the most important thing in our lives.

*Do you think photography is an art?*

I know they talk about the art of photography, but I don't think it should be used as an art. I'm afraid people will get bored by what they see as "art photography" and try to come up with different styles, and that will distort photography. It might go the way painting has gone, from the very naturalistic to impressionistic, expressionistic, minimal. That may make eye-catching photographs that just don't communicate what they should, which is a feeling for the subject that is photographed.

*Your father was an abstract painter.*

Yes, but he always had a subject. His paintings give a very powerful impression of what he wanted to paint. I have two paintings here. One is of the sea at sunset. The other is of the dunes in moonlight. Even though they're semiabstract, they are the most powerful impressions of the sea and of the moonlit dune that I have ever seen.

*Were you a competitor with your father?*

Never. The opposite. We admired each other.

*And your brother?*

Not a competitor. No.

*You admire his work?*

No. It meant nothing to me, you know? There's a whole book of Bauhaus photographs. I think 90% are shot by Lux. They are just snapshots. Occasionally he'd do a good one. But that came as a surprise probably. I don't know. I may be totally wrong.

*You're not interested in him as a painter either?*

No.

*Your other brother is a musician.*

Yes and no. He became a Catholic priest. We had nothing in common. He too is a very nice, friendly guy—no question there. But we do not share an interest as far as our respective professions are concerned, no.

*You've photographed mostly in black and white.*

I still prefer black and white because I have total control in black and white. I can print one negative lighter or darker, with more contrast or less. I can crop parts out of it. I have control, while in color I have no control. I get a 35-millimeter color slide, and that's it, period. If it's too light or too dark, I can't do a thing about it.

*But color is more natural.*

In a way. I think it is also duller, because color is nothing new. We see it all the time. We see the streets and people the way they are. But in black and white I can make it interesting without making it unnatural. To photograph something and get a picture that is exactly the way it looked to the eye is for the birds, I think.

On the *Life* staff 1943-62
Interviewed in New York City on January 13, 1992

We had to go by each one
and feel his neck
to see if he was alive

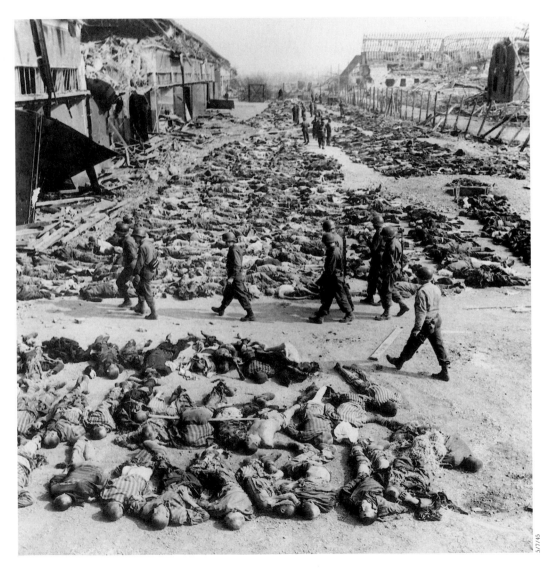

Nordhausen. 1945

# JOHN FLOREA

JOHN FLOREA: I was one of Bach's boys. Clarence Albert Bach had been a 20th Century Fox motion picture cameraman. But he had asthma, so he went to the board of education and promoted the idea of a photography school. They gave him Fremont, about 10 miles outside of downtown Los Angeles. The unique thing is that seven photographers on *Life's* staff went there. George Strock got onto the staff first. He brought in Bob Landry, and Bob brought me in. I brought in Mark Kauffman. After Mark there was Jack Wilkes; then Hank Walker came next. After the war, *Life* established an office in Tokyo—in the Tokyo Bible Institute Building. One day a lieutenant walked in saying, "You know my sister quite well. I went to Fremont High School too." His name was John Dominis, and I got the Army to assign him as my assistant in Tokyo. He took his discharge in Tokyo and stayed and then got on the staff.

*John Loengard: What was Bach like?*

He was very strict. You had to start from the ground up. I had to make my own camera. I made it out of cardboard, painted it black and made a pinhole in it. I made my own emulsion, and I got a piece of celluloid and smeared the emulsion on the celluloid. I put this in the back of the pinhole camera and made a picture—and it had to be a pretty good picture.

I didn't have the ready-made developers that are prevalent today. I had to start from scratch, mixing the various chemicals to develop the film. Bach taught what the chemicals did and the reaction of the chemicals on the film—how their action would develop the silver salts that had been exposed to light and then remove those that hadn't been exposed. He made us take related subjects like

physics, optometry—everything that related to photography. By the end of the first year I'd learned the fundamentals.

He wouldn't stand for any shenanigans. He told us about a lot of things that your father should have told you. Way back then, in 1934, he taught us about condoms. Some of the more romantic guys in the class would end up necking with the girls in the darkroom. I mean these girls were 13 and 14 years old, and we're 14 and 15. "Please leave the girls alone. Concentrate on photography," he said. "You're going to be among pretty women if you get involved in the motion picture business or if you're doing fan magazine things or fashion ads or whatever." He was a wise man.

He ran the class like a managing editor. We would go out at night and prowl the streets and look for accidents or whatever. Basically he was training us to be newspaper photographers. He kept pounding at us that we had to be editor, writer and cameraman combined. We must know the significance of the subject matter. He taught us to talk to our subject, to create moods.

He taught that photojournalists have a twin compulsion to express and communicate—to control what he sees and how he sees it. A photographer who is in control sets his own style, which becomes recognizable. He does this with craftsmanship, and with taste, and with interpretation.

*How would you describe your style?*

I had been working for the San Francisco *Examiner,* and when I started with *Life* magazine I noticed that they had specialists like Andreas Feininger, who did landscapes and barely anything else; Fritz Goro, who did the science thing; and Robert Capa, who did nothing but war stuff. Capa was a great war photographer, but he didn't know anything about lighting. I was determined to do all of the things that any specialist on *Life* magazine could do. I later judged that it was kind of a foolish desire. I should have specialized. I should have cut down on a lot of the styles I was trying to create . . . I was in a hurry.

*You went to the war in 1943.*

When Bob Landry had to go overseas, he introduced me to *Life* magazine. I became a retainer photographer in Los Angeles.

Colonel Jimmy Roosevelt, Franklin Delano Roosevelt's older son, was the commander of the Fourth Marine Raiders. For three months I photographed them training in Southern California, including going through 27-mile hikes. I thought it would make a wonderful 10- or 12-page spread for *Life* magazine. The day they finished the training, Jimmy calls me into his tent out in the boondocks and says, "John, you're going to be drafted pretty soon. The boys like you. I like you. You seem to fit in with the group. Why don't you come along with us? I'd like you to be my public information officer. I'll give you a field commission as a lieutenant."

I looked at him, kind of concerned, and I finally said, "I've got to tell you, Jimmy. I came on the magazine in '41. Pearl Harbor was that December, and I

was low man on the totem pole. It'll be a long time before I can get to be war correspondent, but I'm hoping that I can be."

He said, "Will you go with us if you are a war correspondent?"

I said, "Yes, sir."

He reaches for a phone hanging on the tent pole and rings the operator at Camp Pendleton and says, "Get me the White House." I sat there shocked. He says, "Get me my father," and by God he was put through. He says, "Hi, Dad. How's Mom?" and went into all those things. "I have a young fellow here. We're going to be leaving. I would like to take the young fellow with me, but he does not have war-correspondent credentials. Can you get Steve Early [he was the press secretary to President Roosevelt] to call General So-and-so of the Marines and cut his credentials as fast as we can and notify the FBI and clear him?" Then, "Thank you, thank you," and then he hung up, and he looked at me, and he said, "It's done."

Of course, *Life* was delighted. They flew me to New York and sent me to Abercrombie & Fitch for my uniforms. They were gorgeous uniforms, silk gabardine, cashmere underwear [*laughs*], and in a week I was back in California. Then I sat around waiting for the clearance. My mother and father were immigrants from Romania, naturalized citizens, so the FBI went through when they entered the country and where they worked and where they lived and all of this. But it didn't clear by the time the Fourth Marine Raiders left.

When it did, I went to the Pacific, but I never caught up with the Raiders. Instead I got on the aircraft carrier *Essex*. I reported to the public information officer onboard. He said, "Pick a spot. Have you been in action before?"

I had been through a couple of bombings on the way out, so I said, "Yeah."

When they sounded general quarters for the first time, since it's the flagship, I rushed up to the admiral's bridge. The public information officer says, "Pick another spot because the admiral keeps running around on the bridge looking off both sides. There's a good place for you just behind the bridge on the searchlight platform," he said. It had a railing that was about up to my waist. He said, "Shoot from there. You can see the bow and the aft end of the ship."

When we got near Rabaul, we launched our planes. Then we were attacked by torpedo bombers the first time. The admiral was a Texan, and he rolled his own cigarettes, but during the attack he'd forget to flip the ends and he'd stick it in his mouth as he ran out to see where the bomber was coming from. He'd light it, and the fire would burn the paper because the tobacco had flown out the end that he didn't tie up. I'm shooting pictures of the admiral because the planes are so far out you could hardly see them. One plane did get through and launched a torpedo that went right toward the tail of our ship. It didn't explode. It was a dud fortunately.

We were attacked by 300 Japanese airplanes. When the battle ended an hour and a half later, our aircraft carrier's planes had shot down 55 enemy planes,

and that record still stands. The ship itself shot down 16 airplanes, so we hung up a total of 71.

After the battle, our planes landed, some on fire and some broke up. It was quite a set of pictures.

*Not very many of the pictures you took made the magazine.*

It's a very sad story. The day before we attacked Rabaul, a torpedo plane landed on the deck and out gets Bill Shrout and a wire-service correspondent. They had been on Guadalcanal. Out of three carriers, Strout picks the one carrier that another *Life* photographer is on. I said, "What the hell are you doing here?"

I went to see if I could get him off, but the Navy said, "No. We're not launching anymore planes. They'll never make Guadalcanal before nightfall."

So we stayed on the ship, and I said, "I'll tell you what we do, Bill. I'll take the back half of the ship, and you take the front half of the ship. You go up above the captain's bridge, and I'll stay on the searchlight platform." In the middle of the battle, the PIO officer came to me and said, "Your friend Bill Shrout is down on the next deck. He just wanted you to know that he may be out of it. He's ill and shaky."

I said, "He's got malaria. Why don't you send him to sick bay? I can't do anything for him."

After the battle was over, and there was still light, Bill says, "I'm going to take off on the next plane. I'm going back to Guadalcanal."

I wrapped up all of my film and wrote out the captions. I put a roll of film inside a condom with a pinch of rice and then tied the end. We all carried like a gross of condoms with us. I sent in something like 14 rolls of film, condom wrapped, with the rice inside to keep the humidity out. I said, "Bill, here's my film. It's all wrapped separately."

Bill took off for Guadalcanal, hopped another plane to Pearl Harbor, and turned in all the film and didn't put my name on any of it. The story ran for three or four pages in the magazine and was titled "Carrier Warfare." It was by Bill Shrout. I swore up and down if I ever catch him I would have killed him. That's what happened at my first big battle. Shrout was sent back to the States. I never saw him again after that. That's why I was so upset with George Silk in Germany.

*What happened with Silk?*

After the Rabaul, I went back to Hollywood for a couple of months, shooting movie queens and "*Life* Goes to the Movies" stories until they finally called me and said, "We want you to go to the China-Burma-India area. When I got to London, they said, "Stay here, in case somebody gets hurt on D-day."

Bob Landry was with the First Army, but when the troops got to Paris, Landry didn't want to go any farther, so I took his place. Each of us was assigned an army. Silk was with the British First Army and the Canadian Second Army.

Bill Vandivert was with the Ninth Army. It was kind of a gentleman's code. I was with the First Army. David E. Scherman was with the Third Army, and I don't know who went with the Seventh Army. We stayed in our own army areas because a lot of times one army would just sit there, and nothing would happen, and it would be unfair for other photographers to come down and encroach in your area and beat you out of the pictures that you're waiting for. I sat with the First Army for four weeks with nothing going on, and then George Silk came running in during the Battle of the Bulge. There was a big air raid because it started to snow on December 16th, when the battle started, and we were socked in until the 20th or 21st. Then here comes the huge armada of planes and contrails and everything, and George had snuck into the First Army area trying to get pictures. I caught him near Spa, Belgium.

*The areas weren't so well defined usually, were they?*

I felt that he was poaching, and I told him so. I said, "All right, George. Now let me just tell you one thing. If you come down into my area and poach again, I'll blow your damn head off."

He looked at me and said, "You're kidding!"

"No, George," I said. "If you want to come down here, let me know first."

During the Battle of the Bulge, there were two of the biggest stories that ever happened. One was the firing squad where they shot an American soldier for deserting in the face of the enemy for the first time since the Civil War. The other was the Malmédy massacre. Two of the guys who were wounded in the massacre got out and came down to press camp at Spa. We were only four miles from where it had happened.

*What were your feelings?*

Well, have you ever really gotten hit in the gut hard and lose your breath and fall to your knees? You know how that hurts. I felt someone had hit me so hard—I actually cried. It was the most shocking thing I had ever seen because the boys had no weapons. They had fallen down with their hands up. There was a first-aid medical guy. His eyes were right in front of the camera. *Life* didn't have the nerve to run it the way it was. I guess they were sparing the reader, but they painted over the eyes. His eyes were gouged out, or the birds had eaten them out. None of the other fellows sitting around had their eyes gouged out. Just the medic, and he had on this medical helmet with the round circle and the red cross. He was right in the foreground, and all the rest of their bodies were strewn out. I did several views of this. I just couldn't believe it. The pictures that I shot were used in a Nuremberg war-crime trial to hang the commanding general of the Ninth Panzer Division—the outfit that had mowed down all these soldiers out in the field with their hands up—159 of them. Just mowed them down.

When we captured Cologne, I was sitting on the steps of the cathedral, and I looked down the street, and I see a guy coming toward me. I could see two Rolleiflexes, or, at least, two cameras, hanging down, and he looked strangely like

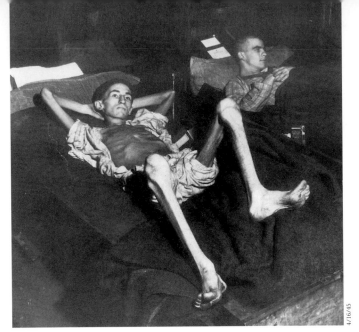

4/16/45

Joe Demler, prisoner of war. 1945
*I asked if they could get up. One kid could not.*

American P.O.W. 1945
*I turned my camera*
*toward him and*
*went up a little closer.*
*I wanted to show what the*
*Nazi bastards did to our guys.*

4/16/45

The Air Force. 1956
*You hear wild stories of the money that Eyerman spent on shooting a whole flock of planes in the air.*

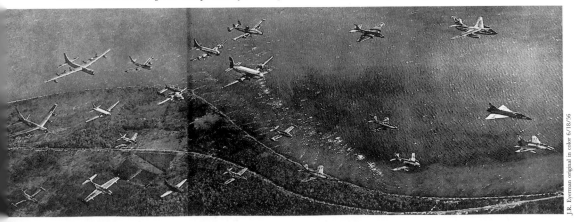

J.R. Eyerman original in color 6/18/56

George Silk. So I looked over at my driver. He had a carbine with him. I never carried a gun. I said, "Lend me your gun." So when the guy coming down the street gets closer to me, I yell, "George Silk!" and he stopped and looked up, and I lifted the rifle up like I was going to shoot him, and he turned and ran. I shot about 20 feet above him. I wasn't going to kill him. I wanted to scare him. If I wanted to kill him, I'd have shot him in the head. So as he was running, there was plaster falling from up above the buildings on him, and he thought I was hitting near him. I wasn't. I was hitting *above* him. He got in a jeep and went all the way back to Paris.

He said, "Florea is battle weary. He's been there too long." In fact, George flew all the way back to New York and reported that I shot at him and was trying to kill him.

Meanwhile, I went on with the First Army. In the town of Limburg we discovered an Allied prison camp. I found the American section. They were all emaciated. I was naturally very upset—more than that. They asked me for food that I didn't have. I did have a roll of Life Savers with me. I always carried little pieces of sugar for energy, and I said to these fellows all in a row, "Fellows, this is all I've got." So I gave each one of these kids a Life Saver out of my roll. Finally, I started to run out and I started breaking them in half and giving each one of them a half. Then I asked a couple of them if they could get up. One kid could not. He weighed something like 70 pounds, and I'll never forget his name. His name was Demler, Joe Demler.

*Have you ever seen him since?*

I got letters from him. He survived. He lives up in Minneapolis. A while after the war, I got a letter forwarded to me and a picture from him, and he had gained back 80 pounds.

As I was photographing Demler, I looked over and I saw this face, just looking up. He was in a daze. He was starving to death, and rather than say anything to him, I turned my camera toward him, went up a little closer and shot pictures of that staring face that I see—you don't know how many times I see those pictures in my mind. I wanted to show how the Nazi bastards—what they did to our guys. It was terrible.

After the P.O.W. camp, we traveled 90 miles a day down autobahns. One day there was a terrible stench in the air. We went down the road to this town called Nordhausen. We went down toward the railroad tracks. and here were three or four warehouses where the stench was coming from. Outside of them were 200 or 300 dead bodies. A Red Cross worker showed me a huge hole 20 feet by 20 feet, and something like 10 or 15 feet deep. A pile of ashes came up above the big square hole. "There are the ashes from 60,000 people," he said. Then he showed me the warehouse. The laborers were lying in the straw. We had to go by each one and feel his neck to see if he was alive. There were hundreds and hundreds of them in there. And then we went down into the base-

ment, and under the stairs from the first floor to the cellar—30 feet—the bodies were stacked like cording. All fresh—pictures that *Life* wouldn't use.

*Why wouldn't* Life *use them?*

They got the first bunch of pictures from me of a concentration camp, and for three weeks I didn't hear anything. I sent a wire asking what happened to the concentration-camp pictures. And the answer I got is that we have forwarded some of this stuff to the Senate in Washington for investigation. It's hard to believe that this is what happened. The pictures they had showed the dead stacked underneath a stairway. We got the Germans in this town to come down and take all those bodies and lay them out in the sun. That one picture was in *Life*. There are 3,000 to 4,000 dead bodies that disappear into the distance.

*There was only one story in* Life *on concentration camps?*

Only one.

*And that was the last page, I think.*

Yeah, the full page with all the dead bodies. I was furious with them for not using the entire set of pictures. There were dead babies laying around in some of the areas. These laborers were digging a tunnel into the side of a mountain, and they were getting maybe a bowl of soup a day. When they could no longer work, they threw them in the warehouse.

*Did you feel that* Life *magazine was ignoring what you did?*

I felt that *Life* was ignoring it at times, yes. Like the gruesome picture of the G.I. medic that they covered up with snow. I think they were afraid that it would upset their advertisers or upset the people who looked at it. They didn't want people in America to know that those nasty things were going on in Germany. I don't know why they wouldn't. I was angry that they didn't use all of the Nordhausen stuff. They used two of the P.O.W. photographs, but I had dozens, dozens. You should have seen the rest of the guys in this P.O.W. camp. Unbelievable. But evidently they were afraid that it would horrify their readers.

*Were the reporters you worked with helpful?*

In some instances, yes. But, don't forget, a photojournalist is basically an editor, he's a writer, he's a cameraman. If you're going to write a story like Roger Butterfield used to write, or a lot of great writers we had used to write, O.K. But I found that *Life* always wanted to send young researchers out with a veteran who'd been through a few things. I kept worrying about whether this guy was going to get hurt or not, and I already had enough to worry about—namely myself and getting the pictures. They were all neophytes that came out of the Ivy League. Time Inc. basically was Ivy League. There were usually two types of people at Time Inc. They were either the glory men or the power men.

*Glory men or power men?*

The glory men were men like John Shaw Billings, who built the magazine up into almost 50 million readers. They were the ones that were interested in content, and cost be damned. You hear some wild stories of the amount of money,

well, the money that Jay Eyerman spent on shooting a whole flock of planes in the air.* The money I spent. But that's why the magazine got so popular. It was the glory men who came up with the great stories, and cost be damned. Later they said, "We closed down *Life* magazine because the production costs got so big and television was too competitive." I don't believe that. I think if they had let *Life* magazine go on as a weekly picture magazine, it would be just as good today. But the power men got control. Billings got so tired of the power men, who were out buying real estate and milk-carton factories and other investments with the money *Life* made. I wasn't there at the time, but I learned of the stories. Wilson Hicks started out as basically a mediocrity and worked himself into a glory man. He was a damn good picture editor, and then later he became an executive editor, and he became a power man.

My battles with Hicks went on and on. After I got back from Europe, he said, "You've got a couple of weeks' vacation," but the next I thing I know I was on my way to Japan. I ended back up with the fleet fighting the Japanese after V-E day. That's how I ended up on the *Missouri* on V-J day. In fact, I was the only war correspondent that covered the end of both wars. I wanted to stay in Japan.

Luce came out to Tokyo one time before Carl Mydans took over the bureau, and I was there alone. I met him at the airport, and I said, "Carl is not here yet. What can I do for you?"

"I'd like to meet General MacArthur," he said.

So I called up the general's aide-de-camp and said, "Henry Luce, my boss, is here, and he'd sure like to talk to General MacArthur."

We lined up breakfast for the next day, and Luce and I went out to talk to MacArthur. Evidently Luce wanted to push him toward a Republican nomination for President. He had something in mind. He never exactly told me, but while we were having breakfast, Luce said to MacArthur, "We have our ace photographer here. We'd like him to shoot some portraits of you."

MacArthur says, "I haven't posed for a portrait since West Point."

Luce says, "I would like to put you on the cover of *Life* magazine in color. Won't you please reconsider?"

MacArthur says, "All right. I'll give him 15 minutes." So Luce was happy and went on his way, and we set it up toward the end of the week. I went up to the Supreme Command Allied Powers headquarters, and I set up a couple of Rolleiflex cameras with black-and-white film and the 4x5 inch Linhof with color. MacArthur came in, and he looked at his watch, and he said, "All right, John. Go ahead." There was a picture of Mount Fuji on the wall. I got him next to it and did as many pictures as I had film with me. I think it was a couple of dozen 4x5s. We did a couple of rolls of black and white, and he thanked me and said, "Time's up," and out of the room he went.

---

* Staff photographer J.R. Eyerman photographed 21 different kinds of Air Force planes flying in a single formation over Florida for a three-page foldout picture in *Life's* 1956 issue on the "Air Age."

We had no way of developing the color film in Japan, so I shipped the pictures undeveloped to New York. I wrapped it in two boxes, marked "Undeveloped Color" and "Undeveloped Black and White," and wrote "Undeveloped Film" all over the package. A week or two later, I get a message back, "Please redo General MacArthur portraits. They have been spoiled in the lab."

I thought, "Wow!" So I sent a wire to Hicks saying, "Please have Mr. Luce call up the general and rearrange the appointment. I don't dare." I only did that to be nasty to Hicks. Actually, I went up to the general, and I told him that the stuff was spoiled in the lab.

He just looked at me and said, "John, if I ran this occupation like *Life* magazine runs their magazine, we'd still be fighting the Japs. O.K., but this time I can't give you more than five minutes."

*Is there a difference between taking a picture to be on the cover and taking one that isn't?*

Eighty percent of the covers on *Life* magazine in those days were women.*
Men rarely sold magazines. MacArthur was important enough to be a cover if the picture had a glimmer to it. They used to put all the possible cover pictures up on the wall, and the one that jumped out at you is the one that they would put on the cover. Evidently the picture I sent of MacArthur the second time didn't jump out on the wall. I thought it was wonderful, but . . .

After I was in Japan a couple of years, I got a wire from Hicks saying, "You've been there long enough. Now we'd like to transfer you to another post. We have two places open: Atlanta, Georgia, and Cairo, Egypt."

I thought that was real insulting and inconsiderate, so I sent him a wire. I said, "I would prefer going back to Hollywood, if you can see your way clear. I think I've done a very good job for *Life* through the wars and everything." He granted me that, and I went back to Hollywood.

Before I went to the war, I did a story on Alfred Hitchcock, who was making *Lifeboat*. It was partly based on a *Life* story by David E. Scherman when he was torpedoed on the *Zamzam*. After that, I started watching directors and watching how they handled their people. I was learning how to handle the emotional quality of some of the glamorous women that I photographed—how the directors treated them, what they said to them. I learned how to handle the emotional quality of the scenes. I was able to go to a director and ask why he did this or that, and I kept notes and everything. I figured my battles with Hicks would come to a head and eventually . . .

*Why did he fire you?*

I suggested a story how people get into the motion pictures. You've heard all these cornball stories: Lana Turner was working as a soda-fountain jerk, and

---

* "A cover must be just one of two things—attractive or startling. To millions a pretty girl is both," managing editor Edward K. Thompson said in 1950. However, there was no pattern. In 1947, two-thirds of *Life's* covers included a woman. In comparison, women appeared on only about one-third of *Life's* covers in 1937, 1957 and 1967.

some talent agent came in and said, "You're beautiful. We ought to get some pictures of you." In those days they had drive-ins where girls skated around and served people in automobiles.

So I said, "We'll pick a girl and follow her for the next six months and see what happens."

We barely got into the fourth or fifth week when she said, "My dad was with the Associated Press, and he knows Wilson Hicks pretty well. I'm going East for a family reunion for a week. Would it do any good if I went to talk to Wilson?" I said that I didn't suppose it could hurt. She asked, "What should I do when I meet him?"

"He's kind of a con artist," I said. "So blow smoke up his ass, and he'll appreciate it." She wrote all of this on the back of an envelope.

When she got back East, she got her dad to call Wilson, and Wilson said, "Come on over." He said, "You're the one that Florea is doing the story on. How's it going?"

She said, "It's going fine." And she had the envelope in her hand, and she's looking down at the envelope where she had made a bunch of notes. Hicks saw her looking at the envelope. So he got up and walked around behind her and reached over and grabbed the envelope and went over and sat down.

"Where did you get this advice from?" he asked. She just sat there horrified. "Did Johnny Florea say this to you?" And she nodded her head, and he said, "Thank you very much."

I got a letter from Wilson Hicks saying, "It seems we can no longer get together. This is the end of the line." It was such a shock to me that Hicks would do that over a silly little thing like that. The right side of my face was paralyzed for six weeks. I had Bell's palsy. I went to the doctor. That's how big a shock it was.

Years later I called him and thanked him because otherwise I would never have gotten into the television business. I've produced or directed or written 130 or 140 television shows. I did *Highway Patrol*. I did *Sea Hunt* and everything, making approximately 10 to 20 times the amount of money I was making at *Life* magazine. The last big one I did was *CHiPs*, which was some 38 episodes. I got into an environment that I enjoyed. But the hilarious thing about it—maybe it's not so hilarious—is I'll never be remembered for that. The only thing I'll be remembered for is what I had done for *Life* magazine.

On the *Life* staff 1943-49
Interviewed in Los Angeles on August 12, 1993

# Suddenly I started to feel something

Pan Am Games. Mexico City. 1955

# GEORGE SILK

GEORGE SILK: The confrontation you're asking about took place in 1945 on the steps of the cathedral at Cologne, right on the edge of the Third Army's and the First Army's territories. I went in and photographed the cathedral and the people in the cellars. In a matter of 10 minutes I'd been through the whole thing and come out, and there was Johnny Florea, another *Life* photographer, just arriving. I was coming down the steps, and Florea came up and shoved a gun in my stomach and said he's going to kill me. A charming incident.

And here I am saying it on tape. I just shouldn't. I don't think it's any good stirring up those sorts of problems because you'll probably be talking to him. Ask him if he wants to say something.

*John Loengard: I will ask him. Was there much competition between photographers?*

I've got to be careful not to say that there *wasn't* because I may be kidding myself. I suppose that the competition was to get space in the magazine. That had to be a competition. You had to get so much space in the magazine or you weren't earning your money. At least that was my outlook. Johnny Florea considered it competition, but I find it hard to talk about.

*Then let me ask you about crossing the Roer River in Germany in 1945.*

Crossing the Roer River was one of the points in the controversy. It took place in the spring after a long winter of nothing happening. It was an assault over the Roer and the Rhine rivers by several armies spread out along the western front. I did it with the Ninth Army. Florea and William Vandivert were with other armies. They thought that we should send all the film in together because it was a coordinated offensive. I just didn't understand that sort of talk. How

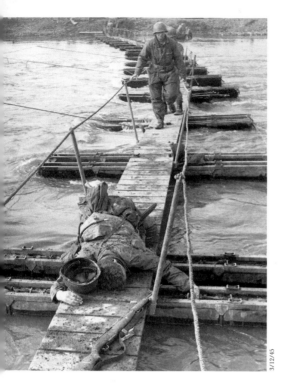

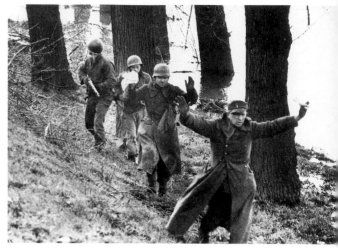

Surrender. Roer River. 1945
*A grenade blew apart the G.I. in front of me.*

Soldier killed crossing the Roer River. 1945
*I was driven by conscience.*

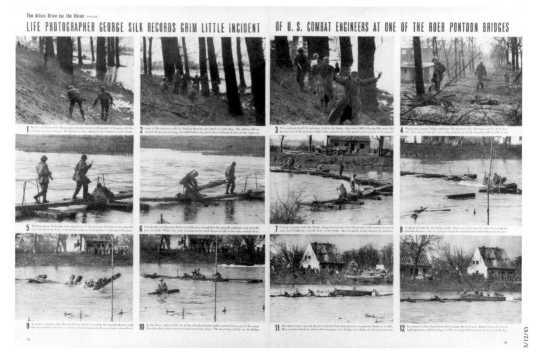

The Allies Drive for the Rhine

LIFE PHOTOGRAPHER GEORGE SILK RECORDS GRIM LITTLE INCIDENT OF U. S. COMBAT ENGINEERS AT ONE OF THE ROER PONTOON BRIDGES

Roer River sequence. 1945  *The magazine recognized what I was doing.*

could I delay my film so that the magazine might not get it until the next battle had started?

My whole story was done between 10 o'clock in the evening, when I got into position, and eight o'clock in the morning, when we had crossed the Roer and I'd been slightly wounded. I made off to the nearest airport, took the film to London, and it was in New York the next day. It was used immediately, long before Florea's or Vandivert's film even got to London. Did I do that to spite them? No. I did it because I thought it was my duty to get my film to New York as quickly as possible.

*Let's talk about the pictures you sent.*

The engineers had got a couple of footbridges across during the night under smoke, and as soon as it got light enough to take pictures, I went across myself. A G.I. was killed just ahead of me, so I jumped over him and then turned around and took one shot of him lying there with the others still coming across.

A lot of G.I.s had gone across in the dark a half an hour before and were already up and down the banks fighting with the Germans and rounding them up. The Germans brought up tanks and were shooting at us, and we were shooting at them. They had rockets going. I'll never forget them—screaming rockets that came over in a whole salvo and scared you to death.

When we got to the opposite side of the river, the group I was with turned right, and we immediately ran into some Germans who had been overlooked in the darkness and now surrendered. There was no fighting, but one of them had a grenade. And as soon as we started to move back toward the bridge to take them over, he pulled the grenade and blew apart the G.I. in front of me. It just blew him apart and wounded all of us a little bit. I got some splinters in my leg, but nothing serious.

I pulled myself together after this guy had pulled the grenade. I looked around, and there is the bridge—it had been hit and was starting to come apart. I started photographing. There was the dead G.I.—the medics had gone out to try and get him, but the whole section started down the river. I didn't even move. I just shot, shot, shot as the picture changed. I just kept shooting and so brought to life a whole feeling of what it's like to cross a big river. One picture wouldn't have shown what I showed by taking all those little pictures. The magazine recognized what I was doing. Just instinctively they were alert enough to use it just as I'd shot it. This sort of astonished me. They might just as well have taken one picture and used it. If they had, I'd have said, "I just won't try anymore."

*Is it worth getting killed for a picture?*

Oh, no! No, absolutely no. Nothing is worth getting killed for, but we have to go back to the fact that I was 21 when the war started. It started for New Zealanders in 1939. I was at the age to be a fighter pilot or PT boat commander or something or other, and so when I got myself this appointment with the Australian Ministry of Information, I carried a little bit of a burden on my

back—my own mental burden—which was that I escaped being a combat soldier like all my pals, my friends, my schoolmates. They were all in fighter planes and PT boats and getting killed, and here was I in this privileged position of being a war correspondent, which was indeed very, very privileged, in as much as you could run away when things got tough—which I did.

I was driven by conscience. I would go up to a front, like the Roer River, very determinedly knowing I wasn't going to stay very long. I would take tremendous risks. But if I *could* get killed in the brief time I went up and exposed myself, to be there in the spearhead made me rock steady and made my brain real alert. And if the enemy started to overwhelm us—out. No point in staying. You can't take pictures when you're being overwhelmed, without getting killed.

That was my philosophy, and it made me do a lot of things that I wouldn't have done if I hadn't had those feelings. I don't blame the correspondents or the photographers who didn't go into combat. Unless they had something to drive them, they'd be nuts to go and get themselves killed, stupid to go anywhere near it.

*I have the impression that there were some glamorous correspondents: Margaret Bourke-White in her way was one, and Robert Capa was in his way another. You, on the other hand, were doing the nitty-gritty. You were doing the little actions. Is that fair?*

Exactly, exactly. You look at the record, and you see that Capa and Bourke-White only did the big ones. They were smarter than me. Bourke-White did marvelous stuff during the war. Some of her stuff is just outstanding. So, of course, was Capa's. They moved in circles that I just didn't move in. They knew the generals by their first names and would play poker with them and whatever. I felt very uncomfortable with generals and big shots, and I never succeeded until very late in the war of having good rapport with higher-ups. I don't know why. I felt when I go to wars I should go and live with the battalion or a platoon and love it. I think I only spent one night in the whole war in Paris, where most of the photographers and correspondents lived. So they never got exposed to the stuff that I exposed myself to. I felt more comfortable with the G.I.s than I did living in Paris trying to be a big shot—or *being* a big shot, not trying to be.

*What kind of reaction did you get from New York? Did you get praise? Did you get thanks?*

I just got tremendous praise for everything I did. I still have the cablegrams upstairs. You know, I was a completely unknown quantity and hired by cable out of the blue. And I immediately became a star, and this caused envy amongst the other photographers. Not Dmitri Kessel or Gjon Mili, but some of the lesser stars. They just couldn't understand it. Wilson Hicks sent me those cablegrams, and I was justifying his choice of hiring me, which had been much criticized within the magazine.

*Why was he criticized?*

For hiring someone on the basis of two pictures.

*What two pictures?*

One was of a cow, and the other photograph showed a blinded Australian.

The blinded soldier's picture was taken in December of '42, when I worked for the Ministry of Information. I was moving with the Australian troops on a perimeter around Gona in New Guinea. Suddenly on the track ahead of me I see these two figures coming toward me. There's just them and me, and I stood over to one side with my Rolleiflex focused at 10 feet. I used the open viewfinder, so that I could see everything. As they came within range I pressed the shutter. As they went on by, neither of them even looked at me. Well, the soldier obviously couldn't look at me, but the native leading him didn't either. I didn't chase after them to take another couple of pictures. That is how I work. I would never consider forcing myself on the people that are in such a situation. If I did not get the picture, then I've been stupid. I couldn't bear going and asking them to do anything.

When I got malaria and dengue fever and was flown down to Sydney to recover, I went into the Department of Information to look at my pictures and I found that this one had been censored. I could not believe it. They said it couldn't be used because you can't use pictures of soldiers in such awful condition. I was shattered. I thought, Well, what the hell am I doing? This doesn't make sense. Why am I up there risking my life to get pictures like this if they're not going to use them? While I am still in hospital, a *Time* correspondent named William Chickering, who was later killed in the Philippines, came by and said he'd heard that I had taken some wonderful pictures outside of Gona. "Where are they?" he asked.

"The Department of Information has them," I explained, "but they've censored the good ones."

"If you can get hold of copies, I won't have any trouble getting them through censorship in Brisbane," he said, intimating that he knew the right person. So I got hold of a print by getting a girl to let me into the lab and making a print at two o'clock in the morning myself. I gave it to Chickering. The next thing I knew, I got a cable from Wilson Hicks saying, "Your picture is a sensation here. Would you like to work for me?"

I cabled back collect, "Yes. Period."

*Was Wilson Hicks an influence on you?*

I was sometimes referred to as Wilson Hicks' golden-haired boy, and I probably was. Everybody said he was nuts hiring me. I know that. I've heard it from other people, so he was taking a beating, and he was always the unpopular person amongst the hierarchy of *Life* magazine. He was never, ever trusted. I don't really understand why. Obviously he was a very bright guy to gather the prime photographers, including me, from all over the world and put them on salary and tie them up. But mainly he never said anything. He'd let you say things, and he would agree or disagree, but he wasn't creative when he was talking. He'd always sort of smile. Not negative, but not very positive.

Maybe that's the way you operate when you've got 40 photographic prima

donnas all around you. But I got mad at him eventually because he hired me for peanuts, $5,000 a year, which was three times as much as I was making, so I thought it was big stuff. Then I got to New York and found he'd just hired Ed Clark for $12,500 and Dmitri Kessel for $22,000. I thought it was unfair and not very friendly. I use the word friendly because we *were* friendly. I thought this was sort of shitty. I don't mean everybody should get the same wage exactly, but I felt that my output was special. So I said to Hicks that I thought that I was being screwed, and he said, "Well, if you do well, you'll get more money."

I said, "If I do well in a year's time, will you double my salary?" And he refused to answer. I mean that's not asking much when you go out and risk your life. I didn't think it was, at any rate, but I didn't get it. He gave me a $1,000 raise when I got married in 1947, and that brought me to $9,000. But I shouldn't complain because he kept me on for four years after the war when I was at loose ends and didn't produce much that was used in the magazine. I mean, he was good to me, and yet he could have been a lot gooder if he had involved himself a little more.

*According to* Life, *at the Wessem Canal in Holland you captured a German officer.*

I didn't capture him, no. I dove into a trench, a covered trench, and he was there. He was there hiding, and he surrendered to me. I didn't capture him. I didn't have any guns. I never carried a gun. You know, you've got to be careful about these things. After all these years, you've got to be careful you're not writing a novel—or speaking a novel.

*It may have been said that he surrendered to you, and I may have used the word captured.*

Oh, well, there's a vast difference. He just decided not to frighten me probably, and he didn't know I was a correspondent or photographer, and we only just spoke briefly, and there was a pretty good war raging around us. I was scared to death by him. He was a German, and I had just dived into this place for shelter. I got out as soon as I could.

*Were you speaking to each other in German?*

No, he spoke in English. He'd been in Oxford or Cambridge or wherever it was.

*Did you ever work with reporters?*

Occasionally. I worked with Will Lang, who was in charge of the bureau in Naples. That's where the story came from that I tried to put a roll of Life Savers in my camera. We were being shelled quite heavily, and I was trying to change the film in my Rolleiflex. We were down in a hole hiding, and I was trying to put the roll in the camera by feel. I put my hand in my pocket to pull out a roll of film—it's wrapped in paper just like the candy—and he saw it, or I realized it, and I screamed with laughter. He wrote it up, and it became a story about me.

*Tell me about Churchill.*

I got word in the spring of 1945 that Churchill was coming across from

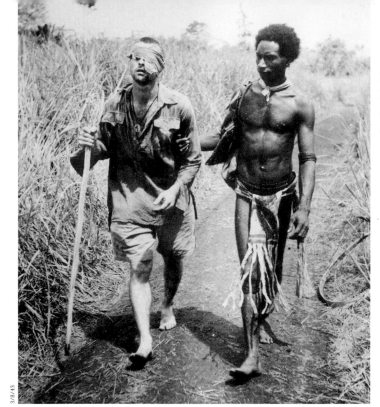

Blind soldier.
New Guinea. 1942
*If I didn't get the picture,*
*then I have been stupid.*

3/8/43

Rice dealer. Hunan, China. 1946
*I don't know whether the people in*
*the crowd put him there.*

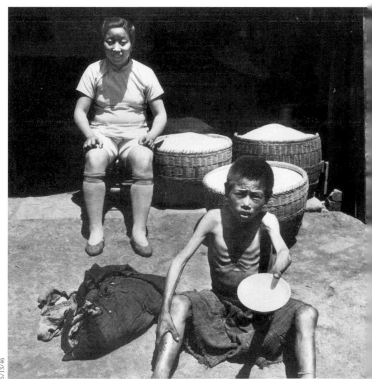

5/13/46

England to the Siegfried Line. A small press party went with him and his aides. I think there was a newspaper photographer and myself and two or three correspondents. When we got to the Siegfried Line, Churchill got out and walked away from us to the line and promptly urinated. It was a very purposeful thing. He had his back to us and his feet spread apart, and it was very obvious he was urinating. I started to raise my camera, and a major immediately threw his arms around me and his stomach into me to stop me from taking a picture. He held me there until Churchill had finished. Then Churchill turned around and walked back toward us with a sly grin on his face. I always felt that it was so sad because Churchill did this thing on purpose and the picture was so perfect from behind. It was one of the most important pictures that I didn't get—that I saw and did not get—in my life.

*After Cologne you decided to go to the Pacific?*

I'd gone to New York straight from Cologne and that encounter with Florea. I'd been recuperating there about a month when Hicks told me W. Eugene Smith had been badly wounded. They needed someone out there, and would I be interested? I said, "Sure," and went out. It was four months before the war ended, and I found that I had completely lost the drive that I had had in Europe. I was scared to death by the whole thing. I thought if I could get on an aircraft carrier, then I wouldn't have to go with the infantry. I went onto an aircraft carrier. I thought I'd fly a bombing run over Tokyo or some such place and take pictures, but I couldn't bring myself to do it. I just completely stopped. I'd had five years of war, and it's really not surprising that I just couldn't work for a while. I just couldn't do it. I just completely stopped.

I really didn't get started again until the war ended—I got General Carl ("Tooey") Spaatz to give me a B-29 to fly the length and breadth of Japan on the day of surrender. And then I had another B-29 waiting to fly the film nonstop to San Francisco, where a *Life* person was waiting to take it to New York. It made four or five pages in the end-of-the-war issue. I got a cablegram saying, "Most amazing performance. You have done it again!" and I had. It's amazing what I did. I got two planes just by asking, and I was back at work. I was back thinking again.

*Were you ready to go home?*

Frankly, after Japan surrendered, I was lost without a war, completely lost. Robert Capa said to me, "What are you going to do, George, when the war ends? All you know how to do is photograph war." He didn't mean to be mean, but it was true, and he spoke nothing but truths. He said this, and it really shocked me. It preyed on my mind. I had never worked for a newspaper. I'd never been a journalist—I'd been a farmer. I'd milked cows night and day for two years for a dollar a week.

In 1946 I went to China and got pretty lost. In Hunan province in the north, I was suddenly dumped in the middle of this town, in the middle of a terrible

famine, and people were lying in the gutters everywhere, dead or dying. We were immediately escorted into the center of town to the best restaurant and given a huge banquet, and these starving people were at the windows looking through at us. It's hard to make your senses work under those circumstances. It was very hard to be there. I felt great sympathy, and I was powerless to do anything. Immediately after lunch, I set out to walk around the town to take pictures. I was surrounded by several hundred people. We moved as a body. No matter where I went, I was surrounded, but they would leave an opening in front for me. They knew I was taking pictures, or doing something, and needed to see. Suddenly here's this plump women selling rice, and I'm taking a picture of her. Then, here comes this emaciated boy. I didn't put him there. Whether people in the crowd did, I don't know. I didn't know what they were saying. I had no interpreter with me. The picture of the rice dealer and the boy, maybe in that sense, was set up by the people themselves. It's so weird for me when I look at it, that there are only two people there, because I was surrounded by hundreds, including three nationalist soldiers who were armed and who argued about whether they should kill me or not because what I was doing was bad publicity for China. I didn't know this until our office in Shanghai discovered a piece, in Chinese, in the Shanghai paper, telling about how a U.N. woman had come along and talked them out of shooting me. She was part of our party, and in the back of the crowd. She saw them and talked to them, but she never told me. Probably she didn't want to scare me. I only learned about it three weeks later when they sent me the piece in translation. I could understand how they felt. We all try to defend our countries in speech and mind, and that's all they were doing. To them shooting someone was nothing.

The Hunan story was medium good, but that's the only thing I did in China worth a damn. Otherwise, I think it was an ultrareaction to the war. There was nothing to do, and so I did nothing, except drink and live it up, which was what everybody was doing. I regret it. I should have done more.

*Was Theodore H. White there at that time? Did you meet him?*

Teddy White and John Hersey were in and out, but I never got to know them because both of them got in trouble with Henry Luce about China, and they both either quit or were fired or it was a mutual arrangement.

*Did you have much contact with Luce at any point?*

Hardly ever, and when I did, I felt very uncomfortable. I didn't understand what he said, and I felt that he was going to jump on me, which he did a couple of times for saying things that he thought were unnecessary. I felt intimidated in his presence.

*Unnecessary?*

Well, once he was talking to a group of us in Los Angeles about world something or other, and I said, "I come from New Zealand. They are in great trouble since the war because nobody will buy their lamb and butter and things like

that. If the United States only bought a very little more, it would be enough to get New Zealand on its feet." He said, "Well, don't you read the magazine?" So I didn't try to have conversations with him. I didn't belong in that sort of conversation. Let's face it.

*Your family came from Scotland originally?*

My father's family did, but where they came from before that nobody is quite sure, but it is presumed Ireland. And it is presumed the name Silk arrived because they had some name that the Celts or the Picks didn't like, like McShit or something, and they told them to change their name or they'd cut their heads off, and so they changed it. That's the story I hear.

*What did your father do?*

He was a musician, and he rode a bicycle around the gravel roads of the North Island in New Zealand, selling musical instruments, pianos and organs to the rich farmers. He'd stay a week at each ranch that he visited and give them a recital on his violin or the piano that they'd just imported. He imported his own instruments and became very wealthy riding a bicycle around New Zealand selling pianos on time payment at huge interest. But he lost it all in the Depression. Just gone.

*How did you get interested in photography?*

My sister had a box camera and asked me to take a roll of film into a camera shop in Auckland and have it developed. I went back the next day to get it, and the gentleman that owned the shop opened the envelope and pulled out the pictures to show me, and I immediately became fascinated. I mean, these came out of that roll? They were various pictures of the family. I was really sort of amazed. I was 16.

My sister had taken pictures before, but I never took any notice. I borrowed the camera. I had a cat that I loved very much. I photographed the cat and couldn't wait to see the pictures. I rushed down and went in, and the same guy said, "Wow! You took some good pictures of your cat."

I am very affected by people who admire my work. The ego thing immediately starts working, and so I started talking to him, excitedly, I suppose, because he said, "We need someone in this shop to handle the developing and printing. Would you like to come and work for me?" This was in the middle of the Depression. You couldn't get a job.

I said, "I'd love to."

You know the old story: the first time that I actually took a negative and put it in an enlarger and made a print and saw it coming up in the soup, I couldn't believe it. It opened a whole world to me. The next thing, I was out taking pictures just every second, and I took pictures of the things that I love to do, sailboat racing and trout fishing and skiing and mountain climbing, and I became the official photographer of the local motorcycle club. I was into everything. I remember going out in a launch one day and photographing my boat with a

Rolleiflex. I put a yellow filter on and took pictures in that lovely clear air down there with big cumulus clouds. The shop said to get a big blowup and put it in the window. I remember putting an enlarger up on a table and cutting off a piece of paper from a roll and putting weights on it to hold it on the floor, and making a print five or six feet long, and swabbing it and everything, and then framing it and putting it in the window. It became sort of a famous picture that people wanted. Suddenly I was a small boy let loose, full of ideas of what I wanted to do, and I did them.

*One of the pictures that you took when you were doing all this was used in "The Family of Man" exhibition at the Museum of Modern Art in 1955.*

The one of the lumbermen. It shows how I instinctively worked with light. I left school when I was 14. I had no knowledge of the classics or how painters used light and things like that. Maybe it was already in me.

*You'd taken pictures of boats and clouds. Why wasn't it easy to take such pictures after the war?*

I think of the beautiful pictures that have been taken of the eroded hills in China. If I had gone to those wonderful hills and done an essay there, my whole life might have been different. But with the war ending and Capa saying, "You don't know anything but war photography," this all adds up.

Capa was going to start the Magnum photo agency and asked would I join him. I thought that was really a bad idea for me. I felt I'd get lost in a hurry if I left *Life* and stepped into the abyss. As it was I *was* lost, and it took a long time to come back.

*How long? When did you really come back, do you feel?*

I moved to Los Angeles and maybe that brought me back. That's where I should have gone right after the war and gone fishing and mountain climbing and skiing. I got involved in photographing sports without really knowing I was doing it. I went to the Pan American Games in Mexico City in 1955. I used a Panon camera, which is a portable panorama camera. I turned it on its side to take pictures of the pole vault. Suddenly I started to feel something. I have to admit *Life* was getting lousy pictures from the average *Life* photographer, who didn't produce interesting sports pictures, and I just easily produced an essay on the games. *Life's* sports editor, Marshall Smith, immediately said, "I want George Silk back in New York, just to do sports photography." Well, I'm not a New Yorker. I'm a Californian, a Pacifican. But it was put to me, "Come back or else." I don't think they said or else, but it was very obvious. I realized I wasn't doing anything in California. My wife Marge agreed, and we came and within a week bought this house we still live in.

But when I arrived in New York, I was really fearful. I had played cricket and rugby and didn't know anything about baseball, and the first thing they did is make me go to Yankee Stadium. I didn't know what was happening. I'd rely on the reporter—often Jack McDermott—who told me what was going on and when I should take a picture. But somehow we muddled through the Yankee

original in color 2/10/58

Skiing essay. Sun Valley, Idaho. 1958 *We put a camera on the ski.*

Halloween.
Chappaqua,
N.Y. 1960
*I looked at the
print, and I went
bananas, it was
so beautiful!*

original in color 10/31/60

Olympic trials. Palo Alto, Calif. 1960 *Just immediately everything I shot was magic.*

7/18/60

Stadium and the football stadium and the ice hockey stadium, and I decided very quickly that I hated crowds and I hated stadiums and I couldn't work with all that noise in my ears. I felt completely squashed by this noise and this crush of people. So I thought, here I am, I bought a house, I've got children, I'm married. I've got to do something because I can't go on. So I said, "Let's do a skiing story." I *know* how to ski. The managing editor said, "What's the point in doing a skiing story? They're not taking any better pictures than they were taking in 1935. They're all the same."

"I'll bring you a story that's different," I said. He shrugged, and Marshall Smith shrugged, and I went and did the story. I'd laid myself on the line to get out of sports arenas and crowds and said that I'd produce pictures that would be different. I don't know why I was always so tempted to commit suicide. I mean it's really incredible that I would open myself up so wide, because I didn't know what I was going to do when I got out there.

I skied and shot pictures for at least a week at Sun Valley. I was by myself and realized that I hadn't done a damn thing that wasn't just a cliché. Every picture I'd taken had been taken before, and they were all clichés that anybody would take. I was in trouble.

I conveyed these feelings to the bartender at midnight at the lodge in Sun Valley. He was a ski bum. I said that I was trying to take some unusual skiing pictures. Did he have any ideas? We talked for several nights at the bar while I drank and he served, and during the day I went skiing with him so we became pretty friendly. He caught on to what I was trying to do, and one night he said, "Why not dig a hole in the snow and put a camera in it, and we'll ski over it?"

"No, that's no good," but that led to what is good. "Have you tried putting a camera on a ski?"

That was said at the bar, and I said, "I don't know whether you could put a camera on a ski." A camera is heavy, but maybe you could put it right on your ankle, where there's no leverage. If you put it on the front or the back of the ski, you couldn't really ski. And he said, "Well, have you tried it?" You know, it was sort of who said what.

We decided to put a camera on the ski the next day. I didn't have motorized cameras in those days, but I always carried a bulb with a hose for doing remote shots, rather than a long cable release. I said, "We'll put the goddamn Panon on." I had used it successfully in Mexico City, doing ridiculous things with it.

*What does the Panon do?*

The moment you take it off a tripod and forget about leveling it, the pictures become magical. It's a camera that produces a negative $2\,^1/4"$ by about six inches long. The lens turns from side to side as it makes the exposure. To make sure that I got some interesting distortion and movement, I set the camera on half a second, figuring that skiing is really a relatively steady thing. If I showed some-

one skiing with me—which turned out to be the bartender—maybe the picture would be interesting. When you set the shutter for a half a second exposure, the lens rotates very, very slowly, so that each part of the film is exposed for half a second. The shutter slit moves across the film in tandem with the lens movement. It took us about three days to get one exposure off on that camera, from everything we had to do in putting the camera on the ski and then learning to ski with it. I finally decided to only ski about 20 feet and have him come up and ski by me and not try to turn. You really couldn't turn. You'd fall over and damage the camera.

Then I sent the film to Los Angeles, and it took a week for them to process it and send it back, which meant a lot of bar time for me. I had no faith that anything would come out, and finally it comes back, you know, one exposure. I took it out and held it up to the light and just said, "Yahoo! Here we are. We're going! That's it!" That gave me that whole essay.

*Wilson Hicks said that you worked best when you were taking pictures that were dangerous to get. Is that a fair description?*

I guess that was true during the war. I went to the dangerous places because I figured that's the place to take a picture. I did it out of necessity, more or less.

*Well, there you are in Sun Valley figuring out the most difficult way to take a picture.*

No, I was figuring out how to take pictures that were—that would be used in *Life* magazine, because that's where I was making my living, and they required pictures that were different. They wouldn't use clichés.

*Most of your colleagues didn't endure great difficulties to take a picture. They'd walk into a room and take a picture of someone. Why didn't you?*

I liked being a participant in things I photographed. I did best when I became—sometimes physically and sometimes in my mind—a participant. Like the America's Cup. I'd go out and crew if they were short a crew member, and this gave me an entree that nobody else had. When I'd go and be on the crew, I didn't take a camera. Obviously I am the ultimate Walter Mitty. I mean *choo-choo, choo-choo, choo-choo,* and he's driving an engine, and that got me excited. And if I was out racing or skiing or photographing the outdoors, I was living my New Zealand background, doing the things that I did when I should have been going to school. Not photographing them, doing them. I learned. My education in New Zealand really became a very important part of my sports photography. I knew what to pick and where to pick it and where not to pick it. I knew how to ski, so I didn't have to learn to ski to be able to go with the skiers. I was a sailor. I climbed mountains. I did a load of other things. I raced a motorcycle. I was a participant, not a scholar. So when I did surfing, I nearly drowned three times because I was a lousy surfer. But Wilson Hicks was right. To get the pictures I had to be part of it. Otherwise, everybody's done it.

*You photographed Mrs. Kennedy, John Kennedy's widow. Why do you cringe?*

Because it's such an awful picture. I was shot off on a moment's notice to

Washington to get a cover on Jacqueline Kennedy. She was being photographed for the first time after his death. She was being filmed by a government filming agency. I was told I'd only have a few minutes, and I was ushered in, and they had a setup with lights everywhere. And here she was sitting at a table, and I was introduced to her, and she gravely nodded her head. I was told to take the picture, and they had all the lights on, and I took the picture. I was in a movie studio, out of my depth entirely. They interrupted their filming for me, and I didn't have the balls to ask them to turn those lights off or change anything. The picture came out, but it's so harsh I'm amazed they used it. It's a terrible picture of her. The movie must have been just as bad because it was their lights. When it came out, Eliot Elisofon asked me, "How could you do that to that beautiful woman? Couldn't you at least have used a soft-focus filter or something?" Well, you know, that's not my bailiwick. As you say, I can't go into a room like the others, and I should never have. That was a real misassignment, but I was at the peak of my career and I was supposed to be able to do anything. I couldn't do everything, and that was a bad one. That hurt—that really hurt—and I realize that.

*Which* Life *photographers do you admire?*

All of them. I was enthralled by Gjon Mili's stroboscopic photography when I first joined the magazine and made him very annoyed when he asked me if I'd like one of his pictures. I'd been very complimentary. I said, "Yes, I'd like a picture of the cat." Do you remember the picture of the cat?

*Blackie.*

Black cat. And he looked aghast and said, "But that's just a picture of a cat. Don't you want the nude going down the stairs or something else?"

I said, "No, I like cats. I just love your picture of the cat." And he reluctantly—it took him about six months to make a print and give it to me. He was very, very good to me. He was in New York when I first came in 1943. He and Dmitri Kessel were both in New York, and they really looked after me and entertained me and fed me and talked photography to me endlessly, endlessly, endlessly, endlessly, and they were obviously fascinated by me, and I was just absolutely fascinated by them.

You asked me what *Life* photographers I admired, and I've only mentioned Dmitri Kessel and Mili. They made a very big impression on me and slowed me down and made me—I was a much more sophisticated person after spending six weeks with them than I had been, no question. They didn't set out to do anything. We just liked each other. But the person that probably had the biggest effect on me was Carl Mydans, because in 1940 I saw his pictures in *Life* magazine of the Finnish war. The soldiers were dressed in white in the snow. Remember them? That brought me to life. That made me realize that what I was trying to do was all possible. You know I was standing there waiting for the big bang. Most photographers did during the war.

*What's the big bang?*

A bridge blowing up or something, and Carl's pictures showed me that the way to photograph the war was the little things, not the big bang. If I'd waited for the big bang I'd have gotten nothing. That story on the Finns fighting the Russians made me realize that I had been just taking pictures, you know, disjointed pictures. So Carl had a very, very important influence.

My good stories are always done with people that I get on with. I never, ever do good work with people I don't like or can't get on with. I freeze. I was never a reporter in the sense that a reporter goes out and digs, digs, digs. I had to feel great sympathy. I went to Quebec, where a whole village had burned down, and I just felt so much for those people that I produced really stunning pictures that you would not have produced if you hadn't really felt deeply. In a way they were fairly ordinary pictures, but they came to be much more than that in my mind and in other people's minds. My wife remembers those pictures more than any other pictures I've taken. She remembers the pictures I took in the little Quebec village that burned down. What she remembers is emotion, sympathy, friendship.

*Let's change the subject and talk about the "strip camera" for a minute. You started using it when you did a story on quarter horses.*

When I was in California, we went out to do a story on the quarter horse. They had a race for the foals of the horses, and what they did was put the mares on one end of the track and let the babies go at the other end. And I thought, "This is not a film. This ain't going to work in a still picture. It's just too dull." I could never be really clear who planted the seed or how it happened, but one of us said, "Get the photo-finish guy to take a picture of them finishing."

The guy said, "Sure," and he handed us the negative. I looked at it and said, "Great," and put it in my pocket and photographed some other things. I took it back to the office and got a print of it, and looked at the print, and I went bananas, it was so beautiful! I showed it to a couple of other people in the office, and they said, "Forget it. You're not going to send that to New York," which was very typical of what a lot of people say about my work. It shocks them. It's too early, too quick for them. I'm there too fast. So we sent it to New York, and they immediately used it, and that started off the business of using the photo-finish camera. I forgot about it really until I went to the Kentucky Derby the next year. Then I thought, "Well, you know, how about a photo-finish shot in color of the Kentucky Derby?" So Jack McDermott arranged with the people at the Kentucky Derby. After the race, I went with Jack to get the film and to look at the camera. I'd already looked at the one in California, and this was the same sort of thing. It was in a steel case and weighed 125 pounds, and you had to plug it in to 110 current. And I said, "I'd like to play around with this camera. How do I get hold of one?"

They said, "We've got some spares. We can lend you one." So I gave them *Life's* address, and sure enough they shipped one just like it without any paper-

4/24/64

Richard Burton. 1964
*Then he says, "Let's do what
the Kiwi wants."*

Logger. New Zealand.
*I instinctively worked with light.*

original in color 5/29/64

Mrs. John F. Kennedy.
Washington. 1964
*That was a bad one.*

work or anything. I brought it home and took black-and-white pictures of my kids running up and down the street and in the driveway, and developed them in the garage under a blanket in a saucepan. Immediately when I saw the negatives, I said, "My God! It's Halloween!" It wasn't Halloween, it was just kids, but they already look like Halloween figures. So I had to figure out how to use this camera. I could use it in my driveway, but that was very limiting. I went to Marty Forscher, who repairs cameras, and asked if he could make it portable.

He said, "I think I can do something with a gramophone motor." When he finished, it had a sling that went around my neck so I could carry it, and on the bottom there was a little tripod, the smallest you can buy, so I could rest it. Just immediately everything I shot was magic.

*How does the camera work?*

The film moves quickly past a narrow open slit that you can adjust from two- to six-thousandths of an inch wide, depending on how fast the subject that you're photographing goes past the camera. Marty made this shutter out of two razor blades. You load with 100-foot rolls of 35-millimeter film.

I went over to Philip Kunhardt's house to work with his children, because I'd worked with mine and I needed a little inspiration. I just went over and said, "O.K., Phil, do something." He threw one kid in front of the camera, and that became a cover. It's really funny. Kunhardt is just so goddamn brilliant and instantaneously brilliant and easy. As a reporter and editor, he was a very important part of my success in the middle part of my photographic life.

Later I used it at the Olympic trials in Palo Alto, and it gave a whole new view to track and field events.

*Do you think photography is an art?*

No, I think it's fun.

*Are you willing to pose pictures?*

Oh, sure, if it's called for, yes. I've posed pictures. I did some great pictures of Richard Burton doing *Hamlet*. I'd only done one theater photo call in my life before. They are intimidating. You've got all these tired people after a performance. Burton said, "What do you want?"

"I'd like you to act out three or four scenes for me," I said. He just stood there. "No—act it out," I said.

"What do you mean? You're taking stills, aren't you?" he said.

I said, "Yep."

And he said, "You goddamn New Zealanders. We can't beat you at rugby, and we can't beat you on the photo call." Then he says, "Let's do what the Kiwi wants." By then, you know, we're like that, and I just went all over him as he did his fencing and stuff. The pictures were great, and he got the word back to me that they were the best pictures he had ever had taken of him. *Life* used one on the cover and five or six pages of him inside the magazine. Why am I telling you this? Because you asked if I posed. There's the answer.

*It's a good answer. It's terrific. I'm happy. Is there anything else you want to say?*

Well, I was asked by the editor of a magazine, "Why do you take all these pictures for *Life* magazine?" He was trying to get me to be a W. Eugene Smith or to make a statement that art is art and farty warty, you know. He was trying to get me to say something, and I said (we'd had one martini already), "It's a hell of an easy way to make a good living."

He slammed his glass down on the table and got up and grabbed his hat and left. But I still stand by that statement. I can't imagine a more delightful way to make a living than to work for *Life* magazine through its prime years, to get reasonably well paid and to be visited by people like John Loengard and the crew he brings along, and that lovely lady who I've insulted twice already. It's just a hell of a nice way to make a living. A little tough at times, but they didn't pay me enough, and they should be paying me for this, because it's my life they're just bleeding away. And if this goes commercial, I demand a share of it. Thank you, Mr. Loengard.

*We'll pick up our hats and leave.*

That little girl is laughing.

On the *Life* staff 1943-72
Interviewed in Westport, Connecticut, on May 21, 1993

I saw a Navy chief petty officer
playing with tears streaming down his face.
I thought to myself,
"My God, what a picture"

Mourning F.D.R. Warm Springs, Ga. 1945

# EDWARD CLARK

**E**DWARD CLARK: In Nashville, Tennessee, my friend Campbell Bligh and I liked to go downtown on Saturday night all dressed up with our straw hats and ties and suits and two-toned shoes to watch the passing scene. We were trying to figure out what to do with our lives after high school to make money. We couldn't go to college. Our parents couldn't afford it. One night, a car, a Studebaker coupé, came by. In those days they had a spare tire in the fender well. The canvas cover over the spare said, "C.J. Burnell, Staff Photographer, the Nashville *Tennessean.*"

I said, "Boy, look at him!" We didn't know a thing about photography. We'd never thought about it before. Suddenly it struck us that we'd like to be photographers on the *Tennessean.* Campbell's mother ran a big boardinghouse. Who should show up one night to rent a room but C.J. Burnell. Campbell dropped out of school and started running around with Burnell to learn something about photography. He learned quickly and became his assistant. One day, after Campbell learned to be a photographer, he called me up and said, "Get in here real quick. Maybe you've got a job. Burnell's got drunk one time too many, so they fired him."

So I went down to see the city editor, and I lied to him and said, "I'm a photographer."

He said, "You can start tomorrow morning." They weren't risking very much because the salary was $40 a month. You worked for the morning paper, the afternoon paper and the Sunday paper, and you were on call 24 hours a day. Burnell took his cameras with him when he got fired. The only camera that the *Tennessean* had was an old 8x10 inch view camera, and that was what I used.

I heard about *Life* before it began publishing. I did a story for the first issue,

but it never ran. It was a boar hunt. "Ideally," they telegraphed, "what we want is a shot over a hunter's shoulder as he shoots a charging boar." Well, to get all those elements in one shot is impossible, I think. Anyway, *Life* always asked for the impossible when they could, and often they got it. But they didn't in this case because I never saw a boar on the hoof in the three days I was up there in the woods. I did nothing more for *Life* for six years.

In 1942 the newspaper's city editor assigned me to cover ex-Sergeant Alvin York signing up for the old man's draft in Pall Mall, Tennessee. York was a Tennessee mountain man to the core. He had captured 120 Germans single-handed in World War I and been awarded the Medal of Honor. Going up there, I got lost, and when I arrived, the wire services had already photographed him as he registered at the country store.

I went to York's house and asked him if he'd come back. He did, and a man came by on a horse. I said, "Wait a minute. Tie your horse up there." These real mountain characters started coming by, and I just put them here and there on the porch of the store and finally filled up the picture. York is standing in the doorway. He's the only one that's got a necktie on. That's the only thing that distinguishes York from everybody else. They were all talking to each other or just sitting there. Everything fitted together perfectly. I wouldn't change one thing about it. I sent a copy to *Life,* and Wilson Hicks, *Life's* picture editor, sent me a wire that said, "Congratulations. The York picture made a double truck in next week's issue." I didn't know what a double truck was.

*John Loengard: What is it?*

Two full pages. But I didn't know that kind of language. I got $100 for it. Then Hicks wrote and said, "I'd like you to spend your vacation up here in New York and do some stories."

I had never been on a Pullman car before in my life. Oh, it was great—a 24-hour ride from Nashville to New York. I did five stories, and three of them ran in the magazine. I thought I was a miserable failure because they didn't all run. I learned later that *Life* did about 10 stories for about every one that got in the magazine. So Wilson Hicks was impressed. By this time I was making $50 a week at the *Tennessean,* and Wilson Hicks offered me $1,000 a month. I said, "I'll work for you in Tennessee and go wherever you want me to go. I have two small boys. I don't want to bring them up in Manhattan."

He said, "We don't have a single employee in the whole state of Tennessee, and we're not going to start now." But Hicks gave me a contract and kept sending me assignments, and I kept getting in the magazine, and finally he said, "O.K., Ed, you win. You can live in Nashville."

In 1943 I went up to the Quebec Conference with President Franklin Roosevelt and Prime Minister Winston Churchill. You had to put your camera on the ground or floor until they got Roosevelt seated. The polio had left him

terribly crippled. He had little locks at his knee level, and they'd lock those locks and he could stand up. Or unlock them and he could sit down. That was the way it was, and nobody tried to steal a picture.

Recently, the picture I took when Roosevelt died has won all sorts of acclaim. Not any awards, but acclaim. Nobody paid much attention to it in 1945. I was in Nashville, and *Life* called me and said, "Get to Warm Springs, Georgia, any way you can." Airplanes were out of the question because it was wartime and I didn't have priority. They could throw me off at any stop they made. So I just got in my car and drove all night to Warm Springs. There must have been 135 photographers there from everywhere. The Secret Service lined us all up behind a barrier in front of a small house they called the little White House so we could photograph the caisson as it came by with Roosevelt's casket on it. A lot of people were on the porch of this cottage, and several of them were crying. I heard this accordion start to play behind me, and I turned around, and I saw a Navy chief petty officer, Graham Jackson, playing with tears streaming down his face. I thought to myself, "My God, what a picture." As the caisson was coming, I took three or four pictures just as fast as I could. No one paid any attention to me. My picture was exclusive. I was the only one who saw it.

Life *reprinted the picture more than 25 years later, and it started getting attention then. Had it been sort of forgotten?*

It was just one of those things that didn't get very much attention at the time. In fact, whoever wrote the credits in *Life* in 1945 credited that picture to George Skadding, another staff photographer. Which made me feel pretty bad, but they very seldom made a mistake like that. Someone just assumed that Skadding had done the picture because he was stationed in Washington, had White House credentials and was with Roosevelt a lot of the time. Wilson Hicks wrote me a letter and sent me a $500 bonus. He said, "Maybe that'll cheer you up."

*After Roosevelt's death, did you immediately go to Europe?*

Pretty soon. I'd never been anywhere. I didn't know where France was, let alone Paris. I was there for a year. Paris was so beautiful that I just started photographing for myself. One day, near the end of that year, I had a bunch of pictures laid out on a table, and Percy Knauth, the bureau chief, came through and said, "You've got a different point of view. This is a good story. I'll let them know you're doing it, and they'll start hollering for the pictures, but don't send them. Keep them until you go back home. It's better to go back with something in hand than to have something that's already been published."

I never shot Paris when the sun was out. It was always on gloomy days. I must have made 600 pictures. When I got back, I'll never forget. Hicks wore half glasses down over his nose, and he's looking through the pictures. Once in a while he'd look up and smile. When he got through, he said, "This is a hell of a set of pictures. Would you like to help to lay it out?" I never thought of being asked anything like that. So I helped. It ran for a cover and nine pages.

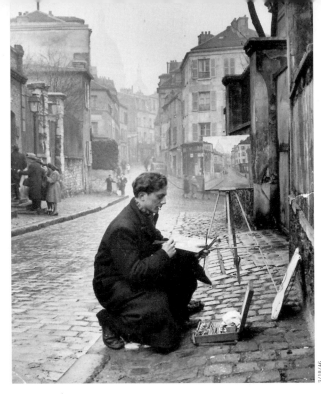

Montmartre. 1946
*I didn't know where France was,
let alone Paris. It was so beautiful
that I just started photographing.*

3/18/46

Segregated school. West Memphis, Ark. 1949  *That's what* Life *was all about—telling a story.*

3/21/49

*Which was your favorite picture?*

My favorite is the artist in Montmartre with Sacre Coeur in the background. That's everybody's favorite.

In 1949, after I got back, *Life* sent me to West Memphis, Arkansas, where the owner of a weekly newspaper was outraged about the fact that the school board had built a new school for the white children. The white children had extra classrooms. The girls had cook stalls, and the boys had woodworking material. The colored boys and girls went to school in a one-room church and had no running water and no toilets inside. I never have seen that many kids packed in one room. It was wintertime. They had an old coal stove. Three or four little girls would sit together and look at one book. I took pictures of degradation like I'd never seen before. It told a story of its own, but the comparison told a much broader story.

I photographed gleaming white fountains and white girls drinking out of them, and then I went back to the Negro school and got a little boy drinking out of a spigot outside the schoolroom. We ran those two pictures side by side. I thought they were a very dramatic comparison. They told a story, and that's what *Life* was all about—telling a story.

I couldn't believe anybody would be that unfeeling toward anybody else in the human race. The school board finally voted the money to build a school for the colored children. I went back for the dedication. The principal said, "The school ought to be called the Ed Clark School because he's responsible for us getting it."

*Did you meet Henry Luce at all?*

I had lunch with him one time in 1948. I had covered Thomas Dewey's campaign when he ran for President in 1944. Mr. Luce said, "I like what you did with Dewey's first campaign. It looks like he's going to run again. I want you to make him look human." Dewey had the reputation of being the little man on the wedding cake, because he was so stiff and formal all the time.

I said, "Do you have any suggestions?"

"No. That's your job," he said.

The campaign train got out to Yellowstone Park, and Jim Haggerty, his press secretary, came by my compartment. I said, "Jim, I've got to make Dewey look relaxed. What can we do?"

Haggerty said, "Well, maybe we can get a picture of him fishing." We arranged for a boat. When Dewey came down to the hotel lobby, he had on a necktie and a jacket. I said, "Governor, you don't want me to photograph you in that." I said, "Please put on a sport shirt."

He said, "I don't have one."

We got one from Haggerty, and that's about as relaxed as ever I got the candidate. But he liked me, and I liked him. He had one rule. He smoked cigarettes in a holder like Franklin D. Roosevelt's, but he never let photographers photograph him smoking. Everybody thought that Dewey was going to win. I had

made a picture of him on a ferry, and *Life* had run the picture with a caption: "The next President of the United States crossing the San Francisco Bay." Jim Haggerty was so sure of it that he bought a house in Washington before the election. I voted for Dewey. I liked him. I thought he'd make a good President.

I also photographed Nixon's famous "Checkers speech" in Los Angeles, in which he referred to his little dog Checkers and his wife's Republican cloth coat. After the speech, there was still some question about whether Eisenhower was going to keep Nixon on the ticket or not. They said, "Come to Wheeling, West Virginia, to meet Eisenhower." The flight, on a DC-6, took forever. Just before we landed, Nixon's press secretary got on the intercom and said, "When we land, they'll wheel steps up to the plane, but don't anybody get off until we find out where Eisenhower is."

I was the only photographer on the plane, so I thought, "That's all right for the writing press, but I'm going to get off as soon as we land to see what's going on." At the airport, the newsreel lights were blinding, and just as I started looking around, I saw Eisenhower getting on the other end of the plane. I ran back, but the police wouldn't let me pass. "I just got off that plane," I said.

"It don't make any difference. You're not going to get on it now," they told me.

The next day I got a telegram from *Life* asking, "Did you get Eisenhower and Nixon together when Eisenhower got on the plane?" I was ready to jump out of the plane window, I was so disgusted.

Just then, somebody sat down beside me, and I looked around. It was Nixon. "Ed, where were you last night?" he asked.

They had met right across the aisle from where I'd been sitting all day. Ike put his arm on Nixon's shoulder and said, "Nixon, you're my boy." I missed it.

After Eisenhower was elected, I used Mathew Brady's own camera to photograph Eisenhower in the Rose Garden. I said, "Mr. President, you'll have to be very still for nine seconds while I make a time exposure."

"All right, Ed," he said. Actually, I figured I needed a six-second exposure and put the holder back over the plate.

"Ed, that wasn't nine seconds. That was six seconds," Eisenhower said. "I'm an old artillery man, and I know."

*Did you get to know Eisenhower fairly well?*

Eisenhower was a very austere man. You didn't get cozy with Eisenhower— ever, ever. I got along very well with Mamie Eisenhower though. She let me photograph at some official dinners. She had three rules: I'd have to dress in white tie and tails. I can't make a picture of Ike with a drink in his hand. I can't use a tripod or a flash. Because there was just candlelight in the White House, I had to back up against the wall and hold real still. Well, another rule was, "I want to okay every picture that you make." She never objected to any of them.

I liked Jackie Kennedy. Before John Kennedy ran for President, *Life* told me to spend a couple of weeks with him to see what he was like. I'd go everywhere

he'd let me go and photograph him. One day he said, "Jackie has invited us up to the N Street house to have lunch. It'll give you an opportunity to get some pictures of us together that you've been hollering for." We had lunch, and I made some pictures of them. I was getting ready to leave, and he said, "Wait a minute. You haven't seen Caroline."

Jackie said, "No, no, she's asleep. You can't bother her."

"Come on, Ed," Kennedy said.

We went up to the third floor with Jackie right behind us saying, "No, no, no. You mustn't wake her." We walked in and, sure enough, she was still asleep. Kennedy went over and kneeled down beside her crib, and Caroline raised her head up for just a second, and that was the picture. By this time, Jackie was pretty annoyed, but when the picture came out with Caroline looking at her father from the bassinet, Jackie wrote me a four-page letter apologizing and saying, please would I send her 75 prints. So we did.

*Which of the people who ran for President did you like the best?*

Wendell Willkie. I covered Willkie's campaign in 1940, and I liked him a lot. He was so accessible. I guess that's the reason I liked him. No matter what you wanted to do, he was all for it. You could stand on his shoes almost and shoot him—he didn't care. And I liked Strom Thurmond. He was 52 years old and the Governor of South Carolina. He'd never been married. One day he fell in love with his secretary, who was about 22 years old. He called her into his office to take a letter, and the letter was a proposal of marriage. She took it down straight-faced and went back and wrote him an answer, accepting him. It made news all over the United States, if not the world, that this old Governor was marrying this young girl. So *Life* sent me down to cover the wedding. I went down there, and we became good friends right away. For example, I went with Jean to pick out her silver pattern. One day we were out in the backyard of the Governor's mansion, and it was hot summertime, and the Governor said, "Ed, aren't you thirsty?"

"Yes I am, Governor," I said. I thought he's going to invite me in for a mint julep, to say the least.

So he said, "Let's go into the dining room and get something cool to drink." So we walked to that dining room, and the Governor said, "What are you going to have, Ed?"

"I don't know. What are you going to have, Governor?" I said.

He said, "I'm going to have a glass of buttermilk."

I said, "Buttermilk? I'll have a glass too." So I hit him on the shoulder. I said, "You must be in pretty good shape if that's as strong as you ever drink."

"I can stand on my head. I'll put on a pair of shorts and show you," he said. So he went upstairs and put on a pair of shorts and came down.

His press secretary could see what was happening and said, "Governor, I wouldn't do that if I were you."

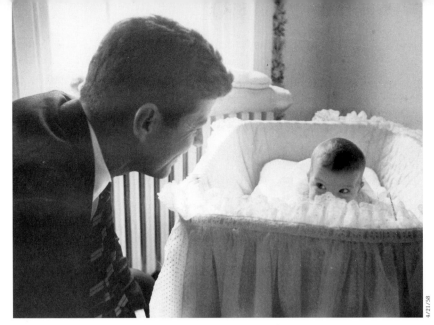

4/21/58

John Kennedy and daughter. 1958 *Wait a minute. You haven't seen Caroline.*

11/17/47

Governor J. Strom Thurmond. Columbia, S.C. 1947. *Ed, aren't you thirsty?*

"Oh, it's all right," Thurmond said. "Ed's here to cover the wedding. This will just be a little picture." Of course, it was the biggest picture we used.

His opponent the next year took that picture and had it blown up as big as a door, and took it all over South Carolina and said, "This undignified man is running this fine state of South Carolina. You want him to be the Governor?" And defeated him. He came back, of course. He's still in the Senate.

*What photographers did you admire?*

I just thought Cartier-Bresson was wonderful. And George Silk and Mark Kauffman and Hank Walker and Loomis Dean all had something. But what threw me was that I was going to be on the same staff with Alfred Eisenstaedt and Margaret Bourke-White and Carl Mydans and people like that.

In 1959 *Life* decided to bring all the staff photographers together in New York for what turned out to be a five-day drunk. A lot of us had never met. There was a group picture taken. Everybody wore suits. You don't see hardly any photographer now that doesn't have a bush jacket or something like that or blue jeans on. But in those days we all wore neckties and suits, and if we got them dirty, we just got them dirty. That's all there was to it.

*Why did you leave* Life?

In 1961 they cut the staff by a third. Thirteen of us were severed at the same time.

*Do you feel that was fair?*

It was eminently fair in my case because I was losing my eyesight in one eye and about to lose it in the other eye. They didn't know that, but I had cataracts, and it was several years before I finally did get them corrected. Meantime, I'd become a builder. I was building houses and apartment houses in Washington very successfully. When I got my eyes fixed, I wanted to be a photographer again, but I couldn't work for *Life* anymore. *Life* had changed so much as a monthly, it was a completely different magazine.

On the *Life* staff 1944-61
Interviewed in Miami on November 3, 1993

One car, with about 50 guys on it, came
down the street. I felt like Ginger Rogers—
I was running backwards on heels

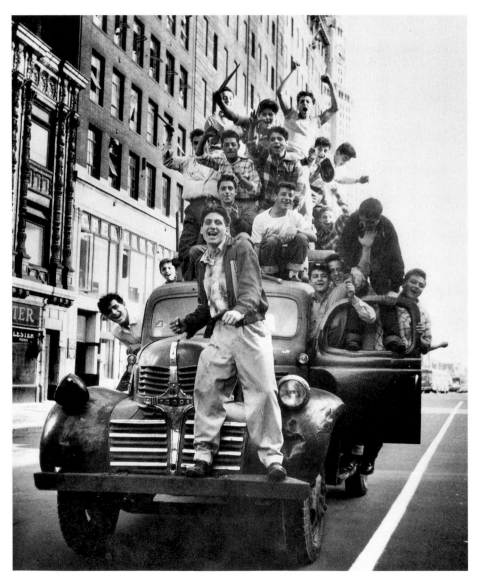

Dodger fans after World Series win. Brooklyn. 1955

# MARTHA HOLMES

**M**ARTHA HOLMES: Marie Hansen was the third *Life* female photographer, after Margaret Bourke-White and Hansel Mieth, and I was the fourth. Wallace Kirkland, who was on the staff, came down to Louisville to photograph the beautiful daughter of the Governor of Kentucky. He came to the *Courier-Journal* darkroom, where I was working, and we got to talking. A while later, an editor in *Life's* Chicago office called and said, "Would you do some jobs for me?" I did them on my days off. There was a houseboat party and a political thing where I got the man in his bathroom shaving, and they thought, "That's great!" Actually, that was very easy. Actors and politicians are wonderful. So they called one day and said, "Would you like to come up to New York?" I really was quite young and scared, and not even all that eager, but my boss, Billy Davis, kept punching me saying, "Go! Go! Go! If you don't like it, come back. Go!" So I went. I went to New York. Then Hollywood. Then Washington. Then back to New York. It was great. *Life* was great. The old *Life*. Well, the new *Life* is marvelous too.

*John Loengard: What made it great?*

Well, it was like a family. In fact, when *Life* died, I felt the same way as when my father died—I'm so emotional . . . Edward K. Thompson, the boss. I called him by his first name, Ed. I thought, well, I'd arrived now. Who else? Of course, Gjon Mili was around. David Duncan, Carl Mydans. They are still around. It was wonderful. They'd get the new phone book, and they'd have a party for it. It was great. I wasn't married, so I didn't have any obligations at home. Now I have two girls, grown. I kept working past when my first daughter was born. I worked into my eighth month on both children. The first one was labor and then

a cesarean, so I was out for a little while. In fact, I missed Elvis Presley because of it. My second child was 15 months later, and she was a cesarean too, so I took a little time off after. But I kept working. I was very lucky to have live-in help. You have to . . . I don't know how some of these women do it. In fact, Gloria Steinem doesn't know how they do it, either. She said it can't be done without great help.

After my second daughter came—we were in the country, and they called and said we need you to go to someplace out of town. I was alone—I mean my husband and I and the kids were alone. I had to call mommy-in-law and ask her please to come up, and she was very good, and did. But that was just too much.

*Did you work with reporters?*

That was what was fun because *Life* considered the photographer the boss. I couldn't handle that too well, but what we said went.

*Did you feel that you weren't asking the people to do enough?*

Yes, and in fact I went to a psychoanalyst to get to the point where I would feel strong enough to say, "I would like you to pose for a couple more minutes." Generally people were wonderful, but if they bucked me, I had a hard time. After three years I could very politely keep them posing.

*Isn't it hard to find a balance between drawing a person out and ordering them around?*

Well, I think it's the end result that matters, and that's what I had to learn. I don't think I've ever been rude, but I've certainly pushed. I've found lately, and it may be because people are seeing a lot of television and plays, that they want direction. They want to be told what to do. Move your shoulder in, or lean out this way, or something like that. If they know you're on their side—and I am—that helps.

*There was a feeling that* Life *magazine was about candid photography. How does direction mix with that?*

I love candid, love candid. Because then I don't have to tell them what to do.

*The diffidence that you overcame, the shyness—do you think that was because you are a woman, or is it just your nature?*

I was just raised that way. I didn't want to push or ask. I'd rather give than take. I know this sounds Pollyanna-ish, but it's true. But I am grateful to my brother, who taught me how to throw a ball, how to hit a ball, how to run, climb a tree, all that. So I have great strength. I'm agile when it comes to climbing a ladder or stepping on a chair. Once I jumped over a fence when ex-President Eisenhower was giving something to a horse. I knew it was wrong, because he was surrounded by Secret Service, but I had to get the picture. I went over, and they really jumped. One of them came over to me later and said, "Don't ever do that again." But I got that shot. I never hesitate about movement. That's why I wear slacks. I used to work Sundays on the *Courier-Journal* because the other photographers were married and had children and they wanted to be home. I

came from church with my frilly little dress—you very seldom had to shoot Sunday, but you had to be there—and there was a fire. It was on the roof in the back of a two-story building downtown, and the fire ladder was up. I had to devise something, so I started wearing culottes. I don't want to be conscious of *me* when I'm shooting. I want all my attention to go to the subject and the lighting and the angle and the decisive moment. Now I wear slacks because it's a very free fashion world. I can do anything.

Also, because of an experience at a party at the Hippopotamus, a very dark discothèque. I had my bag on my hip. They had invited all the stars who had been in the magazine that year, and one of them was the wonderful German actor named Curt Jurgens. I was walking around trying to see where I was, and all of a sudden I heard this *"Ach du lieber Gott!"* or something like that. I don't know how to say it. I had turned around, and a cold beer had been hit by my bag and went right down his front. I immediately grabbed a napkin, and then I thought, *Mmmm.* And I handed it to his very good-looking blonde friend. She dusted him off, but he was very sweet about it. It was just the shock. So now I have an outfit with big patch pockets. I look like a pregnant kangaroo, but I can hold my 180-millimeter lens and my film and my lipstick and my comb and everything. If you wear a tight belt, it's not bad looking. It doesn't weigh you down like a heavy jacket does.

*What do you think is your most American photograph?*

Billy Eckstine. It was before the civil rights movement really got going. I got a picture of a bunch of adoring fans with him. Billy, bless his heart, was a very handsome man, with a very sweet smile. I was so thrilled. But, you know, one of the women editors here took the picture up to Mr. Luce and said, "You can't run this," because the fans were touching Eckstine and he was holding them, which was marvelous. They were white, and he black. American. African American.

And Mr. Luce looked at it, and he said, "Run it." I'm very proud of that.

*You spent some time with Billy Eckstine?*

A week or two. The main picture was taken in a nightclub. I was so lucky because there was a mirror very close to us. I don't like direct light, so I was bouncing my light, and the mirror made it look like a second light. They had assigned me to photograph Billy's sexy voice. Well, that's hard in a still, black-and-white, silent picture. But it was really his mouth. So I got low, and he was quite a singer. With bounce light the light goes to the ceiling or the wall or someplace, and it comes back down on the face, and you get the nice cheekbones. Now, the photographers all do it, I think, but I learned it from Nina Leen.

*How did you feel? There were four women on staff and lots of men. Did you feel like an odd duck, being a woman?*

I felt fine. You see, I had my daddy until I left home. I had my brother. I

Billy Eckstine. New York City.
*Mr. Luce looked at it, and he said, "Run it."*

John L. Lewis. Washington.
*When he came back, the eyebrows were combed up.*

Danny Kaye, June Havoc, Humphrey Bogart and Lauren Bacall. Washington.
*My reporter screamed at me, "No! No!"*

played with boys all the time. I just felt very comfortable with men of any age.

*Did your father have any objections to a daughter going off and being a photographer?*

He was very supportive. In fact, he helped me get my first camera. He was a very proud daddy. He was a bass singer in the church, and he had a law degree but didn't practice. He worked in the Kentucky Tax Research Association. He tried to bring businesses into Louisville. He was a businessman, and he was a good golfer. My mother graduated from Northwestern University, and she taught speech and directed plays, mostly at Catholic schools.

*If you were in Lou-ey-ville today . . .*

Lou-i-ville, honey, Lou-i-ville . . .

*Thank you. If you were someplace in Kentucky now, do you think you'd still become a photographer?*

Oh, yes. I've been in it all my life, and it keeps me trim. I still have the strong muscles. And the blouse with the three pockets. So I'm set.

*Alfred Eisenstaedt says he always comes as a friend. How do you feel?*

My inclination—and it may be Southern, or it may be mommy, or it may be female—I don't know—but a person has to prove to me that they're not nice. I just look at them as pretty wonderful. And if they prove to be naughty, why then I might back off, but I come in liking them and wanting to do right. Maybe that shows. I don't know.

*Have you ever met anyone who proved naughty?*

Bing Crosby was naughty. He would time his eye blinks. Maybe he had bad eyes, but every time you'd flash, he'd go . . .

*What* Life *photographer did you admire?*

Harry Benson has a way of starting out with nothing and making it look absolutely natural and wonderful, and I admired that. Gjon Mili, of course, was magnificent. Oh, he was so nice, and again—this hesitancy on my part. He kept saying, "Come see me. I'll help you." And I never did, except toward the end, when he was ill.

I had photographed an actor with a puppet, and I came to him and said, "I used my Gjon Mili lighting." I thought it was fine.

He looked at it and said, "Where's your third light?" And I looked down, and he was right. Absolutely right. There should have been another light there. Eisenstaedt is very kind. He tries to make you look as best he can. You always look good with him.

*You photographed Jackson Pollock.*

Yes, in the Hamptons somewhere. He had a garage, and these marvelous big canvases on the floor. And I had him do his thing. Beautiful. I'd love to have one. It was very new at the time, but so free. See, I'm not that free. I'm very practical, very realistic, very reportage. Harry Benson can *create* it. Oh, I can create it, but he really knows how.

I do a lot of heads. I pose them because I want to get the right angle. If a man has not much hair, I use a snoot to shadow the top. If he's got glasses, I

use my inky-dink little light and go down like this and light under here. A lot of tricks.

Most people don't know, but I will look at them and in a second you can tell that they should be shot from the left or the right because the eyes are wrong. Liza Minnelli will not let you shoot her anywhere but one side. And she's right.

*When you say the eyes are wrong, what do you mean?*

Well, they're not level. Very few people have level eyes. I think Greta Garbo did, and Anita Hill. So if it's high in the head, you want to—Which is it?—you want to go on that side. I think that's it. The higher side. From that angle, they look level.

*Do you come in very close?*

A little too close, I guess, because I like my 180-millimeter lens. It doesn't distort the nose. John L. Lewis, the head of the United Mine Workers union, was fun. They weren't using big lenses too much at the time. We were down in the Senate Office Building, sitting on the floor under the Senators, and they were putting questions to Mr. Lewis. He would listen to the question, and then he'd move forward to the mike, and that meant a lot of movement for me. He had beautiful blue eyes and big eyebrows. I remember we had a break, and when he came back, they were combed up. A wonderful look.

*In Washington did you spend a lot of time covering hearings?*

Yes, and I learned a good lesson there. They were contesting the First Amendment, and a lot of Hollywood stars had come. I wandered back to the audience because I like fringe stuff, and I remember my reporter screamed at me, "No! No!" because they were throwing Bertolt Brecht or somebody off the stand because he wasn't testifying. I thought, there are 50 photographers shooting that moment. I went back in the back, and I got Humphrey Bogart and Lauren Bacall leaning out like that, listening. That's what *Life* ran, of course. That was the beginning of my fringe shooting, or whatever you want to call it. Edge shooting. I mean, I didn't start it. It's the audience reaction.

I was sent to do the first day of a World Series between the Cincinnati Reds and Baltimore Orioles. It was a Saturday, and the pictures I did would have to hold over for a week. Johnny Bench was the only bachelor on the Cincinnati Reds, and he ate sunflower seeds, so I had him bite the seed and spit the shell out like a kiss. Big head. I was over on the first-base dugout, and while I was shooting Johnny, a ball trickled over to me, and I looked up and it was Jim Palmer warming up. So I picked it up and tossed it to him, and then I was shooting some more and pretty soon the ball was there again. And Palmer said, "Let me see that arm again." I had fun. I got a picture of the seventh-inning stretch, where they have the vacuum go around home plate and pick up all the seeds. The stringer in Cincinnati lost the film. *Mmm-nnnn!* However, that was another fringe take.

*How do you know when you have a good picture?*

Well, the one thing *Life* always taught us. They'd say, "Film is cheap. Use it. Shoot, shoot, shoot." Because you start working on something, and pretty soon something else happens, and there it is. Also, you have a preconceived notion of what you are trying to get—I want this and that person together, or I want this or that reaction. You're looking for it.

I asked Arthur Penn one time how he directs his plays, and he said, "Well, I have in mind what I want it to be." I think you know.

*Life often had scripts written before a photographer was assigned. Did you follow scripts?*

I tried to. You do the best you can, but if it doesn't happen, don't do it. One time, *Life* sent me to a playground over in New Jersey to get pictures of lost children. They had a very good setup, and there was this cute little boy lost and crying, and right behind him was a Ferris wheel. I thought, "Aha!" and started shooting. It turned out that the park public relations person had suggested to the mother that she lose her child for a minute. *Life* said, "It's a setup. Go back and do it again." I found a real kid, although that first one was so cute. *Life* wanted the real thing. They didn't want it set up.

Of course, the picture I took right after the Brooklyn Dodgers won the World Series—it was just one car with about 50 guys on it, coming down the street right after the game. I saw them, and I went running. I felt like Ginger Rogers—I was running backwards on heels. But it was fun; I was a Dodger fan. Of course, they loved it. They were screaming and waving their arms. And with me there, they did it even more so.

*Is there anybody you wish you could go back to?*

That's a good question. I'm sure there are thousands, because when you see the picture on the contact sheet, or see it blown up, you can see all the faults. There are really just a few photographs that I wouldn't change one hair. Like Billy Eckstine's. Not a hair.

*What other?*

Well, there was a picture I did for the American Place Theater. I used the actor Scotty Bloch to represent three acts: she's docile, aggressive and mad. I did it as a triple exposure on one piece of film. I changed the focus, so the last exposure, where someone threw water in her face, was a close-up and had to be right. It worked very well. I wouldn't change a drop . . . Oh, and then there's one I did of this beautiful African-American lady in the South. She had twins, but she had this device she had to hold to her throat in order to talk. And she said, "All I really want is one of these that's automatic. I can't hold both my darlings' hands." So I got her—I just made a complete circle of her hands and arms and face, and—it was very good . . . Beautiful lady . . . I must be very tired, because I don't cry this easily.

Interviewed in New York City on May 18, 1993

# Matisse did not treat me as a photographer who was a pain in the neck, but as a guest

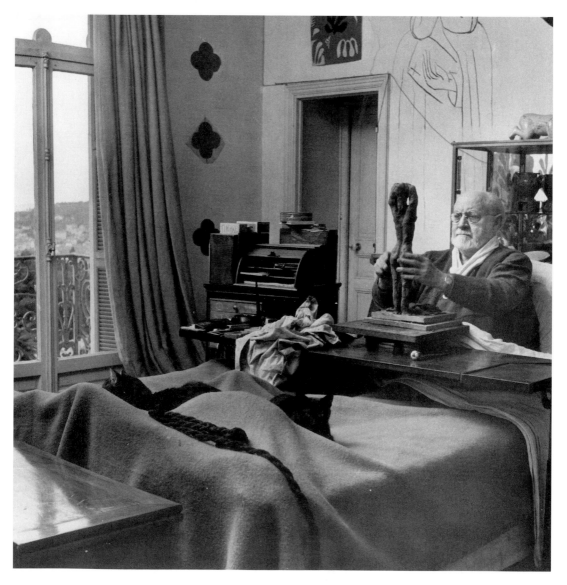

Henri Matisse. Nice, France. 1950

# DMITRI KESSEL

**D**MITRI KESSEL: Edward K. Thompson was a very understanding boss. He came to *Life* in 1937, and he was not very much at ease with all those Ivy League characters, of which we had a number. That was Luce's group, either Yale or Harvard. You would never think this boy from Milwaukee would become the boss. John Shaw Billings, who was the first managing editor, had hardly any contact with photographers. Ed, on the other hand, knew each photographer very well. I remember David Douglas Duncan told me during the Korean War, "I don't work for Time Incorporated. I work for Ed Thompson." And that was my feeling too.

*John Loengard: Some people said they worked for Wilson Hicks.*

He was not a bad fellow, though some people hated him. From 1937 to 1944 I worked for *Life* on a contract. Hicks kept offering me a staff job, and I kept refusing it. I was an advertising and industrial photographer, and that paid me five times as much on assignment as *Life* did. I had an office on 46th Street, and once I went to my accountant on a Saturday to do my income-tax return. When we finished, he gave me a copy, and then I went into *Life* because Hicks wanted to see me. Hicks started working on me again to go on the staff. I said, "Look, Wilson, I don't understand why you insist. I will always give *Life* magazine the first priority, but I want to work for advertising too, because I earn much more money there." I'd have to give that up if I was on staff. I showed him my tax return, and he saw that it was quite a bit.

"I see that we can't match that," he said, "but we would so much rather that you were on the staff."

I was getting a retainer every month, and when I was away, my sister used

to get my paycheck. She sent me a letter when I was in Greece for *Life* in December 1944, saying, "I received your check, and it says *salary* on it, not *retainer*. That means you're on the staff."

I wired Hicks, and he replied, "I'll explain when you get back." When I returned, he said, "The government says that all war correspondents must be on staff."

I doubted it was so, but anyhow I said, "O.K., then we'll have a deal. When I work in the United States, I'll be on a retainer and can work for an advertising agency."

"O.K.," he said. "And when you go overseas, you are on the staff."

So I had an assignment in Houston, Texas, and then he said, "How would you like to go to Paris for a couple of years?" I went to Paris, and I was there nine years. When I came back, they kept on sending me on assignments to Europe or to South America. Finally, they said, "Why don't you go back to Paris?" I did. I'm still there.

*You never regretted giving up your free-lance?*

No. Look, there is the security. Being on the staff I had medical insurance, and then you had this business of profit sharing. Plus there was the prestige of being a staff photographer. You were a big shot. You got the treatment of the diplomat, whatever country you worked in. No, I never regretted it. If I could have seen the future, I would never, never have stayed as a free-lancer.

*As an advertising and industrial photographer, how was it that you ended up as a photographer of churches and art?*

It does not work really that way. Alfred Eisenstaedt tells the story that he took a picture of a dog lifting his leg. Then because he took that famous picture, when they have a story about Niagara Falls, they say, "Ah, water," and they think of him. That's exactly what happened to me. In 1949 they asked me to photograph Hagia Sophia, that famous basilica in Istanbul. I did a pretty good job, and they used it. They came again to a church, and they said, "Ah, Dmitri Kessel." Finally in 1954 they decided to do the great churches of Europe. Five were selected, and I did them. From then on, whenever there was a church, I would do it. The same thing with art. There was one photographer, in his 60s, who copied paintings. Charlie Tudor, the art director, thought only that guy could do it. At that time, *Life* still used color separations, which meant you shot three plates, each through a different color filter, and you had to be very careful to keep them in perfect register; otherwise they wouldn't match. One day I was in the States and having lunch with Tudor. Usually when you had lunch with Tudor, you had a few martinis. After we had a few, he said, "Can you suggest a photographer in Europe who could do artwork as well as my man?"

"I don't know why you make such a fuss," I said. "Nowadays anybody can do it. You don't need to shoot color separations anymore. You can use Kodachrome color film."

"O.K.," he said. "You try it." It was 1950, and I did a story on the Venice Biennale. That was simple. I couldn't miss. So then they gave me a very complicated one on 24 panels by Tintoretto in the Scuola di San Rocco, also in Venice. Venice is a very humid place, and during the war they had taken the panels down and stored them away because they were afraid of bombings. Wherever they were stored, they picked up some humidity. When the war was over, they took them out, dried them for a while, and then cleaned them and put on a coat of varnish. Evidently they were not dry enough. So between the canvas and the varnish, a mold began to form, like a cataract. When you put the lights on, the picture disappeared, like shooting into a mirror, because of the way the light refracted. I tried all sorts of tricks. Nothing doing. So I tried, for the first time, using Polaroid filters where I put a "plus" Polaroid on the light and a "minus" Polaroid on the lens. The color became so brilliant that it looked as though the painting was painted yesterday. But the Polaroids cut out so much light that each sheet of film had to be exposed for two to three hours. It took us one night to do one panel, because I tried to expose three films for each panel. Tudor kept on sending cables, saying, "Look, make sure that it can be done. Because if it can't, we'll pick another subject."

So I did a few and sent them to New York. They wired, "Fine, but they look a little bit too new."

"Well, you can dirty them up a little bit, but that's the way they come," I said. "That's the way he painted."

I was there for a month. We worked nights because people visited the church during the day. We would go there about 4 p.m. They had to build us a scaffold for each panel. Each day we reset the lights. That took a couple of hours. Then we'd go out to have dinner and come back and work until about four or five o'clock in the morning—to do one picture. After that, *Life* decided that I am a genius, and every time they had art, I had to shoot it.

*Had you studied painting?*

Not very seriously. I liked art. I began to collect it when I was still a poor guy. Not that I am a millionaire now.

*Your father owned a sugar-beet farm in Ukraine?*

He had the farm, but mostly he dealt with peasants in the area. He would give them advance money, and he would give them the seeds. They would sign a contract, and he would deliver the sugar beets to the sugar factory in Kiev. Our main home in the country was practically a village. I had one brother and four sisters. We all went to school, but not there. I went to a boarding school about 100 miles away. You began when you were 10 years old, and you graduated when you were 18.

All this went back to Czar Alexander I, who beat Napoleon. He was very impressed with the French schools he saw. When he came back, he decided to start the same system in Russia. Except, he wanted in that school mostly the

children of noblemen. A nobleman in Russia was not necessarily any really noble rank. It could be a businessman who had a lot of land. Otherwise, it was restricted. Only 10% of Roman Catholics got to school, 10% of Jews and 10% of children of peasants. And even then, before you entered that school, there would be a tough examination, and you had to have very good marks. And even then, it still depended. In case of war, this school had it that you were to join the army. When I was 15 years old, they began to give me military training. Marching—and this and that—and then they went into a serious business. So when I graduated, I was immediately inducted into the army with the rank equivalent to a second lieutenant.

But before that, at the end of World War I in 1918, there were a lot of Polish cavalry fighting in Ukraine. They had to live off the country, and they would go into villages to get feed for their horses and for themselves. One day the villages in the area where I was in school rebelled. They attacked an old mansion that was like a castle, where the Poles had 150 men and 200 cavalry. The peasants were a couple of thousand, not very well armed, but a lot of them were ex-soldiers. There was quite a bit of fighting, and then the Poles gave up. The peasants rushed in and killed almost all of them.

I was a curious kid, and with a friend who was a Pole, we ran up there. I had this little box camera that used glass plates. We saw all these Cossacks lying there, and I took a picture of one of them. I took another one of a peasant. "What is that?" he asked.

I said, "It's a camera. I took a picture." He probably didn't know what I was talking about. So he took it there, and shook it, and then banged me on the head with it. He gave it back to me, and this Polish boy began to cry.

"Why are you crying? Are you one of them?" the peasant asked.

"No, no," I said. "He's crying because I was going to give him my camera." So we got out of there.

*When had you started taking pictures?*

At Christmas the year before, I was given a set of watercolors with brushes and paints, and I was not very much interested in painting. Another fellow got a camera, but he was not particularly interested in photography. So he said, "Let's change."

*What did you photograph first?*

Some flowers.

*Was there an interest in the arts in your family?*

No. The only thing was that Russians made beautiful postcards, and I had begun to collect them. They were reproductions of paintings on a very fine paper. It had sort of a grain to it, so it looked like the real McCoy. But I don't think this had anything to do with my future being in photography. I just liked the pictures, and I had the camera, and it was fun.

*Do you think photography is an art?*

Photography can be just a matter of luck. You may come across a subject that is exciting, and there's your picture. I remember one day Gordon Parks came to pick up something in the Paris office at 4 Place de la Concorde, and there was a terrific thunderstorm. Immediately after that, the Place de la Concorde looked absolutely fantastic. He looked out the window, and his eyes popped. He grabbed his camera and shot a picture. That was one of the best pictures ever taken on Place de la Concorde. He walked in, and it was there. He opened the window and shot it. *[See page 318.]*

*Let me ask about some people. You first saw Winston Churchill in Athens in 1944?*

I saw him thanks to flashbulbs. There was a strike on that cut off electricity, so they used hurricane lamps. A British public information officer came over to me and said, "I have something interesting that will need flash. You have flashbulbs, don't you? Would you mind doing it if the Army photographer will be with you?" Then he took me aside and said, "Churchill's coming in, and there'll be this conference to try to settle the civil war."

I gave the Army photographer one of the bulbs I had, and I shot another one. Then I decided that a better picture would be made just using the hurricane lamps that were there. On one side of the table sat Churchill and his party. On the other side sat the Greek government and the rebels, or whatever they called them, who fought against the government. Of course, I concentrated on taking pictures of Churchill's side, because I knew *Life* would only be interested in those faces. I kept shooting, and Churchill said, "Hey, shoot pictures of them. It's their show." I knew when he gets mad that's dangerous. So I went over to his side and popped a couple of the Greeks and then came back and started shooting Churchill again. He almost started screaming. A colonel escorted me to the door, and I was thrown out.

*How did you hold your camera steady in this light.*

Oh, I could get a shot in a fifth of a second or a 10th. You could shoot it.

*There was a story printed at the time that you propped your camera on somebody's bald head.*

Yeah. He was one of the Greek Cabinet. I put my elbows on his shoulders and said, "I'm going to shoot the camera. Please don't move." And I put the camera on his bald head and popped a few shots. These are the ones that were used.

*And you wonder why you got thrown out?*

No, that's not why I was thrown out. I got thrown out because Churchill was making the business that he was not important—the other people were important.

*You photographed Carl Jung.*

I was photographing him in Switzerland while someone was interviewing him, and I told him, "I would like to take a couple of pictures of you outside the office."

"I'm sorry," he said. "I'm going off tomorrow to my country place on the lake."

"That's all right," I said. "I'll take you there."

Churchill in Athens. 1944   *I put the camera on his bald head and popped a few shots.*

Yangtze River. 1946   *The whole issue was just Hiroshima.*

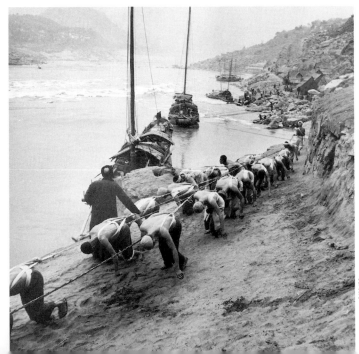

Carl Jung. Lake Zurich,
Switzerland. 1949
*I said, "What's the pistol
for?" He said, "Well,
you never know.
But it's better to feel safe."*

So I hired a car. Jung was a big fellow, you know. He got in and had this big pistol at his side. I said, "What's the pistol for?"

"Well, you never know," he said. "It's better to feel safe." When we got there, while his wife was preparing drinks, he sat at the lake wearing a straw hat, and that's where I photographed him.

*You photographed Aristotle Onassis?*

He was a very, very unpretentious fellow. At least with me he was unpretentious. His yacht was a former American destroyer escort that he had redone in Germany. The commanding officer was a former German submarine commander. The crew, except service, were all Germans. We hired a fisherman to take us out. We came loaded with my equipment and two cases of flashbulbs. When we arrived, they looked at us as though we were baggage. This guy comes over to the rail and says, "What are you doing here?"

"We were invited by Mr. Onassis," we said. He ran back to check with his superiors, and then he came down and took our stuff on.

I was there for a few days, and none of the guests showed up on the deck until about noon or even later. Coffee and Bloody Marys were served, and a brunch of caviar and quail in aspic and that sort of thing. Then they would go off sightseeing, and then they would take a nap, and around six o'clock they started drinking again. Nobody went to sleep until about five o'clock in the morning. Friends on shore gave parties with fireworks and so on. After I worked for four or five days, Onassis asked me if I had a vacation coming, and I said yes.

He said, "Why don't you come with us? We're going to the Greek islands, and you can stay a month." He had the plane aboard, so in case of emergency they would fly me ashore. But I thought I couldn't take this business of drinking till five o'clock in the morning. Then the last day, I wanted to say goodbye. His wife said he was staying at the hotel ashore. When I got back ashore, he was sitting at the bar having a drink. I said, "What are you doing here?"

"I spent the night here," he said. "I can't take all that business, drinking until 5 in the morning with all those guests making noise, so I took the day off."

*In your book of photographs,* On Assignment, *you have a whole chapter on Gianlorenzo Bernini. Why?*

Because with Bernini, the pictures that I had were spectacular. There was a big choice. I had a few hundred to choose from. For example, there's the *Death of the Blessed Ludovica Albertoni* in the Altieri Chapel of the church San Francesco a Ripa in Rome. He built it to go into a niche and had a window put in so the light would fall on her from above. She's lying in bed. It is very dramatic. You know she's dying. I wanted to duplicate his lighting, so I put one light in the window, and then I had a smaller light on the other side to reflect off the wall, so there would not be heavy shadows on the legs.

I always try to get the marble to wake up. But there are some statues done so very well, you don't need to do much—just photograph. In Turkey, once, I

*Death of the Blessed Ludovica Albertonii* by Bernini.   1962
*I always try to get the marble to wake up.*

Aristotle Onassis and Prince Raimundo Lanza di Trabia. Palermo, Italy.   1954
*"What are you doing here?"*

photographed a Greek statue of Alexander the Great that *Life* used on a cover. At first sight, people thought it was a human being that I had posed.

*Of all that you've photographed, what gave you the most pleasure?*

Matisse, actually. With him there was a personal contact. He had a very, very simple—French—personality. He did not treat me as a photographer who was a pain in the neck, but as a guest. Once I came there, and he said, "You're just in time. We're going to take a little trip. I want to show you that our Riviera is much nicer than the Italians'."

I've never learned to drive, and he didn't either, so he ordered a car and we went up from Nice to Ventimiglia—that's the border. You cross it and you're in Italy. To me it was still the same. Maybe on the French side there were more palm trees. But he said, "Look at the light. Look at the sea. *Oooh! Ce n'est pas la même chose.* It's not the same. It's so much softer on our side. It's so much warmer." He was in love with the Côte d'Azur.

*What did you find so special about working for* Life?

You know, with *Life*, the sky was the limit. In 1946, when I was going to China to do two stories, Hicks said, "If you need more, O.K., but try to hold it down to $25,000." That's about $200,000 today.

The Chinese wanted to build a dam on the Yangtze, which they're finally building right now. I did a story on the river. New York liked the story and laid it out for 15 pages. John Hersey worked with me, and had written one full page about a tracker—the guy who pulls the boat along, like a Volga boatman. Hersey left me before I was finished and went on to Japan. He was a free-lancer by then, and he wrote a famous thing for the *New Yorker* on Hiroshima. The whole issue was just Hiroshima. There were no cartoons, no advertising, and so on. And Luce hated the *New Yorker*.

They had just closed my Yangtze story, and Luce came in with the magazine and said, "You've seen it? I'll never print another word by that boy." So they threw my story out. They could have done it without Hersey's text, but they didn't. Then, almost exactly 10 years later, Hersey wrote a book called *A Single Pebble*. It was about a Yangtze River boatman, and it was a big success. Ed Thompson used 10 pages of the pictures of the Yangtze River, matching passages from the book to the photographs.

The only thing more I can tell you is I'm sorry I'm such an old schmo. I wish I were 50 years younger.

*You're 89 years old. What would you be saying if you were 50 years younger?*

I'd say, "I wish I were 20 years younger and still had *Life*." But there are no magazines like *Life* anymore.

On the *Life* staff 1944-67
Interviewed in New York City on September 20, 1993

I thought, "Nobody works
harder than a housewife and
puts in as many hours
and has to do so many things"

8/15/55

Gloria and Kirby Tweten. Seattle. 1955

# MARK
# KAUFFMAN

**M**ARK KAUFFMAN: I had my first cover on *Life* when I was 17. Actually I was only 16. I lied about my age because teenagers always want to be older than they are. As far as I know, I'm still the youngest photographer ever to have a *Life* cover.

Eleanor Roosevelt had been in Los Angeles, and after her regular press conference, she had another one for high school journalism students. My school sent one journalism student and one photographer, and I was selected. Mrs. Roosevelt was sitting in a fancy French chair, and the wall was right behind her, so it was like a studio. I was four feet away and took three or four pictures. I had a really nice portrait. I showed it to my photography teacher, Clarence Bach, and said, "Should I send this to *Life* magazine?"

The picture arrived in New York about three weeks before the King and Queen of England were coming to be guests at the White House in 1939. My timing was perfect. *Life* sent me a telegram saying, "Hundreds of pictures of Mrs. Roosevelt pass over our desks all the time, but we've yet to see one that seems to capture the charm of the First Lady as yours did. Congratulations. We're using it on the cover, and we'll be sending you a check for $50."

*John Loengard: What made Clarence Bach so special as a teacher?*

Bach was a short, asthmatic man (he always had a little squirter for his nose), and he eventually died of asthma. He'd look you straight in the eye. You had a hard time making excuses about anything. He kept saying, "You're not going to learn here in the classroom. You've got to learn by taking pictures." Fremont High School is in South Central Los Angeles, the Watts area, and it was a melting pot. My father was from Russia, and my mother from Poland. Hank Walker's

parents were German. John Dominis' parents came from Yugoslavia. Bob Landry was English. John Florea's parents were Romanian.

My father became a blacksmith in 1903. He was a little man with a big scar on his nose where a horse he was shoeing had kicked him. When horses went out, he went into making ornamental ironwork. I used to have to help my dad, but I really didn't like it. I didn't like getting my hands dirty. I'm still that way. I probably wash my hands more than any surgeon does every day. I was taking clarinet lessons, and I convinced my parents to let me sell the clarinet so I could buy a camera. Johnny Florea and Bob Landry had both graduated from Fremont before me, and they helped me get a job in the *Life* lab in Los Angeles. My first day at work was December 8, 1941, the day after Pearl Harbor. As a result, I wasn't in the lab very much. The three staff photographers there—Landry, Florea and Peter Stackpole—went off to cover military assignments, and I was left covering all the small Hollywood stuff for both *Time* and *Life* until I went in the Marine Corps 10 months later. I was a combat photographer with the 24th Marine Regiment in the Fourth Marine Division. I was in four battles: the Marshall Islands, Saipan, Tinian and Iwo Jima. I landed with the first waves on Saipan and Iwo Jima. In that 10 months after Pearl Harbor in Los Angeles, I had established myself enough so when I got out of the Marines, I was hired as a *Life* staff photographer. As if I hadn't had enough war during World War II, they sent me to cover the civil war in China for most of 1947. Then they asked me if I'd go to London. I was single. I said, "Sure." When I arrived there, I went right away to Finland. It was just after Czechoslovakia fell to the communists, and everyone thought Finland would be the next country to go.

A number of the foreign press were there watching, but the only thing that fell was me. I met a marvelous Finnish woman. I was there a month and saw her every night. When I got back to London, I called her and said, "I'd like to marry you," and she said O.K. She came to London, and we were married. We loved London. My first daughter was born there.

I covered a lot of Africa in those days, because much of it was still part of the British empire. And in Belgium there were huge riots because of King Leopold, who finally had to turn the throne over to his son. There were also riots in Paris. France's government seemed to change every week. I was a paparazzi type of guy. I loved news, I loved sports, but as I grew older I became a little more cultured. Living in England with a very intelligent Swedish-Finnish wife who spoke four languages, I'd go to the theater all the time. I started reading a lot more than I had been reading.

I photographed the Olympics in London in 1948, where the Olympic Committee had four or five official photographers and we couldn't get any field passes. I had some long lenses and photographed from the stands. It was very frustrating. We had no cameras with motors or quick-return mirrors. When I took the picture, the mirror would come up and I couldn't see anymore. When

First issue, *Sports Illustrated.* 1954
*We called it* Mnorks.

Kauffman (left) and Bach at Fremont
High School. Los Angeles. ca. 1957
*You had a hard time making
excuses about anything.*

Eleanor Roosevelt. 1939
*One seems to capture the charm of
the First Lady.*

*The Odd Couple.* 1964
*"Hey, Noodlehead,
what do you want to do now?"*

I was reassigned back to New York, I worked with Marty Forscher, one of the great camera technicians in the country. We took a Bell & Howell camera called a Foton. You wound it up like a clock and it would take four pictures the first second, and then it would run down *dut-dut-dut-dut-dut.* But I'd get about 10 pictures in four seconds. We tore a pair of binoculars in half and made a monocular finder. When I went to an event, I could focus on what I was going to shoot, lift the mirror and then look through the monocular finder and get a series of pictures. Nothing like that had existed before.

It created sort of a revolution because nobody was working at the field level with long lenses. They'd use them on tripods up in the press box. Then Henry Luce decided it was the time to start a leisure magazine. He said, "Get a small group of people together, and have them suggest a new magazine to me. I have my ideas, but I want to hear from other people." It wasn't necessarily to be a sports magazine, but it might be; and because it might be a sports magazine, I was asked to join this small group.

Ernest Havemann, a writer for *Life,* was in charge, and there was Clay Felker, who later became the editor of *New York* magazine and *New West* magazine. There were seven of us, including an art director and an advertising guy. For two weeks we discussed this thing, and about half of the group didn't think a weekly sports magazine would work. They said it would have to have more. It would have to have travel, or it would have to have celebrities other than sports celebrities. But the majority of us prevailed, and Havemann wrote our report to Luce. I went back to Washington, where I was then based. I got a call three weeks later saying, "If you're agreeable, come to New York. Luce has decided he wants a sports magazine."

I went to New York, and we started working on sections of the magazine. We called it *Mnorks,* from the dummy type we used with the same number of letters as *Sports.* We kept putting sections together, and then in December we made our first dummy issue. They printed 500 copies, and those were sent to advertisers to get a reaction. In August of 1954 we came out with the first real issue of *Sports Illustrated.* I was fortunate enough to have the cover and the opening story of the famous Roger Bannister–John Landy four-minute mile. I had practically all the pictures in the first issue, and the cover of the second issue too.

Working on *Mnorks,* we had lunch with Luce once a week upstairs on the 30-something floor to discuss it. In the beginning there were only a handful of us. After about six months there were 15 or 20. Luce would come down to our offices also, in shirtsleeves, and want to go through everything and ask a million questions because he was a very inquisitive man.

*Did Luce have much sense of pictures?*

Well, he didn't. He knew what he wanted and didn't want, and if he saw a picture he didn't like, he was very vocal about it. Or he would like something tremendously, and it may not have been all that good. For instance, he picked

the first cover of *Sports Illustrated*. It's a picture of mine, and it's a very weak picture. Twenty-five pictures were up for selection, and 70% of them were mine, all of which I liked better than that first cover.

A few years later, Luce came to Paris—I was based in Paris then—and decided he wanted to take the photographers to lunch. There were three of us, Dmitri Kessel and Nat Farbman, and our wives. We went to lunch in the Bois de Boulogne, and I mentioned my feelings about the cover to Luce. He said, "I don't agree with you. That picture is generic. The great American pastime? It's baseball. Baseball. You've got to remember, we're going to have anniversaries—10th, 20th anniversaries. That picture will hold up. It will look like it was just taken yesterday. That's why I picked it. Enough?"

"Yes, sir." I said.

*Do you think he was right?*

I think his arguments were right. I just didn't like the picture. I still don't. And it's used all the time. The first issue now is selling for $500 with that cover on it. They had me go back to the Milwaukee County Stadium 25 years later. They also invited the three people that are in the picture. The batter, Ed Matthews, who was the Milwaukee third baseman, he was a Hall of Famer. The catcher was a New York Giant, Wes Westrom. The umpire was Augie Donatelli. They re-created this thing in front of 40,000 people, to show them how I shot this shitty picture.

*In 1955, the year after* Sports Illustrated *was launched, you did a story on a housewife.*

I was based in the Washington bureau. We lived in Bethesda, Maryland, and I cut my toe badly in the lawn mower. I was home for two weeks with my leg up. We had two daughters then (we ended up with four), and they were six and three. I'm sitting at home for the first time watching my wife take care of these little monsters. I thought, "Nobody works harder than a housewife and puts in as many hours and has to do so many things."

I wrote one paragraph saying, "I'd like to do an essay on a housewife. New York immediately said, "Let's do it."

They found this woman in Seattle. Gloria Tweten's husband Del was a milkman. I stayed at a hotel nearby, although I spent a couple nights on their couch so I could get some early morning things. They had three children, and the opening picture was of three-year-old Kirby crawling all over Gloria, waking her up in the morning. Her hair's all tousled. In the closing picture, Gloria's holding Kirby, who was the oldest, hugging him and singing a little lullaby and putting him to bed. None are posed. The title of the story is "The 80-Hour Week." The story was about the physical and emotional labor a housewife does, and we were a little short on the emotional part, except for the opening and the closing pictures—there's certainly love when she's holding the child to put it to bed. But very often photographic essays hinge on one picture or two.

*How did your wife like the story?*

She liked it, but she said, "I bet you'll get a lot of letters saying she should

organize stuff better." Sure enough, they published a couple of letters saying, "It doesn't have to be an 80-hour hassle if she did this and did that and planned it all out."

I think the story made a lot of males aware. It made me aware. The strange thing is it's an obvious idea. It was a reflection of something we take for granted. *Life* had been around for 20 years, and you'd think they'd have done a housewife. But, you know, very often you don't have to have major brainstorms. Something right under your nose suggests the story.

In 1961 I went under contract, and that allowed me to do some advertising work and some corporate work, which I couldn't do on staff. I opened a real fancy studio in New York. That was something I had to get out of my system, just to see if I could do it. It took a lot of dough, and when Eleanor Graves, who was in charge of the Modern Living department, came up with the idea of "LIFE Great Dinners," the *Life* studio wasn't properly equipped—they would have to go out and buy stoves—and my studio was. So we started the series in my studio.

Photographing food is the toughest photography in the world. Food is temperamental, just like actresses. It will wilt right in front of you. You've got to primp it. You've got to put lipstick on it, so to speak. You have to know how to style it. I might say, "I want blue plates. Not white." Photographing food on white is bad because it distracts from the food. These are things you learn.

*Why were "Great Dinners" different from other food photography?*

We tried to get as much motion in them as possible. Things pouring, things flying, the peppercorns on pepper steak flecking. John Dominis took a trout almandine, with the trout being hooked and flying across the picture with almonds flying all over. Without being fully aware of it, I think, as a journalist I wanted things to be happening, even in a food picture. Of the four of us who did most of the dinners, Milton Greene's were mostly design, without motion, because Milton doesn't have a journalistic background. Fred Lyon's, in San Francisco, also were more design. Like rows of eggs and things that were beautiful pictures. But John Dominis and I did most of the dinners. And we always had something happening—you know, we were like a couple of hammy comedians banging on things and all that to get attention. But that's what pictures are about—to get attention.

*Around this time you got spaghetti thrown in your face?*

For two years I was covering Broadway shows as they'd open. I did *Hello, Dolly!* and *Cabaret* and *Mame*. I'd go to two performances, make notes, and after the second performance, all these important Broadway stars were mine, because the producers wanted the publicity. On *The Odd Couple*, Art Carney played the mild guy, and Walter Matthau played the sports editor. There's a scene in which they have an argument. Carney calls the spaghetti by some fancy name, and Matthau says, "What are you calling it that for? It's nothing but spaghetti!" and he throws it offstage.

I set up in position and said, "Throw it right over my head." Matthau's chomping down on his cigar looking right at me, and I got this nice, funny picture. You see this spaghetti and his face just at the top of it. You look at it and know there's no way the photographer's going to get out of the way of that spaghetti. That loosened things up. The rest of that night, Walter Matthau kept calling me Noodlehead. "You look better with those noodles falling off your head," he said. "Hey, Noodlehead, what do you want to do now?"

*Who that you photographed interested you most?*

The one that most scared hell out of me was Winston Churchill. If I have any regrets in my photographic life, it was that I didn't come out with better pictures than I did. I'd go to his home, Chartwell, about an hour south of London, and I could hear him upstairs laughing and walking around. I'd wait for him an hour, two hours, and then he'd come down in his overalls and say "All right. But look, young man, I'll tell you when you may take the pictures. Don't sneak any of them." The first time I was there he showed me around the grounds and all that, and I was trying to accumulate some picture ideas, but almost every time I'd suggest something, he'd say, "No, I don't want to do that." He was very negative about it, and *Life* magazine was paying a million dollars for his memoirs, which was a ton of money in those days. You'd think he'd have been a little more cooperative. I didn't have a good plan. That's why I'm saying this is my big regret. I let him get away, John. That's all I can say. I have no excuses. I should have had a gooder plan and cooked up something. If it had happened 10 years later, I would have figured something out. I was only 27.

I was a very fortunate guy. Time Incorporated at that time was like a big family, and a lot of us still are. You may not see another *Life* photographer or editor or writer for 10 years, but you just sort of pick it up with each other. We're like a bunch of old shoes. Especially in cases where photographers worked in bureaus, which I did. We got to know each other's families, and our kids went to school together. It was a great paternal company. In the old days, you'd have a baby and Luce gave you a porringer from Cartier with an inscription (in my case, "To Linda Kauffman," who is our eldest daughter, "from Henry R. Luce and his friends at Time Incorporated"). It was a little personal touch, and there were a lot of babies born. These things, I found out, cost 90 bucks apiece then. But it isn't that. That's a material thing. There was this deep feeling of camaraderie. We lived *Life* magazine. And unfortunately a lot of marriages suffered because of that. There were a few photographers that lasted, but for a lot of them, it was a rocky home life. I was very fortunate. I was married 42 years before my wife passed away just a few years ago. I can't imagine having a more wonderful life.

On the *Life* staff 1945-60
Interviewed in Los Angeles on August 13, 1993

I have a habit of picking up a magazine
and starting at the back

Lord Louis Mountbatten. Norfolk, Va. 1941

# WALTER B. LANE

WALTER B. LANE: I worked for a moving picture company when I got out of high school, and then I got a job with a photographer on Lexington Avenue. We did a lot of photography for the Cunard Line on the *Queen Mary*. But then his business went down, and he had to let me go. I saw that Pix, a photographic agency, was looking for people. I got hired there in March 1937. Cornell Capa and I were working side by side in the darkroom for over a year. Little photographic jobs came up, and I did them. Pix wanted a photograph of the parade at the beginning of the rodeo at Madison Square Garden. I climbed up in the rafters and got a wonderful shot. *Life* used it and thought, "This boy's good."

By 1941 I was working on a retainer out of the *Life* Washington bureau. One afternoon at the end of August, they said, "Go down to Norfolk. The H.M.S. *Illustrious* is coming in." It was a British aircraft carrier that had been banged up badly in the Mediterranean. Lord Louis Mountbatten was in charge. I couldn't get a train out of Washington that would get there in time, so I went down along the Potomac until I found an overnight boat. It was full, but I talked them into letting me sleep on a bench in the engine room. The boat pulled into Norfolk at a quarter to 7, and I grabbed a taxi and—it was just like a movie—a freight train with about 120 cars came by. Finally I got to the First Street gate, and a Marine guard said, "It's up at the Fourth Street gate."

I go tearing up the street lugging my big camera bag. The Marine there said, "I can't let you up."

I said, "I'll lose my job. You've got to let me onboard."

He said to another Marine, "Take this guy up on topside." As I came on the deck, Mountbatten was coming down reviewing his sailors. I dropped down on

one knee, took the shot, and that was it. I had as tough a time getting back to Washington, and just as soon as I got back to the bureau, they said, "You have to go to Iceland." American troops were being stationed there.

*Life* got me a passport in a couple of hours, and I flew up to Halifax, Nova Scotia. Canada was at war, so all my equipment was confiscated. A Royal Canadian Mounted Policeman was assigned to stay with me until I could get on a freighter to Iceland. I was walking around, and on a newsstand was a row of *Life* magazines stacked on edge. I have a habit of picking up a magazine and starting at the back. When I got to the front of this one, I flipped. That's when I first saw my picture of Mountbatten was on the cover. The editorial staff enlarged the picture so that the sailors were cropped out, and the figure of Mountbatten was large. It made a good cover.

My ship was called the *Godafoss,* which means Golden Waterfall. A Mountie turned my cameras over to the captain, saying, "Don't let him have his stuff till you're 15 miles at sea."

We joined a convoy of 40 ships carrying supplies to England. There were tons and tons of Nazi submarines working out of Greenland busting up all the ships going across the Atlantic. During the war there were all kinds of wreckage down along the Eastern seashore here. We had radio silence. To signal course changes, the ships would run up flags.

We got into Reykjavik, where the United States Army had a small operation. My assignment was to do an essay on the country. To me that meant go all over the place. Transportation wasn't much. After making pictures of Marines coming down the road on an early morning march, I just took off with a Rolleiflex, 20 rolls of film and the clothes on my back. An old beat-up bus came along loaded with Icelanders carrying fish wrapped in newspapers. The bus seats went all the way across, so you just slid in on the end. They were all talking, but I didn't know what they were talking about.

But I remember the wild ponies. As the bus went up this dirt road north, a couple of hundred ponies ran alongside and in front of the bus. They were all over the place. Beautiful little animals.

I ended up in a little town called Akureyri just below the Arctic Circle. Northern Iceland looks just like you're on the moon. My fourth day there, I was in my little room at the hotel, writing up my notes and trying to get myself organized. A knock came on the door. I opened it, and there were three British intelligence officers. They pulled out their badges. They said, "Get yourself back to Reykjavik. They're really upset about you." The Army hadn't liked that I'd just gone off.

I sent my film back on a Navy destroyer to the Navy photo lab in Washington. I was not allowed to send any wireless messages or cables to the office to tell them it was coming, but a good friend of mine, Charles Steinheimer, happened to be at the Navy Department photo lab and saw this package of mine come in. He called the Washington bureau. They got the stuff developed and

past the censor. It was the lead story in the magazine.

*John Loengard: How did you get back?*

The *Godafoss* was going back to New York City. When I got there, I went up to see Wilson Hicks, who was the picture editor. I stood in the doorway and said, "Hello, Mr. Hicks."

He looked at me, "Oh, my God! You made it back! We thought you had drowned." Without being able to radio, there was no way to let them know where I was.

My local draft board had given me a three months' allowance to go up to Iceland, but now I was drafted into the Navy. I was out in the Pacific 28 months, and then I went back out for another 10. I had almost four years in the service. Along the way, I got assigned to the hospital ship *Solace*. In the operating room I got talking with a nurse from Gettysburg, Pennsylvania, and she said, "Let's go outside and have a cup of coffee." We got acquainted and continued to write letters back and forth, and when I got back to the States, we got married.

*In that sense, at least, you had a good war.*

Yes. We ended up with two boys, two girls, and now six grandchildren.

After the war, *Life* needed somebody in Washington. That was ideal for me because my wife could stay in Gettysburg. Fifteen months later they said, "We need someone in Boston to take care of all New England, and we'd like you to consider it." My wife's mother was very ill at the time, and it's one of these crazy situations.

I said, "I would just as soon stay here because it helps me with my personal problems."

They said, "New York says you have to go, or else." So I resigned. I went back to Gettysburg. I opened a studio, and we were successful with it.

On TV I sometimes see the mob of photographers down there at the White House running around in all kinds of Raggedy Ann clothes. It just seems kind of strange. It was different when I did it. Then everything was slower. In 1946 some Congressman was giving President Harry Truman a big crate of strawberries. Mr. Truman comes out from behind his desk and takes out a box and picks one out and pulls it apart and eats it. He comes around and stops in front of me with the box, and he says, "Young fellow, do you like strawberries?"

Well, what else could I say? I said, "Yes, Mr. President."

So he said, "Open your mouth."

He peels one and popped it. The other photographers just stood there. Darn it—not one of them took a picture.

On the *Life* staff 1945-47
Interviewed in New York City on October 26, 1993

I didn't pose it,
even if it looks posed.
Some pictures look posed
that are not posed

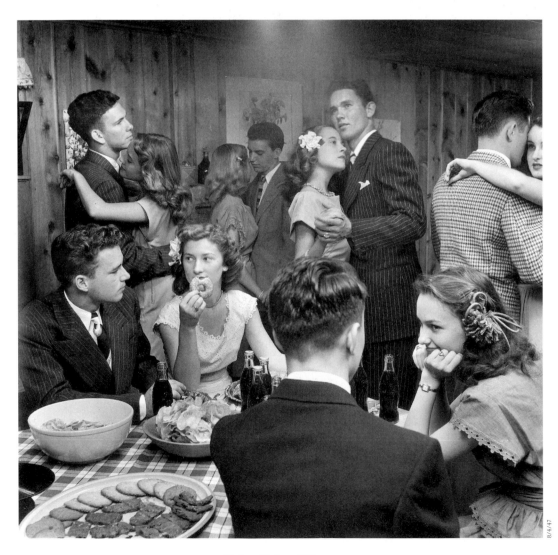

Twins. Tulsa, Okla. 1947

# NINA LEEN

NINA LEEN: I grew up in Germany, in Switzerland, in Italy—in a boarding school much of the time. I could not have animals there, but when I wasn't in school, I had them. I had a monkey for a long time. The monkey's picture is still in my bedroom. I had snakes. I had all kinds of animals. When I started working, I was a zoo photographer, and I thought this was heaven. To have permission to be behind the scenes and see the animals. This was something I couldn't even dream about.

I became fascinated with snakes when I started to observe them. I started to see their movement, and I started to think of humans getting so scared of the snake. The snake is a deaf mute. Usually it uses venom only for defense, and yet when a snake is seen somewhere, humans kill it. I couldn't understand this.

I don't think the snake can become a pet. I consider a pet to be when you have some kind of understanding between the two of you. But a snake is just a beautiful sight. You can have it in the aquarium to see it and to feed it. It lives, and you live, but you don't have anything else in common.

I must say I was scared to death of bats—until I met some very nice bats, which I hadn't known existed. Then I started to read books about them, and it sounded like science fiction. I couldn't believe such an animal existed. I also couldn't believe that there was a time when I was scared of them. It's unbelievable how wrong people are about bats. I decided to make a story. I went to *Life* to talk about it, and they said no.

I started to do the story on my own. My own money. My own everything. The Bronx Zoo people helped me. After I worked for a while, the editor who said he didn't want the story was on vacation, and another editor said he would like to see the pictures I'd taken. I showed them, and he was impressed and said,

"Go ahead. Do whatever you have to do." I wanted to show bats in pictures because words would just fly off into the air. People wouldn't believe it and could not imagine them. I wanted something that stuck, and I think I did that.

I photographed the bats in color, but many stories on people I've done in black and white. I don't think there is a rule. We like color. To take flowers in black and white is always a heartache. You really think they should be in color, and you are right. I also used color for a story on the kings and queens of Europe in 1957, but those pictures are not my favorites. Under the conditions I took them, I had to take what I could get, and sometimes I didn't get much. In Sweden there was big trouble with the Swedish photographers union because they couldn't understand why *Life* had to send a photographer from New York to take a picture of their King and Queen when they had photographers there who could have taken it. I agreed. The situation I photographed could have been taken by any photographer, but there was no choice. I was very glad that they posed. They were particularly nice people. Now, with the Greek people, it was more a personal thing. They were charming. I had the cover on them in *Life International.* Queen Frederika was very nice, but throughout the story, there was one thing that was most bothersome. It's that I did not bring an assistant with me from America. In Sweden I had to take a local photographer. I didn't speak a word of Swedish, and he had never heard people speak English (American, either). This was a problem, and it was sometimes tragic. In Greece I knew that the assistant was very thrilled to be there because his father was a photographer at the court, and he was talking about his father with the King and Queen. Once I did not see that he had not put any film in my camera. I asked him, "Is the camera ready?" because we had to change film, and he said, "Yes, yes. It's ready."

I took it, and I worked with this camera. "Very good pictures," I thought. "Boy, I really have them." But when I opened the camera to take out the film, I saw there was no film.

*John Loengard: What would the pictures have shown?*

They showed them with their dogs. And they were walking, and he had his arms around her. I had one shot of that. But, you know, it's very difficult to remember all of the 36 pictures that were never taken.

*Let me ask about some people. Would you have liked to have photographed Marilyn Monroe?*

I never thought of that. I think she's a pretty woman, a sexy woman, I guess. She posed right. She gave photographers what they expected. And that's that. I was much more interested in Helen Keller. Because I photographed her, I didn't photograph President John Kennedy. I was taking pictures around the White House, and he arrived home from somewhere. I was supposed to take his picture, but I got a phone call that Helen Keller would pose for me if I came over the next day. I gathered my equipment together and phoned Ray Mackland [*Life's*

Snakes. 1962
*Just a beautiful sight.*

Helen Keller and Patty Duke. 1960
*I didn't photograph President John Kennedy.*

King Paul and
Queen Frederika. 1957
*I thought, "Boy,
I really have them."*

picture editor from 1950 to 1961] to tell him that I was going back to New York to do Helen Keller. He said, "But you don't have Kennedy yet."

I said, "No, and maybe you can assign somebody. I just don't want to miss Helen Keller. I always hoped to see her, and I'm leaving now." He was mad as he could be, but I left. I took Helen Keller, and I'm very happy about that.

*In 1951 you photographed a group of painters—*

Yes. "The Irascibles." I was in such a hurry. There were about 20 people. There was nothing in the studio. I posed the group so that I could see every person clearly, and it took maybe 10 minutes. They were so self-conscious, those artists, that it wasn't easy, but I took three versions.

*How do you tell when somebody's self-conscious?*

How do you see if somebody's blind? How do you see if somebody is sick? You see that the person doesn't behave the way they usually would.

*How do you try to put them at ease?*

With some people, their real personality is to be self-conscious. If you want to take their picture, you better let them be the way they are. On the other hand, if I could see that this is not their real personality, that they are somehow intimidated by something, or something is wrong with them and they feel it, then I would just be human, just say, "What's wrong with you? Could I help? Does that bother you? Do you not want other people to be present?" Some people don't like to pose when other people are looking on, you know? You just use the human touch. With the Irascibles, there was no time to talk to 20 people. I needed to take the picture. If I would talk too much and ask them too much—then probably half of them would leave.

I didn't have any encounter with Gregory Peck either when I photographed him in downtown Manhattan. It was one of those cover tries which they wanted to have, and the actor gives you about 15 minutes of his time. Few words, few jokes and so on. But that was all there was. Ed Wynn was very good to work with because he would repeat a trick if he had to, and I kind of liked him, but I didn't have any contact with him, except that I admired him as an artist. I did not know the architect Le Corbusier personally either. The only thing was that he had a schnauzer dog. When the dog died, he made a rug of him, and when I went into his studio and saw the rug and him standing on it, I got sick. But otherwise there is not much to say about him. He's a genius.

Sometimes when I photographed somebody, they became a friend, but not often. I work hard on the story itself, so I have no time to become friends. I liked Thomas Wolfe's family. He wrote *Look Homeward, Angel*. His sister became a personal friend of mine. I liked that story, and I liked the people. This is something which did not always come together. Marjorie Rawlings also became a personal friend of mine. She wrote *The Yearling*. I visited her there in Cross Creek, Florida, and I liked her. This was again a personal relationship.

5/21/45

The American look. 1945
*For me, America wasn't usual.*

12/1/47

Gregory Peck. New York City. 1947
*The actor gives you about 15 minutes of his time. But that was all there was.*

Abstract painters ("the Irascibles"). New York City. 1950\* *They were so self-conscious.*
\* *From left, front row:* Theodoros Stamos, Jimmy Ernst, Barnett Newman, James Brooks, Mark Rothko;
*second row:* Richard Pousette-Dart, William Baziotes, Jackson Pollock, Clyford Still, Robert Motherwell, Bradley
Walker Tomlin; *back row:* Willem de Kooning, Adolph Gottlieb, Ad Reinhardt, Hedda Sterne.

*Do you have any feeling about posing pictures or not posing pictures? Is one better to do than another?*

There is no question about it. You're there with the camera. It's difficult to think that you came there with the camera to cook something. It means you came to shoot a picture. If you can pose a little bit—just move someone away from the door or the window—and if you know what effect the picture should have, then I don't see anything wrong with it. Better to pose a good picture than have an unposed bad one. On the other hand, when I did a story on twin sisters in Oklahoma, I wanted to show where they spent their evenings and what their boyfriends looked like. They were sitting at a table, and some of them danced, and I shot the picture. I didn't pose it, even if it looks posed. Some pictures look posed that are not posed.

Sometimes I've shot a picture in a way that appears not to be good, but when I print it, I show what I really wanted to see in the picture. With printing, I can crop it. I can make a daylight picture into an evening picture. I can make changes which I planned when I took the picture. However, you don't print your own color, so you cannot do in color what you can do in black and white. You can kill a picture through printing too, if it is not right. Printing is not considered important enough today. That's wrong.

*Do you think out your stories in advance?*

Partly. You can't do it all, because you will have picture surprises. You cannot know everything. Still, I don't miss many pictures. I'm like a dog who holds onto something. When I start a story, if I think there is a picture that belongs in the story, I will not give up till I get it. In the 1950s when I came to do a story on teenagers, I asked them questions. I wanted to know when they go out and where they go. I asked what they thought was worth taking. Then I asked if they might do this or this or this. In the end I had a list of 35 pictures, and this was what I started with.

*How would you describe yourself?*

A journalist—a photojournalist. That means that you know when you've found a story and how to put the story into pictures. If I were only a photographer, I would have a selection of single pictures, and they would be good pictures but not a story. Of course, to tell a story in pictures, the story should have something in it that is worth telling—to milk a cow without milk makes no sense. A few years after I came to this country in 1939, *Life* was doing a story on the "American look." They asked other *Life* photographers, and nobody had any kind of idea what it was. I said, "All right, I will try it," and it worked out. But it was typical for Americans not to see what it was, and probably in Italy—or wherever—they would not see their Italian women. To them it was usual—Isn't everybody like that? For me, America *wasn't* usual.

When I came here and first saw American girls, what I saw first was hair. Then a lot of other things: they were scrubbed from head to foot; they were well

built. In Europe, then, if you looked for a picture of a woman in a bathing suit, what you would see was quite frightening. When I lived there it didn't frighten me, but now I saw the difference. People here were very well built. They combed their hair. There was practically nothing wrong in their appearance. I'd seen a lot of countries and a lot of people, and no other country really had this American look. It's why you can see an American in Europe, and you can somehow recognize it's an American.

*Do you think that you brought something to photographing women that a man might not?*

Like I brought to bats? No, I wonder if there *is* a woman's sensibility for this kind of work. The teenagers. They liked me pretty much, and I liked them too. We understood each other very well. But, again, if a man had been there in my place with the same approach, they might have been just as happy. I don't know.

*Did you feel that you were "one of the boys" at Life?*

Not at all. I don't think they wanted me to feel that. They didn't care. Some of them spoke some words to me which I didn't like. I saw that they were jealous, but I didn't care. I didn't let it get on my nerves.

*Did you feel you got some assignments because you were a woman?*

Yes, I know that I got some assignments because I'm a woman. I could persuade people to let me photograph them, somehow, because I'm a woman. They would not pose for anybody else and, all right, I took it. Thank you very much.

On contract, 1945-72
Interviewed in New York City on January 14, 1992

They had no hotel

in Bastrop.

And very little else, as a matter of fact

1918 Ford. Bastrop, Texas. 1941

# CHARLES
# STEINHEIMER

CHARLES STEINHEIMER: I was an experimental-psychology major at Stanford University in the late 1930s, studying eye movements in relation to speed of reading. The psychology department had a 35-millimeter movie camera and a darkroom. The head of the project asked me if I knew about film, and I said yes, but I had never had a serious camera. I went over to the library and got various books. I've always been a kind of technical nut. I realized that with a B.A. in psychology in the late 1930s I would be very lucky to get a job in a service station pumping gas. The alternative was to go on to advanced degrees and teach. I had less interest in teaching than pumping gas.

After I left school, I went to San Francisco and met Hart Preston, who had preceded me at Stanford by four years. He was a teacher of drama and English in San Francisco. We shared an apartment on Telegraph Hill.

Preston had produced a little magazine, *Life in Mexico,* which he'd printed and sold in Mexico, so we went down there. We got an apartment in Mexico City and sent in picture suggestions to everybody—*Life, Collier's,* anybody else we thought would buy pictures. With *Life,* our main contact was Edward K. Thompson, Wilson Hicks' assistant.

*John Loengard: Was* Life *asking you to take particular pictures?*

They sent down suggestions. For example, oil had been expropriated not long before, and the Mexican supreme court had pronounced it was legal to take over the American properties. It was imperative that we get a picture of the supreme court, which was almost impossible because they were rarely all together. Finally, I got the picture, and they ran it. We knew the importance of the expropriation story, but I didn't quite know how *Life* pinned a story to an event or a picture.

They did a huge story on Mexico for 15 pages or so. They weren't all our pictures, but many were.

Wilson Hicks offered to pay my way to New York. For two or three months I worked out of the New York office for Hicks and that lovely Peg Matsui, who worked for him. Then I got into some major disagreements with Mr. Hicks.

*About what?*

We just didn't seem to see eye to eye. I was a country boy in the big city, and I didn't know how things went. I had lived in San Francisco, but New York was intimidating. Hicks wanted me to do a story on what a country hick from Reno, Nevada, would look at in a big city like New York. I worked hard at it, but it was rather an unsuccessful assignment from my standpoint and from his.

*Many people have said that Wilson Hicks was not particularly responsive when looking at pictures.*

Hicks was a very literate person, a very educated person. But he didn't appeal to me as much as Ed Thompson did.

It's really a little bit funny because I wondered what Thompson would do when he retired. A close friend of his, A.B.C. Whipple, who is also a very close friend of mine, said, "He's thinking about writing a book on picture editing."

"Well," I said, "that's the dumbest thing I ever heard." Because Ed would kind of chew on a cigar and say, "You do this, and then, when you get there, you feel around and you get to know some people." He was never specific. But somehow you knew what he wanted. I don't see how you can write a book about that.

He never did, of course.[*] Some people in the picture department would send four- or five-page telegrams saying, "Move in for a close-up. Then back off . . ." The photographers paid no attention. We'd throw those telegrams away. One guy in the picture bureau was guiltier of that than most. I won't say his name because he was a very nice man and I liked him very much. He thought he was doing a great service. But this was in contrast to what Ed did, which was kind of wave his arms and breathe through his nose a couple of times.

I don't know if you know how we worked then, but there were no rental cars. The only credit card was the International Air Travel Card you could use to buy plane tickets, and this was billed directly to your employer. If we were not in a town where we could use a taxi, we had to buy a used car and turn it back in, maybe at a pre-agreed price and maybe in the next town or something. In 1941 I went to do a story on an Army base being built in Bastrop, Texas. I bought a car in Austin to drive over every day because they had no hotel in Bastrop. And very little else, as a matter of fact. I spent about two weeks there. Then, a few months later, I went down again when it was swarming with G.I.s. Nothing was ever heard of either segment of the story. A big news story had come in. They put Bastrop off a week, and then another. You know how those things went. If

---

[*] Edward K. Thompson would finish *A Love Affair with LIFE & Smithsonian* (Columbia, Mo: University of Missouri Press, 1995).

San Quentin. 1947
*We lived in the prison for five weeks.*
*The warden said,*
*"Harm a hair on their heads,*
*and you'll never hear the last of it.*
*I'll be after you."*

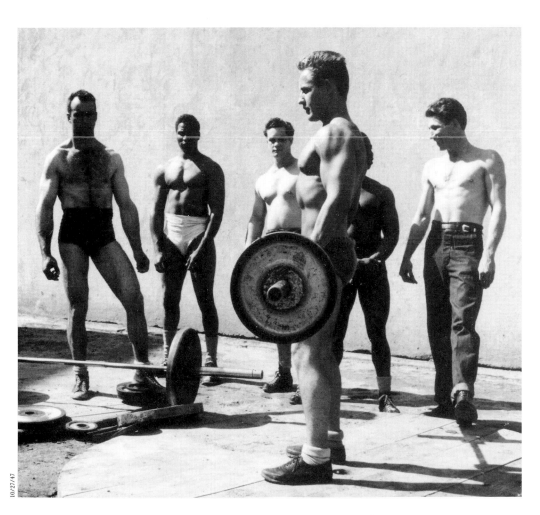

it was put off for a week or two, it was down the drain forever.

*Tell me about San Quentin.*

That was after the war. I got out of the Navy in 1946, and they offered me a staff job in San Francisco. A correspondent, Martin O'Neill, and I lived in the prison for five weeks, every day. Clinton T. Duffy was the warden then. All the cons loved him. He said, "Harm a hair on their heads, and you'll never hear the last of it. I'll be after you." Anything Duffy said, happened in that prison. Never been the same since. I wouldn't want to try to do it again. But he made it possible.

I took a train to New York with the pictures, instead of flying, which nobody liked my doing because they liked to keep the photographers working.

*Were you working every day?*

Boy, close to it. One thing or another. I'd go away and be gone for maybe a month or six weeks. If I wore out a suit, I'd buy one wherever I happened to be.

*What was the effect of this on your family?*

Disastrous. My marriage was a disaster. I couldn't really, in all honesty, take my wife with me, because she couldn't cope with the rigors of the life or the rigors of the work. Travel raised the devil with the lives of a lot of the photographers. I don't know anybody—well, there's Carl Mydans. But Shelley traveled with him all the time. That was different somehow.

*Why did you leave* Life*?*

Something had been bothering me for years. It's the invasion of privacy involved. Some photographers this didn't ever bother. It troubled me greatly. I went to Germany in 1949 during the Berlin airlift. I lived in Berlin for a couple of years. Things were still chaotic. Germany was still in rubble. And although I'm of German descent, I was very unsympathetic to the Germans. But if you take good pictures of people, you take pictures of their involuntary musculature. If you get to know people, a great deal of tragedy shows in their eyes and their gestures. Well, to me, it—I don't know. I just couldn't cope with that problem anymore.

After I quit, I went to live in Paris. I joined Magnum Photos for a while, and I did a story in Yugoslavia and a few other things, but not much. I came back to the United States. I quit professional photography. I went into electronic engineering at the Ampex Corporation. I worked on the first helical scan recorder. The video cameras you have now are a derivation of that scheme.

*Do you think photography is an art?*

I consider that photography is an entity in itself. One of the most wonderful photographers, I think, was a man named Carleton E. Watkins. He came out West in the 19th century and did all kinds of wonderful pictures of Yosemite and panoramas of San Francisco. He used 11x14 inch and 16x20 inch wet plates. He'd have to climb mountains with 2,000 pounds of equipment on mules to take these pictures. The plates had to be developed within minutes of exposure. Even the lenses must have weighed 50 or 60 pounds to cover that kind of plate with any kind of speed at all. He was a wonderful photographer.

When I first got to New York, I got to know Gjon Mili very well. Gjon had some idea that because of my technical interest, I understood all his strobe light equipment. We went to the Army proving grounds outside of Washington. Professor Harold Edgerton had developed a strobe flash of two-millionths of a second, and Gjon was using it to photograph antitank shells hitting armor. We used a microphone to trigger the lights and went through about six or eight cameras.

*Were you doing this head-on?*

Oh, no. From the side. But the shell would explode, and the splinters would hit the camera equipment and the lights as well. A lot of equipment went down.

I got very fond of Gjon. Years later he had that accident. Gjon made a lot of money but wore such ragged clothes, it was terrible. He said that's what he'd like to be, a Gypsy. The paramedics figured this bum had got brushed by a car, and they took him to Bellevue Hospital. He never really recovered from that. He wasn't physically injured much, but it really shook him up. Ruined his self-esteem or something. He was Albanian. Not long after, I went up to the *Life* darkroom. Gjon came in. It broke my heart to see him.

*Is there anything else you'd like to talk about?*

Well, I think we've covered most of the things, but I'll tell you a funny story about Otto Hagel. He died about 20 years ago, and Hansel Mieth had a little gathering of his friends up on their ranch in Santa Rosa. There is a lovely garden outside of the house. They didn't have any minister telling us what to do. People got up to reminisce about Otto and what he'd done.

Imogen Cunningham got up—she's only about this high and weighs 95 pounds wet. She stood up and said, "Otto was the only fat man I ever loved." And sat down. That was her tribute.

I've really not taken any serious pictures since 1953—a long time. But I look at things; I still have a habit of looking at things pretty carefully.

*When you look for pictures, what's your eye especially drawn to?*

Expression and posture. My early psychology training led me to investigate the voluntary and involuntary muscular structure of the body. It's so apparent, if you look for it. Genuine emotions are expressed. I see so little of that on the current TV. I don't think this is any longer real photography.

*So little of?*

Genuine emotions expressed. The difference between a good picture and a terrible picture of the same people in the same situation is involuntary muscular use. I spot a posed picture every time. It just looks phony to me. It's just the way the eyes and the expression of the face and the bodily muscles are different.

*So, in your view, a good picture has to be an invasion of privacy?*

It doesn't have to be. But it usually is.

On the *Life* staff 1945-50
Interviewed in San Francisco on August 13, 1993

247

They would publish my pictures, even
though the magazine's editorial
direction may have been for Eisenhower

Adlai Stevenson. Springfield, Ill. 1952

# CORNELL CAPA

CORNELL CAPA: I was darkroom technician at a picture agency called Pix in 1937, meaning that I worked with all the Pix photographers, which included Alfred Eisenstaedt, George Karger, Hans Knopf and a bevy of other great fellows. I printed for them. Ralph Morse was one of the young photographers who became part of the darkroom staff. Yale Joel was another. W. Eugene Smith kept on coming in as part of the young visitors. Besides these regular people, my brother, Robert Capa,[*] was a correspondent to Pix, and I was in charge of printing his work and corresponding with him because his English was extremely poor and nobody else spoke Hungarian. So I was a bridge between my brother and Pix.

*John Loengard: Why was your English better than his?*

The Imre Madách Gymnasium in Budapest was a classical gymnasium, which is a high school plus. In Bob's time he had to take Latin and Greek. I was five years younger than he, and by the time I got to my fifth grade, where you had to start taking Greek, they allowed us to take a modern language. I took English. So when I came to America I already spoke English fairly well. English-English, because our teacher was an English English teacher, not an American English teacher. Bob had a useless Greek background, and I had a useful English background.

When I finished my studies in 1936, I went to Paris to join my brother. I wanted to become a doctor and forgot that I didn't speak French, so I had to go to

---

[*] Endre and Kornel Friedmann were brothers born in Budapest. By 1936 Endre found that his photographs sold better when his girlfriend told editors they were taken by Robert Capa, a fictitious American photographer. Endre kept using the pseudonym, and Kornel changed *his* name officially when he became a U.S. citizen in 1944. (Richard Whelan, *Robert Capa, a Biography,* New York: Alfred A. Knopf, 1985.)

study French before I could go to medical school. My brother had started to work with Henri Cartier-Bresson and David Seymour. (David Szyimin was his real name, but nobody could pronounce it, so he became known as Chim.) I worked on their pictures in 1936-37 in Paris. I was used to printing 35-millimeter negatives in my bathroom, which I converted into a laboratory. It was Rue Vavin in a small hotel facing the Café Dôme. I had a room on the top floor, and if I stuck my head out from my roof window, I looked right down on the Dôme, where all the photographers, artists, foreigners, philosophers and Parisians met and drank coffee. When I arrived in Paris, the first night I drank black coffee late in the evening and didn't sleep all night, so it was part of my getting used to Parisian life.

Medical school fell by the wayside because of Cartier-Bresson and my brother and Chim being photojournalists. The original idea was that I was to cure the ills of people as a doctor; but as I developed my photographic life, I became a specialist in the ills of mankind in my photography. So actually I enlarged my vision. In 1937 my brother was in Spain to cover the Spanish Civil War, which was the major confrontation of that period, and I became very much involved with it because of my brother's work. I became aware of the effect photography could have on the outcome of revolutions, oppressions, prisoners. I was an 18-year-old fellow, and my political education was totally connected to the photography that Cartier-Bresson, my brother and Chim were practicing. The times I grew up in became part of my conscience and my photography. I was not an artistic photographer and never became one.

*What is an artistic photographer?*

Taking wonderful still lifes of things on tables, of landscapes which are bucolic and beautiful. I haven't taken a landscape picture which was not part of a story. If I saw a peasant working in a field—which was very difficult for him to do—then I took the picture of a peasant with a field. But I didn't take a field without the peasant. The environmental and social condition became part of my photography.

As a printer, I was able to print extremely well. I could understand—like a musician, I could follow a score which the composer had written. If I did Eisenstaedt's prints, I knew what he wanted. I knew his style. I knew what contrast he wanted, the quality of his blacks, the way he wanted to present his work, which of course made me understand how to play a violin—how to play the camera, how to produce pictures with the best effect eventually. I could master the instrument with which I could eye-witness, with which I could comment. It was an academy for a young man to learn how to become a photojournalist.

*At* Life *I heard various editors say your brother was a terrible photographer (as far as technique was concerned) and that you were a wonderful photographer. My question is: Were your brother's negatives a bitch to print?*

Well, this gets us to all kinds of things obviously, and one of the obvious things

is that very few *Life* editors were photographers. I'm making the point that the understanding (or the misunderstanding) of what makes a negative a bitch to print is not exactly an informed position. Editors are interested in images which in their view tell the story which the photographer attempted. When my brother went to China in 1938, all kinds of conditions, including dirty water to develop films, had nothing to do with the quality of the information in his pictures. The two had no relation to each other, and great photographs could have been—and were— taken by him with scratches on them. Or dirt on them. The relationship between a great photograph and a slightly out-of-focus-looking or a dirty print—there's a relationship, obviously, but it is not the important relationship. As for being a great photographer because I have clean and beautiful prints, I can make clean and beautiful prints, but it does not make me a great photographer.

*During the war, you were in the Army Air Force. In 1946 you joined* Life's *staff as a photographer and worked in Texas, doing a lot of little stories. I see a great change in all that when you go to England in 1949.*

Growing up as a photographer is like going to medical school and becoming an intern. You start understanding what the world is about and how to translate it into photographs. You may become more efficient, more proficient, more educated, more intelligent, more loving. If you're not moved by what you're looking at, your pictures will not contain the human response. For me, England was a very wonderful experience because it took me back to Hungary, to the fifth grade where I had my English teacher and I started to read English literature.

I had an interest in the human race and in expressing my interest in words or pictures, or words *and* pictures. My learning period in Texas was five-finger exercises until I went to England, where all my schooling in English literature became a living thing for me. My translations of that into photographs became a joy because I was able to sing a libretto. Until that point in time, I only learned technique. Now I was able to express myself with an understanding and loving potential. I loved the subject, and I responded to the subject, and I could express the subject. England moved me, and New York and Texas hadn't. (I was not ready. The subjects are here, but I didn't understand them.) I loved the idea of the English, so all my interest in telling the world about them became a joyous exercise of photographic information and photographic storytelling.

*How long did you work on the story of the Winchester School?*

About three months. The story of the school was amusingly revelatory about how the Englishman is made. To understand this process and to share their life was very exciting for me. I stayed in a small hotel in the town of Winchester. This hotel had its own Brussels sprouts garden, and I had Brussels sprouts every day, and I hated the Brussels sprouts. To make up for the Brussels sprouts, they also had a wine cellar. We had a Chambertin 1937. I could suffer the Brussels sprouts if I could drink the wine, and this became the routine for three months. The day they informed me that there is no more Chambertin, I finished the story

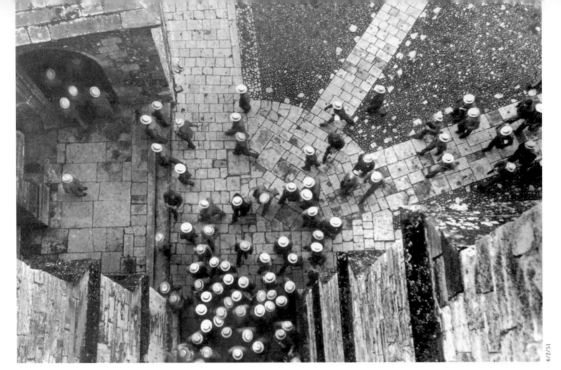

Morning chapel,
Winchester School. England. 1951
*All my schooling in English literature
became a living thing.*

Cold baths,
Winchester School. England. 1951
*I loved the idea of the English.*

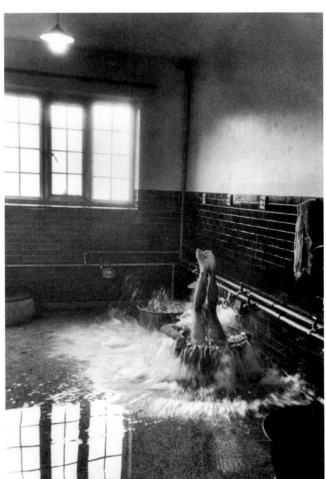

immediately. It's very difficult to start a story and very difficult to say the story is now finished. But the wine did it for me.

*Did you have a voice in the story's layout and text?*

This is one of the mysteries of *Life*. Sometimes you did, and sometimes you didn't; but in this case, being in London, I had absolutely no influence at all. However, the Winchester story was very well done. Edward K. Thompson was the man involved during that period, and it was a great period of *Life* magazine when he was the editor. And there was Bernard Quint, who was an assistant art director then. It's very difficult to pinpoint who understood your work the best and who favored it best. To make a magazine is a very, very complex operation.

*You did a public school, and then you also did the Queen's Guards, which is a further forming of an English gentleman.*

It was my idea. And my third idea, which I never got to do, was the foreign office. By the time I finished the Guards, the time had come to come back here because I kept on hearing the English-speaking voice of Adlai Stevenson on the radio. I was very much interested in the ideas of Adlai Stevenson. I wanted to come back to photograph American politics.

*Why Adlai Stevenson particularly?*

His lofty ideals and his use of language and his ideas were all important things. I was just interested in it. I had filled in for some other photographers in Washington covering Truman. So I was very much interested in the American political idea. Democracy in action, all that. Democracy meant a great lot to a Hungarian who lived under Admiral Horthy's regime in Hungary.

*How much does language mean to you?*

It is becoming fairly clear that my English teacher in Budapest had really done much more than teaching me the language. I was attracted to the English language. I was attracted to come to America. I was attracted to go to England. I was attracted to come back to America because of my linguistic preference— to hear wonderful English spoken. Well, of course, to tell you all of this 40 years later, with my Hungarian accent, you must—

*It has a certain charm. In 1952, Henry Luce favored Eisenhower, after 20 years of Democrats. It's often said that* Time *magazine's coverage was not entirely fair to Stevenson. Did you feel that* Life's *coverage of the campaign was evenhanded?*

I wouldn't know whether *Life* was evenhanded. What was important working for *Life* was that somehow Ed Thompson's kind of editorship reflected good photography and good stories. If my pictures were exciting enough, with insight and understanding and all the rest of it, they would publish my pictures, even though the magazine's editorial direction may have been for Eisenhower.

*You said you became interested in politics—the Spanish Civil War—and that you'd come back from England because of Adlai Stevenson—not language only, but politics.*

Right.

*These are ideas. But, on the other hand, you keep saying that the photography that interests you is*

*very human. And it seems to me that ideas and politics are abstract; humans are not. How do they blend?*

Well, I started to look at Stevenson as a candidate. And in the process of doing the story on him as Governor of Illinois, I learned of the man on a one-to-one basis, confirming who the person was behind the voice I heard on the radio in England. Television made its initial debut at the 1952 Convention, but *Life* magazine still played a tremendously important role in informing the world about the candidates and their ideas in words and pictures. The photographer was the eye-witness selector of what he photographed. A very important person. Me. Nice old Hungarian fellow. I became a very important fellow because it was my job to bring insight to the world about the man called Adlai E. Stevenson.

It was a very interesting campaign because Eisenhower was a likable person and he'd just won the war. One could have been excited about him, but I was not. It brings up the very important question of whether the photographer is an objective onlooker or a participant. This goes back to my brother's work in Spain, where he was on the republican side. He could not possibly be assigned by his newspaper or his magazine to be on Franco's side. He wouldn't have shared the conviction of what that side stood for. I had excitement for whatever Stevenson represented, and my pictures would, as much as I could, present him in a sympathetic kind of a way. *Life* allowed me the freedom to photograph as I would, and presented my work in a clean fashion. It was a very important case in the point of freedom of press—freedom within the press, freedom within the magazine.

*If* Life *wished to make Adlai Stevenson look bad, how would they do it?*

Well, for example, reporting on the results of the British elections in 1951, the magazine published Alfred Eisenstaedt's pictures of Churchill with a V sign and beaming facing a picture of Attlee sleeping. This was a true exaggeration of history, and manipulation of a photographer's work by editors.

*How can a photographer, using an objective box, make people look like what he feels?*

Well, I look to the left or I look to the right. What I photograph will provide material for the magazine eventually to choose from. They have to accept my eye witness, which is from a sympathizing side, not the objecting side.

*You photographed Adlai Stevenson sitting under a tree. Did you ask him to do that?*

You're asking a very good question because normally I wouldn't have asked him. I asked him to do that because it demonstrated to me Ferdinand the bull. Stevenson was not ready. He was very dubious whether he was a man to run for President. He had self-doubts about his value. He reminded me of Ferdinand, the bull who would rather smell the flowers than fight. He was undecided, sitting in a field under the tree during the weeks proceeding the Convention, when he would have to say, "Yes, I'm running." To me it was a symbol. Very seldom would I attempt to make an icon. We are talking about one particular occasion when the photograph is not documentary but expository.

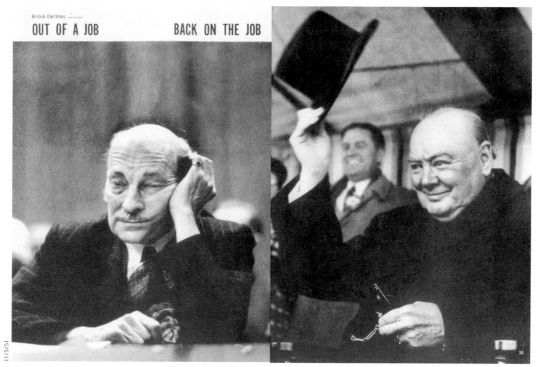

OUT OF A JOB          BACK ON THE JOB

Clement Attlee and Winston Churchill, photographed by Alfred Eisenstaedt. 1951
*This was a true exaggeration of history, and manipulation of a photographer's work by editors.*

Adlai's shoe,
photographed by
Bill Gallagher of the
Flint *Journal*. 1952
*What on earth is
worth taking a picture
of with a flash at
6:30 in the evening?*

*What's your favorite picture of Stevenson?*

The one that will live. So I might as well tell you the terrible story. On Labor Day in Detroit, at the end of a very long day of motorcade caravans, ending up someplace at 6:30 in the evening. A sudden downpour ruined a rally, and there's a couch from somebody's house on top of the outdoor platform. G. Mennen Williams, the Governor of Michigan, and Stevenson are sitting on this couch. The couch is a wreck, so when these two people sat on it, their feet went up as they sank into the couch. I was on the ground, and I was tired. I'd seen enough of Williams, and enough of Stevenson, and the day was over. There was no picture there, as far as I was concerned, so I was circling the platform to see if there was anything else to be done. There was another photographer circling around with a Speed Graphic camera with a flash. A local-looking character who took a picture of the two of them sitting there. I thought to myself, What the hell is he doing? What on earth is worth taking a picture of with a flash at 6:30 in the evening on this platform? Well, that was the famous picture of the hole in Stevenson's shoe. Whether the photographer saw it or not, the Associated Press editor saw it and enlarged the picture. The most famous photograph of Adlai Stevenson was taken right in front of my nose, and I didn't take it. For the next 12 years when I was photographing Stevenson, I kept on telling people about my great love for him and all he stood for and all the wonderful pictures I have taken . . ."Oh, you must have taken the picture with the hole in the shoe." So there you are.

*What does that mean about photojournalism. You are devoted to photography. You're at the top of your profession. You've been following a presidential candidate for several months. Some local photographer snaps a picture, maybe not noticing that there was a hole in the shoe, and that becomes the telling picture. Is there any lesson in that, other than humility?*

It's like Lotto. You have to have money to buy a ticket, and without having bought a ticket, you will not win. Obviously, here, somebody had a better number. But basically it's Lotto because all your intention will not result in a great photograph. Then, again, Edward Steichen said, "How come luck happens to the same people all the time?" So there must be something else too. I am going to write a book eventually with 12 pages blank. There will be 12 stories of where I missed a picture with a blank page to start each.

I'll tell you another. Five missionaries were killed in Ecuador in 1956. I flew down to Ecuador and arrived in a helicopter to the spot where they were burying the murdered missionaries. The grave that they dug was right on the edge of the jungle, and outside of the jungle was very bright. In the jungle it was very dark. I can see right in front of my eyes when they dumped the body of one of the missionaries into the grave, and I could see his leg move from one side to the other as they threw him in there. I took the picture, but I did not adjust the camera sufficiently to have any detail at all. It's a very dark, black picture. I see it now in my mind, but I don't have the picture.

The story of these heroic missionaries, who tried to bring the word of God

to the Amahuaca Indians in Peru, occupied 10 years of my life. Because I kept in touch with people who were involved, I got involved with the Indians and the missionaries. It brought me to all kinds of worlds which I kept going back to. I produced a number of books on it or the same kind of a subject, but I missed the picture, the one that really was the opening key to that story.

So it's like that. I spent 25 years of my life doing different stories in Latin America because it is a terra incognita—an unknown world—because the American press is not very interested in Latin America.

Going back, what *Life* meant depends on the period. *Life* from 1936 to 1941 is exciting. It is just born. It's something fantastic. It brought a world to your living room. All the things which one could say now about television. *Life* was the eye witness of the world. Another very important period began in 1952 when television came in and the competition between video and magazines began. They shared the duty and potential of bringing the world to your living room. But from 1962 to 1970, television won and *Life* declined—not because people were less interested in looking at the world, but the visual imagery on television was much more urgent, made more exciting by words and music. There was a whole new mix which was a more interesting mix than pictures and captions coming a week or two weeks later in a magazine. In my lifetime the panorama of photography has shifted. What does the shift mean to photography? What does it mean to the public? What does it mean about *moving* the public? The hope once was that still photographs were telling the story that war is hell. Still photographs didn't encourage men to be viciously inhuman to their fellow men.

What happened in the last 10, 15 years with television is exactly the opposite. I am very much involved in all of that because of having started the International Center of Photography,[*] which was dedicated to documentary photojournalistic work and its importance. How will the importance of that institution last under the onslaught from television, the usurper of that territory? In my short lifetime there's been a complete shift, from still photography being superimportant to unimportant to important differently. In what way did the Gutenberg Bible change people's thinking? The entrance of still photography in *Life* magazine was as important in the next chapter. The entrance of television is the next chapter, and still photography as work of art is a current chapter. How will it all look when the century ends up?

*You published two books on "concerned photographers." There are 14 photographers in the two books, but your brother, Gordon Parks and W. Eugene Smith were the only three on* Life's *staff. Were other* Life *photographers—say, Leonard McCombe, Alfred Eisenstaedt, Margaret Bourke-White, George Silk—not "concerned photographers"?*

Well, the 14 people I used were indicative of the many. They were outstanding people in their imagery and their conviction and concern about humankind.

[*] At Fifth Avenue and 94th Street in New York City.

There were plenty of others: Dorothea Lange or Alexander Gardner's American Civil War pictures. It's an important segment of photographers that had an optimism that people would see these photographs and feel the power of man's inhumanity to man, and as a result would revolt against inhumanity. It didn't quite work out that way. We're witnessing on television whatever happens in all the different places, but instead of having an awakened conscience, it goes into the mind in a different way than with a still photograph. Something is wrong somewhere. Instead of an awakened conscience, there's indifference. It's very discouraging to the idea that if people know what goes on in the world, it will get better.

The discouraging news today is the feeling that more knowledge and an awakened conscience are no guarantee of betterment. The sacrifice by all the people who died in the process to bring the news back to us visually—my brother killed in Indochina in 1954, Larry Burrows in 1971, Henri Huet—nothing happens. It's very hard to take.

*You yourself covered the Six-Day War.*

I don't want to talk about that because it was accidental. It contradicts what I set out to do, to work peace and not war. I got into that war by accident, and it just complicates the picture.

*Let me change to a technical subject then. What do you find different using color film rather than black and white, if anything?*

I looked at color not for color's sake. Not an artistic decision. The Orthodox Church in Russia, for instance, was more exciting looking in color. It was not an artistic decision. It was a natural decision because *Life* was open for accepting color, so I had an option, and the story looked magnificent in color. *Life* published 18 pages of it because it was exceptionally revelatory and beautiful. I did not go to the Soviet Union for the color opportunity, but because it was a good story: how under a Soviet regime in 1958 the Russian Orthodox Church could do very well indeed.

I brought along stroboscopic lights of all sorts. Available-light photography is one school of photography. I made light available, which is a different school. I would make the invisible more visible by using artificial light but not changing the atmosphere in the photograph.

*This is very different from your mentors. Your brother and Chim and Cartier-Bresson, I suspect, didn't know how to plug a light in on their own.*

We are all learning from the experience of others, but we don't want to be minor copies of our masters. I hope that my stories are more interesting because of my technical capacity to do things which they could not have done.

*Did you work with reporters often?*

It's an interesting question. The television world starts out with a shooting crew of two or three people, and the photojournalist is a loner. I did a story on a Philadelphia family where the old Irish grandmother lived with the family. The difficulty of living with the old-fashioned mother in the new-fashioned family was

very difficult to understand and to translate. It is the role of the photographer to do all of that. Of course understanding and sensitivity to the situation is number one. How to be present and be a fly on the wall. I myself had a very lovely, very strong mother who was an old-fashioned lady—like this Irish lady was. I lived with my mother quite a long time, so I knew exactly what these old-fashioned ladies do—be it the Jewish mother or be it an Irish mother. Injecting one person into a situation changes the temperature of what goes on. To inject two people would totally ruin the idea of what goes on. It took me a week living with the family, and by being a conciliator I made them like each other more. In order to make available light more available, I made the house a stage and put photo flood bulbs in place of regular household bulbs. I would turn lights on, depending on where the action was to take place, and people just got used to having more light, but their actions didn't change particularly.

*The picture where the daughter-in-law and a visiting friend are talking in the foreground and the mother is in the background.*

It was a totally unposed, natural picture. The two women are at the kitchen table, and then the mother is in an adjoining room. As I said before, I had a mother, so for me to be in a position of where I was in that house, I understood what the picture was. For the moment, two young women live in the same house but in a different world than that old lady does. So it shouted at me.

*How do you feel about posing people? You did Stevenson, but—*

It's a very delicate area, how to be a commentator and how to be an observer. What is within the range of allowable freedom to make things tighter, make them be more natural? When is a posed picture more representative of the real importance of a particular relationship? It's a very delicate subject. I mean—to be pure could mean to be lousy. And to be very skilled, could be fake.

*Would I recognize it as fake?*

No.

*Do you think fake photographs are believed?*

Well, maybe the word fake isn't—maybe *posed* is a more relevant remark. I'm not very sure that it's not legitimate to ask them to move closer to each other.

*Not really sure that it's not. So it is legitimate?*

[*Pause*] I'm trying to find a way to define what the change is. The world is a stage, said some Shakespearean fellow. And the players are the players. The stage is there. The players are there. The photographer is there and wants to get a photograph which is indicative of the players' relationship. Asking them to do something that is going to be more explicable, more characteristic—How to say that this is posed? Everything is real except I asked them to do something. To move closer. How does that change the meaning of the photograph, except making it more meaningful?

*Did you pose any in the White House?*

No. I went to the Inaugural, January 20, 1960, which was the coldest day in

that part of history. And I heard John Kennedy's Inaugural speech, which moved me very much. Language and spirit fused again. I went to the telephone and called my friend Dick Grossman at Simon & Schuster because I had an idea. Kennedy said that the torch has passed to a new generation of Americans. The phrase rang in my ears. I called him and said, "Dick, I just witnessed the great Inaugural, the speech. Now, how would it be if we would photograph what Kennedy sketched out—the immediate future of America. We'd have 10 photographers and 10 historians to create an instant book, which would come out on the 110th day?"

He said, "That's fantastic. Wonderful idea."

So we did exactly that. I chose the White House to be my own photographic part, because I knew John F. Kennedy and knew Jackie from earlier stories. It was a Magnum project, not a *Life* project. Cartier-Bresson went to do Robert Kennedy. Someone else went to Detroit to do the unemployment in the automobile industry. And so on. We closed each chapter separately, so the last chapter was the only thing we had to do on the 90th and 100th day.

There was only one terrible problem. On the 97th day, the Bay of Pigs happened. Which sort of spoiled things a little bit. On the 110th day, we did publish the book, which was an instant success. The final picture is my photograph looking at this presidential chair saying January 20, 1961, from the back, and you can see the top of J.F.K.'s head—his hair. There was an empty page facing it, so we asked Barbara Ward to write a piece on the Bay of Pigs.

*How close did you get to John Kennedy? Did you feel you knew him at all?*

No.

*Robert Kennedy?*

No. But I spent an incredible day with Robert Kennedy, after the assassination, when he ran for Senator of New York State. We went to Buffalo, to Albany and all that in his private plane called the *Caroline,* and I witnessed how he became J.F.K. in the process. He tried to get away from his brother's movements and all this, but in no time at all he fell into an imitation, and that's how people reacted to him. They thought that this was John F. Kennedy come back from the dead. It was a most incredible 24 hours I spent with him.

*How did you hear about your own brother's death?*

Oh, God. How much do you want to open this subject?

*As much as you want.*

O.K. I was doing a retarded-children essay, which was one of my most important pieces of work actually. I was having dinner with some people at this Connecticut place. I forgot the name of it. And the phone rang, and Ray Mackland, my assignment editor, was on the phone telling me the incredible news: "Before you see it on television, I have to tell you." And then he told me that my brother stepped on an antipersonnel mine in Indochina and that he died.

Thereby hangs my whole professional life. My personal life took a tremen-

dous turn. I left the *Life* staff. I became a contributor to *Life*. My whole understanding of the meaning of having photographs of the past uncared for—left to be forgotten—how important the preservation of work and dissemination of past work is. The whole idea of the International Center for Photography developed out of it. I was thrown in this melee of what photography's role is in the 20th century. It completely changed my outlook on the importance of past work and how to look at photography in the contemporary world. It has shaped my actions as a photographer and as a founder of an institution that is dedicated to photography, its preservation and its importance.

*Did you or your family blame* Life *for your brother's death?*

No. Well . . . how much does one believe in fate? Bob had a very, very exciting life, and he was protected by . . . whoever. He was very, very smart about his brave actions, so he seemed to have known how to take the right risk at the right time. He didn't look at it as bravery. He was a gambler in his personal life, so he knew the odds. And whether the odds are in favor or not, bravery could not change that, as far as he was concerned. He was not calculating as such, but when he went out to do what he wanted to do, he attempted to do it the best. It's the difference between the amateur and the professional. He was a professional war photographer. He knew how to be in the action and be as safe as you can be. He declared in 1947 that he wanted to be an unemployed war photographer for the rest of his life. It was a proper, war-hating kind of declaration, and he broke that once for the War of Independence in Israel, for all kinds of reasons which are too complicated to tell. He did cover that one, and did some marvelous photography. Following that, he went to Japan in 1954 at the invitation of two Japanese friends. They all knew each other from 1936 Paris days, and invited him to Japan for an exhibition. A camera magazine was being launched, and they wanted Bob to do a story on something that he wanted to do in Japan, so he photographed the children of Japan, which was a lovely type of a story of his. A family problem of a *Life* photographer who was in Indochina suddenly meant that the photographer had to come back to the United States on a family compassion visit. His mother was very ill. A natural thing occurred. *Life's* assignment editor knew that Bob was in Tokyo and just asked, an innocent suggestion: "Would you want to replace him for a couple of weeks?" Bob was free to say yay or nay. And he was saying nay for some time because he wanted to be an unemployed war photographer. Why he said yes—Who knows? Pride of living his own mythical figure? Whatever you want to imagine. He had been involved in all kinds of things, writing books, working on all kinds of other projects. He was not a professional war photographer anymore. Normally his answer to that offer would have been, "Why would I do that?" But that was not his answer.

He went to Indochina, and there was no great story there. But he died on a not-important road, in a not-important action. It had to be fate for him to do

Grandmother. Philadelphia. 1959 *I had a mother, so I understood what the picture was.*

Boris Pasternak. 1958 *A Russian garden which has doom written all over it.*

that. There's no other way to explain it. He had a full life cycle behind him. It was a question of what does one do for an encore in a different kind of world. Become a writer, become a television producer, become whatever one needs to become? His work was finished as a great war photographer who photographed war in all its monstrosity all over the world, and he brought us the picture of what war was all about—psychologically, physically, spiritually. Since Bob's death, I have organized a great number of books on his work. Putting it all together, he gave us a picture of Dante's Inferno. One man's view. It was a finished piece of work, and nothing he would have done after that would have added to his great contribution to our understanding of ourselves. So I think it was a proper ending of a great story.

*If the world were ending, and you could escape to Mars but take only one of your pictures with you, which would you take?*

We didn't talk about Boris Pasternak, I suppose.

*No, we didn't. We can right now.*

When I was in the Soviet Union in 1958 to do the Russian Orthodox religion, Jerry Cook, a fellow photographer, came to Moscow and brought with him *Doctor Zhivago*, the English edition. In this terrible hotel of mine, I was cold as all hell. We're in November. It was just as unfriendly cold as you could have. I was reading *Doctor Zhivago*, totally coincidentally, and then came the news that the Nobel Prize was given to Pasternak. The dean of the American correspondents in Moscow, Henry Shapiro, arranged for me to go to the dacha of Pasternak the following day. And so I did, and had the most incredible day with Pasternak. It was his wife's namesake day. He made a toast to Madam—wonderful picture; a toast to freedom. Then in the cherry orchard, behind him is this terrific picture of a Russian garden which has doom written all over it. My final look at Pasternak was sitting on a garden bench with the incredible scene of that orchard garden. You couldn't get a sadder picture—wanting to remember *Doctor Zhivago* or Boris Pasternak—and that picture was the last one taken of him being visited by a foreigner: me.

*Did you suggest he sit?*

Maybe it's a Stevenson picture.

*This becomes a category of photography: "Stevenson picture"?*

It was there. It was part of the association of ideas.

On the *Life* staff 1946-54
Interviewed in New York City on October 25, 1993

# I stayed on to cover the children, and I was arrested by the NKVD

Warsaw. 1946

# ANTHONY LINCK

ANTHONY LINCK: I grew up on a farm on the western slopes of the Adirondacks between Utica and Watertown in a town called Booneville. I had two goals in my life as a teenager. I had always wanted to fly, and then I became interested in photography. I started free-lancing for the Rome *Sentinel*, covering basketball games and school activities north of Rome, New York.

When the war came along, I tried to enlist in the Air Force, but I couldn't get in because I wore glasses. I had started to take pilot lessons in 1939, but there wasn't any chance to do civilian flying on the East Coast during the war. I started submitting pictures to *Life*, and my first big assignment was on bobsledding at Lake Placid. I stood in the trough as the sled came down, and that was the lead picture. That got Wilson Hicks' attention.

As soon as the war was over, I got my pilot's license. Hicks asked me to join the staff, and I went overseas for *Life* in 1946. I still have my British pilot's license from then, and I got a French pilot's license too. I flew around that area just because I loved flying.

*John Loengard: You didn't use a plane to photograph?*

Not then. I had done aerial photography as a photographer with a pilot, as all photographers have, but it was not until I came back from overseas in 1948 and bought a surplus Taylor craft for 800 bucks that I started doing aerial photography seriously. I sold that plane for $1,600 a year later and bought a faster one. In 1958 I bought the first low-wing Mooney. My wife and I flew it everywhere. Al Mooney was an airplane designer in Kerrville, Texas, who later went over to Lockheed.

In a Mooney you sit in front of the wing, which gives you a clear view forward. When I'm photographing something, I bank around it so my subject is like the hub of a wheel and I'm on the rim, going around. That way the subject stays relatively still, and I can keep it in view at all times. In a high-wing aircraft, which is the kind often used for photography, you have to bank away from the subject to keep the wing out of the picture.

If it's an event where other aircraft are doing the same thing, I'll hire a pilot to do the flying and watch the traffic while I take pictures. But I prefer to fly myself because I can see where my picture's going to be and I don't have to voice it out to the pilot.

I photographed all the NASA liftoffs from Apollo 9 to 17. Apollo 17 was just before the weekly *Life* suspended publication, but I was doing it for *Time*. It was a night liftoff that sent the last men to the moon, and I planned what I'd do for several months. The liftoff was delayed so I orbited for four hours, but since I had seven hours of gas onboard, I just stayed up there at loitering speed until the rocket went off at 1:30 in the morning. I listened to the countdown on my radio so I could turn precisely and photograph the rocket taking off.

As soon as I could hear ignition, I started my film. I shot three or four frames a second at a 15th of a second each. I worked on the water reflection as the rocket was going off. I had a special camera with a 135-millimeter lens and a 250-exposure-long roll of film loaded in a special back. I figured at least one out of five exposures would be sharp enough.

*Why did you leave* Life?

I decided I really wanted to make use of my airplanes. I left the *Life* staff in 1949 to free-lance as an industrial photographer. I did annual reports for United States Steel and other corporations. I used my machine—my airplane—to travel to and from plants and do aerials. And I also took a lot of pictures on the ground.

*When St. Peter asks, "What did you do down there?" would you answer, "I was a pilot," or say, "I was a photographer"?*

"Photographer." I love flying, but it was a tool to use in my photography. I got not only a single- but a multiengine rating. I even flew a 707 for a while on a *Life* assignment. The 707 was the first four-engine jet passenger plane. Boeing was training airline pilots out off the end of Long Island, and I was along as a journalist. While the two pilots were practicing how to do an emergency landing gear wind-down, the Boeing pilot handed the 707 over to me to fly. I flew it back to Idlewild [John F. Kennedy] Airport. It flies like it's got two wings, a tail and an elevator. It flies just like a big Mooney.

*Did you miss not doing things on the ground? On* Life's *staff in Europe, you were doing stories on crime, youth—I'm looking at your assignment list—Sir Stafford Cripps, sports, a wide variety of things. Did you miss that?*

When I was transferred to the Paris bureau, my first assignment was in

Warsaw to cover the Polish elections. Then I stayed on after that to cover the children of Warsaw—children who had been maimed by land mines, the crippled children of Warsaw. They were terrifically poor. Devastated. And I was arrested by the Russian police, the NKVD, with Flora Lewis, who was then a free-lance correspondent there for *Time* and *Life*. We were arrested and marched off and then separated and questioned. But on the way past our hotel, I saw the First Secretary of the American legation. I called to him. He's coming on over, and I had two guys with tommy guns poking me in the ribs to march me off. They didn't want me to talk to him, of course. I was rather belligerent. I guess when you're young, just in your 20s, you don't care. I pushed the barrel and said, "Get that damn thing out of my ribs." Of course, they didn't know what I was saying, and I didn't know what they were saying. They didn't speak English, and I didn't speak Polish or Russian.

But they let me stop and talk to the First Secretary, and that was a most fortunate thing. I learned 12 hours later that the legation dropped everything to get me released. The Russians wanted me to sign papers. First it was in Polish, and I said, "I can't read this." I gave it back to them. Then they wrote it in English, and I read it and said, "I didn't do that. That's not true." They wanted to make out that I was a spy. I had given a child some candy bars after I had taken his picture. It was a little kid on a homemade crutch with one leg gone. That's the point when they came up. But they'd been following me before that.

I didn't sign anything, and finally the First Secretary appeared and said, "O.K., we're leaving." They took the film that I had with me, but that was no big deal.

*You didn't miss this kind of adventure when you were flying for U.S. Steel?*

Well, it was a little different, I guess.

*What photographers did you admire?*

I admire Alfred Eisenstaedt. We were all photographing on V-J day in Times Square. I photographed sailors kissing nurses too, but Eisie became famous with his picture. He has that natural ability to put that Leica in front of his face and get great pictures. What a talent!

Also, I admire William Garnett, who uses a high-wing Cessna-172. He's a great photographer. I don't know if he's still flying. I doubt if he is anymore. At some point we all have to quit. But I'm 74 and not retired.

*You don't look it.*

Maybe I shouldn't have said that.

On the *Life* staff 1946-49
Interviewed in New York City on October 25, 1993

As we rounded a corner,
there on this village wall was
the head of General Ting

Tsingpu Hsien, China. 1949

# JACK BIRNS

JACK BIRNS: My favorite picture never ran. It was of a Chinese general. He had been a collaborator with the Japanese during World War II. Consequently he was persona non grata with the Nationalist government, so he went over to the communists. They gave him a detachment of soldiers, and he attacked a small village some miles south of Shanghai. I heard this on the radio and called for our driver to come get me. We went flying down there, and as we rounded a corner, there on this village wall was the head of General Ting Hsi-shan. His body lay in front of him. On the right were a number of bodies which had been disemboweled by spears. They were lying half in this turgid creek and half on the mud bank.

You tremble when you see something like that. I took about half a roll of good pictures before the villagers started to crowd around. They were angry because I had photographed this atrocity. They had lost face. Mr. Chang, our driver, knew this was a tense situation. He took my camera bag and slung it crosswise over his chest. "Time to go, Mr. Birns," he said.

I got great kudos from New York. The picture was laid out for a full page as the "Picture of the Week." On Saturday, the magazine's closing night, it was up on the wall with all the other pictures, and Mr. Luce came down from the 33rd floor. He saw it, and (as I got the story) screeched, "Pull that damn picture!"

*John Loengard: Why do you think Henry Luce didn't want it in the magazine?*

He was very friendly to the Nationalist government and to Chinese generally. I presume he felt such a picture would put the Chinese in a bad light. It was not that it was a gory picture. It was the effect it would have, he thought, on people's judgment of the Chinese.

*Did you meet Luce?*

Never. I've always regretted that because a lot of other photographers had relationships with him. He talked with them and explained his thoughts about journalism. I have a letter from Daniel Longwell, who was chairman of the Board of Editors at that time. He wrote that he and Luce shared a judgment that camera journalism was as important as written journalism. He felt that the images made by the camera imparted such dramatic clout that no writer could match them simply with words. That was a letter Longwell sent me after I was awarded an Overseas Press Club honor.

*Did you know Longwell?*

I met him. He was a sort of a stooped-over, quiet guy. I have to explain I never spent much time in New York. I was a sort of a visitor from outer space. Wilson Hicks called me in to offer me a job after I had been free-lancing for *Life* in Los Angeles for six months. "We have a lot of people who can spend months on a story and come back with beautiful stuff," he said. "But we don't have any news photographers. You're a news photographer, and we'd like to have you go to China."

I went back to Los Angeles and had quite a dramatic meeting with my wife. I said, "Honey, how would you like to go to China?" She passed that off—it was like going to the moon. She said, "I've got to tell you. Today I found out we're pregnant." Pregnancy or no, we packed up and were off to China.

*When did you meet writer Roy Rowan?*

I got there in December of 1947, and, as I recall, Rowan came out in March to replace John Purcell as correspondent. Purcell and I were to go up to Mukden, Manchuria. On the way, we stopped in Peking, and while we were there, Purcell got a cable saying that he was being reassigned. He was through, so far as China was concerned, so he said, "Jack, you take it from here." I went up to Mukden not knowing anybody, not knowing where to go, not knowing who to contact. Fortunately, on the plane I met a Scripps-Howard correspondent who gave me a couple of tips of where to stay. It was 33° below zero. When the Russians marched into Manchuria, they stripped the factories of everything of value. The snow was two feet deep everywhere. I clumped around wearing aviator's boots, which are like snowshoes, and aviator's clothes over regular clothes. I felt as if I weighed 300 pounds with all that gear on.

I went into this empty factory. It was dead silent. I was going to take pictures, and as I looked down into the camera, a gunshot echoed around this empty factory. I threw up my hands, turned around and clumped out, not knowing if I was going to get a second bullet in the back. There wasn't another shot. Maybe it was a deserter. I don't know whether he missed on purpose, but he didn't want me there.

*Where was your wife at this point?*

In Shanghai at the Broadway Mansions. Our child was born May 1st at the Wusi Nursing Home.

*You grew up in Ohio. It's your first trip overseas. You're in the Far East. Your wife's expecting a child in Shanghai. You're alone in Manchuria being shot at in an abandoned factory. This seems like jumping into the world of the foreign correspondent without putting your finger in first to see what the water's like. How did you feel at this time?*

Exhilarated. I think when you're 28 years old you can conquer the world. For a young photographer, getting into *Life* was the dream, so when you got there, you gave it all. There were other times I was shot at. Roy Rowan and I went on a story in Malaya, during the insurrection. In Kuala Lumpur we met this British police captain, William Stafford, who took us home for a very nice dinner. We met his wife and two little kids. He had a couple of bodyguards to take us back to our billets, and we turned in. Stafford didn't say anything like "Stay close. We're going someplace tonight." Nothing.

About 2:30 in the morning the bodyguards rapped on our door and said, "Get dressed. We are moving." I took both my cameras and some bulbs, and one thing or another, and away we went. I put a flashlight in my pocket.

It was just getting dawn when we got to a clearing which was the center of a rebel enclave. The squad we were with had just killed the number-two communist in Malaya, and a local commander, and captured a third.

There were two female prisoners and one male. One of the guys in the squad was the interrogator. He was a mean one. He wanted to find out where the rest of the people were. Every time the male prisoner didn't answer a question, he'd hit him and my hands holding the camera would flinch. It was involuntary. So those pictures are a mite fuzzy. I got a close-up of this man just covered with welts where he got beaten.

A Tamil was assigned to guard the two women, who were crouched down, their hands tied behind their backs. When the counterattack came, the Tamil couldn't watch the women and he couldn't release them. So he gave them a spurt from his Sten gun. That's how quick, how easily and how mercilessly you can get killed.

I was changing film when the counterattack came. It was hairy. Rowan and I lost sight of each other. Rowan is an ex-Army man. He hit the deck, just digging his face into the ground to get as low as possible, because a machine gunner and several riflemen were shooting over his head at the attackers. When I dropped, I dropped to one knee because I didn't want to bust my camera. I closed it, then rolled over into a ditch with a creek in it. Then I just took off. The adrenaline just sends you away. There was a sort of a protective bank with kunai grass growing along the top. I crouched down, and I didn't really know whether I was going toward the attackers or away from the attackers. In a jungle you can't tell where you're going. I will never forget the sound of bullets going through the leaves. They went *flip-flip, flip-flip* as they clipped the leaves. I heard this over my head, and it made me crouch even lower. Then I hid behind a tree until my bodyguard found me. He had a rifle, and he signaled for me to take

my gun out, thinking I had one. I pulled out the flashlight I'd brought along, and he laughed like a hyena. Here was this American armed to the teeth with a flashlight. He gave me his gun, and I felt better. Pretty soon the sergeant came looking for both of us. He had a tommy gun, and I felt even better.

I heard a voice calling "Jaack! Jaack!" It was Rowan. Oh, I was so glad to see him. I thought he'd been killed. Twenty-seven other people were killed that morning right at that spot.

The Associated Press put on the wire that two Americans were nearly killed in a battle, so our names were in the New York papers long before the film got to New York. The editors knew that we were involved in the shoot-out, and they expected a good story. They ran it as a five-page lead. That was *Life's* biggest story of the 10-year Malaysian insurgency.

*William P. Gray, who was the Shanghai bureau chief while you were there, wrote, "I don't think Birns likes the Orient at all, but he can hardly be more productively in love with the job of covering its news."*

I used to complain about the Orient, but I did like it. I had nothing but good experiences with the Chinese that I met. Not with the ones who shot at me, but they were just trying to defend themselves. They didn't know who I was. But it was difficult to work in China. You need an interpreter. You don't have the freedom of making a phone call. Somebody else has to do it for you. You need somebody to pave the way. I had come as a rookie, and two years later, by the time I left Asia, I felt old.

But Bill Gray was right, I couldn't wait to finish one story and to get on to another. I was eager. Rowan and I did a story on the Indian state of Hyderabad and on Jawaharlal Nehru in Delhi. We did an insurrection in Burma in 11 days and got two stories out of that one. We did gun smuggling in Thailand. A dope story in Indochina. We did Malaya and all sorts of things in the Philippines and China. I had the largest territory of any *Life* magazine photographer. It extended from Bombay in the west to Manila in the east. That's the distance from Hawaii to Bermuda, and from Panama to God-knows-where in Canada. Just one guy flitting around that whole territory.

*Did other photographers come in and do stories?*

At the end of the communist-Nationalist war, things were happening very quickly, and the editors in New York said that there was no way that I could cover it all. They asked Carl Mydans to come from Tokyo. Roy and I resented it. China was our war. We didn't want anybody else to cover it.

Carl went to a place about 50 miles up-country from Nanking and did a story and went back to Tokyo. Henri Cartier-Bresson came, but he was mostly working for *Paris Match*. He did a story on the collapse of the monetary system in China. He didn't have a place to stay, so he stayed in our apartment in Shanghai. He didn't have a heavy coat, so my wife let him use my pile-lined jacket. But, as I remember, those were the only two incursions into our area.

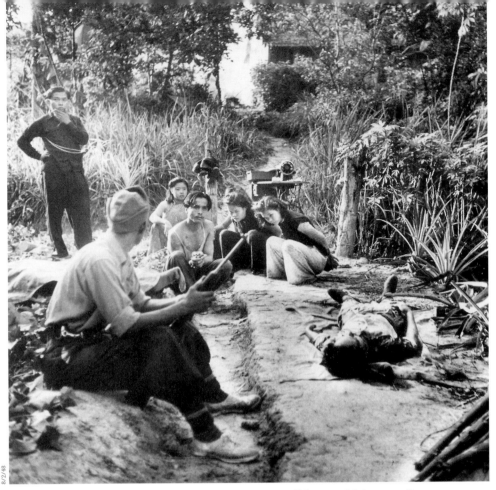

8/2/48

Prisoners. Malaya. 1948
*The Tamil couldn't release them.*

4/2/51

Alger Hiss (right).
New York City. 1951
*The fact that the man posed
the way he did was luck.*

Both of them were very brief. Nobody really wanted to go to China.

*Life* took great pride in us as a team. Advertisements referred to Birns and Rowan as the *Life* team. For two years running I had more pictures and pages published than any other photographer.

*Neither of you covered the Korean War?*

Roy did. I didn't. My daughter Rebecca was born at the end of October 1950, and I didn't feel like going off to war with three little children. Also, I had a terrible feeling that I had probably stretched my luck as far as it was going to stretch. I would have gone had they asked me, but I was not going to volunteer.

*You both were assigned to Rome in 1950. In Rome you had an altercation with Roberto Rossellini.*

Well, Rossellini had gotten his paramour Ingrid Bergman with child, and she lay in this hospital. And Rossellini would come every day to visit Ingrid and see his little Robertino. Roy and I and Max Desfor of the Associated Press went out to the hospital and waited for him. I found a back door that led through the kitchen. I got up to the second floor, but I did not know what room Bergman was in. I should have just gone down the floor and opened doors to see if I could find her, but I didn't think fast enough. I was spotted by the sisters. They hustled me out of the place in a tirade of Italian.

By that time, Rossellini drove up and came charging up the stairs. I got a picture of him with his fist in front of him, threatening me. Then he swung, and he grabbed for my flashbulb. It had just gone off, and it was still very hot when he grabbed it. He burned his hand and was very angry.

That was the end of it, but Max Desfor had shot a picture of this happening and went scooting back to town to put it on the wire. This was one of those Saturdays when nothing was happening around the world, and Ingrid Bergman was a number-one story. Rossellini's altercation with a photographer was played big. One of the Los Angeles papers put it on the front page.

*How do you feel about invading people's privacy—trying to find Ingrid Bergman when she doesn't want to be found?*

She was an actress in the public eye. She was still married to Dr. Petter Lindstrom. I don't think she was entitled to any particular privacy. I think a lot of people are, and I have respected their privacy, but she was a story. Thousands of people had considered Ingrid Bergman a role model. Now that she fell off the pedestal, she was a story. She had to be covered.

*Alger Hiss?*

I covered Hiss in New York after he'd been sentenced to five years in prison for perjury and was on his way to the Tombs. Twenty-five New York press photographers gathered in the lobby of this building. I said, "I am not going to wait here and get the same shot as all these jokers." So I went outside onto the steps, and when he came through the door, he was manacled to another man. That man did not want to be photographed, and he had a derby which he held over his face. That's what made the picture. It ran as the "Picture of the Week."

*How important is luck?*

Fifty percent probably. Fifty percent was not wanting to get the same picture as the other guys. The fact that Hiss came out manacled to the man who posed the way he did was luck, and I had nothing to do with that. The fact that my picture was totally different from everyone else's picture—*that* I had something to do with.

*Shortly after this, you left the staff of the magazine.*

Wilson Hicks had promised that when I came back from Asia I could have my pick of places to work. But when I came back, Hicks was gone. I was offered Dallas, Chicago or Boston, but I wanted to go back to Los Angeles. I said, "You don't understand. I want to go home. My wife wants to go home. She wants to be with her people. They want to see their grandchildren."

They said, "Jack, you're tired. Take a two months' vacation."

I went home to L.A. My wife and I signed the escrow papers on a little house in the Valley. When I got back to New York, they said, "We'd like for you to work in New York for a couple of months." I worked there, living out of a hotel, and I didn't like that. Finally they offered me Washington, D.C. Had they offered me that plum before, I would have taken it. It would have given me the news challenge that I wanted, and I would have stayed. But they didn't. So I quit.

*Roy Rowan said that your eye might not be as great as some others, but you had a terrific story sense. Is that a fair description?*

I was always proud of that. *Life* photographers, the essayists, would go somewhere and do a long essay on something and come back with elegant pictures, but they wouldn't do the little stories. I was taught that editors need the little stuff to shovel around the advertising in the back of the book. They can't just use 11-page essays.

*Do you think photography is an art?*

It's a form of art. To tell a story in pictures is a very high form of art, but I don't think that every picture is artistic.

*What photographers did you admire?*

Dmitri Kessel, for one. He did beautiful pictures on a river in China with John Hersey. He is an excellent, excellent photographer, but a lot of the big-name photographers I didn't have a whole lot of use for. I really liked Eliot Elisofon, but that was for a personal reason. I only met him once, in a hallway. "You're Jack Birns," he said. "I'm happy to meet you." And he spilled out this story:

"I was in Thailand, and the army had a coup," he said. "I was sitting in my room in the hotel, and all these gunshots were going off. There was a cable delivered from *Life*. It said, 'Assume you covering coup.' I sent them a cable back. I wrote, 'Who do you think I am? Jack Birns?'"

On the *Life* staff 1947-51
Interviewed in Los Angeles on August 14, 1993

We got out there, and he said,

"Splendid! Splendid!

What an idea! If only we had a piano"

Noël Coward. Las Vegas. 1954

# LOOMIS DEAN

**L**OOMIS DEAN: When I was working in Paris, I had a beautiful leather camera case made. It looked like a diplomat's briefcase. With a necktie on, and if my suit fit, I could walk right into places where they threw the other bums out.

I photographed 11 kings. I got the kings of Norway, Sweden and Belgium, and the Queen of Holland, and two would-be kings of France, and the crown prince of Germany (the Kaiser's grandson) and the kings of Italy, Spain, Morocco and Jordan.

My favorite was Juanito, the son of Don Juan, who was supposed to become king except Franco selected his son, Juan Carlos. We were on a first-name basis for a long time. Oh, don't forget, the King of Greece—I did the father and son. The son, Constantine, is married to the little Danish girl. He and I were great buddies too. They were a poor family, poor kings, and they wanted him to marry a rich queen. So they flew the two fat Dutch girls down there, and he wouldn't have them. He married the beautiful little Danish princess whose sister married the King of Spain. I did a whole round of princesses when Princess Margaret in England got married to Antony Armstrong-Jones. When I went to do the Greek ones, I told the palace, "I want something totally informal."

They said, "The girls are in a sailing race tomorrow."

"That's ideal," I said. They were charming, and I got them down on the boat and saw them putting up the sails and all that. Some kid, barefooted and in a pair of white shorts, was helping them with the boat. I thought he was a little familiar with them, but he was speaking English, so I said, "Hey, kid. Help me with that bag there."

How'd I know he was the crown prince? Later, at some great, lavish country

house, he helped me set things up. He said, "How are you getting along?"

I said, "I love everything in Greece but that terrible retsina wine."

He said, "Oh, you don't like retsina?"

I said, "It tastes like paint thinner." (It does, too.)

"You haven't had the good stuff," he said. "Come with me." We went back into the kitchen, and he told them, "Bring out so-and-so and so-and-so," and he had about six or eight bottles. Constantine and I were sitting back there tasting it.

He said, "Don't you like that?"

I said, "It still tastes like kerosene."

He made a good king, until he got thrown out.

*John Loengard: How about the Queen of England?*

Never got close. But I made some hellish good pictures at the Queen's birthday party in the gardens of Buckingham Palace. I got up on the roof of the palace. I had an 8x10 inch camera up there. The Queen was dressed in pink so you could spot her. Big aisles opened up, and she would walk down and go over and shake hands. All the ushers with their gray toppers were clustered together, and I made a pattern picture. But I never got close to her.

*F. Scott Fitzgerald said, "The rich are different." Do you think that's true?*

Sure, they are. Kings have got manners. They've got built-in good taste. If they say they're going to do something, they will. They'll cooperate and they'll be gracious and helpful. That's the *old* rich. Everybody's rich now.

*Everybody's got manners and taste?*

No, they haven't. That's what I'm pointing out. They don't have manners and taste, but they're all rich. Look at them. Everybody's a millionaire in the United States.

My mother was a very compassionate lady, and anything her children did was all right with her. She was a schoolteacher and an art historian and a librarian. I had a scholarship to Ringling Art School in Sarasota because my father worked at the Ringling museum. I went there for a year, but it just proved I couldn't draw. So I went to engineering school at the University of Florida. My second year there, some kid in the dormitory was developing pictures in the bathroom. I saw that first image come up out of that developer, and I was hooked. The only school in the nation that taught photography was Rochester Institute of Technology, which was called Rochester Athenaeum and Mechanics Institute at the time. That was 1937.

I'd rather photograph clowns and girls and elephants than, say, linoleum, so after R.I.T., I went to the Ringling Brothers and Barnum & Bailey Circus. This was the biggest circus ever. It had 1,600 people and 1,000 animals and four railroad trains. We moved it every day, so there was a lot of action. I worked as an usher the first year, but I was snapping pictures all the time and selling them to the acrobats. The second year, they hired me on in the press department. I had

my own elephant named Jewel. Jewel was incontinent, so none of the girls would work with her. She was old and sick, but she could do all her tricks and I could use her anytime I wanted. I had a clown and a girl made up every morning at six o'clock. I'd pick up the local photographers and see that they got their pictures for the afternoon papers.

I admired those newspaper guys. They could produce in a certain length of time, and they were aggressive enough to get it done. I'd take them to the cookhouse and sit them at the freaks' table—the fat lady and the giant and so on. The giant, by the way, was a skilled artist. A very intelligent man, a good friend of mine and a very good photographer. He had hands so big that he'd sell rings (as a little concession) that were the size of 50-cent pieces. His fingers were enormous, but he had a little Leica cuddled in those huge hands. He'd sit there, and all these people would gawk at him. He'd spread his hands and snap pictures with his Leica. We got a lot of play out of that. All of the photo magazines ran that stuff. We dressed him as a cowboy. He was 8'6" tall, and with the cowboy hat and a pair of boots on, he was 10 feet tall.

We did 123 cities in 1939—101 one-day stands. We were going across western Canada, where there were terrible little towns. You'd think we wouldn't draw flies, but we set the thing up. The show had 600 performers, three rings and four stages. Of course, in 1939 there wasn't any other action out there. These farmers would come from miles around, and every Indian in the world showed up. Funny, the circus freaks would go out and take pictures of the Indians.

The circus played Dayton, Ohio, and I had to take around a Colonel Goddard, who was the head of the entire photographic section of the Air Force. He said, "If the draft board starts breathing on you, let me know." It did a year or so after I left the circus, when the war started, and he got me a commission. Wright Field, in Dayton, had experimental aircraft. Having been a press agent on the circus, I knew how I could plant a story a week. I'd ship off big batches of 11x14 inch prints to all the rotogravure sections—those brown pictorial sections in the Sunday newspapers. There were 38 of them in the States at that time.

I practically commuted out to California to do a story on bat bombers. There was a professor at U.S.C. who said that bats were impervious to altitude but that they became dormant at about 45°. Bats can carry 10 times their weight, so the chemical boys got together and designed little incendiary bombs the size of peanuts to put on these bats. I'd go into the Carlsbad Caverns where they roost and hold the sack. The professor would reach up and pull down about 500 at once. I'd close the sack and cool them down and we'd have instant ammunition. We'd put them in an egg crate and clip a bomb on them and take them up in an airplane, and chuck them out to see where they went.

Since they were nocturnal, they would go to a dark place. We went out in the middle of the New Mexican desert where there was an auxiliary airfield and not a tree for 50 miles. We'd drop them out with dummy bombs, and there was

only one place to go—these buildings out there. I had to photograph them underneath the eaves and the steps and the like. Everything checked out splendidly, and then somebody loaded them with live bombs. They had timers on them set for from 15 minutes to 15 hours. The bats had a field day, and the Air Force was rather pleased with the results. They burned up three buildings and five cars and two trucks and two airplanes and the control tower. The whole idea was to have a fleet of B-24 bombers fly them over Japan and loose them at dawn, so they'd go and find a hiding place. I got all these marvelous pictures and rushed back to Wright Field and printed them up. What a story!

The Pentagon classified the whole thing Secret. The story only came out about a year ago. It's pretty funny.

Edward K. Thompson had edited an Air Force magazine called *Impact*, and then toward the end of the war Bob Girvin had taken it over. I loaded it every month with tons of stuff. After the war, Girvin became assistant picture editor at *Life*. He called me up in Sarasota, where I was vacationing, and said, "Do you still have any contacts with the circus?"

"Sure," I said. So I did a story on winter quarters and got a cover of a clown and a giraffe. Lou Jacobs, the number-one clown, put on his makeup in the middle of spring, two months before they were going on the road, and came out and did that picture on the cover for me.

*After one assignment and one cover, Wilson Hicks asked you to join the staff? Just like that, "Nice picture, join the staff"?*

Yeah. More or less. I liked Hicks. I got along with him extremely well. I did not get along with Ed Thompson all that well. He was grumpy and bad tempered. I never got his sense of humor, either. After Hicks hired me, I stayed in New York a year, and then they sent me to Hollywood.

*You photographed Noël Coward in Las Vegas.*

He was playing the Desert Inn. They'd had Maurice Chevalier, and he bombed. Then they brought on Edith Piaf. The greatest singer in France. She lasted one show—"Who's that old lady in the black dress singing all by herself on that huge stage?" Out she went. Then they brought in Coward. He was a little man out there in a black suit, in the middle of the stage, all by himself.

He was sensational.

*Why?*

He just was. I was backstage, and the showgirls were popping their eyes out. One said, "I don't know who it is. There was some guy out there doing 45 minutes of his own material, but he's killing 'em out there."

For our picture, I told him we wanted to do "Mad dogs and Englishmen go out in the midday sun."

"Oh, dear boy, I don't get up until four o'clock in the afternoon," he said.

"Oh, hell, we'll do it then," I said. We found a dry lake 15 miles out of town. I hired a Cadillac limousine and filled the back of it with a washtub full of booze

and cold drinks and beer and tonic and ice cubes. The temperature was 119°.

We picked him up at four o'clock and took him out. He loved it. We got out there, and he said, "Splendid! Splendid! What an idea! If only we had a piano."

He was in his underwear in the back of the car, and his dresser dressed him in his tuxedo. I stood on top of the Cadillac. He had the cigarette holder, and we did a few variations, but it was just perfect with that dry lake and one little black figure and that long shadow. I only shot one roll on a Rolleiflex.

Later, one of those smart little researchers in New York said, "It doesn't look like it's noonday to me. Look at that shadow." I pointed out we could use his other line, "That tho' the English are effete, they're quite impervious to heat," which would have done as well, but they didn't use it.

It was so bloody hot the Cadillac had a vapor lock. The engine had stopped, and the air conditioning went off. You could die in that heat. The whole gang of us, the chauffeur and all, had to push to get it started. Coward had stripped back down to his underclothes by that time. I wanted to get that picture too, but I was pushing. It's like taking a picture of a fire. Do you save the little girl or take the picture?

*What are you looking for when you take pictures?*

Oh, God! What am I looking for? A picture that will run in a magazine. That's the only satisfaction I get out of a picture. Seeing it published. And I try to do everything I can to make it amusing or interesting.

*Do you try to draw people out?*

Not really. I chat them up, but some of these sexy photographers say, "I want you to feel the essence of this thing." You know. All that crap. No, I don't try that. Another thing—I don't make friends with them, either. That was a cardinal law.

*Why?*

You can joke with them and so on, but don't take it too far because if the story doesn't run, you're dead. So you act professional with them and do your best. But none of that asking them out to dinner and all that sort of stuff—or trying to put the make on them. No, it's just not done. Actually, you'll spend a lot of time with celebrities, and you'll see them on the street the next day, and they won't know you from Adam. They're thinking of themselves only.

*You took a photograph of Darryl Zanuck.*

Zanuck threw a party to start his daughter Susan off on her singing career and insisted that everybody be there. I went down and lit the place with six big strobes. They brought in a comedy musical act that performed with a trapeze. They would hang by their heels and play their horns and a bass fiddle. It was a very funny act. Zanuck took the trapeze and said, "I'm now going to chin myself with one hand. There are only five people in the world that can do this." He took his shirt off and said, "No pictures, please."

Here he is with his suspenders hanging down and his shirt off, and he's

pulling up with this skinny little arm. I went boom with those big strobe lights. All of the little starlets and young boys came around and said, "The boss said, 'No pictures!'" By this time, Zanuck's wife was swinging on the bar.

A big lawyer who was a number-one society lawyer came up there and said, "You heard the boss. He said, 'No pictures,'" and he started to put his hand in front of my camera. My assistant clubbed him, and we fled.

Oh, they called up the Luces that night because Henry and Clare Luce owned a piece of 20th Century Fox, and said, "We can't have that picture in your magazine."

But Ed Thompson said, "If it's any good, we'll run it." And he did. It was not all that good, but it was good enough. It was just Zanuck straining there. He couldn't get his chin up to the bar. That was a fun Hollywood story. They loved it in the end. They always do. And Susan Zanuck never became a singer.

Two years later in 1956, when I transferred to the Paris bureau, my family and I had two first-class cabins on the *Ile de France*. On the first night out from New York, we had a few drinks with Andrew Heiskell, *Life's* publisher, and his wife Madeleine Carroll, who were going on vacation. I got my kids to bed as early as I could, and my wife and me too. About midnight Andy rapped on my door in his pajamas. He said, "It looks to me like there's a shipwreck out there. Maybe we ought to make a few snaps."

There was a boat all lit up about a half a mile away. We tried to get on a lifeboat going over to pick people up, but they wouldn't let us. The first people off the *Andrea Doria* were the Italian crew. I looked at the Italian photographer, and he was immaculate in his whites and everything. I said, "Did you make any pictures?"

"Hell, no, the boat's sinking," he said.

We found three Austrians, exchange students at Northwestern. I said, "Did you get any pictures?"

One said, "I think I did." We handed over a fistful of $50 bills. It was a gold mine. Any disasters, you have to figure on some passengers getting pictures, because every third person has a camera. We bought some other pictures too, but it was the Austrian's that showed them getting in the lifeboats and all that sort of thing.

From the deck I could see the *Stockholm* too. Leaving New York Harbor, it was right behind us, and I had photographed my kids on the stern of the *Ile de France*, with the *Stockholm* right behind them. It was a beautiful white boat. Now there it was, over there with its whole bow knocked off. It was upright.

I shot everything down below when passengers arrived from the *Andrea Doria*, and as soon as there was any daylight at all, I got all the activity on the deck. Andy Heiskell was with me the whole time, and he spoke fluent French. He was educated in France. So he interviewed people and the captain and so on. You couldn't make any sense out of the Italians. They were screaming and yelling,

Darryl Zanuck. Hollywood. 1954
*"No pictures, please."*

Royal wedding. Seville, Spain. 1961
*They threw the other bums out.*

The *Andrea Doria* sinking. 1956
*"You won't believe this, but I slept through it all."*

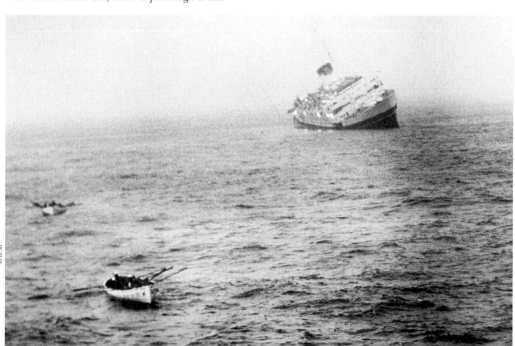

and the captain of the *Ile de France* rounded up all the priests—there were nine of them aboard—and said, "You go take care of those Italians." Which they did. *The cover picture of the Andrea Doria listing on its side was taken at dawn. The last of the rescuing lifeboats were coming back over. Had it gone any quicker, you would have missed that picture.*

I guess so. I thought it was a hell of a color picture with all those lights reflected in the water. That's the only one I shot in color. It looked pretty out there. All the rest I shot in black and white.

*Was there excitement about your pictures?*

Sure, there was excitement. The picture editor, Ray Mackland, called on the ship-to-shore phone. Trying to put a little humor in it, I said, "Ray, you won't believe this, but I slept through it all." [*Laughs*] We arrived back in New York later that day, so the people we had rescued could disembark. My family stayed onboard, but I got off to develop my film, and I flew over later. I never did get a chance to take an ocean liner to Europe.

*Howard Sochurek tells about sending you his film from Moscow.*

That was a couple of years later. Sox had given it to a guy to deliver to us, and we were supposed to meet him at the airport. But Pepé and I missed him. Pepé was a legendary chauffeur of the Paris bureau who was a genius and could do everything. He was also an excellent photo assistant. He was a strobe light expert and a number-one chauffeur. He could fix things. He knew exactly how much to bribe whom.

Anyhow, this guy called from the Plaza Athénée, one of the poshest hotels in town. He said he only was going to be in Paris until four o'clock that afternoon, and Sochurek had promised that we'd show him the town. I said, "We'll show you the town, fine. We've got a chauffeur and a car, and he knows everything, and he'll take you around and show you the Eiffel Tower and the Arc de Triomphe and the Louvre and all those places."

He said, "No, no, no. You don't understand. I want some action. I was in that bloody Moscow, and there's nothing there. No action in Moscow."

So we said, "We'll meet you at the office."

He showed up in a cab, and he had the film, but he wouldn't turn it loose. He said, "Where's the champagne?"

Next door is the Crillon Hotel, so we go in there. It's only 10 o'clock, and the bar isn't open yet. But Louis is cleaning up and polishing glasses. He lets us in, and we say, "Champagne for everybody."

"Where are the broads?" our visitor asked.

I said, "If you want to see them, stay overnight, and you go to the Lido or the Crazy Horse Saloon and all that."

"Oh, no. I've got to go at four o'clock on a plane," he said. Well, there are two or three crummy bars in a very posh section of town right behind the Madeleine. We go over there and, on the way, every woman he saw on the

street, he thought was a tart. He said, "God, that's a good-looking one there. Look at her." It was some beautiful model coming out of Lanvin or someplace. We get near the Madeleine, and there are two or three high-class, expensive ones around the street. He says, "Look at that. Go get her for me."

Pepé said, "I'm no pimp. You can get your own girls." Finally we stopped in one of those little bars, and there wasn't anybody in there but this one girl. A beauty too. So I went down to the far end of the bar and nodded to the madam—I mean to the bartender—the old lady there, and said, "Is that one?" She said, "Yeah, she works." So we approached her and asked her name. I think it was Jacqueline. He's still clutching that film. We couldn't get it away from him. He said, "You promised you'd show me the town."

I introduced her, and I said, "Mademoiselle Jacqueline, Monsieur Bush. Monsieur Bush, this is Mademoiselle Jacqueline." And they reached out and shook hands.

He says, "How can I ever thank you?"

I said, "Give me that film." [*Laughs*] We left him there. God knows, he might still be there.

*Why did you leave the magazine?*

Oh, they dumped 20 of us old guys all at once in the 1960s and put us on contract. It wasn't a bad deal. It allowed us to do work on the outside, and I picked up a lot of movie jobs. Like Sean Connery—all the James Bond stuff.

*Is there anything else you'd like to talk about?*

No, I loved it all, except being terrified of being moved.

*Terrified of being moved?*

Well, yeah, I mean. They might have sent me to Chicago.

On the *Life* staff 1947-61
Interviewed in Miami on November 4, 1993

I was postponed, day in, day out,
which . . . made me the
last photographer to photograph her

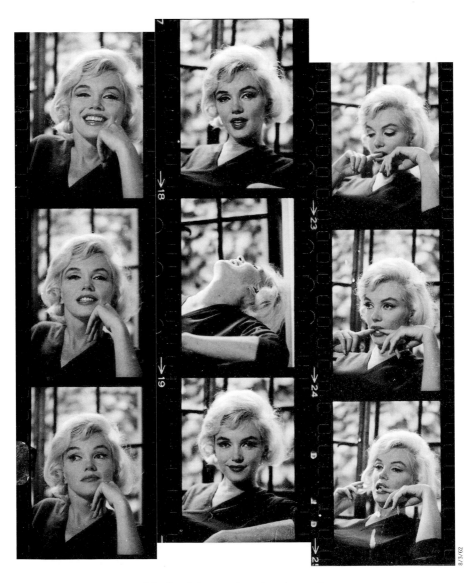

Marilyn Monroe. Los Angeles. 1962

# ALLAN GRANT

ALLAN GRANT: I wanted to be an aeronautical engineer, and my dad didn't have any dough to put me through college. "Besides," he said, it's no place for a Jew. What's your second choice?"

"I really don't know," I said, "but I'll find one." I was a member of the aeronautics club in high school. I used to build model airplanes, and I brought one to school, and this kid wanted it desperately. The kid had just got a camera for his birthday, so we swapped. My father didn't object to photography, and after high school I got work as a printer in a darkroom across from a nightclub in New York. Girls with Speed Graphics took pictures of patrons for a buck, and they'd run the film across the street to me, and I would develop and print it. One of the girls turned out to be my first wife.

Then I got a job printing the photographs of Bob Capa and Alfred Eisenstaedt and Nina Leen at a picture agency called Pix, and I started taking pictures on my own. I shot a story on a flying school in New Jersey. I got $100 for it. I had two young sons by then. I put the money into $1 bills. I remember standing on the bed and saying to my wife, "Irene, come in here a minute. I want to show you something." She came in, and I threw the money up in the air, and it floated down. "I'm going to become a photographer," I told her.

Six months later I got an assignment from *Parade* magazine to shoot kids learning how to sail in Connecticut. While I was there, I met Sam Shere. Sam was one of the guys who shot the zeppelin *Hindenburg* blowing up, which was a picture that impressed the hell out of me. I had been 16 years old when the airship had flown over New York, and I got a picture of it with the same camera I'd swapped for my airplane model. While I was unrolling the film to develop it, I heard over the radio that the *Hindenburg* had blown up and killed a lot of peo-

ple. Something I can't explain happened to me. I had frozen something in time. All these people are still alive. It impressed the hell out of me that I could stop moments in time and have them forever.

Shere and I had lunch together and talked. I did my stuff for *Parade*, and the next morning I got a phone call from my agent, "Guess what? You got a *Life* assignment. Shere has to go to Florida. They want you to go back to Connecticut and pick up where he left off." So I went back to Connecticut with Shere's researcher from *Life* and shot more pictures on the story and sent them in.

Two days later I get a phone call from *Life*, "You have a cover. Come in. We want to meet you." It was a picture of kids rigging the sails on a sailboat. It ran in August of 1945.

*John Loengard: How much did you get paid?*

Fifty bucks, but it didn't matter. I would have paid *them* 50 bucks, you know? I met the whole megillah up there. I couldn't believe that I was going into the territory of the staff photographers. I was scared. But the photographers literally suggested what to do, and Ed Clark even helped me shoot a story. I was amazed by that, just really amazed by that.

*Why do you think they did it?*

I guess they were just so very secure, but I'll never forget their help. The next year, I had more space in the magazine than Alfred Eisenstaedt. Then on election night in North Attleboro, Massachusetts, I took a picture of Representative Joseph W. Martin, who became the Speaker of the House. I had just parked my car across the street from his hometown newspaper and saw this scene through the window. I thought, "That's the shot I want." I got inside, and I lit it like I'd seen it. I asked Martin to get back on the telephone. Returns were being called in, and I had wires running everywhere and had a battery pack for triggering the flashes. We didn't have electric-eye photo cells in those days, so I had to connect all the lights together. Fortunately, my father was an electrician and I had that background.

But I've got to tell you, it was like setting up a movie shot—lighting the place and moving the people around—but that was the only way to do it. I shot two frames through the window and came back to New York. Later I got a memo from Edward K. Thompson, who was an assistant managing editor at the time, saying, "Allan, thank God you were there. You saved the issue. Now you're going to have to join the staff." So I did. They asked me to go out to the bureau in Los Angeles, and I've been here ever since.

*In contrast to that election-night news picture, the ones you took of Marilyn Monroe seem very casual, taken against a tangled background.*

This was to illustrate an interview that Richard Meryman had done with Marilyn. *Life* didn't want glamour pictures of her. They just wanted pictures of this human, rather lovely looking woman, telling her sad tale. I tried to get a

Learning to sail.
Connecticut. 1945
*"Guess what?
You got a* Life *assignment."*

8/6/45

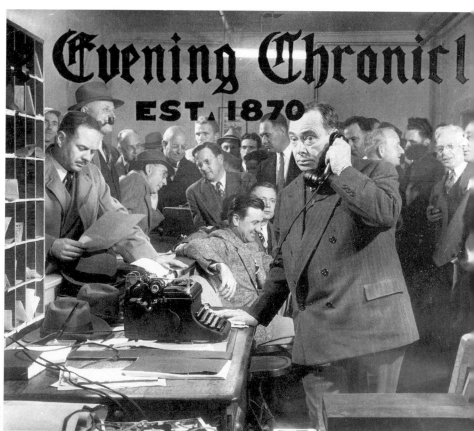

Rep. Joseph W.
Martin. North
Attleboro,
Mass. 1946
*Fortunately,
my father was
an electrician.*

11/18/46

nitty-gritty look that matched the sound of the tapes of the interview. Marilyn had reasons to be disturbed: 20th Century Fox was canning her, and I don't know what was going on with her love life. While Meryman had done the interview, there had been no sense in me being around. It would have interfered with the dialogue between the two of them. I finally went over to her house after being postponed, day in, day out, which was very lucky for me because it made me the last photographer to photograph her.

When we took a break, she took me around and showed me the house that she had just bought, five minutes away from where I live. She was very enthusiastic about the house, but she'd been very uptight when I was photographing her. She asked me if the light was O.K., and I said, "To tell you the truth, this is the first time I've done a portrait, and I really don't know where the lights should be." She took that seriously. Her publicist said, "Allan, for God's sake, don't fool with Marilyn that way."

"It's a joke," I said. "I'm sorry."

*What else did you talk about?*

We were talking about the interview, and as I photographed, her publicist would ask her questions that appeared on the transcript. Marilyn knew exactly what to give photographers, rather than the photographers knowing what to get from her. But some of the expressions on her face were so grim, it made me wonder when I looked at them later. Was she giving me that, or did I capture that?

*Did you ever photograph John Kennedy?*

No, but I covered the assassination. The phone rang, and it was the office saying that John Kennedy had been shot. Being a practical jokester myself, I did not believe it until the bureau chief got on the phone and said, "Grant, turn on the TV set and get your ass out to the airport and get on an airplane. I'll meet you there with film."

When we got to Dallas, the *Life* writer Tommy Thompson and I formed a team. They had caught Oswald, so we went to the courthouse. I'd never seen so many photographers standing on tables, chairs, whatever, to get one picture of a guy just walking down the corridor. I said, "Tommy, let's get the hell out of here. Let's find out what else we can do." He got on the telephone and found out where Lee Harvey lived. The landlady let us into his room, which had a bed and table and a lamp. She said the FBI had been there and had taken everything of importance with them.

Tommy asked her what she knew about Lee Harvey. She said, "All I know is that he would come here during the week and go home during the weekend."

Tommy asked, "Any idea where that was?"

"He used to call long distance," she said, "and one time the operator called back because he hadn't put enough money in. It was Irving, Texas."

So we got in the car and drove to the little sheriff's station in Irving. Tommy

Marina Oswald.
Irving, Texas. 1963
*God, she was so
confused by it all.*

11/29/63

Marina and Robert Oswald.
Dallas. 1963
*I registered them as Mr. and Mrs. Allan Grant.*

was from Dallas. He got out of the car with his Southern accent and started asking the deputy had he heard anything about the FBI coming.

The deputy said, "Oh, yeah."

"Where does this man live?" Tommy asked.

"I only know what street he's on," the deputy answered, "but I don't know the address." And he gave us the name of the street.

We drove there and parked. It was about four blocks long and then it turned around. We didn't know what to do. We saw a car pull up across the street from us, and a guy got out. We figured maybe he would know, because he lived there, so I threw two cameras around my neck, and we went over to the guy, who was unloading his groceries. He looked up and said, "I didn't expect you guys so soon. I guess you might as well come in now."

Tommy and I looked at each other. He let us into the house. He introduced himself. It turned out that his divorced wife lived there with Marina Oswald. There was Marguerite Oswald, Lee Harvey's mother, sitting on a couch with her nurse's uniform on. Her stockings were rolled down just below the knees, really strange. I just started shooting pictures. Suddenly Lee Harvey's mother leaped at me from the couch, saying, "Stop that. Stop that. What are you doing? I want to get paid for this."

Tommy said, "O.K., wait a minute. What do you want to get paid for?"

"I'm Lee Harvey's mother," she said. "I know things that nobody else knows, and I want money from *Life* magazine."

Tommy said, "Let me call New York and see what we can do."

He called George P. Hunt, who was the managing editor. George said, "Tommy, we don't want to pay money to the mother of an assassin."

Tommy came back in the room and said, "I have to call back later." By this time, they had got used to me, and I'm shooting pictures of the kid and whatever. What Mrs. Oswald wanted most was to see her son, wherever he was.

"We'll call and get visitation rights for you and for Marina," Tommy said. "We'll take you to the hotel and make arrangements from there."

So we took them to the hotel and gave them my room, and I moved in with Tommy. We had an exclusive, because nobody had seen the mother, let alone Marina and her two children. By now we had a Russian interpreter that we hired so that we could understand what Marina was saying, because she didn't speak English.

We took them down to the district attorney, and they spent six hours at the jail trying to see Oswald. They finally got to see him for 20 minutes and came back to the hotel. I had shot photographs of Marina diapering the baby in the hotel room and of Lee Harvey's brother Robert, who showed up. It was all exclusive stuff.

By this time, we thought, somebody in the press would know that we had custody of them. We decided to take them to the outskirts of town near the airport

and put them in a motel. I registered them as Mr. and Mrs. Allan Grant. I gave her some money, and I embraced Marina and wished her well. It was a touching moment. God, she was so confused by it all.

Then we had a meeting. Richard B. Stolley, who was the bureau chief, knew pretty much what each photographer had. He said, "Well, Grant, you might as well go back because I don't think we're going to get anything from this point on. Somebody here can cover anything if it comes up.

So I got to Los Angeles about midnight and went to bed. The next morning I called a friend to say I was back, and he said, "What the hell are you doing back? They just shot Oswald!"

The story in *Life* used one small picture of Marina. A German magazine picked up on it for the 25th anniversary of Kennedy's death, and they did a wonderful layout. That story should have been seen in this country. The Kennedy family—Jackie and the kids—were victims. The Oswald family—Marina and the kids—were victims. It was another side of the coin. I felt very strongly about that. What *Life* showed, naturally, was the President's wife and kids and the funeral. But I kept thinking, "What's going to happen to these other two kids now? They lost their dad, and their mother doesn't speak English."

*What convinced you so much, from the start, that she wasn't involved?*

Sometimes more than just looking through a finder in a camera, you really get to know people, and when you leave, you've left a small piece of yourself. She looked so innocent and so confused that I couldn't believe that this woman, standing in the doorway with this little tiny girl about 18 months old, could have known about it. She was a very sweet lady. I couldn't conceive of her being involved in the assassination.

On the *Life* staff 1947-62
Interviewed in Los Angeles on August 13, 1993

As I made the adjustments, he announced,
"If you bring those lights any closer,
you're going to blow my brains out"

Dr. Kogbetliantz's three-dimensional chessboard. New York City. 1952

# YALE JOEL

**Y**ALE JOEL: Henry Luce, as you may know, kept his mitts off *Life* magazine because he always considered *Time* magazine his baby and devoted most of his attention to it. I guess he felt an inferiority complex visually and may have felt that words were his forte.

Every *Life* photographer had their own special quality in their pictures. Many of the pictures I've done have been pre-visualized to the extent that I've accomplished the imaginative approach before taking the picture and then consummated it in actuality. I found a small item in the New York *Times* about a Hungarian mathematician, Dr. Ervand Kogbetliantz. He had designed a three-dimensional chessboard and was looking for someone to play with him. I called him up and invited him to come to the *Life* studio to have a picture of himself with his chessboard. He came down, and I spent the morning at the studio shooting pictures of him, using heavy-duty strobes to get enough light so that I could get a close-up of the chessmen in the foreground and the doctor in the rear.

*John Loengard: Did the game really work?*

It only worked for Dr. Kogbetliantz because he could never find anyone to play with him. He had a very astute mind mathematically. He looked at these strobe units as I kept drawing them closer and closer to his ears, and he finally came up with a mathematical computation. He announced as I made the last adjustments, "If you bring those lights any closer than they are now, you're going to blow my brains out."

*You're also noted for using one special wide-angle camera.*

The Hypergon camera was an 8x10 inch camera with an extreme wide-angle lens that looked like a Ping-Pong ball and had a propeller in front of it. The pur-

pose of the propeller was to even the light out at the edges of the film. Once the edges were exposed, you could drop the propeller from in front of the lens and expose the center of the picture. It was a complicated procedure, but since it was designed for architectural photography, where an exposure might be five minutes, you had time to adjust the propeller and connect up the hoses to blow air into it to make it turn. I used it to photograph Admiral Hyman Rickover, who pioneered the atomic submarine. I set the camera up in a stainless-steel nuclear reactor. I asked Rickover to stand on the ladder so his head was only 12 inches from the lens. He stood on the ladder peering up into the lens. The picture in *Life* showed him with an enormous head and a receding, elongated body. To my way of thinking, it was a very true picture of Rickover, because he *was* a tiny guy with a huge head and a small body. But I was uncertain how Rickover would like the picture. I ran into him a couple of weeks after it was published. I had trepidations, but he put his arms around me and welcomed me like a long-lost friend.

*Alfred Eisenstaedt says that he always comes to his subject as a friend. How do you come?*

In much the same way. I photographed General George Marshall at his home near Washington the evening he was nominated as Secretary of State. I arrived and set up near the fireplace, where I hoped to get him standing. He came and stood there with a cocktail glass in his hand. I looked at the glass pointedly. In those days people tried to avoid getting a picture of themselves with a drink in hand so they wouldn't look like an alcoholic. Which many politicians were. Marshall was smart enough to see my glance, and the first words out of his mouth were "I'm no politician," and he held on to that cocktail glass.

*One of your first stories for* Life *was on John F. Kennedy.*

Kennedy was running for Congress in Boston in 1946, and I spent a week with him. I liked him. He had a skinny kind of vulnerable look. He was full of enthusiasm and photogenic. No matter what angle you pointed a camera at him, the picture would look interesting.

But I saw a more confident guy in 1952 when he defeated Henry Cabot Lodge for the Senate. He had established a method of campaigning in Boston— the tea-party technique. He conducted tea parties all over Massachusetts. It provided some wonderful pictures of him surrounded by old ladies.

The next time I saw Kennedy was in Chicago in 1956 during the Democratic National Convention, when he came very close to being nominated as Vice President. This was before air conditioning, and in the heat of summer the convention hall was like an oven. Politicians had hideaways in various places to get away from the crowds and rest. Kennedy had one stashed away in a corner, and at the very last minute, when the vote for Vice President was getting close, Bobby Kennedy asked me to accompany him down to the floor to be available just in case.

So I pranced after Bobby carrying my three cameras on my chest. Each one had a different lens. When we arrived at this hideaway, Bobby opened the door with a key and we entered the place, which was a cavernlike room, totally unfur-

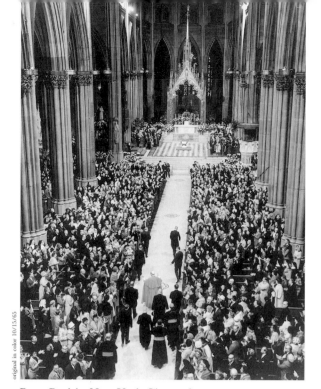

original in color 10/15/65

Pope Paul in New York City. 1965
*The best of two possible worlds occurred.*

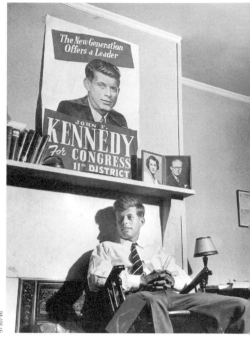

9/30/46

John F. Kennedy. Boston. 1946
*No matter what angle you pointed a camera
at him, the picture would look interesting.*

Admiral Hyman
Rickover. 1956
*He put his arms
around me
and welcomed me
like a long-lost friend.*

2/18/57

nished except in one corner, where there was an Army cot and a skinny figure of Jack Kennedy stretched out wearing only a pair of drawers.

Hearing his brother entering the room with me trailing behind him and three cameras prominently displayed on my chest, and wearing his underdrawers only, I can imagine what his feelings may have been, as a budding Vice President.

He leaned off the bed and stared, not at Bobby but at me, half-expecting cameras to take pictures of him. But I didn't shoot a single picture.

*Why not?*

I felt it would be an invasion of privacy. Here's a guy who might be Vice President, in his drawers, sitting on the edge of an Army cot and completely vulnerable to a picture that might be historically an interesting artifact but certainly was something that I felt I couldn't do.

*What was your feeling about Bobby?*

He was much more difficult to know than Jack. Jack had the qualities of embracing you and—

*Literally embracing you?*

No, not the Clinton type of embrace. It was a way of taking you into his confidence more than anything else. Bobby was more stand-offish.

*You were a specialist in lighting big places?*

When I graduated from high school, in the Bronx in 1937, I found a job at Seidman Photo Service at 1 East 42nd Street. It was a small operation run by this old gentleman who used to be a press photographer. Sy Seidman had a photographer who did all the commercial work, and that photographer was a born teacher. Everything that he taught me sunk in—except I can't remember his name. He had quirks. I'd take care of all his camera equipment, and I once found myself cleaning the lens because it appeared to be so dirty. He saw me, and he stopped me immediately. "That's not the way I want my lens cleaned," he said (I had been cleaning the entire lens.) "The only part of that lens that I use is the tiny center because I stop the aperture down to its maximum. The rest can be dirty."

He was correct—that's what he used—but it just didn't make any sense. I spent a year working with him and learned how to use flash powder. I photographed New Year's Eve in Times Square. All the photographers collected on the marquee of the Astor Hotel. I had a Speed Graphic on a tripod. The trick was, How do you illuminate a huge area? The way they did it was simplicity itself. They would take flash powder from each photographer to make a mountain of powder on one flash pan, so that one flash would be used by all the photographers. The guy who handled the flash would yell, "One!" and you would open the shutter. At two he would fire the flash powder, which would go off with an enormous roar and illuminate the entire island of Manhattan. That was my first experience illuminating big places.

When Pope Paul came to New York iin 1965, I illuminated St. Patrick's

Cathedral. Today you see images of the Cardinal at St. Patrick's, and beautiful lighting with floodlights that have been brought in over the years, and now it's a simple thing. But in those days there was no light in the cathedral. *Life* magazine had to bring in their own strobe lights. We didn't have enough lights at *Life* magazine to accomplish that, so I had to rent strobe units from New York to Chicago. I used at least half a ton of lights and miles of wire because I couldn't depend upon the usual electric eyes or radios to join the units. We had to string wire throughout St. Patrick's. It took a week to do. I was standing in the choir loft on 50th Street and Fifth Avenue.

These lights were very unpredictable. On one occasion in the Waldorf-Astoria grand ballroom, I had placed all the heavy units under an empty table in a balcony box overlooking the ballroom. People started sitting at that table to chat, never realizing that they were sitting around enough electricity to electrocute a couple of hundred people. Unfortunately, one of the capacitors in the unit exploded during the middle of the party. I was close enough to see the table raise about six inches in the air. It was like a seance. Those people were shocked out of their senses. But since it was *Life* magazine, they were very cooperative. Nobody sued.

At St. Patrick's the recycle time between flashes was approximately 10 seconds. Today it's practically instantaneous. When the Pope entered the building, I had to discipline myself to avoid firing prematurely. The cathedral extends a block from Fifth Avenue to Madison Avenue. I was looking from the back of the audience, with the Pope walking away from me. My guess was that he would stop somewhere and give me an opportunity for at least two pictures. The first picture I shot was when he was one-third of the way down. He turned and leaned over enough for me to see his face, and the people in the church turned around to look at the Pope. The best of two possible worlds occurred: everyone looked at the Pope, and the Pope gave me a view of himself. That was my first picture. I knew when the flashes went off I had it. I took the second picture when he was further away, but it didn't matter any longer.

*How do you know when you have a good picture?*

You never know with absolute certainty, but when you shoot with a flash you can see the instant taken by the illumination of the flash. And you have a momentary still photograph in your brain to tell you the precise configuration of the expression on the individual, or whatever else went on in the picture. You're pretty well guaranteed that what you see in your brain is going to be on the film.

*Do you close one eye when you do that?*

You can have both of them open. It's what goes on in the brain that counts.

On the *Life* staff 1947-72
Interviewed in New York City on May 20, 1993

# I had it well diagrammed,
## but when the photographers
## came back from a long martini lunch,
## they were pretty raucous

The 37 photographers on *Life's* staff in 1960,
with managing editor Edward K. Thompson on the floor.*

*\* Left to right, front row:* James Whitmore, Paul Schutzer, Walter Sanders,
Michael Rougier, Nina Leen, Peter Stackpole, Alfred Eisenstaedt, Margaret Bourke-White,
Thomas McAvoy, Carl Mydans, Al Fenn, Ralph Morse, Francis Miller.
*Middle row:* Grey Villet, Hank Walker, Dmitri Kessel, N.R. Farbman, Yale Joel,
John Dominis, Gordon Parks, James Burke, Andreas Feininger, Fritz Goro,
Allan Grant, Eliot Elisofon, Frank Scherschel.
*Back row:* Edward Clark, Loomis Dean, Joe Scherschel, Stan Wayman, Robert Kelley,
J.R. Eyerman, Ralph Crane, Leonard McCombe, Howard Sochurek,
Wallace Kirkland, Mark Kauffman, George Silk.

# WILLIAM J. SUMITS

WILLIAM J. SUMITS: My mother was a seamstress and a good one. When it became apparent that I was going to follow photography, she was quite elated. I became chief photographer of Trans World Airlines and was there for 11 years until 1946 when a pilots' strike almost bankrupted the company and they lopped off the photo department. I came to New York from Kansas City to see J.R. Eyerman, who was then chief photographer at *Life*. He asked, "Have you ever had anything printed in our magazine?" Luckily I had. Cardinal Spellman had chartered a TWA Constellation to take his entourage over to a consistory in Rome, and they asked me to go along and shoot pictures. I had a couple of friends at International News Photos, and they asked me to shoot some color and set me up in an organ loft. It was the perfect spot to see the Cardinals prostrate in front of St. Peter's altar. I shot three 4x5s and turned them over to INP and didn't think anything more about it. A week later, I open *Life* and there's this double-page picture. Four weeks after that, they reproduced the same picture in color (that's as quickly as they could print color in those days), which was unusual. Eyerman said, "We knew somebody had shot it for INP, but they wouldn't tell us who."

His whole attitude changed. He said, "We're going into color in a big way, and we need people with color experience." He took me to Wilson Hicks, the picture editor, and Hicks asked, "How much education have you had?" I knew that *Life* was very oriented toward people with college educations.

I said, "Wilson, I never finished high school."

It didn't phase him a bit. He said, "Has it ever bothered you in any way?"

I said, "No, because if there are things I want to learn about, I make up my mind to do so."

He said, "I'll accept that. Why don't you stick around and do a few assignments for us?" Pretty soon they asked if I'd like to go to London to illustrate Winston Churchill's memoirs. I was told by a press photographer in London, "You've got a tough row to hoe with the old man. He'll allow you three pictures and that's all."

The first time I saw him, I was rattled. I had equipment problems. The flashes didn't synchronize, and nothing worked. After three exposures, I said, "Thank you very much."

He said, "Young man, you're having problems, aren't you?"

I said, "Yes, sir, I certainly am."

He said, "Well, carry on until you get your picture." If I could have shot candids, I could have got some great pictures, but Churchill wanted to pose all the time. At Lord Beaverbrook's villa near Monte Carlo, Churchill was teaching Merle Oberon how to paint. I *did* shoot a couple of candids, and he was furious, "Young man, don't you ever shoot a picture of me until I am ready."

On the Riviera the prudent thing to do was to check with the Scotland Yard man every day and find out what mood Churchill was in. Sergeant Williams would say, "You'd better stay away from him today" or "He's feeling pretty good. Come on down."

The last thing I had to do was a picture of Churchill with Beaverbrook in front of the villa. That morning he was in a terrible mood, which later was explained by the fact that he came down with pneumonia. I heard him ranting around inside the house saying to Beaverbrook, "Tell the man from *Life* magazine to go home. I'm not going to pose for any pictures today."

And Beaverbrook said, "Aoooh, yes, you are."

They posed, but it wasn't a good picture. Once I did get a good picture of him and Lady Churchill with their dog having tea in their London town house. I hooked up three cameras to get nine pictures for my "three pictures." When Churchill walked in, the place looked like it was wired for the telephone company. I was also supposed to shoot Lady Churchill in her study. She was in a bad mood that morning. She let me in and said, "There's the desk. Help yourself."

"Mrs. Churchill," I said, "I thought the plan was to have you at your desk."

She said, "I'm too busy."

So I set up and went through the motions of shooting an empty desk. She came by later, and I said, "Would you care to look at the picture I'm going to take?" She looked in the ground glass.

I said, "It'd be much nicer with you in the picture."

She walked right over and sat down. No argument at all. I found in dealing with these people a little diplomacy went a long way.

*John Loengard: What made you come back to the United States?*

Well, actually, I was let go from *Life* in February of 1950. Wilson Hicks did

not think I was productive in my last few months in London. I went back and did a couple of jobs for TWA. Then, that August, Frank Scherschel, who was running the *Life* lab, said, "What would you think about being my assistant?"

I said, "I'd love that."

The lab then was on 48th Street in an old, old loft building that didn't fit with the prestige the magazine had. Edward K. Thompson, *Life's* managing editor, wanted the whole operation under one roof, so that's when they decided to build a new lab right in the Time & Life Building. I also planned the lab we have now in the current Time & Life Building, built in 1960. There, a great emphasis in the design was on the color lab. We knew that color was becoming the prime part of the magazine.

*How many black-and-white printers did you have in the 1950s?*

Twelve. They had an early morning shift, a day shift and a twilight shift, but nothing overnight, unless you had a late closing. If somebody printed an essay, I'd have the printer put his name on the prints. They were the top technicians in the world.

I had fun in the lab, working with other photographers, like George Silk when he had the idea of using the strip camera they used in racehorse finishes. The stumbling block was to adjust the speed of the film going through the strip camera to the speed of the event that was taking place. I suggested to Marty Forscher, the camera technician, that he use an old gramophone motor that you crank up. They have a speed adjustment on those old gramophones, and, sure enough, that was the answer, except in cold weather, when the gramophone motor would slow down. We solved that by putting little pocket hand warmers in the camera housing to keep the temperature up.

*In 1960 the staff photographers gathered for a group portrait.*

I was the photographer. I had it well diagrammed, but when the photographers came back from a long martini lunch, they were pretty raucous. At some point Ed Thompson went over and lay down on the floor in front of Margaret Bourke-White and Alfred Eisenstaedt. It was a lot of fun. Especially with Eisie with his foot on Ed's head.

*You caught that. Are there pictures you didn't?*

There was one of Churchill on the Riviera. He and his entourage and the security men were walking to a spot where he wanted to paint, but Winston had weak kidneys and he had to stop this entourage and relieve himself, right there off the path. He turned to me with a gleam in his eye and said, "Take a picture of this for your magazine, young man."

I didn't dare. I didn't dare.

On the *Life* staff 1947-50
Interviewed in New York City on October 27, 1993

I've never seen a meaner mob in my life.
These kids were literally run off.
The next thing said was,
"Get the guy from
the nigger-loving magazine"

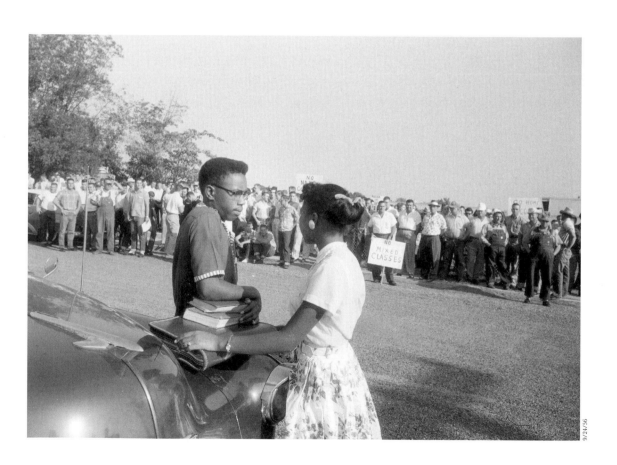

Texarkana, Texas. 1956

# JOE
# SCHERSCHEL

JOE SCHERSCHEL: My brother Frank was more than 12 years older than me. Both my parents had passed away, and when I was 13, I went to live with Frank full time. He was chief photographer for the Milwaukee *Journal,* and I could not imagine why anybody would be a photographer. Every time I saw photographers, they were hiding underneath a black cloth, and it looked like an awful drab thing. Frank had tried to get me to do some printing for him, and I figured he was trying to brush off some work on me and there was no way he was going to do that. But, later, when I did realize I had an interest, he ignored me. Finally he allowed me to go with him on assignments—as a vice president, which meant I held the lights. He and Edward K. Thompson, who was the *Journal's* picture editor, worked closely together. Thompson went to *Life* in 1937, and after that Frank would get assignments from the magazine. When the war came, he was interested in being a correspondent and applied for it. Ed Thompson helped pave the way. That's how Frank came to *Life.*

When I finished high school, I had a scholarship to go to Princeton for swimming; but I was more interested in photography, and so I went to Art Center School in Los Angeles. After Pearl Harbor, I went into the Navy. When I got out, Frank was based in Chicago, and he had a little studio that I took over. One night Hugh Moffet, the *Life* bureau chief in Chicago, came looking for Frank. He wasn't there, and Moffet said, "Well, what are you doing?"

I said, "I'm available."

That opened the door for me to do more things. When I joined the staff two years later, I worked mostly in the bureaus. I was in Chicago, Dallas, Tokyo. Then back to Dallas. Then New York. And then Washington.

*John Loengard: Tokyo was during the Korean War?*

I was not a very good war correspondent. I was quick to learn that that was not my bailiwick. I just didn't have the stomach or heart for it.

*Did you volunteer to go?*

I did.

*Why?*

I wanted to see if I could do it.

*You did not always avoid trouble. In 1956 you were in Texarkana, Texas.*

Those were the early days of the integration after the Supreme Court ruling. Two students were trying to be admitted to Texarkana College. I've never seen a meaner mob in my life than the one that surrounded them. I felt nothing but sympathy for them. I would shoot six to 10 frames and immediately change film in the camera. I'd put it in the left-hand pocket. I kept unexposed film in my right-hand pocket. These kids were literally run off by the mob. And the next thing said was, "Get the guy from the nigger-loving magazine." There were at least three Texas Rangers in that crowd, and not a one of them lifted a finger. The mob came at me, and they said, "We want your film."

I said, "Sure, you can have my film." I opened the camera. I had already changed the roll. I carefully pulled out the film to expose it and gave it to them. It was just a blank roll of film, but I wasn't going to have them develop it and come back at me for the real thing.

I'd learned about that before—in Los Angeles at the funeral of Al Jolson, who starred in the first talkie, *The Jazz Singer*. I had managed to get into the synagogue when his casket was brought in. They opened the thing, and I made four or five exposures before I got thrown out. The rest of the L.A. press knew exactly what happened, and they came after me. I did a quick switch with film. But unfortunately I didn't expose the film, and they came back and said, "You sonofabitch. You gave us a blank roll of film."

So I learned what I had to do. Take the film out and expose it and say, "You can have the film, but you're not gonna sell my pictures."

*Is luck important?*

It helps if you can recognize when it happens. Sometimes you don't recognize it. I often didn't demonstrate a good ability as a news photographer. I'll never forget when I was at the *Journal*, I was on my way to the office and there was a terrible accident. I got out of the car and got my camera, and an elderly man was standing there with a great big cut on his throat, just laying open and blood gushing out. I stood there and I was aghast. I just was frozen. I couldn't move. Anybody with proper reflexes in doing news work would have had a very dramatic picture. I can still see it to this day. Even though you may have the luck of being at the right place, you have to have your senses about you. You have to train yourself.

*Did that apply to the opening of the Shamrock Hotel in Dallas?*

The picture that received the most criticism dramatized the flamboyancy of a Texas opening. It was a picture of a wide-beam elderly lady with an atrocious fox fur over her shoulders with its head hanging down her back.

*What do you think about pictures being cruel?*

If it's cruel, then so be it.

*Well, you didn't photograph an accident because you were so shocked. Do you feel shy about entering people's lives?*

I do. I have a difficult time with that. I've been scared off more than I've been successful. I did a story on Buckshot Lane in Warden County, Texas. This bee-eyed little character described himself as being mean and nasty. He said his two eyes were like two pee holes in the snow. One day he was sitting at his desk behind a counter in the police station, and a black woman came in. She was being booked for some domestic disturbance thing. She had kind of a flip attitude, and old Buck's short fuse went off. He pulled open the drawer and got out a razor strap and came around and whipped the living bejesus out of her. I photographed the whole thing. People like that I have no problem documenting.

*What do you look for when you take pictures?*

I'm trying to simulate a third dimension on a two-dimensional piece of paper. The only way of doing that is with lighting or textures or how I handle my subject matter. I try to document what gives me a feeling about the person.

The 1940s and 1950s were an era where innovation had a large role to play. If you could adapt a different kind of a lens, it gave you a new look at something. Today you have a different kind of challenge. One person can photograph a very dramatic actor and document him, and another person can make a *photograph* of him. It's the same person, but it's how they're handled.

*What makes the difference?*

Ask Alfred Eisenstaedt.

*After you left the staff, you went to work for the* National Geographic *magazine. What difference did you find between the* Geographic *and* Life*?*

It took me a while to recognize that they did not shoot an essay there as you do at *Life*. At the *Geographic*, routinely, you're on location for three to six months. You do the seasons. You do people in government. You do schools, universities, science, scenery, agriculture, the festivities, parades, all the things that are fun in life. As the old expression about *Geographic* goes, it's tits, tots and flowers.

At *Life* you shoot an opening picture, and then you do related pictures, and then you shoot a closer.

*What made an opening picture for* Life*?*

It's a drama. Whether it's dramatic in terms of lighting or expression, somebody's going to stop and look at it and say, "How in the hell did you get that?"

On the *Life* staff 1948-61
Interviewed in New York City on October 22, 1993

307

The first thing Elijah Muhammad
asked me was,
"Why you working for the white devils?"

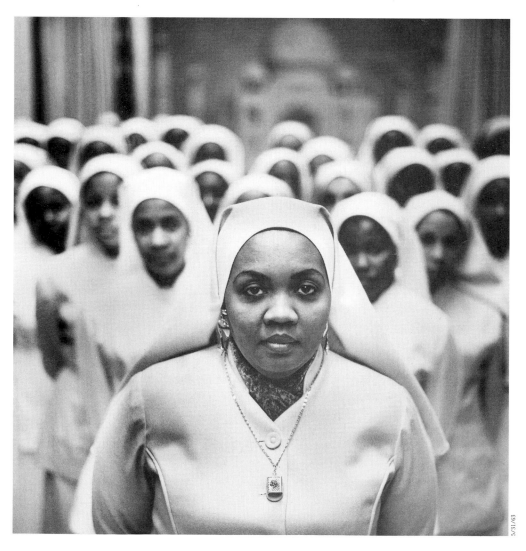

Ethel Sharrieff, Elijah Muhammad's daughter. Chicago. 1963

# GORDON PARKS

GORDON PARKS: In the 1960s, *Life* didn't know whether they could trust me to cover the Black Panthers or the Muslims fairly. The Panthers and the Muslims felt the same way. The first thing Elijah Muhammad asked me when I went with Malcolm X to visit him in Arizona was "Why you working for the white devils?"

I gave him sort of a Trojan horse bit: I'd be more helpful inside. He didn't really buy that, and the conversation lasted at most 15 minutes, even though Malcolm and I had flown all the way from New York. But when I left, Malcolm said, "I think he likes you." Sure enough, a week later he offered me a half a million dollars to do a book and motion picture on the Muslims.

I told him that I was very flattered, but I was afraid he would try to have an influence over me. "You bet," he said. "If I gave you a half million dollars, I would try to influence you." Just like that. So I went to the car again and was ready to get in—again I hadn't been there 20 minutes—and he said, "I like the fact that you just turned down half a million dollars because of principles. I think I can trust you. Brother Malcolm is going to be your guide. I'm going to allow you to go through the world of Islam. If we like your pictures and what you say, we're going to send you a box of cigars. If we don't like it, we'll be out to visit you." That was the way I entered that story.

*John Loengard: You weren't intimidated?*

No, I wasn't intimidated. They *did* come out to visit me after I wrote the story on the death of Malcolm. That's when the FBI notified *Life* magazine that I was supposed to be assassinated. *Life* put my whole family, including me and my kids and grandsons, on a jet out of the country.

They stayed away for about two months, but I felt if I was going to be assassinated, I didn't want to be around my children and grandchildren, so I came back to New York. *Life* wouldn't allow me to stay in my apartment on Beekman Place, so they got me a suite at the Plaza Hotel. Two detectives were stationed at each end of my suite, and a third, roaming detective was the head of the squad. I lived that way for a month until I was just sort of sick of it. Every place I went, the detectives had to go. People would come up to shake my hand, and these guys had their hands on their guns. They're all Dick Tracys, you know. I remember one particular night the detectives were sitting around the dining room, and suddenly they jumped up and ran into the lobby. There were two young boys out there. They were dressed in black, and they looked like Muslims. They suddenly found themselves faced with three detectives with guns in their faces. It turned out to be kids who washed dishes in the Plaza, and this one night they wanted to come up and see what the lobby was like. And they almost got shot. I realized that if someone could kill Kennedy and kill Martin Luther King—people like that—they could certainly get me, no matter if I've got a couple of detectives around me. I slipped away from them, drove up to Harlem, walked into Shabazz's restaurant and asked for Brother Joseph, who was the head of the goon squad. They said, "He's not here."

I said, "I just saw him walk through the door." Sure enough, Brother Joseph was peeping out the kitchen door, and I said, "Brother Joseph just looked out." So he came out and I said. "Let's have some tea."

We sat down. We didn't talk about Malcolm being killed, and we didn't talk about anything that had to do with Muslims. We just talked about the weather and our families, and I got up and left. I came back and asked *Life* magazine to take away the detectives, and they did.

*What in the article had angered them so?*

They thought the piece was too sympathetic toward Malcolm, although I did not try to be. I just told what I felt, and some of the members in the movement left the movement after they read the article.

*Did you ever photograph Martin Luther King?*

I photographed Martin twice, for the March on Washington and so forth. I didn't really know him well. We talked on the telephone a couple of times. He wanted me to come down and speak someplace, but I couldn't go because I was on an assignment. I photographed him in Washington, D.C. That's about it.

*Did you think he wasn't a story, or was not dramatic enough, or—*

No, I was just never assigned to him. I don't know why, because I was assigned to everything else.

*You say that you were assigned to the Muslims?*

*Life* had tried to do the Muslims for about a year or two. They sent Eve Arnold, but she wasn't getting anyplace. The Muslims kept making promises to her. Finally *Life* asked me if I thought I could do it with a white reporter. I said,

"No, I don't even know if I can do it at all. But certainly I can't do it with a white reporter."

So they said, "Why don't you try it with a black reporter?"

I said, "If I do this story, I have to write it myself. I have to be responsible for it. I don't trust what anybody's going to say. My neck's on the line. And it's a dangerous story to do. I have to write it."

They said O.K., and that's the way I got in.

Thinking back, *Life* gave me most of my stories because they thought I could bring a certain drama to them. They didn't send me off to do stories particularly because I was black. They sent me as a photographer, yet there were those stories during the '60s which no white photographer could have covered. Like the Muslims, and the Panthers, and Stokely Carmichael, and people of that sort to travel with. Otherwise, they used me in a very normal way, like the rest of the photographers, and gave me special license when it came to things like fashion.

*What are you doing now?*

I'm painting.

*When did you become a painter?*

My first show on 57th Street was five years ago. I first worked in oil. I did not start watercolor until six months ago, after I finished a novel on J.M.W. Turner, the 18th century painter in England. After I finished that book, I sort of went into a dark hole. I felt the typewriter was dead, after six years. I looked and—nothing to do. And I saw some of Turner's beautiful watercolors, so I decided, Why don't I try a few? After a few, I realized I was not going to be a Turner, and I felt that I'd better give it another dimension. How can I do that? I took a dead leaf which had taken on a very beautiful character of its own and placed it on the painting. I tried photographing it there. Then I realized that I needed depth, so it didn't look like it was just a leaf laid on a painting. So I had to get depth in the painting and then get depth from the aperture of the camera, separately. The first ones were rather successful. Publishers came to see them. The Museum of Modern Art came. Three or four people wanted to buy them for their walls, and so now they're about to be published.

*If you wanted to be listed for posterity, but you could get only one tag—painter, writer, photographer, journalist, musician, composer, pianist—I don't know whether you've ever danced—dancer?—which one would you like?*

If I had my druthers, I would become a concert pianist. That's probably my biggest dream. Certain parts of my works I can play as well as a trained concert pianist. Certain parts I can't play because I don't have the fingering. But I think I could have been a fine concert pianist. I love the photography. I love the writing. But if I had only two things to do and everything else was taken away, I would probably just write poetry and compose music.

*One side of being a concert pianist, instead of being a photographer or writer, is that your audience is right there.*

I don't think I would even know the audience was out there. I get so involved in the music that the audience would be absent as far as I was concerned.

*A concerto you wrote was performed in Venice in 1952. Could you watch the audience?*

I was sitting in the audience. I was very nervous that my first big piece was being played in the Doge's Palace with a 101-piece orchestra. I traveled all the way from America to hear it that night, in the romantic moonlight, and I didn't hear it. It went in one ear and out the other. I didn't recognize anything I'd done, and I was sitting there, stunned at the end, when the conductor raised his baton for me to stand up and accept applause. The woman next to me had to poke me and say, "They're asking you to stand up. Stand up." I didn't hear the piece until I got back to America and heard a tape.

When I got older, I thought that things were going to lighten up, but I'm more in demand now than I've ever been in my life. It's a little frightening because I realize that I've got X number of years left. I want to compose more and compose differently. I want to write more. I want to make at least two or three more films. This all takes time, and I'm 80 years old. I think I'm going to write at least three more books. That's the way I must keep myself thinking, and it's a little frightening.

*What's the difference between movies and still pictures?*

In movies your camera remains stationary and your subjects move, but I could not have become a director unless I'd had the training with the still camera. The camera taught me to see. Especially the 35-millimeter frame, although in 1969 *The Learning Tree,* my first picture, was in Panavision. I had to adjust to the big, wide screen. I was fortunate. I had written the novel and was asked to compose the music, and I was going to be the first black director. I needed a certain kind of clout, and Warner Bros. suggested that I produce it as well. I told the crew, "I'm the only amateur on the set, but I'm the boss, so you do what I want. If I'm wrong, take me aside and tell me. If you can't do it, let me know why you can't do it."

It was traumatic as all get-out, because I went back to my hometown, Fort Scott, Kansas, to shoot it, and then I saw my family's grave, my mother's and father's segregated graves, and they had a Gordon Parks Day. The Governor of Kansas came, and I made this big speech. At the end of it I said, "I'm glad to be back, but I'm sorry to see that you're still segregating black people's graves out here. Since I've fought bigotry and discrimination so long, I'm going to have trouble lying here in this grave unless you do something about it."

First they decided they wanted to do a monument for me, and I said I did not want that. The next thing they wanted to do was move my mother's grave to the white side. I said, "No, I don't want that. My mother wanted to lie where she is amongst her friends. Just do me a favor. Pave the road around that way. Bring in some new trees. Cut down that big, rotten tree that stands about 30 feet from my mother's grave, and stop burning the reeds and the trash on the black side." They promised to do all that, and they promised me that now the grave-

yard will be integrated. I don't know whether it's going to turn out that way, but I do have problems with allowing myself to be taken back there one day.

My parents and my 14 brothers and sisters all wanted me to be somebody, for some reason or other. And I was determined to be somebody. I did anything I could get my hands on as far as a job was concerned: piano playing, professional basketball, herding cattle. The photography was an accident. But everything was an accident. I had not prepared myself for anything. Ralph Ellison and I were doing a story on psychiatric treatment in Harlem for a magazine being published that was named after each year. There was *1947*—the next year it was *1948*. It folded right about when our story was ready. Instead of my just going home like Ralph did with his manuscript, I went to *Life* magazine to show Wilson Hicks my work. I'd never seen Hicks before. I just took a chance, like I did a lot of things in those days. I still do. Someone showed me where his office was. I walked up and said, "May I come in?"

"What do you want?" he said.

"I want to show you some photographs." I had already worked for the Farm Security Administration, where Dorothea Lange, Walker Evans, Carl Mydans had been before me, and John Vachon, Marion Post Wolcott and Russell Lee, all great documentary photographers, were working when I was there. Wilson asked me, "Well, what do you want to do?" And I said, off the top of my head, "I want to shoot a story on Harlem gangs." I hadn't thought of it five seconds before, but I wanted something that would excite Hicks. Hicks looked at me and said, "I'll give you $500."

I joined *Life's* staff in 1949 after the gang story and was assigned to Paris for a two-year stay in 1950. I took my whole family, and it changed my life. I was all mixed up with problems in America: discriminatory practices, prejudices, things I had suffered here. I was not giving enough time to other things inside me that I was capable of doing, like writing poetry, composing music, things of that sort. When I went to Paris, I put America behind and began to pursue these other things, and it changed my whole outlook. But I wasn't about to become an expatriate. Richard Wright encouraged me to stay in Europe, but I said, "No, Richard, you did your thing"—he wrote *Native Son*, *Black Boy* and all those wonderful essays—"but I have to go back to do mine now." I learned an awful lot in Paris. I'd hang out with writers. I went to listen to a lot of symphonic music, which I'd never had much access to. I had a chance to meet a lot of the French literary crowd. I met Pablo Neruda, the poet, in Rome. He inspired me.

*You say you express your emotions in poetry and music. Do you feel you can express them in photography?*

In photography I do it through other people. With poetry I sit down at a desk and take my pen and start writing. With music I sit down at the piano and start composing. In photography I expressed my feelings—about poverty, for example—through Flavio, the little boy in Brazil.

*When you were photographing Flavio, what made a picture good?*

Well, Flavio's movements, his everyday situation. I was watching this kid practically die before me of bronchial asthma and four or five other diseases. I was watching every movement, to try to convey his situation to the reader. I had been sent to photograph poverty in Latin America. I was supposed to find a family and zero in on the father to see what *his* problems are. That was going to be a humdrum story. One day I was sitting under a jacaranda tree with José Gallo, *Life's* stringer in Brazil. It was hot. My ankles were swollen from walking the mountainside, and little Flavio walked by with a five-gallon bucket of water on his head. He turned and smiled, and he was such a beautiful kid. He was dirty as all get-out, and he had ragged pants on, barefoot. I looked at him, and I smiled back. I said to José, "I want to follow that kid." We walked up behind him, and I asked him if he'd like me to help him with this water. He said, no, no, he can carry it. Then I told him that he can carry my camera, I'll take his water. So he did that for a little while, and then he gave the camera back to me and took the water again, and that's how we got to the top of the mountains. That's where he lived with his seven brothers and sisters, whom he was taking care of. His mother and father worked down at the bottom of the mountains selling kerosene and water. At first the father didn't want me to stay, but when I mentioned money, I was welcome. He wasn't a very nice father. Flavio's mother was a very wonderful woman, and all the kids were lovely, but the father was not much good. Now and then he cuffed Flavio around a little bit, and I heard about that. I cabled *Life* saying, "I've found this wonderful little boy, and I would like to pursue that story." They said go ahead. Take your time. Do it right.

*You paid the father?*

No, I didn't pay him. I just brought some small gifts, like, I couldn't bring up too much food because it would spoil my story. That's a pain. I knew very well that I could feed that family every day, and I could buy them clothes. I knew I could make them comfortable. I had the money to do it, but then I'd ruin my story. They would offer me dried beans and things they were eating, and I would eat them because I did not want them to feel as though I was too good for it. The father would say, "Here, here, eat, eat." And I would eat. I slept on the floor sometimes. Little Zacarias slept in the crib. All the rest of the family with the mother and father slept in one bed. And I had an old Army blanket that I spread on the floor. The shack was very, very small. It had an old stove that had burned through the floor. It was slanted on the hillside. It was a miserable, miserable place.

They had about three plates. The main plate was for the father. The mother had a plate too. And the rest of the kids picked off the other plate. They had two or three knives and forks and things that they traded, depending upon what they were eating. Sometimes they ate with their hands, you know. It was very painful. I left my clothes and things down in the fancy hotel along the waterfront, and

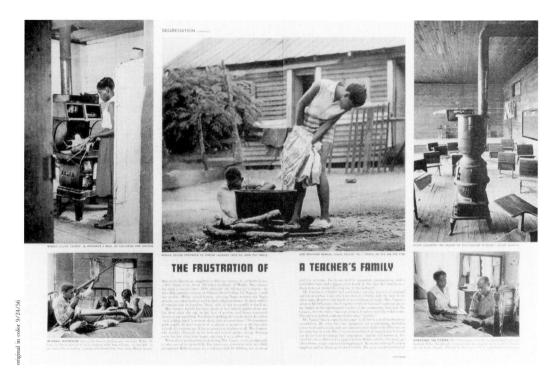

Essay on segregation. 1956
*I just barely got out of there alive. That was the only time that I really disliked an editor.*

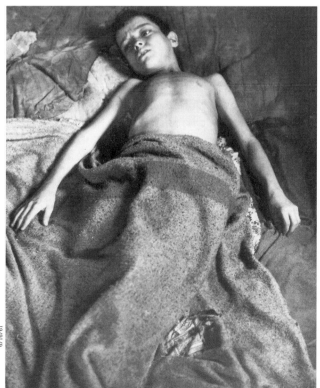

Flavio. 1961
*I expressed my feelings through
Flavio, the little boy in Brazil.*

put on a pair of jeans, and just stayed in the clothes that I had on. Once a week I'd go down and take a shower. Eat a decent meal. Near the end I began to bring them food. When I left to go back, I left them money, stuff on my own. But when the story was published, *Life* readers sent $30,000 in less than three weeks. Letters came in that said, "You have to go back and get that kid. You can't leave him down there." *Life* magazine gave me another $25,000, so I had enough to move them out of the favela to a nice home, and get them all clothes, and get the old man a truck to work with. They were living in luxury practically.

There had been a problem when I first got back with the film. Tim Foote was my editor, and he came down from the layout room with a look of despair on his face. "I hate to tell you, Gordon, but Edward K. Thompson [then *Life's* managing editor] is going to run only one picture of Flavio—and a picture of a rich Argentinean lady on the opposite page."

I said, "Really?"

I went right to my office and wrote out my letter of resignation, and I said, "Tim, give this to Ed. I'm finished."

He said, "Hold on till Monday."

I wasn't going to change my mind, but I agreed. That weekend Dean Rusk, the Secretary of State, said if we don't do something about poverty in Latin America, the communists are going to take over. We got seven pages. Just like that.

*Why didn't you go to Thompson yourself?*

Ed was tough. I didn't think Ed would change his mind. And I was impassioned with the story and felt that I had given it my best and that Flavio deserved more. The world had to find out how this kid was living.

*Did you admire the editors at* Life?

I admired Ed in the end, you know. There's one or two editors I didn't like. One nearly cost me my life. I went to do segregation in the South, which was very dangerous in 1956. This editor, who was also a bureau chief down there, said, "I don't find that much discrimination in the South." Well, anybody who didn't find it where *he* lived, wasn't looking. He was supposed to be working with me, but he would never be seen with me.

I called Kenneth MacLeish, an editor in New York, and said, "This guy is frightened. Every place I go, people seem to be tipped off that I'm coming."

They wanted me to go into a bus station to shoot separate-but-equal facilities for blacks and whites. Samuel F. Yette, the black boy I took with me as an assistant reporter and researcher, said, "Come on, Parks. Let's sit on over here on the white side." We did. A big gang of workmen come in with shovels and picks. They didn't speak to me. They just talked about niggers and what they do to niggers. How they lynch niggers down—this is in Birmingham, Alabama. I did not know whether we were going to get out of town alive or not. We did get on a Pullman train. I had a room. Sam had a berth. I said, "Sam, you want to come

up and sleep in my room?" Because some of these guys followed us to the train. "I wouldn't sleep out there. I don't know what's going to happen."

He said, "No. Nobody's going to bother me."

We weren't out of Birmingham 10 minutes before I hear a noise outside. I had a big flashgun with me. One with triple batteries. It's a lethal weapon. I jumped out, and two guys were struggling with Sam underneath the bed trying to get the film. I started flailing away with this thing. They had timed it right, because the train slowed down at that spot, and these guys jumped off. Well, Sam and I had a little consult. I said, "I know somebody is ratting on us. Somebody knows everyplace we go. Who can it be? Only one man knows we're here. Let's test him. Tomorrow we're supposed to be at Nashville. He said he didn't want to go to Nashville with us. Why? Why did he take the car and send us on the train?" So what we did—I was supposed to photograph a black professor leaving a bus station where it said "Colored" enter here and "White" here. He's a college professor at Fisk. I said, "We will shoot this guy in the morning and get the hell out of there by afternoon."

In the afternoon we sent in a black photographer from Fisk University as a decoy, and they grabbed him. He said, "I'm a student from campus. I'm just down here shooting pictures." They let him go, but then we knew that it had been set up.

I came back to New York, and I was telling Alfred Eisenstaedt about it. Eisenstaedt says, "That's awful."

Eisenstaedt went and told Irene Saint, the editor in charge of all the correspondents in America. She said, "I don't believe that story. I don't believe it for a minute."

She called me in, and I said, "Well, Irene, since you called me in here, yes, it's true." I said, "I just barely got out of there alive."

Three days later, a family that I photographed had all their clothes taken, all their furniture taken, and they were run out of their house. Their cattle were taken. They were put on the highway—the wife, with three children. They were supposed to contact the bureau chief for help in case they got in trouble, but he'd gone on "vacation." They telephoned me from the highway collect. Then we realized that it was so. The bureau guy was brought back to New York, put at a little desk outside Irene's office, and that was the last anyone ever heard of him.

That was the only time that I really disliked an editor. I told the story in a book, but I never used his name because I didn't want his children or his wife to think that he would do such a thing. When two other editors, Hugh Moffet and Richard B. Stolley, went to Birmingham to try to get the home back for this black family, a crew with shotguns and rifles was waiting. They went to the mayor's office. The mayor was a woman. She said, "Yes, and if we'd have caught that nigger Gordon Parks, we were going to hang him, and drag him down the road, and tar and feather him."

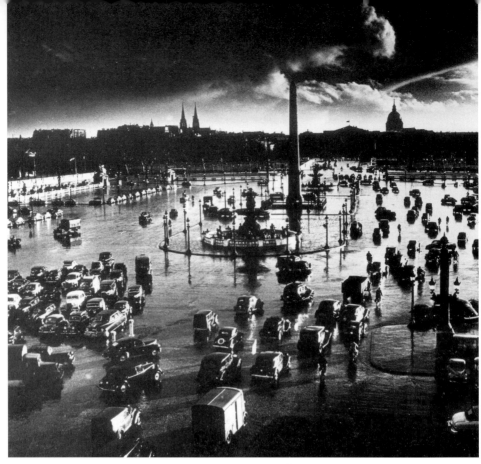

7/30/51

Place de la Concorde. Paris. 1951
Life *gave me most of my stories*
*because they thought I could bring a certain*
*drama to them.*

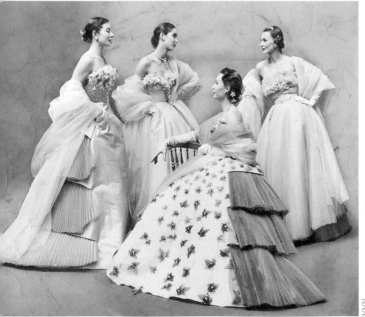

3/5/51

Fashion. Paris. 1951
*You've got to insert your own*
*feeling and emotion, and you*
*have to take chances.*

That's how close my life was to that. They never got the guy, Willie Causey, his home back, but *Life* did a wonderful thing again. This guy was a sharecropper. He cut lumber. He made $10 a year. They gave him $25,000. His wife took half, he took half, and they split. They'd wanted to part from one another all their lives. She was a teacher. The professor we shot was this woman's brother.

*Do you think the series on segregation did any good?*

I think that it did good. I have people talk to me about it even nowadays. I'm sure the Southerners would rather *Life* had not done it. But I think it was a responsibility of *Life's* to do it.

*On the* Life *staff, whom did you admire as a photographer?*

I admired Carl Mydans, because he could write and photograph. I liked that second dimension. He inspired me to do that myself. I liked Robert Capa. He was a romantic, crazy guy. We knew each other in Paris. I remember Howard Sochurek's story on the new jet airplanes—the jet age story in the early 1950s. I thought that was beautifully done. I liked certain things Grey Villet would do, and Margaret Bourke-White and Eisenstaedt, but I really never had any heroes. I thought W. Eugene Smith had a wonderful sense of humanity. We were friendly with one another. We always got our stuff printed alike. I found a lot of emotion in Gene's work. More so than I did in most of the other photographers. Other photographers would come up with something now and then, but if you saw a story of Gene's, you expected it to be packed with emotion. Leonard McCombe had a good style with a certain chord. You know what I mean? A touch. I think Leonard could have been a good fashion photographer if he'd applied himself.

*What makes a good fashion photographer?*

Fashion photography is very difficult. You've got to know the woman's body. You've got to know the clothes. You've got to know what the designer's after. You've got to insert your own feeling and emotion, and you have to take chances. Designers complain today that they aren't respected and that the photographer's only concerned with getting a crazy, wonderful picture. If you design a dress, you want to see the way it flows. I just told the model straight out, "Don't steal from the clothes. Lay back. Let the clothes do the work, sweetheart." The great models were aware of it. Suzy Parker and some of the great models from Paris and London were very much aware that the clothes should take the lead.

*You may be the only* Life *photographer in 60 years who never photographed a Kennedy, but did you photograph Winston Churchill?*

Churchill? Well, I was on the same boat, returning to America from Paris with my family. *Life* cabled me to try to get an interview with him and pictures. I couldn't get anyplace. I was on the same deck he was, but there were always guys with derbies, security men, outside his cabin. I had given up. We were getting close to New York, and I came out early in the morning to see the skyline. I looked down the deck, and I see Churchill. I can recognize him by his square

body, and he's with Anthony Eden. He had a homburg on, and there was a little girl in between them, skipping, and they were holding her hand and talking to her. And after I got closer I could see, well, my God, it's my daughter Toni! So she said, "Daddy, Daddy!"

I said, "Hi."

And Churchill said, "Is this your daughter? She's a charming lass."

I said, "Thank you, thank you. She did better than I did. I've been trying to get close to you for nearly five days out here, and I couldn't get in. I'm from *Life* magazine. They called me on the boat and said, 'See if you can get an interview with Churchill and pictures.'"

He said, "Oh, I'm too ugly to photograph. No, but come on in the cabin. You want a brandy?"

And I said, "Yes, well, I would like a brandy."

He said, "Have a cigar."

I went in, and I didn't have a camera with me, and it was about that time the phone rang. Eden said, "Sir, it's the President of the United States."

I said, "Well."

He said, "I'm sorry. Take a cigar and brandy. Take it with you."

I kept the cigar for years until it crumbled, and then I finally smoked it in my pipe one day. *Life* sent me back to cover his funeral. I felt like a vulture.

*Let me ask about that. How do you feel about intruding on people? How close is too close?*

I don't know. You just have to—I put myself in other people's places. If I know that I wouldn't want to be photographed in a certain condition, I don't do it. I've sacrificed some good pictures, but I've never found that I lost anything by that. There are just certain pictures I drew back and wouldn't take.

*You chose not to photograph Muhammad Ali after a fight.*

Muhammad Ali was a funny guy. He trusted me, but we had a little problem in London once when this guy wrote a story about him in *Life International*. Ali came barging into my hotel room, saying, "This guy wrote this awful story about me and told about my mama and papa and everything else. There's some pictures of yours in there. I thought you was my friend."

I said, "I didn't know that story was coming out. I work for *Life* magazine. I didn't know *Life International* was going to use them. And I haven't read the story."

He said, "All of you answer to Judson 6-1212 [then the telephone number for Time Inc. in New York]. You're all the same." Later he said to me he was sorry about what he'd said. Ali used to call me the Champ. So after the fight on the night you asked about, he told one of the Muslims, "Go out and tell the Champ I said to come in. I want to see the Champ."

*What did you call him?*

I called him Monster. We had a lot of nicknames, but, in any case, after the fight they had kicked all the other newsmen out because Ali had broken his jaw and his jaw was swelling. They didn't want the picture made. And then he said

to me, "Come on in." I walked in, and he says, "You going to take a picture of me with my jaw swollen up like this?"

I said, "I'd love to, but I just ran out of film."

Later, at *Life*, Marshall Smith, the sports editor said, "I hear you were in there. I hear you got the picture."

I said, "No, I didn't get the picture."

"Why?"

I said, "I don't know. It was just suddenly Ali was bigger than *Life* to me, and I didn't take it."

Well, *Life* printed that I was there and I didn't take the picture. I wouldn't have been happy to have shown Muhammad Ali with a big, busted jaw. I suppose I should have. It was my job. I was sent by *Life* magazine. But they were forgiving.

*If you were to be presented to St. Peter and could take only one photograph with you, what would you want to show him?*

I would probably show him the lady with the mop and broom. It was my first professional photograph. Now it's getting to be one of my best known. In 1942 Roy Emerson Stryker, the chief of the historical section of the Farm Security Administration, asked me what I knew about Washington. I had just come from Minnesota. I told him, "Well, it's where the President lives, the seat of democracy," and so forth.

He said, "Uh-huh. You don't know much about Washington. Well, O.K., I'm going give you an assignment. Put your camera up. I want you to go to Julius Garfinckel's department store and get yourself a topcoat cause it's gonna be really cool down here."

"Topcoat, yes."

"Across the street from Julius Garfinckel's, right on the corner, is a restaurant. Want you to go in there and get lunch. You listening?"

I said, "Yep."

"After you have lunch, go catty-corner across the street to the theater. I want you to see that movie in there."

I said, "Well, what's all this for?"

"That's your assignment."

Well, at Julius Garfinckel's I ran into all kinds of problems. The guys couldn't find a coat my size. They wouldn't try. They'd say, "We just don't have your size." So I stretched myself on a white lounge on the third or fourth floor, and I realized what was happening, and they called the manager, and I said, "Look, I'm up here to buy a coat, and nobody wants to wait on me."

One of the guys steps up, "Well, we don't have his size."

I said, "You never asked me my size."

And so the manager begins to say, "General So-and-so was here, even before you. We couldn't wait on him. It was too busy."

I said, "There's not a soul on this floor but me and these dudes. What are

Ella Watson. Washington. 1942

*"You have to get at the root of the problem."*

you talking about?"

And so, to get me off of that white couch by the elevator, he said, "Show him a coat."

I said, "No, I wouldn't take your coat now if you gave it to me," and stormed out of the place.

I went across the street to the restaurant and sat down. The guy was astounded. "Don't you know colored people can't eat in this place! Come on, get outa here! If you want to eat, go around to the back!" This is in 1942.

Embarrassed. I'd just come from Minnesota, where I had sodas with my kids every day at lunch counters. You know, every Saturday, the big treat. I walked across to the movie. Same treatment, "You can't go in here." This is Washington, D.C., in 1942.

So I stormed back to the building at 14 Independence Avenue. Roy says, "Well, how'd it go?"

I said, "You know how it went."

"What you gonna do about it?"

I said, "I don't know. What do I do about it?"

He said, "What'd you bring your camera here for?"

I said, "Oh, I see."

He said, "You don't just go out and photograph a man because he refused you a seat or refused to wait on you and title it 'Bigot,' because bigots have a way of looking that's good or better sometime than everybody else. You have to get at the root of a problem. Talk to some older black people who have suffered what you suffered today and survived it. Get some understanding of the situation. Then use your camera." He said, "There is a lady down the hall. She's been here a long time. She's a charwoman. Had she been white, she'd have been in an office working as a clerk. I know her. But I can't promote her. She's black. Talk to her after I leave."

He left. I talked to her. She told me about how her father had been lynched. How her daughter died at childbirth. How she was bringing up two kids on a salary fit for a half a person.

And I said, "Would you mind my photographing you?"

She said, "No. Where do you want me to stand?"

And I was so angry I saw the American flag draped to the floor, and that's when I put her in front of the American flag. Put a broom in one hand and a mop in the other. And I said, "Now think about what you just told me." And I took the picture.

On the *Life* staff 1949-60
Interviewed in New York City on May 18, 1993

For some reason
one baboon didn't get off.
It turned and faced the leopard,
and the leopard killed it

original in color 1/6/67

Botswana. 1966

# JOHN DOMINIS

**J**OHN DOMINIS: Fremont High School was my neighborhood school, and it was really the only good photography school in the country. To teach photography, C.A. Bach had got money from the Smith-Hughes Act, which provided grants for vocational high school training. If we heard a fire engine go by, half the kids in the class would grab their cameras. And anytime there was a flood in Los Angeles, we knew one place where there were stop signs that were lower than the normal stop signs. One of us would sit in the water next to the sign, and the other guy would shoot this picture so it looked like the water was five feet deep. We would take that picture to the papers. They would run it, and then the Associated Press would pick it up. It ran very well in Florida. They loved to see rain in California.

I graduated from high school in 1940 and went to U.S.C., and then I went into the Air Force in 1943. While I was still in the service in Tokyo, I'd go down to the press club every day. I got to know everybody, and I started shooting pictures for writers who came over and needed some photographs. I was ready to be discharged in 1946, but to stay in Japan as a civilian at that time, you had to work for the government or be accredited to a specific news agency. There were no free-lance photographers. I got to know a United Press photographer, and he wrote a letter for me on their stationery requesting that John Dominis be discharged in Japan to go to work for UP.

I was the only free-lancer in Japan. It was totally illegal. I couldn't get on a train because you needed orders to get on a train. I couldn't go to the PX and buy anything. Correspondents and photographers like John Florea from *Life* bought my toothpaste and stuff. But one day there was an announcement that the Americans could buy surplus jeeps for $200. I picked out a jeep and drove

it up to the gate, and gave the guard the money, and he waved me on. I would drive up to a PX gas station, and they never asked for a card because I'm in a jeep—I'm an American—and so they'd fill it up. Then I was really operating. I could drive around Japan. I had a Japanese girlfriend, and we would go out in the country and buy rice and bring it back to distribute around to her family and friends and neighbors. We had the only bath in the neighborhood. Everybody used it. It was fantastic to have something like that because after the war it was very, very destitute in Japan.

I didn't work hard. I took pictures for *Collier's*, the *Saturday Evening Post* and a little bit for *Life* when Florea was busy or needed an extra hand. He was older than me, but from the same high school, so I knew him well. A group of writers and editors were starting a magazine. I was getting tired of being illegal, so I asked them to make me their official photographer. They requested Washington to accredit me, and Washington sent a cable back saying, "This magazine is a fly-by-night operation that won't last six months. Who is Dominis, and what is he doing there? If he's not accredited to anyone, he's got to leave."

So I was out. Hank Walker, another schoolmate from Fremont High, was being transferred by *Life* from the Chicago bureau to Germany. He suggested I go to New York and say to *Life*, "I'm going to go to Chicago. I'll be there if you need anybody. I'd really like to get some work." I met everybody in the Chicago bureau. It was *Life's* busiest bureau, and they used me all the time. Then Charles Steinheimer, a staff photographer in San Francisco, went off to Europe, and *Life* sent me out to take his place. I was still not on the staff, but when the Korean War came along, I volunteered. They had to put me on staff in order for me to go. I went in the winter of 1950.

I felt as though I had to go. It was a big event. One of the stories that no one had done was on the North Korean tactic of blocking roads with logs so everybody gets ganged up and becomes a good target for machine-gun fire. I was with a patrol, and, sure enough, we ran into a roadblock. The patrol started using mine detectors to see if there were mines laid around it. While they were doing that, I climbed up a hill and took pictures. We went through the roadblock, and then the North Koreans opened fire. I was still back in a fairly safe spot, and our men came up with machine guns and fired back. As they did that, each of our soldiers would run back, one at a time. I photographed these guys puffing and scared. The pictures turned out real well, and the story ran. Later, I figured that while I was on that hill looking down, the only reason they didn't shoot me was because it would have spoiled the surprise of the ambush. It was a dumb thing to do. I wouldn't have done it if I'd had more experience.

Of course, no picture is worth dying for. I don't think it's even worth getting hurt. However, I didn't think I would die. I don't think anybody thinks they are going to get hurt. You're just very busy, and the camera feels like protection.

You're hiding behind the camera, and it's real safe back there. [*Laughs*] You never even open your left eye.

*John Loengard: Were you in Tokyo when General Douglas MacArthur was relieved of his command by President Truman?*

I photographed MacArthur entering his headquarters in the Dai Ichi Building. I went over there at 10 o'clock in the morning and hung out all day. It started getting dark, and I didn't have any flash equipment. When he came, the luck was that while my shutter was open, another photographer fired a flash from the other side, and I got this terrific back-lit shot, which I never could have gotten with a flash of my own.

Covering the Korean War, I was in and out of Japan for a year. Then I went back to Dallas and then to Washington, and in 1956 they sent me back to Asia. I was in Singapore and Hong Kong for six years and covered little wars there that were serious for me, although they weren't as big deals as Korea.

I went back to Washington in 1962 and went to Berlin with President John F. Kennedy. Trying to photograph there was just about impossible. They put us on a truck, and we're so far back we can't even see Kennedy's car. Normally the press photographers' truck should be in front of the President. We were screaming at the driver. Finally, when we got to the square where Kennedy was to make his speech, it was impossible to shoot anything. You had to be up in a building. For a photographer, it was an angry, fighting situation. But, then, when Kennedy started to speak, and he said, "I am a Berliner,"[*] God, everybody was crying. It was a fantastic experience. I'll never forget that, but it was frustrating too. I could only shoot some pictures of the two or three Germans next to me. I couldn't see anything.

*Was it any better going to China with President Richard Nixon?*

[*Laughs*] When Premier Chou En-lai and Nixon were walking on the wall, just as it started to get good, Walter Cronkite goes out and stands right next to Chou En-lai and starts talking to them. We started screaming at him, and finally he moved to the side and we got a pretty good picture.

*How much of a problem has television been?*

Television is a huge problem. It got to be worse and worse. At first they were an annoyance, and *we* were running everything. Then *they* started running everything, and we became the annoyance.

But, you know, when we went over to China, the White House press secretary said, "This is a very touchy situation. We'll be guests there. I don't want you to get into any fights. Don't be aggressive. Take it easy." We went to the first meeting of Nixon and Chou En-lai and lined up in a row with the Chinese pho-

---

[*] Kennedy said in German, *"Ich bin ein Berliner!"*

General Douglas MacArthur. Tokyo. 1951  *I hung out all day.*

Woodstock. 1969  *Everybody was so generous, handing out pot.*

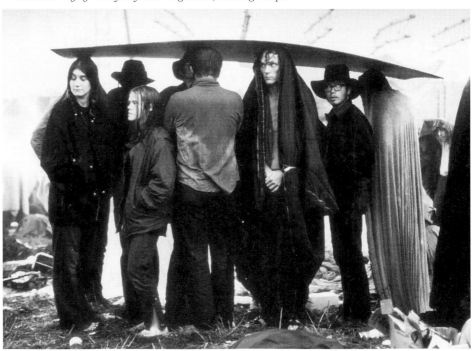

tographers. When Chou En-lai and Nixon sat down, the Chinese moved in close with wide-angle lenses so they're standing in front of us. So we charged in and started elbowing them to get the shots too. Afterwards, the White House was furious. They said, "You ruined it. You spoiled the whole trip. You wrecked everything." Actually it didn't seem to matter. The Chinese photographers were just the same as we. They were used to the battle.

*Good elbows?*

Good elbows. Often, though, there's an advantage if you're the pool photographer at something like that. That's when they only let in only one wire-service photographer, say, and one magazine photographer and one TV cameraman. Everyone else who's on the trip gets to use the pictures they take in that situation. When there are only two or three photographers in the room, you can stay back and do a little bit more. When Nixon was making his speech at the dinner, I used a short telephoto to bring him and Chou En-lai together a little bit in the picture. Chou En-lai was sitting at the table behind Nixon, very contemplative and facing toward me. He's thinking, and Nixon is out of focus, but clearly it's Nixon standing up with a microphone by himself.

I was free to walk around, and for the actual toast I knew they were going to face each other. I had them close to me, and in my picture there are other cameramen in the back of them with all the people. It gave a good sense of the moment. Without a huge number of photographers in the room, you could do a little extra.

*Let's go to something else, which is Woodstock.*

Ah, Woodstock. I put it alongside of Kennedy's Berlin speech as places to be. For me it was fantastic. I was a little older than most of the kids there, but not too old to really enjoy it. I wasn't one of the normal pot smokers, but I had had a little, and up there everybody was so generous, handing out pot.

But the thing that was great there for me was that we actually lived it. We got a tent, and we slept in our tent the same way as the kids did, although a lot of them didn't even have tents. The music was going on during the night while you were sleeping. And, then, during the day, all around the edges, there were these quiet kids gathering together and meditating and saying, "Ohm." A guy was in a tree playing a guitar by himself. I wasn't so interested in the music. It was not my music, and so I didn't go to the stage much. Bill Eppridge, the other *Life* photographer there, was younger than me. He took pictures of people singing on the stage and kids in the audience dancing. Mine were quieter. It was obvious to all the editors, and to Bill and me later, that our pictures were different. They made a terrific combination.

It rained and rained. I had a terrific shot of six really wet and bedraggled kids standing there in the cold with a 4x8 sheet of plywood on top of their heads to keep the rain off. They aren't even holding it with their hands. They're just standing there, supporting it with their heads.

*Was Woodstock what you expected?*

Nobody thought we were going to cover a big event. If we had, I'm sure we would have had five photographers there, but it turned out to be a big thing, and *Life* put out a special issue. We didn't have enough pictures for it. They had to buy a lot of pictures.

*You had photographed the Beatles in 1964.*

All of a sudden *Life* decided they were big and they had to be on a cover. They asked me to do it. God knows why—I'm not a cover expert, in the least. They put me on a plane to London. Somebody met me and put me on a train, and I went up to wherever it was that the Beatles were performing, a five-hour train ride. They showed me the only place where I could shoot. It was right on the stage. Behind me was a curtain and a band playing. It was a huge noise, because this rock band was playing four feet from me, warming the audience up for the Beatles. I put some boxes up to seat four people. The Beatles arrived and were wild and running around. I couldn't get them to sit down, and they were going to go perform in a minute. The pressure is huge to get this cover. So I went over to John Lennon and said, "Can we shoot this?" John said, "Come on, fellas. Let's go over and do this." Without him I could never have gotten it. I made not more than six frames. You know, with four people, half the time somebody's going to be looking the wrong way or having their eyes closed or something. They went onstage. I got back on the train, got back on the plane and got back to New York. They processed the film, and I was scared to death, but the picture was O.K. Nothing great, but it ran on the cover.

*You say you weren't an expert on covers. What's different about covers?*

Well, I mean portraits of people and lighting. I like to shoot people where I am the fly on the wall. I try to not interfere. I just hang around, hoping they don't even notice me. But when it comes to doing a portrait and talking to someone and relaxing them and lighting it well (and making a meaningful portrait of them), I think I'm terrible at that. I wish I could do that, but I can't.

*You also photographed Frank Sinatra?*

I was a little wary. It was Sinatra's 50th birthday, and what he probably thought that he was going to have was a long interview with a writer and maybe a few formal pictures. Often with famous people, when it comes to actually taking real pictures of their lifestyle, they balk. They don't want a guy hanging around every minute of the day and night. But that's what we wanted to do.

I went down to Florida, where Sinatra was performing. I met him and hung around backstage. After the show he'd eat with a bunch of friends. For about a week I just hung around. People would come by all the time, and he'd say, "Hey, John, take a picture of old Joe and me." So I'd go snap and take this snapshot.

We went out to Las Vegas, and at some point on the plane I said, "Everything's great, but I'd like to start getting some of the stuff we hear about. You have parties late at night with some of your old buddies and things like

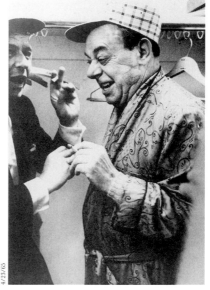

Frank Sinatra. Las Vegas. 1965
*He ended up singing in the closet
with Joe E. Lewis.*

Frank Sinatra. Las Vegas. 1965
*He jerked the tablecloth out.
I'd never seen that trick done.*

Trout amandine. 1964   *We didn't want our pictures to look like ones in all the food magazines.*

that." So he invited me to a party. He had all these girls there and guys up in his suite, and they drank, and he jerked the tablecloth out from under all the dinner dishes on a table. I'd never seen that trick really done. It worked. I was amazed. He didn't spill any dishes on the floor. I shot all this, and he got smashed and ended up singing in the closet with Joe E. Lewis. Good stuff. The next day I got him in the sauna room.

I took three months with Sinatra. That's unheard of nowadays. Steve McQueen was really a nice guy, but he's another of the ones who didn't really want to have even one picture taken, even though he'd agreed to the story. We couldn't even find him. He'd got on his motorcycle and had gone off out in the desert. His public relations man didn't know where he was. Finally we found him at his home in Palm Springs. I had done quite a lot of sports-car racing when I lived in Hong Kong, so for fun I rented a Jaguar. I knew he had a Jaguar, and I thought it would help a little bit. I met him, and we talked. He drove my car, and I drove his. I started shooting a few pictures. I didn't hang around him a long time, maybe three weeks, and finally he relaxed and I got a few candid, intimate pictures of him at home with his kids. I got him with his wife in the bathtub up in Northern California at Esalen, where they have these hot-springwater baths outside that overlook the Pacific. He was cooperative to let me get that. They were both nude, and they had a bottle of wine sitting on the edge of the tub. That was fun.

*Can we talk about the "LIFE Great Dinners"?*

Eleanor Graves, the editor in charge of *Life's* Modern Living department, thought up the menus. To this day, people use the book that was compiled from the stories and swear that everything works out well. That's something for a cookbook. Most recipes you have to adjust to the way you cook, but hers really work.

We didn't want our pictures to look like ones in all the food and women's magazines that are done in studios in New York by all the expert food photographers. We had to have something with life to it, so we kept thinking up ideas. In 1964 I came up with an idea for a trout amandine. I got these slivered almonds, and put this trout in there with a fishing line on it, and pulled it out and got this picture of a trout jumping out of this lake of almonds.

When I first did that, I put the wire in the trout and hooked it in the back, and the assistant pulled on it. The trout was soft from being cooked, and it just fell apart. I had a terrible time trying to figure out what to do. Finally, I cooked the trout on one side to make it the proper color, and then I put the line in and put it in the freezer. When it was stiff and firm, we put it in the almonds and my assistant pulled it out. It looked great jumping up in a splash of almonds.

Two years later, Eleanor's husband, Ralph Graves, who was an assistant managing editor, gave me the assignment to do "The Cats of the World." I went to Africa, and the leopard alone took me three months. I called up New York and said, "I suggest we cut this down to "The Cats of Africa." I had photographed

some animals before, though I certainly wasn't a cat expert, but I could hire people who knew things.

Pat Hunt, the head of *Life's* Nature department, lined up a hunter in Botswana who was a hunter for zoos. He had caught a leopard, and he put the leopard in the back of the truck, and we went out into the desert. He would release the leopard, and most of the time the leopard would chase the baboons and they would run off and climb trees. I had photographed all this. But for some reason one baboon didn't get off. It turned and faced the leopard, and the leopard killed it. We didn't know that this was going to happen. I just turned on the camera motor, and I got this terrific shot of this confrontation.

*What's your feeling about injecting yourself into the natural order of things to get pictures?*

There was a different feeling about that in the 1960s. We were always setting up pictures of some sort. I think they probably still do it now. But now there are many, many more competent photographers doing this stuff over long periods of time—four or five years if a scientist is on a big study. They're getting good stuff without helping the picture. But no one was working that way then. Scientists couldn't handle the crude cameras that we had well enough to get good stuff.

I felt that my job was to get the pictures. I learned how to bait animals and do things from the experts in Africa. We shot a gazelle and put it in a tree and waited for a cat to come. I didn't feel bad about it at all. It sounds terrible now, I know, and maybe my attitude would be different now. But it wasn't then, and I don't know what more to say about it. I know, I've been criticized for that a lot. But to me, I had to do what I did.

On the *Life* staff 1950-72
Interviewed in New York City on October, 27, 1993

A lot died on the march.
Some French photographers
were among them

8/2/54

P.O.W. (with a lime) after the battle of Dien Bien Phu. 1954

# HOWARD
# SOCHUREK

**H**OWARD SOCHUREK: I took the picture of Emperor Hirohito meeting General Douglas MacArthur in Tokyo in 1945. It's not a great picture. It was f/8 at 10 feet. *Bang!* One exposure. I was brought in and out of the room by a full bird colonel. There were also a couple of civilian photographers, but the only official Army picture was the one that I made. *Life* ran it.

Hirohito was an emaciated guy. He had lost the war, and it showed on his face. Tired, weak, disturbed, defeated. Very formal. Very few words. For the Emperor of Japan to come to the office of the conquering general was historic. I was still a kid. I was awed.

When Pearl Harbor had come along in 1941, I was immediately assigned to the Signal Corps. They did not want to denude the colleges of people, so I was sent to Princeton, where I studied Arabic. I was commissioned out of Princeton three years later, and the next day was on a plane heading for the Philippines as the commanding officer of the 3234th Signal Photographic Detachment. I was 20 years old. The enlisted men were all 34 to 38. You're the officer in charge, which means you've got to find housing, and feed them, and do the paperwork, and assign them, and get the film back. You either fish or cut bait on that, I'll tell you. So I was over my head very, very young.

There was a bunch of islands around Okinawa that had to be taken. I came ashore on Ie Shima. The Japanese had the custom of living in spider holes. They'd dig a hole in the ground, put the turf back on top of them, and wait till a unit passed by. Then they'd lift themselves up and knock off the stragglers. One of my sergeants had Ernie Pyle, the famous newspaper correspondent, in tow and took him up to the lines in one of our jeeps. On their way back, a sniper start-

ed shooting at the jeep. My man and Pyle got out and hid in a ditch. But Pyle was restless. He said, "I've got to get back. Let me see if there's any action." He lifted his head up. He had a helmet on, but he tipped the top up so he could see, and one shot went right into his forehead and killed him instantly. My man was O.K. A squad came through and wiped out the sniper 10 minutes later, and that's when I came up. It's terrible to say, but the War Department had a great set of pictures from our 3234th team of the death of Ernie Pyle.

After I got out of the Army, I had the option to go back to Princeton for another year because I had not graduated. But based on my having been a photographic officer with MacArthur, the Milwaukee *Journal*, my hometown paper, hired me.

My father was a college graduate, and I remember his not being able to get employment during the Depression. Subconsciously I said, "This isn't going to happen to me." I wanted to be good at something that wasn't a "job."

I'm a Depression baby. Economics were a very big part of what propelled me. I was making 60 bucks a week on the *Journal*, and if you did an assignment for *Life*, you were paid $75 a day. I went to New York to see Wilson Hicks, who was then *Life's* executive editor. I spent an hour talking to him about philosophy and what books I was reading and what did I think of the head of the Arabic department at Princeton University.

Hicks was really something. First he kept me waiting for half an hour, and then he didn't talk about photography at all. He talked about everything but photographs. And at the end he said, "I saw one picture you did—a snowscape of a bunch of people on a hill. It looks like Currier & Ives. It's the best picture you've ever made." And then he closed the door and never said, "I'll hire you," or "Drop dead," or anything else. So then—

*John Loengard: Was he right?*

Well, the picture was a memorable picture, yeah. It ran in the Milwaukee *Journal* eight columns wide as a feature picture.

So then I decided if I was going to get work from *Life*, I had to be more aggressive. I went to see Bob Drew, who was reporting for *Life* in Detroit. He said, "I'm going to look a lot better if I have a photographer based here." He made no commitment. It would just be a $75 a day rate for whatever he could assign me to do. I quit the *Journal*.

A year later the Korean War broke out. I was put on the staff—at a very low salary, I must say—and went to Korea. The first story I did was a combat parachute jump behind the enemy lines 100 miles north of Pyongyang, the North Korean capital. A lot of American prisoners of war were being taken by train up into China, and the reason for the jump was to seal off the train before it got too far north. Then we would take the prisoners back to our own lines.

*Did you take training to jump?*

No, I just jumped. You were supposed to take training, but I was 26 and high-

ly competitive. Covering the Korean War, David Douglas Duncan was already the star of stars. And Carl Mydans was the guy who had been captured in the Philippines and was MacArthur's favorite photographer and was known as one of the most distinguished *Life* photographers. I was very ambitious and very anxious to do something competitive. It was ingrained in me to take some gambles.

The jump was all fouled up. Several thousand men were supposed to take off from Seoul at dawn, but we were fogged in. We finally jumped at two o'clock in the afternoon. When I got to the door in the plane, everything in me rebelled. There was ground fire coming up. I saw little marks under the wings. The fuel tanks are in the wing of a C-119, and gas was running out these holes. I just did not want to go out that door. A lieutenant colonel behind me put his foot in the small of my back and shoved me out.

I had a little automatic spring-driven camera strapped to my chest so I could click off sequences while I was going down. As I jumped, I started the camera. We jumped at 800 feet, and that doesn't give you a lot of time. The chute jerked open, and all of a sudden I was on my back on the ground. I sprained my ankle very badly, and they gave me a shot so it numbed it and I could get by.

By this time, the train with prisoners on it had gotten north of the drop zone. We learned that the guards on the train panicked when they saw us dropping to the south of them and killed all the prisoners. We gathered up all the dog tags and whatever we could, and then buried everybody right up there because we had no transportation to get the bodies out. My closing picture in the *Life* story was a helmet full of the personal effects of the prisoners that had been killed.

All this was after the landings in Inchon, and it seemed the Korean War was under control. So Edward K. Thompson, *Life's* managing editor, cabled me to go to Saigon to meet Eric Gibbs, the bureau chief of Time-Life in Paris. Gibbs was a great personal friend of Henry Luce's and, being French Canadian, spoke fluent French. The week before I arrived, all but one of the northern border posts manned by the French army were taken by Ho Chi Minh and Chinese troops. In one week they completely destroyed the border between China and Vietnam. Gibbs and I took an open-cockpit plane to the remaining French post and crashed on landing. It was Thanksgiving Day 1950, and we were stuck with a bunch of French Foreign Legionnaires surrounded by Vietnamese forces. That was the beginning of my coverage of the Vietnamese war. We sat there for four days, and finally they sent in a relief plane and flew us back to Saigon.

I have spent more time in Vietnam than anywhere else. By 1954 I had developed a relationship with a French general, René Cogny. He sent his aide-de-camp to wake me up at 4 one morning. "I've got a good story for you," he said. It was the day the very first paratroopers landed in Dien Bien Phu.

Dien Bien Phu is in a valley, and if you controlled that valley, then you could also control the supply routes into Laos. I flew over the area with Cogny, and I told the general, "I want to get in there." He landed at a small airstrip and put

me on a helicopter, and I went in before the operation was completed. I'll never forget one of the young paratroopers had a chute failure. This poor guy came down into a soft rice field, and he dug into that ground maybe four feet. *Ssshhhhuw*. He died right there. I'll never forget that.

*Life* did a lead story on my first day at Dien Bien Phu, and throughout the next months I went back. Two nights before Dien Bien Phu fell, I was going to do a night drop with the French. Thank God, it was aborted. Dien Bien Phu was just a terrible military disaster.

When the communists turned over to the French all the prisoners they had marched out, I covered that. A lot had died on the march, and among the few that remained, I saw people that I knew quite well. Some French photographers were among them. Somebody gave one prisoner a lime. There is this picture of his terrible, emaciated face and that lime.

*Do you think it's worth dying to take a photograph?*

My own experience is based on military operations we should never have gotten into. If I think in those terms, then the answer would have to be, "No, it's not." But I lost a brother in World War II. He was a pilot over the Ploesti oil fields. So maybe in covering that war, I would have said, "Yes, it was justified." I'm torn. I just feel terribly lucky to have had the experience I had and to have lived through it. I also think of our colleagues Robert Capa and Paul Schutzer and Larry Burrows, who didn't.

*Capa came to Vietnam after Dien Bien Phu?*

Yes, he was there for the month I went home on leave when my mother had a heart attack. Ed Thompson said, "You're coming back through Tokyo. See Capa there. He may cover Indochina while you're gone." Capa was exhibiting his pictures at one of the department stores and also had quite a nice assignment with a lot of money to photograph in Japan. That's what had brought him to Tokyo.

We had dinner together in the old Imperial Hotel that Frank Lloyd Wright built. It had 5'6" ceilings (or so it seemed), but they had a grill downstairs that served terrific steaks. We talked from 7 at night until 1 in the morning about what I had covered, and how the war was going, and how dangerous it was.

He kept saying, "This is one war I've never covered, and I've never wanted to cover." He was under great pressure from his brother not to go, and John Morris, the head of Magnum Photos, sent him a cable saying, "No way do you go." I know he needed the money. He said a little bit about that. In those times the money was quite good, as a matter of fact.

*How did you feel when you heard Capa had been killed?*

I felt I was responsible. That was my beat he was covering. I was in a taxicab at 6 in the morning, going from my hotel in San Francisco to the airport on my way back to Saigon. The guy had the radio on, and it announced Capa had been killed. If Capa had lived another three days, he would have been back in

Tokyo. I tried to get back as soon as I could, but they dealt the cards.

Months later I got a terrible case of malaria in Burma and ended up in a hospital in Singapore. Thompson said, "Bring him back to New York. Get his health back." By this time, Bob Drew, whom I'd worked with in Detroit, had transferred to New York and was working on a special issue called "The Air Age." Drew was a fighter pilot during the war, and he was intrigued by the visual experience of flight that no one had recorded. He was looking for a photographer to assign.

I remember going into a meeting with Edward K. Thompson and Charles Tudor, who was the art director. Drew started telling about some of his wartime fighter-pilot experiences. Thompson said to me, "This is at night. It's got to be in color. Color film is slow. You're traveling at high speeds. It sounds technically very difficult."

I said, "Let me give it a shot." I went out to an airbase in Arizona. I didn't find out until later that Tudor's idea was to let me make pictures, and then he'd get an artist to paint from them. I worked for a month in a T-33 trainer jet. I mounted cameras on wing tips, and I mounted cameras looking back at pilots. I flew at dusk and at sunrise, and it was very, very exciting. What Drew had said was very true. It was a unique visual experience.

At the end, I went up one night and wanted to photograph the afterburners of some fighter jets going into the sunset. Here are these three red balls up here and one red ball down there. I thought that would be terrific. I was with a not-too-experienced pilot. We got up to 41,000 feet, and the canopy blew. It's a phenomenon called explosive decompression, where the canopy actually is stressed to the point where it explodes. You lose the antenna, which is on top of the canopy. I could no longer communicate with the pilot, and he couldn't communicate with me.

My mask blew off. He put the plane in a steep dive to get down. He put the air brakes down, and the plane just started to shudder. I had an option to grab the handle and get out of there. Explosive ejection of the seat is what you're told to do, and then free-fall till you get lower because you can't breathe at 40,000 feet. You can't live up there too long. Every piece of your skin feels like there are millions of needles pricking you as the oxygen bubbles up out of your blood. It's quite an experience.

The question was, Do I stay and ride it down, or should I eject? I couldn't talk to the pilot, and anyhow he was too busy trying to keep control of the aircraft in this tremendous buffeting and shuddering. I decided to stay in there. I thought I might as well die crashing as die ejecting. Plus I had my camera and all the film that I'd shot up to that time. You know, you can't do these things over and over again. Is photography art? Well, if you can't ever do it again, maybe it is.

We were pretty much over the runway. They were launching night flights of inexperienced pilots. Three at a time would come up; another three came up;

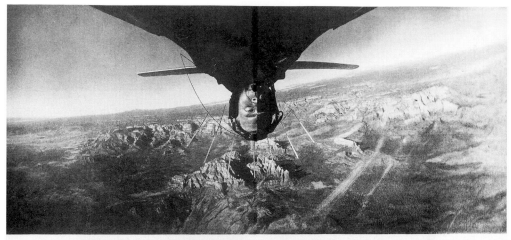

**HEAD DOWN** over Arizona, Air Force instructor rolls a trainer, leaving the state's highest point, 12,600-foot Humphreys Peak, to hold up the rim of the world.

**STEEP BANK** tilts horizon and a dry creek on the line. In his three-view pictures, Stackpole fixed his camera facing the pilot and on linked at the front seat.

**WORLD UPSET** hangs lopsided overhead, loosely southwesterly; the pilot, he is used to it, this is the proper state of things. Right-side-up is the way he is.

originals in color 6/18/56

"The Air Age." 1956
*I thought I might as well
die crashing as die ejecting.*

another three. We couldn't communicate, and yet we had to get down. The tower was furious because we were coming around the field for a landing in the middle of the launching of all the students. They were sending up red flares meaning, "You can't land." In the meantime, my pilot's scared stiff. *Life* magazine is in the backseat. He doesn't know if I'm alive or dead. He doesn't want to get all the publicity connected with this one. Finally, the tower saw that we were going to come through, so they stopped the ground operations. We came down, and an ambulance and a staff car came running up to us and saw a plane without a canopy. They took us to a hospital. We overnighted, but fortunately we hadn't suffered enough exposure to cold and lack of oxygen to be seriously hurt.

I didn't make a big deal out of it until I got to New York and the film was developed. And they had a meeting to assess what do we do now with this story. Should we go on with it? At this meeting I remember finding out somehow that Charlie Tudor had really wanted to take the film and use it as artist reference film. Thompson and he looked at the film. Tudor left the room for a minute, and I said, "I didn't tell you this before, Ed, but several nights ago, I had a little bit of trouble doing this thing." I told him about it.

I said, "I just want to tell you that I don't want any artist in a pink buttondown collar taking these pictures and using them to make drawings from them. Because I've put too much into this."

He looked up at me, and I guess the story of explosive decompression had gotten to him. Charlie came back in, and Ed said to him, "Maybe we could do a photographic essay out of this. Have you committed?"

"I got a guy in mind. I told him about it," Tudor said.

Ed said, "Let's let Howard go ahead and see if we can't do this in photography. It's real, and it looks good. He's got some pretty interesting stuff here."

Charlie said, "Sure." And walked out.

*You opened a* Life *bureau in Moscow?*

Josef Stalin had closed down the Time-Life Moscow bureau after World War II, and there had been little direct Time Inc. coverage of the Soviet Union since then. But just after Sputnik went up in 1958, I learned that the Soviets were trying to develop trade with the West. I wangled a 30-day tourist visa by arranging to import a hundred Russian photographic lenses to the United States.

They made a 1,000-millimeter mirror lens that was unique for its time and quite good. I'd used one, and I thought other professional photographers might like them. I agreed to buy 100. Actually, the *Life* lab took two, but the whole thing was a disaster. I ended up losing about $4,000 on the deal, but that's just the way things go. Later the Japanese came up with a smaller, sharper, better lens, but at the time it was a good lens.

Anyway, once I got to Moscow, I got permission to do a story on a Russian student that *Life* wanted. (Someone in Chicago was going to do an American.) The Russians got me this hardworking brilliant young guy, a terrific whiz at

Kitchen Debate. Moscow. 1959
*While I was photographing them, this girl was interpreting . . . I ended up marrying her.*

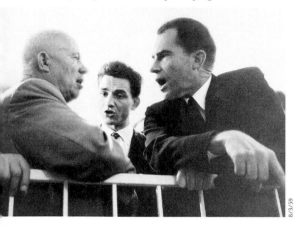

8/3/59

10/22/45

Hirohito meets MacArthur. Tokyo. 1945
*I was still a kid. I was awed.*

Moscow school. 1958
*He studied all night under a green eyeshade.*

3/24/58

physics and chemistry, who lived with his widowed mother. He studied all night under a green eyeshade. The guy in north Chicago was not devoted to much of anything but having a gay old time.

I finished the story, and of course I wanted to stay on. Since it was illegal to ship undeveloped, uninspected film out of the Soviet Union in February of 1958, I got in a cab and went out to the airport. You could spot an American in Moscow a mile off in those days because they looked so unique. There was this very heavyset, tough-looking guy. He had gone through Customs and had gone into the men's washroom. I went in after him and introduced myself. I told him what my problem was. Would he take my film to Paris? He looked at me and said, "You *Life* photographers get around, don't you? Did you live in Paris?"

"Yes," I said.

"I'll do this if you fix me up there," he said.

"I can't guarantee that because I'm here," I said, "but I'll ask Loomis Dean, another *Life* photographer, to meet you in Paris."

He agreed, and I called Loomis to meet the plane.

The Russians liked the article on the students, and so I got my visa extended. By the fall of 1959, things were opening up a little more. Khrushchev permitted the American embassy to set up an exposition of American goods and services in the outskirts of Moscow. A group of young American girls and boys who spoke Russian were invited to come be interpreters. Vice President Richard Nixon invited himself to the opening day. I was in the model American middle-class kitchen in one of the geodesic domes they'd set up. Nixon and Khrushchev came, and stopped, and began their famous exchange. Khrushchev would say, "You don't really have stuff like this. This is all baloney."

Nixon replied, "We have better things than we're showing here," and back and forth. The experience changed my life. While I was photographing them, this girl was interpreting for one of the groups, and I ended up marrying her.

*Did you get married right after the Kitchen Debate?*

No, she came back to Columbia to get her master's degree, and I went to Harvard on the Nieman Fellowship. That was in 1960. I hadn't seen her for a while, and one day I was walking down to Kirkland House in Cambridge, and she was up there for a weekend. I saw her, and I took her to one of the famous Saturday lectures by the historian Merle Fainsod, who was an expert on Russia. I guess she thought anybody who was bright enough to attend a Fainsod lecture must have something there.

*Three years later, you quit* Life. *Why?*

I left, John, because I got married. I had been living out of a suitcase for all those years.

On the *Life* staff 1950-63
Interviewed in New York City on October 28, 1993

The brothers talked very quietly.
I made one picture and waited outside for
Bobby to come out. When he did,
he was furious. Bobby was hitting his hand
like this, saying, "Shit, shit, shit"

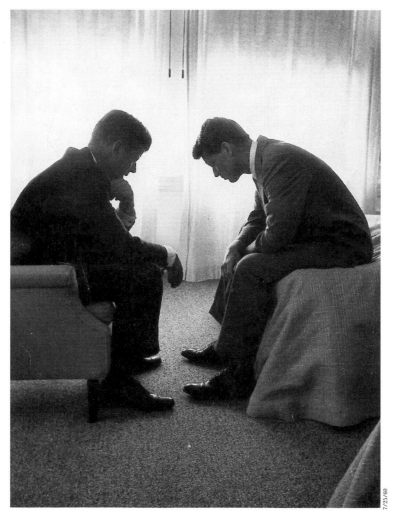

Democratic Convention. Los Angeles. 1960

# HANK WALKER

**H**ANK WALKER: At the 1960 Democratic Convention, where everybody was shooting pictures like crazy, I was doing a story on Bobby Kennedy. The morning after Jack was nominated, we went up to his room. The brothers talked very quietly, and Jack told Bobby who he was going to choose as Vice President. I only made one picture in there, and then I waited outside for Bobby to come out. When he did, he was furious. We were walking back down the stairs, and Bobby was hitting his hand like this, saying, "Shit, shit, shit." You know, he really hated Johnson.

I knew both Kennedys well from being around Washington. All the press guys and Bobby used to play touch football every Sunday in the playground at a Catholic school across the street from my house. Bobby had been very upset with me at the start of the convention. He thought I was a traitor because I had just done a three-part series on James Hoffa and the Teamsters.

I had made a deal with Hoffa that we could follow him wherever we wanted. We could walk right into his office without knocking. If he was on the phone, we could pick up an extension and listen to the conversation. Roy Rowan did the story with me.

Hoffa was the most realistic guy I've ever met. When I asked him to do the story (Roy wasn't involved at that time), he said, "I know I'm not going to like it, but I don't think you'll screw me." And when we took the final issue to him, he looked at it, and read it, and said, "Hank, that's pretty fair." He took it right on the chin, you know.

Hoffa had taken over the Teamsters from Dave Beck. Beck had this palatial suite of rooms overlooking Rock Creek Park in Washington, and a chauffeur-driven car and everything. The only thing Hoffa used was the bedroom and

kitchen. He drove his own Chevy to the Teamsters office.

Roy and I followed him all over for two months. We'd visit these different Teamsters locals, and I was watching for red trucks in order to pose the cover. We were flying down a highway in California, and I saw a whole yard full of red trucks. I said, "Hey, Jimmy! There's the truck."

We pulled in, and Jimmy doesn't go to the office. He went to the back and said, "We're going to make some pictures here. What do you want, Hank?" They started moving trucks.

The manager comes out, and he's furious, "What in the hell is going on here?" Then he sees Hoffa, and he says, "Hey, Jimmy! How are you! Great to see you! What can we do for you?" And everything was fine.

Hoffa ruled the union with an iron hand, and everybody knew him. We were riding in a plane in coach once, and a guy came over and shook hands. He said, "I'm one of the long-haul drivers."

Jimmy said, "See that? That's one of the things we fought for. These guys, if they don't get them a ride back, they fly them back to their home base after two days." He was flying back first class, and Jimmy Hoffa was flying coach.

There were a lot of contradictions about him that I didn't quite understand. We photographed him with people that had been indicted, but nobody that had been convicted. I don't know whether he was a hoodlum. I guess he must have been, but I admired him. Politicians and Jimmy Hoffa, people like that, have egos just like a movie star. If you can appeal to that ego, they usually let you do the story.

*John Loengard: Did you ever photograph anybody you didn't like?*

Well, when I was free-lancing, I was assigned to a story on a fat boy. He was about 18 years old, and he was so fat he had to go through the door sideways. They ran it, and Henry Luce wrote a memo, "This is the most atrocious, outrageous, repulsive thing I have ever seen. I prefer that stories like this be dumped before they're shot," or something like that.

*Did you have much contact with Luce?*

In the early days, yeah. I used to see him a lot. He used to come around to the bureaus. Once, the whole bureau was invited over to see him at the Drake Hotel in Chicago. We all sat around in his suite. I hardly had shot any stories for *Life*, but I was there anyhow.

The door opened, and Luce bounded in and looked around the room, and he asks, "What's wrong with life in Chicago?"

That was his first question. And he went around pointing at everybody, and I said, "How do I know? I just got here." He just used to upset everybody.

Bureau chiefs would tell how when they had to go out to meet him at the airport, they would travel the route and find out as much history as they could, because Luce would ask, "What's that building?" or "Why is that there." He expected them to know.

One bureau chief said, "I spent a week making that trip in from the airport, and he still asked me three questions that I didn't have the answer to."

Every story you did, you had to feel that you were educating somebody. I mean, you were showing a side of something to somebody that they may have not seen.

*Were you doing that during the McCarthy hearings?*

Joseph McCarthy held up a paper—he was doing this all the time—and said, "I have the name of 41 people in the State Department right here," and blah-blah-blah. But he would never let anybody read it. I had a long lens on, and he held the paper up, and I took a couple of pictures, and McCarthy stopped dead.

He said, "That *Life* photographer, Hank Walker (and we're on television), just made close-ups of the papers I'm holding."

So the chairman, Senator John McClellan said, "Would you please turn over the pictures to the committee? I don't want to have to confiscate them." I don't know whether he could have, but I had been unloading all my cameras while McCarthy was talking. I had some fresh rolls ready to go. I grabbed one of those rolls and threw it across the table.

On television there was a close-up of a roll of film going across this big Senate table there. Walter Cronkite said, "I'll never forget that." I took the real pictures back to the lab and blew them up, but they didn't show anything that made sense.

*How did that feel, being singled out by Joe McCarthy?*

I didn't want to give the film to him. The line I always used was, "This isn't my film. I can't give it to you. It belongs to *Life* magazine. Once I click the shutter, I don't own it any longer." That's what I always used to tell everybody. I don't think McClellan had a right to take it. But I gave it up—or supposedly.

When McCarthy was dead, Hank Suydam, a Washington correspondent, and I went out to the hospital mortuary in Bethesda. I had borrowed a doctor's black satchel bag, and I put my camera in there. We're walking down the hallway, and here comes a gurney, and they got McCarthy on it. I open up the bag and pull out a camera, and the guys pushing the gurney get scared and run off to get security and leave McCarthy lying there. I shot pictures of this bare bulb hanging down over the gurney with the dead McCarthy. I gave the film to Hank, and he buried it in the bushes before the guards came back. We got it later, but *Life* never used it.

Covering Harry Truman was more fun. He'd go for his morning walks when he was in town, and we'd have to follow him. He would wait until he'd get to an intersection. He'd look like he was going to cross it, and we'd be running ahead of him. Then he would turn left and walk real fast, and we'd have to run like hell to catch up and get ahead of him again. And he would laugh.

Of course, we were so out of shape it was criminal. But he enjoyed it. He thought that was a big joke.

*Why did you decide to become a photographer?*

I decided when I was in junior high school. Mark Kauffman and I started the camera club, and when we went to Fremont High School, we could take photography for four hours every day. C.A. Bach, the photography teacher, had been a motion picture man, and he taught us movie technique as the basis for our stills. Movies have great pictures that tell a story in a sequential way. Although we didn't know what we were learning, he was teaching us photojournalism before there was photojournalism. I graduated in 1939.

*How did you feel when your classmate Kauffman had a picture on the cover of* Life*?*

Mark took Eleanor Roosevelt's picture at a press conference she had for high school journalists. I, being smart, took a ride in the Goodyear blimp to make an aerial of her visit to Los Angeles. Mark got the cover, and I was extremely jealous. I cursed my luck for going the wrong way on that one.

*So how did you get to* Life*?*

After the war, Mark was working for Hugh Moffet in the Chicago bureau. I went there with my severance pay from the service. I only had one suit, a gray plaid double-breasted Hickey-Freeman. I wore it until it was shiny, and then I gave it to Moffet, who wore it until it had holes in it. He never cared much for clothes, and it was about three sizes too big, but he wore it anyhow. He was the bureau chief, and he went slopping around in this old suit.

When Mark introduced me, Moffet said, "Chicago's known as the Windy City. Go do a story on the wind."

I was a bit nonplussed. But Wallace Kirkland, another staff photographer who was a really great guy, lent me cameras. I started right on the bridge there. I had people chasing their hats, and girls with their umbrellas turned inside out and their skirts blowing up, and surprisingly enough I made about 25 or 30 pictures that were pretty interesting.

*Did that story run?*

No.

*Did you get paid?*

No. Moffet just enjoyed it. He said, "Not bad. I didn't think you could do this well." Then he threw it in the wastepaper basket, but he started assigning me to stories.

I also began doing a lot of advertising stuff, and after a while *Life* offered me $12,000 a year to go on staff, which was a pretty good salary in those days, but I was making more than that just from the advertising agencies.

*You were doing well with advertising. Why did the Korean War make you want to join the staff?*

I had been a Marine photographer during World War II. I had landed in the second wave at Saipan, and I made a landing on Tinian. The idea of covering the war in Korea just appealed to me. I don't know why, but it did.

*Do you think your photographs from Korea changed anything?*

No.

Walker handing film to Sen. McClellan. Washington. 1954
*McCarthy stopped dead.*

Massacre witness. Korea. 1950
*At least they showed people there was a war going on.*

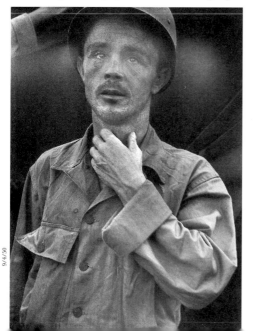

James R. Hoffa. 1959
*The most realistic guy I've ever met.*

*Made any difference?*

I don't know. They might have. At least they showed the people that there was a war going on. At Inchon they first landed the Marines on this little island in the harbor and then ran little boats in because there was a 14-foot tide. There were about eight guys on a boat, so they wouldn't draw much water and could run up right to this seawall. They had ladders, and we scaled up over the wall. Jim Bell, a *Life* correspondent, and I, one on each of the boats, were in the second wave. There were only 16 guys on the shore ahead of us. We started marching and took Kimpo Airfield quickly. You know, all the usual war stories. We hid in the breweries and all that stuff.

*Do you think the photographs were worth dying for?*

That's a question other people have asked me. The only way I can describe it is that when I went into combat, I had a positive feeling that something's going to happen to me, but I always thought that the worst thing that could happen is that I could be wounded. I didn't think that I would get killed.

I guess what I thought I was—well, I don't know what I thought—but I thought it out afterwards. I did some of these things I did because I identified with the Marine Corps. It was almost as if I were still in the Corps, although the Marines I was with couldn't understand why a civilian was there.

During the fighting on the Pusan perimeter, months before, the Associated Press had carried a story that I had been captured. Actually I had gone to this outfit and joined them as night was falling. I am a notoriously sound sleeper, so I thought, "God, what if they bug out in the middle of the night?" So I bummed a stretcher—one of those things that had legs on it about six inches off the ground. I thought, "They might leave me, but they won't leave their stretcher."

I woke up the next morning, and the birds are singing and everything is quiet. I look around, and there's nobody there. So I had to start walking back to join them, and, thank God, a reconnaissance outfit came along. They gave me a ride back to the unit.

But the Associated Press thought we had been overrun, and they carried a story that I was a prisoner of war. All my family and everybody went nuts, until I got back to press headquarters about a week later and said, "What do you mean? I haven't been captured. Nothing happened to me."

*You left* Life *to work for the* Saturday Evening Post *in 1962. But then you stopped taking pictures.*

Right. After 17 years you get your fill of taking pictures, you know? After you do the same thing for the fourth or fifth time, it's not new anymore, and *Life* was changing very radically. In the early days, *Life* used to be very picture conscious, and if you made a good picture, the editors would run it. Toward the end, they got away from that. There was text all over the place and not many picture stories. I decided I was going to leave.

Clay Blair Jr., who'd been a *Life* correspondent, called me and wanted me to

come to the *Post* as an assistant managing editor. I decided to go there. It was sort of like riding off into the mouth of the dragon, because I knew the *Post* was in big trouble. Clay explained that to me, but we thought we could save it. We couldn't. We got into a civil war at the *Post*, and we defeated the guys we should have. But we didn't kill them. We let them off the hook, and they came back and killed us. We had our throats cut very nicely.

The whole climate was changing for magazines. Television was the reason. And *Life* was trying to adapt too. None of it worked.

*Did you feel that there was more you could do in life than take pictures? That they didn't use all your abilities?*

I never had any ambition to do anything else in life other than photography. But when I went to the *Post*, they gave me a huge budget and several departments that I ran. I found out that I was quite good at it. And I liked it. I had a lot of money that I was throwing around, and I had to spend it wisely, and I had to get results with it. Actually, that convinced me to go into business afterwards.

At the end, it was really hard for me to pull that camera out of the bag and shoot the first picture. Once I did that, I was all right. Then I went on through. But I spent more time on airplanes than I did at home. For a long time, it was very exciting, and of course most of the stories and the people that I was photographing were very interesting and glamorous. And the people I worked with on *Life* were very talented. I felt it was an honor to be working for them and with them, but that eventually wears off. You can't go on doing that forever.

On the *Life* staff 1950-62
Interviewed in Miami on September 29, 1994

# "My God, what's this?" he said

4/5/54

Speaking of pictures. New York City. 1954

# GREY VILLET

REY VILLET: I became absolutely intrigued by watching a print being developed. Somebody I knew had a darkroom. He took a picture and developed it and enlarged it. My God, there was this print emerging out of the blank paper. I was about 18 and living 30 miles outside of Cape Town, South Africa, in the suburb where I grew up. I became a medical student for a year and a half, and did terribly. Then I met a friend of my sister's who was a reporter on a small newspaper. He said I could get a job as a photographer, so I quit college and started working. I didn't know one end of a Speed Graphic from the other. But I worked there for eight months.

That was when South Africa was still an adjunct of the British empire and England was the place where people went to find broader experience. I went there in 1948 and worked on a newspaper in Bristol for a couple of years. After that I went back to London and worked at Reuters. We'd go on an assignment, and there'd be 30 other photographers jostling for a spot and sometimes fighting. It was a hell of a lot of fun.

I photographed old Queen Mary and Prince Charles when he was a year old. I was always on the periphery, of course, doing car pictures. I'd stand outside Buckingham Palace, and a big limousine would go by, and there'd be someone sitting inside and I'd have to swing the camera and try to get a usable picture. There was this one photographer, and that's all he would do. He had incredible reflexes. Even if a car was doing 50 miles an hour, he could fill the frame with the person sitting inside.

Once, I went out to Winston Churchill's house. There was going to be a union of the Liberal Party and the Tory party, and Churchill and the leaders of the Liberal Party were sitting, very stiffly, staring at the cameras. I said, "Why

don't you gentlemen just pretend you're discussing something?" I was trying to get a little bit of informality. So Churchill started reciting, "The boy stood on the burning deck . . . the boy stood on the burning deck."

*John Loengard: Not much discussion.*

Certainly not in front of the lowest member of the human race, a press photographer. We were very poorly regarded in England. I'd always really wanted to be a magazine photographer, and I figured *Life* was obviously at the top of the field in photojournalism. We didn't use that term in those days, of course, but—

*What did you call it?*

"Magazine photography." I turned up in New York in January of 1954. I got a job bending iron for wrought-iron table legs and did that for three months. Meantime, I went to see the personnel people at *Life*. They didn't know what to do with me, so they sent me to see Ruth Lester, who looked at free-lance portfolios. She sent me on to John Bryson, who was an assistant picture editor. He promised to try me out.

Some researcher on the magazine had discovered that there was a fellow who was known to all the pigeons in New York. This guy ran a little antiques store, and it was said that whenever he'd come out from his store, pigeons would come flocking down and knock him over, they were so anxious to get the peanuts he was giving out. As you can easily guess, that was a load of bullshit, but it was my first assignment. I duly went, with great misgivings, to see the antiques dealer. Out of my few remaining pennies, I bought him a few packets of peanuts— I hadn't discovered the expense account yet.

We went into the streets, and no bloody pigeons appeared. Not one. I thought that I shouldn't come back empty-handed, so I went to the 50th floor of a building on Sixth Avenue and asked the secretaries working there if I could open a window and take a picture. They said sure, so I went to the window and climbed out on the ledge. They panicked and thought I was going to jump. But I sat on the ledge and stuck my feet out, so that my feet were in the foreground looking straight down at Sixth Avenue below. I shot three frames of that and went back and gave Bryson the contacts. I had shot a few things of the antiques dealer, but they were really feeble. Anyway, Bryson was looking through the contact sheet, and he said, "My God, what's this?" It ran the next week. He started giving me assignments after that. I got 40 or 50 small assignments around New York City. The next year, they sent me to the Chicago bureau. I went on the staff shortly after.

*How would you describe yourself as a photographer?*

Despite what I've just described, I hate to set up stuff. I'd much rather let people act as they are, and reflect that. If I've got the patience, that'll give me a better picture than anything I can dream up, for my sort of stuff.

*What's your sort of stuff?*

As real as you can get it.

*One* Life *editor says that he's worked with photographers enough to know what is going to make a good picture for them, but when you're taking pictures, he can't understand what on earth you're taking a picture of. Then he sees the results, and there it is.*

That's why I am a photographer and he isn't. In the last 10 years I've been doing more pictorial photographs than I did when I was working for *Life*. Then, I wasn't interested in pictorialism in the slightest. My rule then was play it as it lays. I had to be able to see something and instantly compose it so that it becomes interesting. My main thing was always to try and make the picture as bold and as strong in its shape as possible. So that that shape then relates to what is happening inside the subject.

*Often, your pictures are close-ups of faces. You've used them effectively in many stories—for example, when the foam-rubber salesman is chewing out an employee—*

Well, then it's the shadow of expression in the face and eyes that intrigues me. But that's not really photography. It's psychology more than photography; you're trying to reflect what somebody is thinking. You can see that people are registering emotion of some sort. You're bearing down on them.

*How do you engineer yourself to be in situations where people will have expression?*

You have to get to know them, if that's what you mean by engineering a situation. It's very hard to go in cold. You can do that physically, but I can't respond to someone until I know something about them, in order to sense how they're going to act and see what's true in the emotions that show on their face.

Also there's the subject's guardedness. They have to know something about you to be able to show their feelings with a certain freedom, although there's less guardedness now, I think, than there was 20 or 30 years ago. People have become so accustomed to seeing themselves and other people on the television screen that they react more strongly now than they used to. The last thing you would expect would be somebody to burst into tears in front of a camera, and yet they do.

*What story do you like best that you've done?*

They fall into different categories, don't they? Some are much more interesting than others. Others are much more exciting.

*What's the most exciting?*

Fidel Castro's victory in Cuba, because I'd been in Cuba a couple of times before and seen the tremendous oppression during Batista's regime. It was exciting to see everybody suddenly exhilarated and free. Jerry Hannifin, a correspondent based in Washington, and I flew down to the middle of the island and found Castro there and then rode in his convoy into Havana. There were maybe a dozen cars in the convoy, all bullet-ridden, doors ripped off, windows shattered, and all his men's guns sticking out of the windows. In every little tiny town that we passed, he'd stop and talk for six or eight hours. This went on for days and

then finally wound up with us driving into Havana itself at 80 miles an hour through packed streets, and everybody cheering and a tremendous feeling of liberation.

I stupidly gave my film to another photographer, who then mysteriously lost it for a day while his own film was being processed.

*Did that prevent your film from being used?*

Some of it was, but his was largely used, and I had as good, if not better, pictures. That was one of the few times in which there was that sort of cutthroat competition amongst photographers working for *Life*. I found them always to be extremely fair and generous toward each other. They really were an absolutely marvelous bunch of people. But this guy wasn't a staff photographer.

*You went back to see Castro in 1964?*

I spent a week. Breakfast, lunch and dinner with El Maximum, as we used to call him.

*To his face?*

Oh, no. He was still being greeted with great adulation wherever he went. It was his fifth anniversary. He speaks English quite well. He was a very intelligent, very likable fellow. We went snorkeling, and he caught an enormous fish. He prepared it. He was a good cook.

*There was a very moody color picture of him lighting a cigar.*

Yeah, and playing baseball. I also did some tight close-ups of him, and got some pretty good expressions. That was black and white. I was shooting black and white as well as color.

*What's the difference between black and white and color?*

Color-print film has a similarity to black and white. It can convey the drama of a situation. Slide film tends to paint things in such brilliant colors that it distracts from the subject matter.

*You don't ever use lights?*

If you go around setting up lights, people do not behave as naturally as they do if you don't do that. At times I have used flashbulbs or strobe lights aimed at the ceiling to increase the level of illumination in a room, but I try to keep away from that because it is so distracting. Hence, "fuzziographs."

*Fuzziographs?*

Taking pictures in light so dim it shouldn't be used. When I'm exposing the film at a fifth of a second with the lens wide open, something is going to give, and what gives is the sharpness of the image.

*If Castro was the most exciting story, what was the most interesting?*

The guy who sold foam rubber was interesting in the way that he manipulated people. He was a puppet master within his own very small theater. Barbara Cummiskey, who's my wife now, was interested in doing a series on fame, fortune and success. She came up with this young man who was trying to make a million dollars. He was extremely ambitious and filled with energy—the

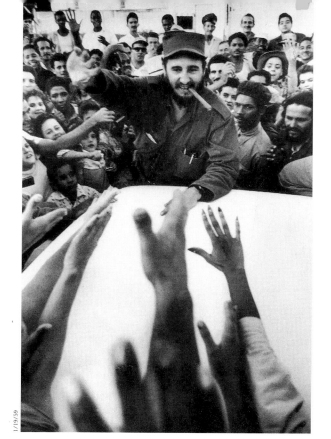

1/19/59

Fidel Castro. Near Matanzas, Cuba. 1959
*I stupidly gave my film to another photographer.*

original in color 10/86

Cocaine users. California. 1986
*They broke out the crack.*

11/16/62

Furniture salesman. Chicago. 1962
*We'd say, "You can read it, but we won't necessarily change a word or a picture."*

American story. He fitted into one of Barbara's categories by dealing with schlock material, and through his own genius, amassing money.

Essentially, he made a door with a foam-rubber pad on it as a couch or bed for people without much money. It was fairly good furniture and supplied a need. You'd use it for three years, then throw it away. He had stores all over the country—New York, Miami, Chicago, Los Angeles. He had expanded the business entirely by his own efforts.

*What were your feelings toward him?*

After a while, I got to admire his quickness of mind. He was an extremely intelligent fellow and a manipulator, which I tried to show.

*Did you talk to him after the story appeared?*

No, he didn't want anything to do with us. He'd seen the entire story, and had it read to him—knew exactly what was going to be in it. But I think that he got a hard time from his friends after it was published. I don't really know what happened to him. We tried to re-establish contact but never succeeded.

*Wasn't it unusual to show the subject a story before it was published?*

Yes. But sometimes as a courtesy, especially with a story of this nature, where you were digging into the guy's soul, we'd say, "You can read it, but we won't necessarily change a word or a picture or anything." Of course, some film stars insist on seeing everything before it gets published, and they insist upon having a veto on photographs and words.

*Did* Life *give them that?*

The only experience I had with that was with Marilyn Monroe, who insisted upon having the right to cut out pictures. And we refused. Barbara and I didn't do a story on her.

*In 1986 you did a story on cocaine users. How did you find the two men?*

The reporter was based in Los Angeles, so we went to a clinic there that was making money out of rehabilitating users. While we were waiting in the office, this guy walked in. Both of us immediately said, "That's it."

*Why?*

Intuition. We explained what we were trying to do. The basis of the story was middle-class drug users. He was living with another fellow, who was also a user. We spent two weeks with them—getting to know them, and them getting to know us—before they actually used in front of us. Finally, they decided that they trusted us enough, and they broke out the crack. Everything fell into place. I shot a good bit of the story that night. Preparing the crack, and smoking it, and going off and buying more.

*Did you just sit there with your camera poised?*

To a certain extent you have to keep it in evidence or people don't think you're serious about taking a picture. But you also have to be there as a human being. You have to show that you have some sort of empathy toward them, what-

ever dilemma they happen to be in. And you are there, of course, because they're in a dilemma of some sort.

*If it's not luck, how do you anticipate the right moments?*

No, it's more persistence. Just hanging around. Spending an awful lot of time and patience just being there.

*Do you frame the picture and wait for the right gesture?*

No, I think, "If I go over there, maybe that's the best place to take this situation from." If it happens to be the best place, then I'm lucky. When I look at the pictures afterwards, I say, "Jesus Christ, it worked!" I really can't tell beforehand.

*Is it a conflict between two people that you're looking for?*

Without conflict I wouldn't exist as a photographer. There's got to be opposing emotions. I would say that applies to just about all of photojournalism.

It's not just pretty pictures.

On the *Life* staff 1955-72
Interviewed in New York City on October 29, 1993

# Nobody complains
# when someone
# looks posed in a painting

The photographer Brassai. Paris. 1981

# JOHN
# LOENGARD

JOHN LOENGARD: I've photographed Alfred Eisenstaedt several times. It is very simple because he says, "I'll stand here, and you take a picture." Usually it works. When you go to photograph somebody else, they say, "What do you want me to do?" Those are the most frightening words in the English language. I want to say, "Please, go over into good light and do something unusual," but I can't ask that.

When I photograph someone, I hope to get around their look of self-consciousness. Nobody complains when someone looks posed in a painting, but everybody notices what looks posed in a photograph. However, if I'm very close in on the face, expression doesn't exist. The face becomes a landscape of the lakes of the eyes and the hills of the nose and the valley of the cleft of the chin.

I was photographing the photographer Brassai. He had very large eyes, like a frog's. As I focused my lens, he brought his hand up and pretended to focus his eye. He did it as a joke, but it added mystery to the picture. If something like fingers comes into the picture, there's a sense of action in this very small world. Or if there is smoke—Allen Ginsberg was with people smoking cigarettes—there's a sense of motion. It makes much out of very little.

*Kathy Sulkes:\* It's an interesting notion that you get past the expression in somebody's face, to get closer to something more intimate. Did you discover that over time after spending time with subjects?*

Actually, I spent a long time trying to figure out how to take horizontal photographs of people's faces. When I was in college and just after, I became interested in cropping the face in ways that were satisfying. When I say it, it seems

\* At CBS between 1978 and 1986, Sulkes frequently interviewed photographers. See page 9.

like something you can figure out in five minutes, but I spent years trying to figure out where I can cut the face so the viewer doesn't want to see more.

*Are there particular subjects where you recall having to work a long time to get them to ease up?*

Georgia O'Keeffe, the painter, met me at the door of her house in Abiquiu, 75 miles north of Santa Fe, New Mexico, and asked, "How long will the pictures take?"

"They might take two or three days," I said.

"Why?" she asked.

"You never know how big a story will be," I said. "It depends on the pictures." Which was true. She was skeptical but showed me around and invited me to lunch. We went to a second house she had at Ghost Ranch. She had a cook there.

I hadn't taken any pictures because she'd been photographed by so many photographers. Alfred Stieglitz had been her husband, and Ansel Adams was a friend. I wanted to interest her in the thought that I might do something different. Yousuf Karsh and Philippe Halsman and Arnold Newman had all made portraits of her. I wanted to start with something unexpected.

She talked about the rattlesnakes she'd killed on her walks. She'd gone *swack!* with her stick and killed them. As we were having lunch, she pulled out from the sideboard boxes of the rattles that she'd collected. I figured O'Keeffe would like to be known to the readers of *Life* magazine as a killer. I asked if I might take pictures at the table. "Certainly," she said. I photographed her hand moving the rattles around one of the little boxes with a wooden match. After lunch, I didn't hear any more questions about time. She seemed happy to have me around, and I was delighted to be there.

*How did you start at* Life*?*

In 1956 *Life* was 20 years old and worrying that its staff photographers were getting older. They gave a group of five young photographers assignments. We were all about 21, 22, 23. Bruce Davidson, Ken Heyman, Bob Henriques, Frank Horch and myself. The hope was we'd end up as staff photographers and replenish the staff. I was the only one who actually chose to do that. Bruce went his way, and Ken went his, and so forth.

*What makes a photograph a classic?*

We keep seeing more into it, or we keep seeing it freshly whenever it turns up. It's rare and wonderful when you have a photograph that does that. Why it does is something I think every photographer wonders, because if I knew just how it was done, I'd do it all the time. It doesn't work that way.

*Do you think photography is an art?*

Well, certain photographs move people in the way other works of art do, and enough people have been moved by photography, so the question seems to be settled. Of course, this has led to a curious specialty: the "art photographer." It's odd. No one refers to Leo Tolstoy as an "art writer."

*You know photographers very well. Was there anything different when you came to a session shoot-*

*ing Gjon Mili toward the end of his life? Were you more careful?*

Gjon had been hit by a cab while crossing the street several years before. It was terrible. Mili had a wonderful mind. We had spent hours talking about photography, to my great pleasure. For some reason, after the accident, his mind kept locking up. It became harder and harder for his personality to come out. Finally, somebody who worked with him daily suggested that if I wanted to photograph him, I'd better do it soon. I came down to his office in the Time & Life Building and said, "Gjon, I've come to photograph you."

He said, "All right." I'm sure he knew why I was there, and that this was his last portrait. I asked him to put his elbow on his light table. He moved, glacially slow, into position. I'm sure that if he saw the picture, he'd tell me how bad it was.

*Was that a difficult picture just because it was so clearly the last one and there was all this weight attached to it?*

Emotionally it was difficult to see him in this state. But photographers are very practical. It was difficult because Gjon couldn't respond to me. I couldn't draw him out. That's what made it so difficult to take a good picture.

*How about when the tables were turned. You've been photographed by Carl Mydans.*

In 1966 all the *Life* photographers photographed each other. Carl Mydans photographed me in his house, and I learned something very important from him. He put lights up and had me sit in a chair, and I watched this well-known, distinguished gent in his 50s crouching, seriously looking at my face, and hopping around and taking pictures of me. His concentration was very flattering, but what impressed me most was that he kept telling me the pictures were terrific. It was like being at the dentist and being told it's just about over. Having your picture taken is a mystery, and people don't like mysteries. They're uncomfortable if you just go about your business.

*You were not always alone on these assignments. Tell me about your relationship with the reporters that you were to work with.*

In the 1950s a reporter's performance was judged by the success of the story, and that depended pretty much on the success of the photographer. In the early 1960s, in a reaction to television, a column of text was often tacked onto the end of stories. Before that, reporters had worked anonymously. Now they might sign their names to these "trailing texts," which rivaled the photographs as a means of telling the story and became the reporters' focus. The more such bylines they got, the better it was for their careers, especially if they wanted to work on other magazines that didn't use photographs to tell stories, as *Life* does.

In 1965 I was photographing Louis Armstrong at his home in Queens. It was an important story to me, and a young reporter was sent along with strict instructions to keep quiet and just take notes. But he got into a discussion with Armstrong and suggested Armstrong was an Uncle Tom. Armstrong asked us to leave. It was an important story for me, and I was angry. When I got back to

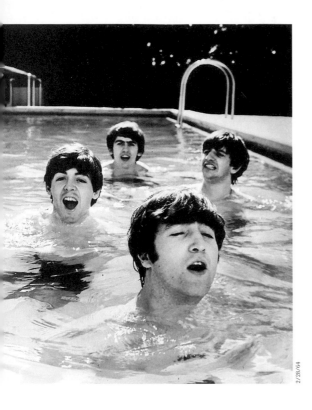

2/28/64

Gjon Mili. New York City. 1983
*"Gjon," I said. "I've come*
*to photograph you."*

The Beatles. Miami Beach. 1964
*The swimming pool was about as*
*American as you can get.*

Bill Cosby. Beverly Hills. 1969   *I saw the reason it works.*

4/11/69

the office, I said I didn't want to work with any reporters in the future, and I very rarely did. Working alone got me more involved with my subjects, which was good, but it also meant there was nobody in the office pushing my stories because they had worked on them too.

*Did you have friends back at the ranch? For example, editors to whom you could turn?*

My key was Bernard Quint, *Life's* art director in the 1960s. If he made a layout, the story became concrete. But I'd come in with a Monday-morning appointment to see Bernie and sit outside his door for three or four days until he'd finally have time. Then he'd focus on my story and put it on the pages. Bernie understood what was in a photograph and saw how to bring it out. He understood the space of the magazine page with precision and knew how to relate pictures within it. I've never seen anyone match him. Bernie laid out a story I did on the religious group the Shakers, and he was very proud of his layouts before they got changed a bit by the managing editor. But pretty proud even afterwards. Michelangelo Antonioni's film *L'Avventura* was the hot thing in New York then, and Bernie felt his layout was like the film. Undramatic scenes were put together to give a dramatic sense of the whole. That's Bernie's comparison, not mine, but it's what I usually want to do—photograph bits of a subject and join them together so the drama occurs on the page.

*You started to become interested in being an editor yourself, a photo editor?*

When I was 21, I thought that by the time I was 35 I'd be a picture editor. One of the things about photography is that it's very quick. I've never understood what I should do with the rest of my time. I sat in for the picture editor in the late '60s and found that I was good at it and enjoyed it. As an editor, I learned that a photographer can make an interesting picture only if there is something interesting in front of the camera. If you consider what cameras do, this makes sense.

I was in Gulfport, Mississippi, in 1970, six months after Hurricane Camille had passed through. The destruction was still evident. I spent the first morning photographing twisted shapes and odd forms, and suddenly it dawned on me that some aspect of any good photograph can be identified as odd or particular. Always. Peculiar is the right word because it means both odd and particular (as when we say, "Peculiar as the nose on your face").

In Gulfport, a part of what made some of my pictures peculiar was that I used a film that sees only infrared light. The chlorophyll that makes plants green reflects infrared light, so grass and leaves are whitish on the film. The film does not record blue light, so the sky became black. A different example of something peculiar is when Georgia O'Keeffe showed me a stone in her rock collection. The black stone rests on her hand in front her black skirt, and the highlight on its surface faintly suggests a hole. That is not the *meaning* of the picture, but it's a peculiarity.

*You're describing knowing when you've got it, and yet there are moments when you're not sure until you get back. You wrote about the MacGuffin. I'm thinking specifically of the photograph of Bill Cosby.*

When I first went to California, I was struck by all the sunny, whitewashed walls. By exposing for the wall, somebody standing against it will be thrown into silhouette. I photographed Bill Cosby, the comedian, at 10 o'clock in the morning. He was sleepy. He was grumpy. He had a backyard, and I photographed him standing against a wall there while his business manager was trying to get him to sign things. I asked the guy to hold up the papers and keep the sun off Cosby's shoulder. Cosby held a cigar. The exposure made him into a silhouette. I felt sure this worked, but when I developed the film, I saw the reason it works is because Cosby's wearing glasses with wire frames. If he'd been wearing tortoiseshell frames, it wouldn't have worked at all. It works because the shiny metal of the wire frame reflects light and *isn't* in silhouette. Alfred Hitchcock, the film director, called this the MacGuffin. The audience would be watching the MacGuffin, as I was watching the silhouette, but actually the picture's secret is in the glasses' frame.

*Is there anything in particular that you wanted to photograph?*

I can't just sit in a studio and photograph whatever comes through the door. I have to find a personal reason to take a picture. It doesn't have to be a deep feeling. Curiosity about a shape in a certain light is enough to start me off, but if the pictures I'm taking on assignment are not as meaningful to me as ones I'm taking for myself, something's very wrong. When I was photographing O'Keeffe, for example, I was also photographing my family in a summer house that we had. That became an essay too.[*] I always try to have a project of my own going on.

The project I have now is to photograph negatives of other photographers.[**] I don't understand why collectors aren't interested in them. When Paul Strand's prints leave the bank vault where they're stored, they are insured for $250,000 each. The negatives to the same pictures are insured for $200 each because there's no market for them.

*You were one of the few* Life *photographers that insisted on making your own prints. What does the print have that the negative doesn't?*

A good print simply shows how the light struck the subject. It is alive with the play of light, the play of tones within the picture. It's a wonderful performance of the negative. I think that Ansel Adams' remark—he was a concert pianist—that the negative is the score and the print is the performance is correct. You can get a performance from a negative that has a wonderful quality, but it doesn't change the negative, any more than the orchestra's performance changes the score.

---

[*] "Magic of a Summer House," *Life*, May 2, 1969.
[**] *Celebrating the Negative*, New York: Arcade Publishing, 1994.

*In your interviews, you've asked this question of everybody else. What do you consider your most American photograph?*

What a silly question.

*It's of your making.*

I know. When I was asking other photographers, I was wondering what my own answer would be, and the only photograph that keeps coming to my mind is the Beatles in a swimming pool, and it does for two reasons. These British high school kids were hitting America for the first time. It was the big time for them. A swimming pool was something that you didn't have in Liverpool backyards, because of the climate, but you did have in Miami.

Everybody had swimming pools. If you were to fly around the globe and look down in the southern tier of the United States, the remarkable thing you see is all these little blue patches of water down there. I suppose it's a Roman invention, but Americans have taken it over, and I think that these guys hitting their success in the swimming pool was about as American as you can get.

*That's great. I would never have thought that. That's just a wonderful explanation. O.K., you're going to hate this one too, but it was such a wonderful question. You're in front of St. Peter, and I'm assuming you want to get in. What photograph is in your hand to show him?*

[*Pause*] Well, of course, you start wondering about what St. Peter would like, don't you? I mean you start thinking what your audience might be. If there were one photograph, I could take O'Keeffe, her hand with a rock.

But, also, I photographed the photographer Annie Leibovitz a couple of years ago. She had decided that what she would do was to walk out on one of the gargoyles jutting off the Chrysler Building in Manhattan to take a picture. She wanted to be photographed there as Margaret Bourke-White had been. I don't know how she convinced the Chrysler Building to let all this happen, but she did. So maybe I'll also take this photograph of Annie out on a gargoyle 60 floors above the street, with her assistant, who is passing her film. It is quite a wonderful scene.

The whole question of how much the photographer brings and how much the subject brings, and how much somebody else can bring to the photograph, is all tied together. The sculptor Henry Moore was in his 80s in 1983. At four o'clock the first day I was at his estate outside London, it started to snow. It was getting dark. I thought the snow might pile up gently overnight. I said to Todd Brewster, a writer I was with, "Let's come back at dawn." It was wonderful then. Snow was still falling, and everything was pristine. Moore kept several statues in his fields. His neighbor's sheep grazed around them and gave them scale.

One sculpture was called *Sheep Piece*, but the sheep were way, way off in another corner of the field. I went over to them, but I am raised in New York City, so when I approached, they backed off. I turned to the writer, who'd grown up in Indiana, and said, "Todd, what about you?" He went over to the sheep, and I don't know. Either it was because he grew up in Indiana or because he smelled right, but they followed him until he stood hidden behind the sculpture.

Abiquiu, New Mexico. 1966
*I figured O'Keeffe would*
*like to be known as a killer.*

3/1/68

Louis Armstrong puts
balm on his lips. Las Vegas. 1965
*I was angry.*

4/15/66

Henry Moore's estate. England. 1983   *"Let's come back at dawn."*

5/83

And all the sheep stood around Todd, just happy as clams, or happy as sheep, or whatever they were. It made a wonderful picture.

I am thankful to Todd because I couldn't have done it without him, but I also couldn't have done it without the sheep—so I'm thankful to the sheep. I couldn't have done it without Mr. Moore and the shape of his sculpture. I could not have done it without God, putting snow over the whole thing. So I don't know where I start and where they all left off. But I think you have to be very humble as a photographer.

*This sort of calls up my last question. In that whole scene, you're describing some element of magic that happened. Is magic a part of it?*

Oh, magic's always a part of photography. I got interested in photography when I was about 11. It was just after the war. My father was talking about buying a new camera because that was suddenly possible. Suddenly, the thought that you could take pictures just struck me as a magical idea.

I rushed out and bought film for a box camera the family had, and started doing it, and it's always seemed magical to me—and I think there's some sense of magic in the fact that what's out there can be caught in this little box. You can catch it, and once it's caught, you can see it forever. I still feel like a little boy in China with his pet cricket in a box. I can take the cricket out and look at it forever.

On the *Life* staff 1961-72
Interviewed in New York City on May 22, 1993

Natalie tried to be so sophisticated,
but her idea of art was
to collect Walter Keane paintings—
the children with the big eyes

Natalie Wood. Los Angeles. 1963

# BILL RAY

**B**ILL RAY: I was born 90 miles west of Omaha, Nebraska, in a little town of about 600 people, called Shelby. One of the reasons I went into photography was to get out of there. I started taking pictures when I was 11. My mother was an artist. My older brother was an artist, and I went around to do photographs for them so that they could paint scenes from them. It just evolved from there. Before I graduated from high school, I talked my way into a job on the Lincoln, Nebraska, newspaper, the *Journal Star*. I worked there a couple of years, then went to Chicago, then to the Minneapolis *Star & Tribune*. Roy Rowan, who was *Life's* Chicago bureau chief then, liked the work I did for them. In fact, I was recruited by both the *National Geographic* and *Life*.

I turned down a paying job with *Geographic* (which was kind of silly) just to come to New York in 1957 and free-lance. I liked meeting people and going places, and I thought that would be more interesting than doing a bunch of monkeys in the jungle. At that age, 20 or 21, I didn't have any doubts. I worked constantly for *Life* on everything from poverty in Appalachia to Soviet Premier Nikita Khrushchev and President Dwight Eisenhower at the United Nations. It was the news, but fun news to cover. In 1963 I was offered a staff job in the Beverly Hills bureau. I liked movie people very much. I liked getting them away from the set and working with them, because working on a movie set is really boring. I spent a couple of months with Natalie Wood. It was a story on the life of a top Hollywood star who had 20 people and the William Morris Agency looking after her. Natalie tried to be so sophisticated, but her idea of art was to collect Walter Keane paintings—the children with the big eyes—buy the originals, not the postcards—and after a dinner throw all the plates into the swimming pool. Things

like that. She was really kind of funny. Very sweet. Very nice. Very pretty. Very photogenic. It didn't take much encouragement to get an actress then to pull out her cigarette holder and start throwing her arms around. She was marvelous. I don't think I ever said, "Why don't you stand right there and do such and such?" It was just kind of getting her to get into situations.

In 1964, then, there was a special issue on Japan, and I went there for three-and-a-half months. I did pictures of Konosuke Matsushita, the Henry Ford of Japan. I had him walking through his garden—a beautiful rock garden—and if I wanted him to go back and do it again, he did it. I don't know if I asked him in English or what. I guess I waved at him or something. A lot of gardeners would come out and rake all the stones just in the right place, and he'd walk again. I wanted to do a picture of him with all of his products, which turned out to be impossible because some of them were enormous turbines weighing tons, but I did a picture of him with most of his products. It took a week or two. I was given a staff of people and a big room and I would come by from time to time and tell them where to put all the TVs, where to put the bicycles and all that sort of thing. Finally we had it just right for Mr. Matsushita to come and sit. We did one picture of him in his kimono and one picture of him in his business suit.

Nowadays, you don't have people falling down, asking, "Where do you want the ladder? When's the fire truck coming?", or whatever. That sort of thing doesn't happen anymore. When a *Life* magazine photographer came to a small town in America, the headline might be "Missouri Floods—100,000 Homeless; *Life* Photographer Eisenstaedt in Town." You know, to cover a flood. I mean, it was a very big thing.

I was at *Life* toward the end of the great days. I got to meet some of the key players, but I suppose if television had come to Nebraska earlier, I would have been smart enough to have known then that the end was at hand.

*John Loengard: You did a story on a coed dorm, which was a brand-new concept in 1970. Did you have difficulty doing the story?*

It's interesting on a campus how, from year to year, students are very different. Then, they were very questioning of the media, which, I think, probably they should have been. On a campus like that, I was used to "Oh, *Life* magazine is here! The *Life* photographer is here! When is it going to appear?" That sort of thing. At that time at Oberlin, it was more like, "You are out here trying to perpetuate middle-class values." Things that I'm not so sure I really thought about, and they were probably right.

*You were looking in on their love life. Did you feel that you were snooping?*

I think you're always snooping. There's nothing wrong with snooping, is there? They were young and attractive, and that was all fun. I did another story, "Hell Breaks Loose in Paradise," on a public school in the small town of Paradise

9/11/65

Konosuke Matsushita. Japan. 1965
*Nowadays, you don't have people falling down,
asking, "Where do you want the ladder?"*

Kennedy-Onassis wedding.
Skorpiós, Greece. 1968
*Then it was all quite different
than I had expected.*

original in color 11/1/58

Paradise, Calif. 1963
*I saw her out of the corner of my eye, and
bang, bang, bang, and that was it.*

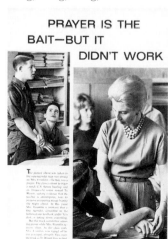

## PRAYER IS THE BAIT—BUT IT DIDN'T WORK

4/26/63

in California. A liberal, presumably very accomplished, teacher was being attacked by the right wing. I was taking pictures, and she just walked over and grabbed a book from a student and opened it. I was lucky enough to get the picture. She had thought there might be a tape recorder in the book, but didn't know there was. I didn't know there was a tape recorder in there either. She's a wonderful, impulsive lady, and she just walked over after class and grabbed the book. That kid had been doing this kind of surveillance to uncover the commie influence.

*How important is luck?*

Very. It was lucky that the camera was set right—and film in the camera, there was plenty of it left. I saw her out of the corner of my eye, and *bang, bang, bang,* and that was it. It's never going to happen again.

*Was it luck to be at Jacqueline Kennedy's wedding to Aristotle Onassis?*

You might call it that. I got the straw, but whether it was long or short, I don't know. Just a small group of press were invited to a beautiful island. It was always sunny. Never rained. I thought it would be absolutely marvelous. I wore my best shoes. Of course, it poured all day long, and we were never invited inside. Stood out in the rain. It got dark. They finally came out of the chapel. The strobe, which was drenched at this point, fired about three times and then tried to electrocute me. Then Onassis jumps on a golf cart and tries to run over me and whoever else was there. That amused him, and it was all quite different than I had expected.

We were the handful of press that had been invited. There was a reception on the yacht, and we were sort of semi-invited. We were allowed onto the fantail and could take pictures through the window. Then, afterwards, Jackie comes out, and with her little limp hand, she said, "How are you? It's so nice of you to come."

*You don't sound like a fan of hers.*

She's very strange. Very strange person.

*You were taking pictures without flash?*

Through a window, yes. I didn't need the flash at that point. But, also, the flash didn't work either, so there was no option.

*Had you done anything with the Kennedys before?*

Sure. The Inauguration, and then of course the campaign, and any number of times with Jack, Bobby and so on.

*Did you get to know them?*

Well, I guess I didn't get to know her, because she didn't remember me or anyone else, but I think—I think people who traveled with the Kennedys all thought they knew the Kennedys. We all had the PT-109 tie clip, and we all thought we knew them, so on and such forth. But I didn't know them at all.

*How do you feel the press should be treated?*

In contempt, I guess.

*You do?*

Probably, yes.

*Does the treatment given you affect you during the story?*

Oh, I think so. Sure.

*So that if the subject is smart, he would treat you well?*

Yes.

*Did Jane Fonda treat you well?*

She was fine, very smart, and sort of interesting, but certainly very nice. The surprising thing I felt about Jane Fonda is that she had absolutely no sex appeal. Just zip. Yet she's a marvelous actress. You see her on the screen, and she's fantastic.

*In a still photograph, could you produce that feeling?*

If she followed my directions, I suppose, yes, but it wasn't that kind of a story. It was Jane Fonda, committed activist. She was flying around day and night. I don't think she wanted any sex in it.

*How much does a photographer control his story?*

Oh, I think that depends on so many things.

*Like what?*

Well, on the people you're dealing with; and in the case of *Life* magazine, it would depend a great deal on the editors. I could do a lot of stories that might not even appear in print. I worked on the Parker Ranch in Hawaii for a couple of months. Marvelous story, but the editor changed during that time; and when I came back from Hawaii, they said, "We don't do that kind of story anymore." I rode around with the Hell's Angels in California for six weeks or so. Fantastic experience. Marvelous. And the managing editor said, "Well, we don't want to do pictures of people with a bunch of goddamn beards." So those never appeared. And so on and so forth. I'd say they had total control.

*Why would anybody let you spend time doing a story on Hell's Angels if the managing editor categorically didn't want to run it?*

That's a good question. I don't know. I guess it was bad communications. Joe Bride, the reporter, had made this deal with the San Bernardino chapter of the Hell's Angels—which was the roughest, toughest crew of them all—that we would not be killed or something. We thought we were just onto the hottest little scoop ever.

*Did you enjoy working for* Life*?*

Absolutely. It was terrific. I got to travel everywhere. Went through the Straits of Magellan with Samuel Eliot Morison. To Dead Horse, Alaska. All through South America. My family and I lived in Paris for three-and-a-half years. I met a lot of interesting people, some of the most interesting people of that time.

*Did you volunteer to go to Vietnam?*

Sure. I wanted to go. There was never any doubt in my mind. I made three trips there. The longest was with the Seventh Fleet. I was on the flagship—the

cruiser *Oklahoma City*—which was commissioned toward the end of World War II and had never fired her guns in action. All the ladders had mahogany rails, and the wardroom was like the Waldorf—it was absolutely marvelous. And in the barbette all the shells had things like "To Tojo with love" written on them in chalk. They had never been fired. The first salvo off the coast of North Vietnam took all the glass out on the bridge, and we're just crunching around on glass the whole morning. They fired several hundred rounds, and everybody was so excited. The captain had been the gunnery officer on the battleship *Missouri*, so this was really his idea of a good time. It never occurred to anybody to ask what they were shooting at. Word had come back from the little forward air command: Mission accomplished. Target annihilated. And everybody was saying, "Wonderful! Isn't this great! We're winning the war!" Finally, someone asked what the hell were we shooting at? It was a herd of suspected V.C. water buffalo.

Later, I did a frustrating story on Soviet medicine. You couldn't do what you wanted to, or go where you wanted to go, but then it was incredible what they *would* show you. We went out to a mental hospital which had been a marvelous mansion, a private estate before the revolution. Sitting around Moscow, I'd done nothing but read books on Russia and, of course, read all the Solzhenitsyn. All those stories stuck in my mind. In *The First Circle*, Solzhenitsyn talks about being in this horrible cell with hundreds of other people, and they hadn't bathed or changed or shaved in who knows how long. Filthy! Some could sleep on the floor; some could stand up. When Eleanor Roosevelt was coming, they were all bathed and put in a nice, clean thing. There were two to a cell and clean clothes and so on.

So we went out to this estate, and you couldn't tell who was actually a mental patient and who was a KGB agent. They were sitting around playing chess and so on and such forth. But the drawing room was just beautiful, and there was a great marble fireplace, and on the fireplace was this French ormolu clock, really something to see there. And while I was taken around, I said, "That's a simply beautiful clock."

"That's interesting," the doctor in charge said. "That was Eleanor Roosevelt's favorite clock too." So I got the feeling we were just following in the footsteps, you know . . .

*You photographed your mother's funeral for* Life*? You felt that she would have liked it?*

Oh, I'm sure she would have.

*Was she still of the attitude that when* Life *comes to town, it's big news?*

Well, I don't know. I wasn't thinking about that so much. It was that "One Day in the Life of America" issue in 1974. I was scheduled to go off and make pictures in a missile silo or something in North Dakota, and my mother died, and her funeral was on that day. So that was my assignment.

*Do you think photography is an art?*

I've never thought I was competing with Michelangelo or Rubens, or anyone like

that. Somehow, photographers seem elevated to a higher standard than a really good carpenter, which is probably a big mistake. Anything's an art these days, so why not? Go over to the Whitney Museum. But certainly not a high art. Not an art in the sense of Renaissance art, no. I always did the best I could. I think I did some good pictures, and that's it. I admire the same photographers I admired when I was growing up in Nebraska. Eisenstaedt was famous then, and still is. Still alive and still absolutely marvelous. Carl Mydans. David Douglas Duncan.

*You and I were talking about the biography of W. Eugene Smith. Would you consider Smith to be an artist?*

I suppose so. Certainly crazy enough. I always thought it was strange when I first started working for *Life's* picture editor and I'd come up to that bench outside of the picture editor's office and sit there and wait for an assignment, and there was Gene Smith. And I thought, Isn't this strange, one of the most famous photographers in the world, and what is he doing? Waiting for the same bone to come flying out the door that I'm looking for.

*Before you go to take pictures, do you imagine what they're going to be?*

Yes, I try to. Hopefully you find something better. Hopefully something magic will happen, but I always do try to think of what I'm going to try to get.

*What had you imagined for the Onassis—*

Oh, I had absolutely no idea, I mean, since it was all so different than I thought it was going to be. John, I wore my best suit. The only time I ever had a pair of handmade shoes. I had no idea I was going to stand out there in a monsoon on a place where it never rained and be run over by the golf cart, you know.

*Did you miss the picture?*

No, I got the cover. One of the two or three flashes that went off before I was electrocuted—I got the cover. So it all kind of worked out.

On the *Life* staff 1963-72
Interviewed in New York City on October 26, 1993

Bobby said, "I'm going this way,"
and pointed back to the kitchen . . .
which meant
he didn't have us in front of him

Robert Kennedy. Los Angeles. 1968

# BILL EPPRIDGE

**B**ILL EPPRIDGE: When I joined the magazine as a young photographer, I was cannon fodder. Whenever anything hit the fan, I was sent. I did a number of revolutions in Latin America—in Panama and the Dominican Republic. I was in Vietnam for a while in 1965. I did a few civil rights stories in the South.

When the bodies of James Chaney, Michael Schwerner and Andrew Goodman were found buried in a dike in 1963, I went and lived with the James Chaney family for a day or two. The reporter was Mike Murphy. Mike was a great, big, tall, imposing figure, about 6'5". We went into the ghetto area of Philadelphia, Mississippi, where the Chaney family lived, just as bold as could be. We walked up and knocked on the door, and introduced ourselves and asked, "Can we stay?"

They said, "Please do. Come in. Join us." I was constantly amazed at the type of reception that *Life* would get in situations like that. I don't remember all the pictures I took, but I do remember the funeral. I remember Ben Chaney, the young brother, had a broken arm. The family was sitting in the car, and he was sobbing. He was saying, "I'm going to kill them. I'm going to kill them. I'm going to kill them."

He was just a little boy, and it sent shivers up my back when I heard this. We went to the church, and at the funeral service I was sitting in front of the grieving family. I made a wonderful picture of Ben and his mother, tears running down his face. Years later I was reading a newspaper, and I saw a little piece that said Ben Chaney, brother of James Chaney, had been accused in the murder of four white people.

I went to Philip Kunhardt, who was the acting managing editor at the time,

and said, "Let's see if we can photograph this boy in jail." We did. As Chaney came up to the bars, I shot a Polaroid test and saw that the lighting was O.K. We talked, and he became a little more friendly. When the film got back to New York, Kunhardt looked at it and said, "I don't like any of these pictures." I had sent him the Polaroid test to show what the picture was going to look like. Kunhardt said, "That is the one I want to use." It was that first moment, when there was still that fear on his face.

*John Loengard: You say, "We." Did you always work with a reporter?*

I very seldom worked alone. I would use the reporter as another pair of eyes. And the other way around, I would be a spare pair of ears for him. A lot of times, people will say things when there's a photographer around that they won't say when there's a writer around. James Mills and I did a major story on heroin addiction in New York that became the movie *Panic in Needle Park.*

On that story, in situations where there may be three or four things going on in a room, I'd be photographing one thing, and every once in a while I'd glance up at Mills. Working with Mills is like working with a bird dog. If you've ever hunted, you know that when a bird dog gets on point, there's something there. Mills would just lean forward and get a look on his face. As soon as I finished with what I was doing, I'd mosey on over to look over his shoulder to see if he had something. Generally he did.

*What makes a picture?*

I think what makes a picture is a moment that is completely spontaneous and natural and unaffected by the photographer.

*Mills is over six feet tall, and you're not a midget—and you have cameras. Doesn't your presence affect a situation?*

I try not to. I dress to fit the occasion. If I'm with a group of junkies, then I look like them. If I'm with a bunch of politicians, I wear a coat and tie. I'm not carrying a lot of equipment. I very seldom use strobes. A flash does affect a situation. I have missed pictures because I did not have lights with me, but I've gotten other pictures that I would not have because I don't use one. I have always been a believer in using the quietest cameras I can find. The click of a camera affects people.

*Why did the drug addicts let you take pictures?*

We said to Karen and John, "We don't want to stop you from doing anything you're doing. Just keep doing things the way you're doing, and we will follow." We told them this was their chance to do something for society. To help people, which they might never have a chance to do otherwise.

They listened and thought about it and said, "O.K. This gives us a chance to do something good." And it did. They had a significant effect on the way we think about drug addiction, and heroin addiction in particular.

Ben Chaney.
Philadelphia, Miss. 1964
*"I'm going to kill them.*
*I'm going to kill them.*
*I'm going to kill them."*

Ben Chaney. Columbia, S.C. 1970
*There was still that fear on his face.*

6/19/70

Needle Park. New York City. 1965
*I was simply an eye.*

Drug overdose. New York City. 1965
*"You better get up here. We got some trouble," Karen said.*

I spent the most time with them. Mills would come in and out of the situation as things demanded. I'd be sitting there looking like a junkie, but Jim would wear gray pants and a white shirt and a striped tie and a blazer, and look like he just came out of Yale Law School. He'd walk right in and be accepted too. I don't know. There are funny little ways you blend in. When something significant looked like it would happen, I'd call Jim up and say, "You might want to be here tomorrow."

*You photographed the addict John burglarizing a parked taxicab. Did you feel any responsibility for the driver of the taxi?*

Not really. I was simply an eye. Had it been an armed robbery, I might have thought about it differently. I did have a problem with the overdose sequence. Karen had gone up to buy some drugs in a hotel, and I said, "I'm not going up with you. I don't really know these people. I'll wait in the bar." So I stopped in the bar with my cameras and had a beer and was sitting there.

The phone rang, and the bartender said, "It's for you."

Karen said, "You'd better get up here. We got some trouble."

I went up and found the guy that she had gone to see had overdosed. He was pretty close to dying. Things started going through my head, "Do I call the police? Do I call an ambulance?"

Karen said, "I can bring him around. I've done this before." So I started taking pictures. Luckily enough, he came up out of it. But had he gone under, then there probably would have been a little bit of trouble. I don't really want to think about that.

*Was Mills with you then?*

No, I was alone.

*Did you take notes on what Karen was saying?*

I would write things down occasionally, and I took pretty good mental notes. I was able to brief Jim about the things that happened.

*Have you heard from the couple since?*

After the article made them public figures, we offered to put them under the care of a psychiatrist in Chicago who had a history of dealing with addicts. We said, "As long as you want to be under his care, we will take care of you through him." For a couple of years they were, but little by little they separated, and then suddenly there was no contact at all with them. I don't know where they are. I don't think I even want to know. They may be terribly successful people now. I'd like to think that. I do wonder, but I would hate to go back into that time of their life.

*Let me ask about a different kind of story. Why did you go to Woodstock?*

Two months before Woodstock happened, I saw a little piece in the paper that said the people in the town of Woodstock had refused to give a permit for the concert. I thought, "They're going to get mad. They're going to have that

concert, and that concert's going to be big." I went to the head of a department that I used to call the freak department. All kinds of strange, weird kids worked in that department.

He said, "No. We're doing something on country-and-western music." A week and a half before the concert, he calls and says, "Bill, how do we cover Woodstock?"

I said, "Get a motor home, and park it next to the stage." The concert comes to happen and here we are, right next to the stage. That's where we lived. There were two photographers working, John Dominis and myself, and about four or five reporters.

We had terrible problems with the security. We couldn't get in and out of where we were living. Finally, they gave us jackets that all the security men had, which meant you could go anyplace you wanted to go. That's how we covered Woodstock. Total movement. We could do anything we wanted. I was crawling around on the stage. I didn't have any trouble.

*Did you partake in the celebration?*

To tell you the truth, that drug story I did scared me so much that I had trouble taking an aspirin. No, I didn't. There were some really strange drugs going on. The problem was, not being a member of that drug cult, at times I wasn't sure what was significant. I found a guy who was a member of that society, and who was pretty stoned most of the time. I'd go around with him, and we'd go and look into a place, and he'd see something and go, "Oh, wow!" Then I'd shoot it. Had I partaken, I wouldn't have been able to make pictures anyhow.

*Can you drink and photograph?*

Not really. You start seeing things that aren't there. You go back and look at your contact sheets and realize that you made absolutely nothing. I mean it's nice to have one at the end of a day. But, no.

*Are there pictures in your mind you know you've missed?*

Yes, there are a lot of pictures that I miss because I'm not in the right place, or I'm thinking about something else, or my camera's pointed in one direction and it happens over here. In the heroin story, I missed one. I saw it out of the corner of my eye. John hit Karen. I think my camera was coming up at the time, but it was just too slow. I have a little philosophy on things like that. When you miss it, you put it completely out of your mind. You forget about it. You just wipe that thing off your brain, because if you think too much about it, pretty soon you start going crazy, thinking about the ones that you missed. And you start missing more because you're thinking about them. I'll go so far that if I'm reloading a camera, I'll turn my back on what's going on, because I don't want to see the pictures that happen while I'm reloading.

*You photographed Robert Kennedy traveling around the country campaigning for others in 1966 and covered his campaign for President in 1968. You were with him the night he was shot.*

In Los Angeles I got off the stage in the hotel ballroom before Senator

Kennedy did. The cameramen would form a wedge in front of a political candidate. The candidate is right behind us while we're backing through the crowd. It gives him a little bit of room to shake hands, and we can make pictures. We had this wedge formed. The Senator came down, and Bill Barry, his bodyguard, said, "This way, Senator," and Bobby said, "No, Bill, I'm going this way," and pointed back to the kitchen. Barry said to him again, "Senator, this way." Kennedy said, "Bill, I'm going this way," and he turned and he went, which meant he went on his own. He had no wedge in front of him. He didn't have his protection. He didn't have us in front of him.

We scrambled to catch up with him. There was a curtain you went through to get into the kitchen. I was just at the curtain with Jimmy Wilson, a CBS cameraman, and I heard the shots. I grew up hunting, and I knew exactly what they were. I grabbed Jimmy and said, "Jimmy, .25 caliber." We proceeded a couple of feet, but it seemed like a mile. We came upon a body on the floor, bleeding, and Jimmy Wilson put on his camera light, and we realized it was a representative of the AFL-CIO. Sirhan fired eight shots. He hit the Senator three times and hit five other people. Then we came upon the Senator. He was lying there with his head toward me, and Jimmy stopped there. He loved the Senator, and he started breaking down. His sound man grabbed him on one side. His electrician grabbed him by the other side. On the film you can hear them yelling, "Shoot, Jimmy, shoot!" One of them actually had Jimmy's hand and was squeezing it on the trigger of his Arriflex camera. They made sure that Jimmy kept shooting.

I looked, and I did something that you should never do. I didn't take a picture. I went around to the other side, to the Senator's feet. Before I got there, there was a pile of people on the ground, and I realized that they were on top of somebody. Things seem to happen very slowly when something like this happens. I recognized who was in that pile. It was Bill Barry. It was Roosevelt Grier and Rafer Johnson and George Plimpton. Somebody was yelling, "Don't kill him! Don't kill him!" I had to make a quick decision whether to shoot that or to turn to the Senator.

I couldn't see Sirhan, and I turned, and there in front of me was the Senator on the floor being held by the busboy. There was nobody else around, and I made my first frame, and I forgot to focus the camera. The second frame was a little more in focus, and the busboy is looking down at him. And then just for a second, while everything was open, the busboy looked up, and he had this look in his eye. I made that picture, and then suddenly the whole situation closed in again. And it became bedlam.

People started coming in swarms. People coming in to help and people bending over. I kept shooting. The pictures became more historical documents, more of a record. Ethel came in. I was back at the Senator's head. She saw him, and the first thing that Ethel did was—photographers were standing up on top of a

piece of kitchen apparatus—and Ethel goes over and has them thrown out of the room. Herself.

I felt that I had to stay. It was my job—my duty—to make all the pictures I could make. I made pictures until I felt that if I didn't leave I was going to get thrown out. I had the camera hanging around my neck, and I went to hold the crowd back. Jimmy Wilson had run out of film, and he threw—smashed—his camera on the floor and ran into the crowd. He became a one-man crowd mover. He was pushing them all the way back, all over the place. He turned into a maniac, almost. I went and I held my arms out to hold the crowd back, knowing that they would not throw me out of the room if I looked like I was doing something worthwhile.

I had a camera dangling around my neck, and Ethel was right there in front of me, leaning over the Senator, talking to him very quietly. So quiet you couldn't hear. But I know that he was moving his lips, and I knew she was talking to him. They were saying something, but I couldn't hear. Every once in a while, I would reach down and go click. When I felt nobody was watching me, I'd reach down and click off another frame.

Consequently I got that one frame that we did use of her bending over him, that I think is a rather significant moment. It's a picture that nobody else got.

We used one of Harry Benson's pictures in the magazine, and it's a picture of Ethel holding up her hand. I always wondered why I missed that picture. I felt that if she had done that, she would have done that in my direction.

As it turns out—I went back to look at the contact sheets, look at them real closely—and there indeed is Harry Benson in that room. But he's back up on the steam table with all the photographers who were thrown out. When Ethel is doing that to him, she has turned around away from the Senator, and is 10 feet away, and is telling the cameramen to get out of the room. But I sort of wondered how Harry got so close to hearing every word that Ethel said to the Senator, when according to my pictures, there certainly wasn't anybody that close.

*You also competed against Harry when the Beatles came to New York.*

Yes, when the Beatles first came to this country. I looked at where the plane was going to park at J.F.K. I introduced myself to the photographer next to me. He was Eddie Adams from the Associated Press. I said, "If you had your choice, what position would you like to have at this event?" We both agreed we would want to be right behind the Beatles as they come out of the plane, looking down, across them, over this whole huge mob of people standing there.

The plane pulls up to the ramp, and the door opens. A Pan Am stewardess comes off, and out come the four Beatles. Then this character comes out right behind them, and he starts posing them. Eddie and I looked at each other and said, "Who is that?" We had no idea. It was Harry Benson's first trip to the

United States. It's been going on like that for years. Every time you'd know what the best spot is, who shows up in that spot? Harry Benson.

*Did you volunteer to go to Vietnam?*

No, I was kind of shy to volunteer. I thought famous guys got to go to wars— like Larry Burrows and David Douglas Duncan. I didn't realize that's how you become famous. As soon as I was asked if I would like to do it, I said, "Oh, God, yes!" I was complimented.

*How long did you stay?*

I was only there for a couple of months in 1965. My job was to sit and wait with the Marines in Da Nang until we got a little bit of action. When a little fighting broke out, the Marine commanding general, Lewis M. Walt, called Eddie Adams and me and said, "You guys want to go to a little fight?"

We flew off to war in his helicopter and landed in the middle of a firefight. General Walt put the chopper down, and we got out, and he said, "You guys going to be O.K.?"

We said, "Fine." And off he went.

A couple of Marines took us back up through the lines. We came on a civilian-looking guy. Three Marines had grabbed him, feeling that he was Viet Cong and that he had popped up out of an underground cavern. They were going to take him to our lines, and the guy broke away and ran. One of the Marines ran after him and tackled him. Brought him back. He struggled. He broke away again. The Marine ran off. Tackled him. Brought him back. These were two privates and a corporal.

They brought him back, and a third time he got away again, and he ran, and the corporal said, "Kill him." One of the privates went down. He put the rifle up and bang. Shot him in the back. Killed him. The guy went boom, fell over dead. Eddie and I were sitting behind this guy. We're both photographing it. Both of us had it. I'm thinking to myself, "My God! We've never seen this before."

Eddie and I spent the rest of the day and then got out, and my film went back to New York. His went to Saigon. I saw Eddie a couple of days later. He said, "My film got lost in the lab."

I got *Life* magazine later, and there's a picture that I had shot. It was this guy, lying on the ground, dead, and the three Marines walking past him. None of the sequences of the thing that had happened. I called up Dick Pollard, the director of photography,[*] and said, "Did you see that sequence?"

He said, "The managing editor looked at that, and the quote was: 'Marines

---

[*] Richard O. Pollard, a staff correspondent in the Los Angeles and San Francisco bureaus since the 1930s, was *Life's* London bureau chief for two years before he became the magazine's picture editor (or director of photography, as the job was then called) from 1963 to 1972.

never shoot anybody in the back.' " That was it. The sequence never saw the light of day.

*Is it in the files?*

No.

*What happened to it?*

I don't know.

*Did you ever see it?*

Yes, I saw it later. I made the pictures. I did see them. I don't know why they are gone.

*Did you become famous because you went to Vietnam?*

No, I don't think it really did a lot for my career. Of course, not many of my Vietnam pictures were published.

*Do you miss working for* Life*?*

Yes, very much. I miss the camaraderie. The photographers were always around, and ideas get transmitted. I miss the photographers' room. In 1959 I had won the college picture competition at the University of Missouri Journalism School, the first prize of which was a week at *Life*. I found all those photographers that I had admired in Room #28-50. Later as a free-lance photographer, I'd be sitting there editing some film, and if I was very quiet, I could learn things. I think #28-50 was my graduate school.

The person that I wanted to be the most like was Gordon Parks. It was the love that he seemed to have for people that came through in his pictures. I liked Grey Villet's ability to get close to people. I liked his ability to take an idea and turn it into a candid photograph. It's that type of work that I have always respected.

I felt that if I was ever going to go to war, I wanted to make the pictures that Robert Capa made. Capa was a photographer of people who happened to go to war. His sympathy was to the innocent person caught up in a war, rather than toward the glory of a war. Dave Douglas Duncan's pictures felt for the soldier. Duncan was a Marine, and he was a photographer of Marines. He could look at that really hard outside and find a human being in there. But David was looking at soldiers. Bob Capa was looking at human beings.

Carl Mydans' picture of MacArthur coming ashore in the Philippines was *the* moment. The building collapsing in Tokyo during the earthquake is just an extraordinary picture. I always wondered how in the world somebody there at that moment could have the presence of mind to make that picture. Carl's picture of railroad commuters reading the newspapers headlining the death of President Kennedy is haunting. Carl just sees wonderfully.

*What picture do you like best that you've taken?*

I suspect that the most significant picture that I made is that picture of Senator Kennedy lying on the floor. With that busboy holding him.

Because I had covered his campaign, I was invited on the Kennedy funeral train from New York to Arlington Cemetery. I wasn't going to shoot, but two other *Life* photographers who were supposed to be on that train didn't make it. All that long train trip, the tracks were crowded with people. I hung my head out of the window and photographed. That was easy because you don't cry so much. When we got to the cemetery, I said, "No, I'm not shooting this, and I went and stood by a tree and held a candle."

On the *Life* staff 1964-72
Interviewed in New York City on January 14, 1992

When you're competing with the paparazzi,
who make their living
photographing celebrities, they'll kill you.
They will kill you

original in color 9/86

Caroline Kennedy weds Edwin Arthur Schlossberg. Centerville, Mass. 1986

# HENRY
# GROSKINSKY

**H**ENRY GROSKINSKY: During the Iran-*contra* scandal, the press was usually swarming around Oliver North when he left his house. The idea was to show what this circus looked like. I went off to suburban Washington, D.C., where he lived. I got there at three o'clock in the morning. I set my camera up on a tripod across the road from his driveway. The house was completely dark.

I'm waiting and waiting. Nobody else shows up, and I figured, "Maybe I got the wrong address." As the sky was getting a little bit of light, my assistant said, "There's somebody by the station wagon in the back." There was not a light anywhere—just a little light in the car from the door being open. Sure enough, here comes the station wagon down the driveway. I didn't know what to do other than to cross the road and wave my arms. I introduced myself. I told him I'm from *Life* magazine and said, "Could I make a photograph of you?"

He said O.K., then I look in the back of the wagon. He nodded and said, "Some days it's cookies for the Girl Scouts; other days it's arms for the *contras.*"

I go back to my camera and pop a picture. I thanked him, and off he went.

I got back to New York and told the news editor about the Girl Scout cookies. He's jumping up and down, "Go sit and write it down as you remember it." Then, of course, I realized that this is the kind of a quote that a reporter would die for. It wasn't that important to me at the time. My picture was important.

I have always been interested in photography, even as a small kid. When I was 12, right after World War II, I got an old 8x10 inch camera from my uncle who was an amateur photographer. It was a magical thing.

I went to the High School of Industrial Arts, on 51st Street off Lexington Avenue, where they taught commercial and advertising photography. There was

a night job in the lab at *Life* magazine. When I graduated in 1952, I started assisting different *Life* photographers, first at the *Life* studio on 43rd Street off Sixth Avenue. Then *Life* moved its studio to a building on West 54th Street, which had a huge elevator, so we could bring in things like cars and bulls and lions and stuff like this. Actually, city inspectors came around when a neighbor complained about the bull, and once Andreas Feininger brought a big white python. It was cold, so it was O.K. They set him up, and then we put this big 5,000-watt floodlight on him. After a while you could see this snake was getting warmed up, and he kind of felt good. Its handler said, "You'd better turn off the light. He might get a little too rambunctious."

My ambition was to be a photographer, and in 1964 Time Inc. was looking for a corporate photographer—somebody who could do still-life setups and all kinds of small in-house pictures. They said, "Do you want to be the highest-paid assistant or the lowest-paid photographer?" I didn't have to think about that much at all.

*John Loengard: What do you look for when you take a picture?*

I try to get a lot of information in a picture and to have a classic, no-nonsense look about it. I will often compose the picture so it is symmetrical. If you have a strange angle, it's as if there's not enough in the subject so the photographer has done something to jazz it up. I find that the most direct, pure approach is the best way to go: *Here it is. This is what it looks like. That's the way I see it.*

I happen to like equipment. I like working with big cameras and big lenses. But I like to use lights so that you don't know I've used lights. So that they just make it possible for the image to be put down on film.

*Talking about you, somebody said, "Henry does all these complicated setups." But that's often not what you do at all. What you set up with Oliver North couldn't be simpler—or the year before at Caroline Kennedy's wedding in Centerville, Massachusetts.*

The toughest thing about the Kennedy picture was getting into the proper position, because when you're competing with the paparazzi, who make their living photographing celebrities, they'll kill you. They will kill you. They were in position days before. I thought eight o'clock was early enough to come to photograph a wedding that's going to happen at four o'clock in the afternoon, but there was a veritable wall of photographers with all their long lenses.

So I walked right in front of them with my tripod and this big camera, and I said, "I think I'll work right from here." First they got all excited, a number of them did, and then they realized that I was kidding. I said, "No, I'll work on the end—on the far end." Actually, being on the end with a view camera worked out, because they had the wedding car in front of them and I didn't.

I shot the couple as they came out. The idea was to give the viewer a sense of place, to show the wedding and the church. All the paparazzi cared about was

Colonel Oliver North. Virginia. 1987   *A quote a reporter would die for.*

Eclipse. Winnipeg, Canada. 1979   *I tried to unjam it, but it was stuck.*

zeroing in on the celebrities. I used a 5x7 inch camera because you get super quality. With the lens shifts, the picture has the integrity of being square-on, although you're on the side.[*] And even though the viewer might not realize it, he is affected by looking at that architecturally correct photograph.

*Your photograph of an eclipse of the sun in 1979 also appears to be simple.*

Someone looks at the eclipse picture, and they think, "All he did was just go *click, click, click, click.*" But what happened first was that I had to find a place to shoot the eclipse over the city of Winnipeg in Canada. I was right on the edge of a flat roof. Then, because I wanted to show the sun's progress across the sky in a multiple exposure, I had to compute the exact time of totality over the city. I started my exposures more than an hour before the eclipse. I had a whole script drawn up. You know, cross off exposure #1. Nine minutes later, click. Exposure #2. It was Winnipeg in January, so it was very cold up there. I exposed the sun every nine minutes to allow equal space between each image. I needed heavy neutral density filters[**] because the sun remains bright even in partial eclipse. It's only when it goes into full eclipse that I could take off the filters. I made this series through the beginning of totality.

Then I had already set up my primary camera to make a dramatic picture of the city at the moment of totality. I was going to shoot as many pictures as I could while the sun was hidden. I had all my holders ready to go. There are a lot of mysterious happenings attached to eclipses. In this case, the eclipse began, and I started shooting with the primary camera, but the shutter didn't sound right. I ran around to the front of the camera, and I tried to unjam it, but it was stuck.

I thought, "Hell, I'll jettison the multiple-exposure idea and start running film through the other camera." Then I thought, "No, I'm not going to touch that camera." I was still fiddling with the shutter when, all of a sudden, it starts getting light. The eclipse is over. As soon as it got light, the shutter worked, and it has worked ever since.

I got back to New York. I didn't know what I had. The one camera jammed, but I had two pieces of film from it. If there is anything on them, it would be a good exposure test for processing the rest. I process one piece of film; it's blank. I process the next piece; it's blank. I have the one piece of film from the secondary camera left. I say, "It probably needs a tiny bit of a push in the development, maybe a half a stop. That can't hurt it." I put it through, and there it was.

*Are there any pictures you've missed completely?*

I had always believed, "If you can see it, you can photograph it." But I missed

---

[*] The lens of a view camera can be shifted up or down (and right or left) to avoid tilting (or turning) the camera. This allows the film to stay parallel to the façade of a building so the building's parallel lines remain parallel in the picture.

[**] Neutral density filters cut down the light reaching the film but do not change its color.

a picture of a laser being shot to the moon from Texas. I went out to this observatory, and they were making a test the night before. There's this green beam going right up to the moon. It is as clear as can be. I said, "Wow, a piece of cake."

The astronauts who went to the moon had set up a mirror. This laser was going to hit that mirror and come back to earth. I lit the observatory with one little tiny spotlight, and I made a very long exposure. The next night, they were going to do the real thing, but, luckily for me, clouds came in and the whole thing was scrubbed.

Still, I had the photograph of the test developed. Nothing showed up. There was no laser. Then I spoke to scientists, and they said, "We've had that problem too." The brain reads it, but the film can't. On film it's making an exposure of a millionth of a second, which is much too short. Each pulse is too faint to register. The brain will interpret it—there's a persistence of memory or whatever.

*Do you find yourself talking to scientists often?*

If I can find somebody who's in the field and has done some photography, then I will ask them what they think. But it was a post mortem in the laser situation. They said, "The only way you can do it is if you get your camera right behind the beam and look straight up it. Then you're looking up the column of light, not across it." I would have pursued that if they were going to do the experiment later. But they couldn't do it because the positions of the earth and the moon had changed.

*What do you think your most American picture is?*

It might be the picture of everybody who works at Disney World. At Disney World everything throughout the whole park is on a P.A. system. When I first set the picture up, I realized that I really needed everyone closer to the camera. So on the microphone I said, "Would you take one giant step forward."

*How many people are you talking to?*

Thousands. They all moved forward in unison. It was incredible. I thought, "My God, let me do that again." I had them move up a little bit more.

*What makes a good photographer?*

Hard work and preparation. Simple as that. I try to cover all of the options that might happen, and I try to make a picture that's kind of fun. And, also, I would like to try to make every photograph a photograph that you'd like to hang up on the wall.

*In your house?*

I have only a few.

On the *Life staff* 1965-72
Interviewed in New York City on October 20, 1993

# Violent is not the word

Snow monkey. Japan. 1969

# CO
# RENTMEESTER

CO RENTMEESTER: I was wounded during the first week of the Tet offensive. I got shot in a French cemetery near Tan Son Nhut airport in Saigon. We were taking fire, and I was to the side of a ditch, lying on my stomach. I thought I was safe. Suddenly machine-gun fire was coming down the center of the ditch, which meant that somebody was shooting straight down it, not across it. In a split second, trying to figure out how the rounds were hitting in front of me, it was too late. I pushed myself up with both my hands, and while I pushed myself up, the camera with a 200-millimeter lens was out to the side a little bit. One round came through the lens and through my hand. I got out of there very fast. I ran over to a wall and jumped over it. I found some South Vietnamese soldiers on the other side, looking through little peepholes and not doing anything. I ran another 100 yards back and ran into John Olson, a young *Stars and Stripes* photographer who had also come to the scene. He took my cameras, and then I ran into Don Moser, *Life's* Saigon bureau chief, another 100 yards further back, and that's where they started to patch me up with some bandages.

I went to the hospital and had serious hand surgery. The tendons had to be replaced, and pins had to be put in. I had what is called an abdomen-flap transferal of tissue. I was stabilized in Saigon; then *Life* flew me back to Los Angeles, where at that time there was the best hand surgeon in the country.

I had also picked up malaria in Laos doing a story, so I was hit with malaria while I was in the hospital. It became a miserable six months. The mobility of my hand was established at about 60%. I lost 40%. I cannot roll my thumb. If I focus, I have to do it with my wrist.

Veterans hospital.
New York City. 1970
*I was pushing a paraplegic
around in another wheelchair.
In his lap he had my cameras.*

5/22/70

Farm auction. 1971   *I was just sort of trembling, getting it on film.*

6/25/71

*John Loengard: Did you think you could keep on taking pictures?*

There was an enormous anxiety. I had, at that time, marital problems, and I was in the hospital and getting these malaria attacks. It was all sort of miserable. I was extremely concerned whether I could just handle a camera again. I had a call from Richard O. Pollard, the director of photography. Dick asked me, "Co, when you get out of the hospital, why don't you take a sabbatical for a year and a half? We'll take care of your financial needs. Go to U.C.L.A. We'll take care of the costs. Go and take some film courses in motion pictures."

I was stunned. I thought, "Am I being put on the sideline?" I was suspicious. I said to him, "Let me think about that." Of course, motion pictures had become very much of an interest to me, but somehow I felt I had to really prove the fact that I could work again. I called him back and said, "Dick, thank you very much, but I want to go back to Hong Kong as soon as I can, assuming you can assign me to something that is not involved with the war."

He sent me back in April of 1969. I started to work on a completely different line of photography. I did a major essay on Java, Indonesia. And then Bali followed. And then I did the period in which I suddenly became a wildlife photographer. I did the orangutans in Malaysia. I did the snow monkeys in Japan, and polar bears. Then I went to sports photography.

*Did being Dutch have a certain resonance in Java?*

Sure. It was a colony of Holland for 368 years, and the top Javanese in Sumatra and the top Balinese in Bali were educated in Dutch universities. Their generals and colonels were all trained by the Dutch. To them it was a matter of pride to be bilingual. Even during the Sukarno years, when there was an anti-Western environment, he and I would talk in Dutch with each other. We had a great time together. I love Indonesia. It's a magnificent country. I still think of it as one of the most glorious places in Southeast Asia. It consists of about 2,000 islands over 4,000 miles. I think it's beautiful.

*In the story on Bali, you're looking down on a huge group of people who are praying?*

No, it is a play, the *Ramayana*, a sort of counterpoint to Greek mythology. Fifty to 60 young men will play the monkey dances. They sit in circular rows and at certain moments hiss like monkeys in stress or in anger. When you hear 60 people hiss or bark like a monkey, in a disciplined chorus, it's a wonderful effect. All this was happening amid smoky flames in the jungle, and the smell of hibiscus is everywhere. It is spooky but terribly romantic and very beautiful. I took the liberty of emphasizing this. I increased that monkey group from 60 to about 300 by hiring five groups to perform. This mass of 600 arms would shoot up in the air, and their fingers would flutter like butterflies, and then the chorus voice would thunder over the jungle area. It was very dramatic, and it made a beautiful picture. It ran as a double page in *Life*.

*Did you point out to the editors at the time that you'd hired extra groups?*

No, I never did. I felt it was visually O.K. I didn't change the dance. It is just bigger.

*What do you do when you come to a place and you want to take a picture and you don't see one?*

Why would you be there in the first place? If one goes professionally to a certain area, you have some notion of what you're going after.

*You did a story on a dying small town. There was nothing much there.*

No, there wasn't. But, for instance, this old man and his wife had not done very well with their farmland. They had hocked themselves into tremendous debt with the local bank for machinery and so forth. The land looked beautiful, but they couldn't make it, and that place was foreclosed, and that's what the story was about. Her family had owned the house, and she was raised in the same crib that was still in her childhood bedroom upstairs. This little crib on this wooden old floor became a tremendously powerful little symbol. I was just sort of trembling, getting it on film.

The land was tilled, but nothing had been seeded. It had a starkness to it, a death to it. I had this man with this dog walk on a long ridge over an abandoned wheat field where there was nothing. Tiny little figures, and this tilled earth surrounding, and then a white sky behind. It was extremely graphic, and it told the story.

*When you're working on a story, do you make a list of pictures that you want to take?*

In most cases, I have to make very quick decisions when I get on location. I illustrate in my own mind how I want to capture certain things to tell a story. I think through what I believe is the essence of what I'm hoping to do. Then you have these small elements to build on. That was the case with the farm.

*The story on the veterans hospital was also graphically strong.*

That was a whole different thing. We were the first ones to really go into a veterans hospital full of wounded from Vietnam, in the Bronx, New York. We had heard from people that the hospital was in dreadful disarray, that people were zonked out on tranquilizers in order to keep them quiet.

In order to prove that, we had to go in there in a surreptitious way, which always has a big question mark to it. Basically a veterans hospital is a public place. I should present myself as a *Life* photographer and try to do the best I can. I should go to the administrator of that hospital and say, "We have heard this. Would you mind showing us around?"

But we made a decision. I let my beard grow for three days or so, and I took a couple of little Leicas, which are quiet cameras, and I was pushing a paraplegic around in a wheelchair. In his lap he had my cameras. For days I pushed this little wheelchair around, and when I saw something, I would grab under the towel where his hands were. I would grab a camera and snap a couple of snaps and put the camera back under his towel.

It became an enormous story that aroused the entire country. The administration at that time accused *Life* magazine, and me personally, of fabricating a

story. There was nothing fabricated. We had not announced that I was working there—that is true. But no photograph was created or manipulated.

I was asked even by fellow newsmen, "Didn't you fool around a little bit with these pictures?" And it would just drive me insane. I would get furious, trying to deny it. Anyway, the story then finally subsided, and about a year later I had the greatest satisfaction. They ripped the whole ward down where the paraplegics were housed with feces and urine on the floor, and guys just sitting there or lying in bed staring out into nowhere, zonked out on tranquilizers. They put $12 million into cleaning it all up. Very quietly. I felt that somehow I had a little part in that.

*Did you photograph any Kennedys?*

I did Ted Kennedy for a cover in 1980, but I had been asked in the past by *Life* magazine, "Would you be interested to cover a convention or political story?" That was one of the few times that I said no. I don't like politicians. In fact, I despise them, and I'm afraid that somehow this would come through in my photography.

*But you were willing to do Kennedy?*

They had to get somebody out there, and so I did it. It was not such a bad experience, after all. I must admit that. But I do recall the Nixon thing. His daughter Patricia married this kid from the Cox family. The atmosphere around the White House—the guys standing there, and the Secret Service, and the top officers of the press room. They were looking at the press surrounding them. They gazed down at you like you were some kind of rabble in the street.

I had a very funny feeling, and I told Dick Pollard that I will never do it again, because I had the feeling that when I was standing there in the White House, and these guys were trotting around me, with their suits on and their little American flags, the only thing that was really missing was the swastikas on their armbands.

They had this superior look, and it reminded me of when I was a little kid, when the Germans were walking through the streets of Amsterdam, and I felt there was this guy looking down, and it made me angry. I decided this is not for me. That's why I never did it.

*Your mother died during the Occupation. Did she die as a result of the Occupation?*

Yes, indirectly. My mother died when she was very young, when I was a little kid, in 1943. She died of pneumonia. We couldn't get medicine and all this other stuff. It was very difficult.

I'm born in 1936. I'm 57 now. I was raised in Holland. I went to school and college there, and had to serve in the Dutch army. My father was a violinist. A very serious one. A very good one. He had his own ensemble for chamber music, and he played in the very top restaurants in Amsterdam. He played for the Dutch Radio.

Mostly, my youth was preoccupied with two things. One was race rowing.

The single sculls and double sculls. I rowed for Holland at the Olympics in Rome in 1960. We were fourth in the finals and missed a medal by half a second.

The other hobby was photography, which I was doing since I was 11. My father was a fanatic dry-fly fisherman. He took me on these trips, and I had this old 1936 Rolleiflex. That little thing was like a jewel to me. I was always playing with it. While we were fishing, I took my first pictures.

After the 1960 Olympics, I was invited by some American rowing friends to come to the United States and pursue a career in the lumber business. While I was there, I was approached by the University of Washington to row in the Tokyo Olympics for the United States with Jack Kelly and Bill Knecht, whom I had beaten in Rome in double sculls. But I decided not. The lumber business discouraged me. I made up my mind that if I made $500 a week or $50 a week or $5,000 a week, it didn't make any difference. I was going to do something that I really liked. And I liked photography. I applied to the Art Center School in Los Angeles, and they accepted me.

I had to support myself with part-time work. In the beginning I was a gas station attendant, and then I worked as an assistant to another photographer, and then I started to shoot little publicity pictures for Bethlehem Steel. Finally, I was introduced to people at the Time Inc. bureau in Beverly Hills. I got little assignments from *Time* magazine. I did my first *Life* story on rubella—German measles. *Life* asked me to do one picture, but the story developed itself rather dramatically, so it ended up being, while I was still in school, eight pages and a cover. That was a hell of a good start.

Two weeks after I graduated, I walked into the office, still very much in the European fashion, with a tie and a shirt and a jacket and so forth, and they asked me if I was interested in covering the riot that had just started in Watts. I sort of hesitated. I said, "I'm not really dressed for that."

Don Moser, the bureau chief, said, "No hard feelings if you prefer not to go."

I said, "No, I'll go." I picked up a rental car because I didn't want to use my own car going in there. I had one of those hard hats from my old Bethlehem Steel client that I put on. And I had a pair of shatterproof glasses that I put on my nose, and that's how I drove in, just to look around. I had heard on the radio that all the press had gathered in some police station on Imperial Avenue. But if I was going to sit there with 200 other guys from the networks and magazines, I wasn't going to get anything special.

So I got some cameras ready next to me in the seat and drove in cold. Buildings were going up in flames. Looting was taking place right in front of me, and I was shooting it and taking the exposed film and putting it in my socks because I had a tremendous apprehension that somehow I was going to get into trouble here.

*What did you have on film?*

It showed the wounded. The shooting. The fires. The looting. The anger.

Especially anger. I was confronted all the time by African Americans who raged at me. I would thicken my Dutch accent to show I was not an American. But sometimes the most dangerous situations occurred when I was confronted. One guy had a knife and wanted to stick me. Another black guy said, "Absolutely not." While this conversation was raging between the two guys, whether they were going to stick me or not, a bunch of firemen working about 100 yards away with some cops noticed that I had ended up in this commotion. They dropped their hoses and came storming out to the group and rescued me. There were some very tough moments.

After many, many hours working nonstop, I got on the phone and called the office. They were worried because they hadn't heard from me. I said, "I got the film. It is now a matter of just getting it out."

They sent in a black driver with a van, and we met at a gas station, and I exchanged exposed film for fresh film. I kept on going with a couple of other people for the next two days. And the upshot was I had completely exclusive film. *Life* ran it for 13 pages and a cover.

*Were you there because you felt an ambition to do something for* Life*?*

I was ready to charge. I was burning with energy. I had to really prove my point. I came out of school. I had won some races in rowing, and I was going to do the same goddamned thing with my photography. That is basically the start: a lot of energy still trying to find a discipline to direct it to. I was aware that this was a great opportunity. Whether I had any great sympathy in the political or racial issue, that was not really a question in my mind. I looked at that as a professional thing. I was really astounded by my black colleagues, African Americans, who resented that I was out there working—in the sense that that was their turf. I had to walk away from some very angry words.

After I was wounded in Vietnam, I guess maybe Dick Pollard was trying to think of what he could send me to do for my first story after coming out of the hospital. I did the orangutans in Borneo. At that time I had trouble, because little silver pins were working out of the bones of my thumb. They would just come out, and I had to pull these little silver rods out while I was in a jungle. [*Laughs*] It was not so funny, but I couldn't work otherwise. My thumb was all swollen.

One day I walked down this little jungle path and came around a turn, and here in the middle sits a 400-pound female orangutan on the ground. Huge. I was stunned. I had never been confronted with such a big animal in the wild. I stopped in my tracks. I started to slowly back up, and she wobbled over to me, and she grabbed my left hand, the wounded hand, and she drew my whole arm and hand to her mouth, with such persistent force—not violent, but persistent strong force—that somehow I felt if I start to fight it, I will panic her, or something will go wrong.

So I reluctantly let her do what she had in mind. She pulled my hand, which had very clearly a visible scar of the transplant of the skin, and she took it to her

mouth, and she sort of felt it with her lips. An orangutan has these soft, long lips. She sort of touched the skin like this, and she kept looking at me, and then she let my hand go. She just sort of looked at me like, "You poor bastard. Did it hurt?"

*You seem to have a certain empathy for apes and monkeys.*

I love the orangutans because somehow they're far more sympathetic and human in a way, and softer. The snow monkey is an unusual offshoot of the rhesus monkey. They are more aggressive and more—violent is not the word. But you have to watch out because you can really be bitten. They exist in the snowy mountains. They're in an area of natural hot springs and geysers. They keep warming themselves on hot rocks. You have a fluffy, silvery-gray monkey with a reddish face sitting in the brilliantly white snow in a natural steam bath. You can imagine that that is so startling and enchanting that it would make a wonderful story, which it did. It's still the most popular story I ever did. Pat Hunt, who was the editor in charge of all the wildlife stories at *Life* magazine, also asked me to go up to the Hudson Bay area to see if I could do some kind of a major picture on polar bears. What she asked me to do was—I remember the quote: "I'd like to see 12 polar bears, just coming at you."

I won't repeat what I thought, but I said, "Twelve bears is a tall order."

I went up to Churchill, Manitoba, which is a little town on the Hudson Bay and started to talk. It was 40 below. It was *unbelievably* cold. I tried to figure out what and how we were going to do it.

I found this helicopter guy. He said, "There's a patch out there where snow has been blown off." We were talking about baiting, since the polar bear can smell seals, for instance, from 25 miles away. Their sense of smell is that keen. But their eyesight is rather terrible.

I got myself a couple of gallons of sardine oil and cans of sardines. One day the weather cleared, and I plunked down all this oil around this mossy little area where the wind had blown away the ice and snow. It was as big as a very large room.

Then we took off, and lost five days because the weather was stormy. Finally, there was a beautiful day. We eagerly climbed into the helicopter to fly out to this little spot. From a distance, I could see these six fluffy rear ends running away from the helicopter.

Of course, each of these fluffy rear ends represented maybe a thousand pounds of polar bear. I suggested he put me down on the grassy knoll with the Canadian wildlife guy, who was with us with a rifle. Then the helicopter could take off and chase the bears back toward the camera.

We were going to be downwind, so they will not smell us. I said to the helicopter pilot, "Make sure that when they come within 100 yards, that you cut them off." The helicopter takes off, and I can see from its position that the bears had already moved miles away. So we just waited and waited, and I see the helicopter working back and forth and getting slowly bigger and bigger and bigger, and I see that he has only four bears, and he's slowly just working those bears

The *Ramayana*. Bali. 1968
*This mass of 600 arms would shoot up in the air, and their fingers would flutter like butterflies,
and then the chorus voice would thunder over the jungle.*

Polar bears. Hudson Bay, Canada. 1969
*I won't repeat what I thought, but I said, "Twelve bears is a tall order."*

closer and closer and closer, and he lost again another bear. Then, within about 250 yards, the bears became a little bigger in the camera, but it's still not good enough.

Then the bears came closer and closer. Now there were only two. Suddenly, then, within 100 yards, the bears were there. I took some pictures. Very quietly. Not using the motor drive because I was still concerned about sound. Sound and smell is what they get immediately. It's very dangerous with them. I was just stopping. I looked at the wildlife guy, who was standing right behind me because we wanted to be one little compact kind of a thing there. The bears would not see us in that way.

Then, by some fluke, the bears made a 90° angle. They were trotting, and they were out of breath because of all the chasing by the helicopter. They came toward the camera, and I just sort of slowly ducked my head down, and they were at 50 yards, and I didn't dare to fire the shutter at that distance.

The helicopter pilot had somehow lost the aspect of the wind. In order to make a 180° turn, he has to fly into the wind. You cannot fly out of the wind in order to make a turn. It's a matter of aerodynamics. He was caught in the worst way possible. But we didn't know that. It was panicsville right there. The Canadian wildlife guy, who had had polio as a child, walked with a limp. He took this one little step back, in order to get a field of fire, and the bears, both of them standing on their rear ends, their legs, just up in the air for just a split second, looking at us, and then kind of storming to us.

My first reaction was just panic. I turned around and tried to run in the snow, and I fell within about five yards. I fell flat on my stomach in the snow. I just thought, that's it, and I looked over my shoulder, and here I see this—I see the Canadian wildlife guy. He had the high-powered rifle, and he shot the first bear from about 40 feet. He shoots it through the chest. The huge 900-pound animal, because of its enormous momentum, kept on rumbling through, but started to stumble. He fired again and hit it from 15 feet away. And the bear went down.

*Had the bears suddenly got wind of you?*

No, they saw some motion.

*And they stood up?*

That's the first reaction. They stand on their rear legs, and when they stand up on their hind legs, they are 12 feet high.

*And you didn't take a picture?*

[*Laughs*] Everybody has asked me that. No, I didn't. I knew that was panicsville right there, and I'm not that good.

By that time, the second bear had come in on a 30° angle to his right of him, and he was about as far away as from you to me, about 10 feet. The third round he fired from the hip and hit the bear in the chest, and knocked it right back because of the high-powered rifle.

The world stood still—my mind stopped—and then we both stood there. It

was 60 seconds before we said anything. By that time, the helicopter pilot had landed, absolutely in total panic, and apologizing profusely and saying, "I would have landed on top of you. I would never have let this happen." Blah-blah-blah.

We trembled like leaves, standing there, and those magnificent animals bleeding to death. We shot them through the head immediately and killed them off, so that there was no suffering.

*Was that as scared as you've ever been?*

The word scared did not even—it was complete, total acceptance. I was just waiting the split second before my spine would be snapped. Because of the winter gear and boots, you're already so awkward. I had fallen in deep snow; and only just sort of looking over my shoulder, I saw this whole scene take place just about five yards behind me, in which this man stumbling on his bad leg was fighting off these two bears. This was the most heroic, unbelievable scene that I've ever seen in my life.

On the *Life* staff 1966-72
Interviewed in New York City on May 19, 1993

# The pig was
# overwhelmingly cooperative.
# What are you suggesting?

Arnold. Los Angeles. 1970

# VERNON MERRITT

**V**ERNON MERRITT: I studied journalism at the University of Alabama, but photojournalism was more to my liking, so I left in my senior year to go to the Art Center School in Los Angeles and finished just when the riots in Birmingham were under way in 1963.

I came to *Life* magazine without my mother's enthusiasm. Well, that may be somewhat of an exaggeration, but I would say the statement would apply to my father. For much of his life, he was frustrated by what I did and for whom I did it.

In Tuskegee there'd been an order that the schools were to be integrated. They closed the schools for a long time, and then it was decided black students would be bused 15 miles to an adjoining town. I sneaked on the bus to ride along with them on the first day. When we got there, Sheriff Jim Clark came onboard. I had a couple of Nikons around my neck, and he snatched them off and whacked me with a cattle prod. I was shocked a few times and hit a couple of times and then thrown out on the street. I wound up in jail.

My father had to come get me and take me back to Montgomery, where my car was. I think that created a sort of a public thing with Governor George Wallace. My father had been secretary of state of Alabama in the 1950s, and although my father was not a Wallace man, it was still a political strain for him. He felt it reflected on him in a way that was uncomfortable at times, that his son was working for people like *Newsweek* and the *Saturday Evening Post* and, when God was especially good, for *Life*.

Of course, I was trying to bring myself to *Life's* attention. I tried to be as energetic as possible, letting them know that I was alive out there. When James Meredith began his march from Memphis down through Mississippi, *Life* wasn't

sure it was going to be very interesting, so I decided to go on my own. When he got shot, it certainly became a story.

After Meredith, I went to Vietnam as a free-lance and was wounded. I had been working with Co Rentmeester that particular week. Co was working for *Life*, and I was doing something for *Newsweek* on the First Division, which was based in a Michelin rubber plantation. They expected contact with Viet Cong that never developed, so I said, "I'm going to go back to Saigon and get some rest." I landed at Tan Son Nhut air base and was headed for a taxi when I just could not continue. Something forced me to get on a little light cargo plane and go back. Coming in on that plane, I was shot through the coccyx, at the base of the spine. They thought that I might be paraplegic, but that was the consequence of swelling around the nerve sheath. I was quite fortunate.

*John Loengard: Being a free-lance photographer, who took care of you?*

Who paid the bills for the hospitalization? I assume *Newsweek* did. I was on assignment for them. In any case, for the time I spent in military hospitals, the all-inclusive charge was $50 a day. That included surgeons' fees and transportation and an ambulance airplane back from Vietnam to California. So the costs weren't significant, whoever had to bear them. I think it took 17 weeks in recuperation of one kind or another until I was able to ambulate with cameras on my shoulder.

*Did you feel—I've asked this of many people—that it is worth dying for a picture?*

Probably not, but in those days we were children. For an immature young man who imagined, at 25, that his presence in Vietnam was going to expose him to photographic opportunities—well, at the time, risks weren't measured very carefully. Looking back, I think, "God, what ill-considered things I did."

I never went back. There were other opportunities to cover warlike activities, but I was never drawn to it after that—well, that's actually not quite true. I went later to West Africa when the eastern part of Nigeria seceded, but it hadn't developed into full-blown warfare. I recognized at the time that my luck wasn't shaped in a fashion that made that kind of activity very intelligent for me.

*So you were back at work, and joined* Life's *staff in 1968 and took a picture of a pig.*

Yes, I did. I was working for *Life* on staff out in Los Angeles. The pig was O.K. It was kind of fun to do. What are you suggesting?

*I remember seeing it taped up on countless refrigerator doors. Do you think your Alabama, maybe slightly rural, background gave you—*

That special understanding of [*laughs*] the porcine nature? It could have been. It could have been. That pig played Arnold on *Green Acres*. We rented him, and he came with his handler, and the pig would do anything you wanted the pig to do. The handler would click one of those little clickers, and every time he did, he'd give the pig a little something to eat. The pig was overwhelmingly cooperative.

I also photographed a couple of the moon shots. We would go down to the

cape and be with the wives. We'd be in their living rooms, and the yard would be full of all the other journalists, who despised us thoroughly for having what they felt was an unfair advantage. We waited for what might happen, and the wives knew it. I was with Jan Armstrong when her husband lifted off. I was photographing her from behind as the rocket headed up and this huge spume of smoke appeared. It was natural, but I imagined, "Jesus, this thing is coming to pieces!" You had those thoughts in your mind.

*Was there ever a time when you could have taken a picture but you decided not to?*

I suppose that in all those funerals and terrible things that we photographed in the South, there must have been such occasions. I'm thinking of the Chaney funeral, where we were huddled like beasts in front of that poor woman and that little boy. They were sitting there just crying as though they were alone. I remember at Dr. Martin Luther King's funeral, it was horrifying how we behaved. There was Mrs. King and the children, and we were separated from them by only a gravestone or two, and people are clambering up on gravestones to get special angles. But at the same time, you told yourself that the image you might make was so compelling that it warranted that kind of behavior.

*Was your photograph in the graveyard used?*

I think Harry Benson's ran, and Harry was on the highest gravestone. [*Laughs*]

*How did you feel when* Life *stopped publishing weekly?*

It left me not knowing what in photography was left to be interested in. I had little interest in going back and trying to grind pictures out on two-day assignments here and there. Plus, I was interested in trying to start a magazine, so I just shot off in a different direction. I started a little magazine about horses called *Equus* that I would wind up selling to the American Heritage Publishing Co. Now when I look at *Life*, I look for Co Rentmeester's work and Harry Benson's and wonder what it must be like nowadays to be a photographer. It's probably harder. There's less of an opportunity for self-indulgence than there used to be. I'm glad that I had the experience I did, when I did. I'm fortunate. I have a little publishing company. We do books and magazines for doctors and special projects for pharmaceutical companies. It's not the be-all and end-all in the way that photography once was for me, but it's an engaging and pleasant activity that gives me an opportunity to ride around on a sailboat and do other things.

*Did you consider yourself what Cornell Capa calls a "concerned photographer"?*

I felt the work I was doing in the civil rights movement (and to a lesser degree in Vietnam) had value. I was telling stories that maybe people weren't getting fully in other ways. That was a remarkable period of being able to get involved in things that you cared about, where the heart might be engaged in a substantial way. I did feel it was important for me to be there.

On the staff of *Life* 1968-72
Interviewed in New York City on October 27, 1993

No form of photography can do a
battle like that justice. We can't bring
home 100% of what it feels like

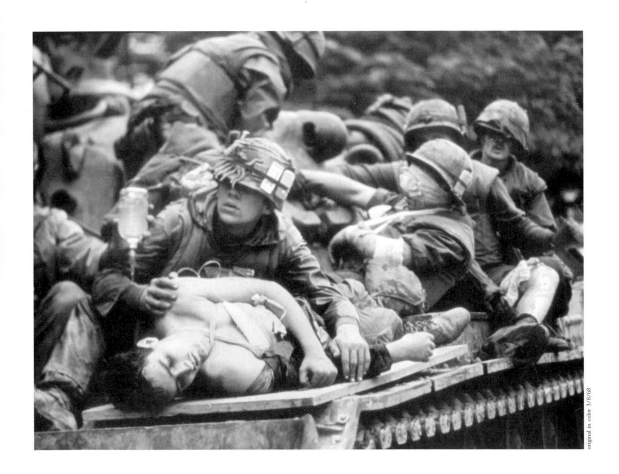

original in color 3/8/68

Evacuation of Marines. Hué, Vietnam. 1968

# JOHN OLSON

**J**OHN OLSON: From the age of 10, I wanted to be a photographer. My father was a farmer, and when he passed away, he was still mystified that you took this little box out and pushed a button and a week later, from the drugstore, these images came back. My mother's father was in advertising and took photographs. That wasn't my inspiration, but I think that that's where the gift came from.

By the time I was 18, I was free-lancing for the Minneapolis *Star and Tribune*. I was determined that I'd be on the staff of *Life* magazine by the time I was 25. My father said I really had to go to college to make anything of myself. This was difficult because I was a horrible high school student. I lasted six weeks at the University of Minnesota. I was up all night photographing some event I don't remember, and I slept through all my exams. So my education was over, and I moved to New York. I got a job in the mailroom at United Press International. I wanted to go to Vietnam for UPI, but before that could happen, I was drafted. I went there in the infantry, but when I arrived, I got myself transferred to *Stars and Stripes*, the daily newspaper that the Department of Defense put out for the military. I had to extend my time in Vietnam to get the transfer.

There were four reporters and myself. If I had really wanted to avoid the war and eat well at night in Saigon, I could certainly do that. But I wanted to go out and make pictures and make my mark. The reporters made a deal with me: I could go anyplace I wanted as long as they didn't have to come along.

The photographs I took could be shared with the wire services and the other publications. Everyone felt that it would be a real feather in the cap to have the New York *Times,* or the Associated Press, or someone else, credit *Stars and Stripes* for pictures.

I shot photographs the day the Tet offensive started in February 1968, and *Time* magazine ran one. Then I went into the Battle of Hué, where the Marines participated in their first street fighting of the war. They took horrendous casualties. I'd been in Vietnam over a year. I'd been in a lot of combat, and I felt pretty experienced. I realized it was a tough battle and that the casualties were very large. There was little of the artillery and air support that we were accustomed to. The weather in Hué was very rainy and overcast, so the Marines were using any means they could to evacuate their wounded and their dead. One tank had been turned into this ambulance. I remember the scene, but I don't remember the exact moment of making that frame. I had no idea what impact the picture would have. It didn't strike me as something that would be published hundreds of times. In fact, when I first saw the article in *Life*, I was underwhelmed. No form of photography can do a battle like that justice. No matter how good we are at our jobs, we can't bring home 100% of what it feels like to be in a situation like that.

*John Loengard: What's missing?*

[*Pause*] The reality that you may be the next to die.

After the Hué story came out, a number of congratulatory cables came to the bureau. They were followed shortly by a number of cables from the Department of Defense asking why a military-affiliated publication was providing pictures to the public of Americans dying?

I went from being a hero to being threatened with court-martial. A week after the battle, *Life* asked me if I could go under contract. I had to explain that I'd love to, but I still had certain obligations—for another three months—to my current employer. When I came back to the United States and was discharged, I went under contract to *Life* and went back to Vietnam for the magazine. In January 1969 I went on an amphibious assault operation with the Marines near the DMZ. There wasn't any hostility when we hit the beach. But riding on top of a tank, I had a real bad feeling about it. I said to myself, "I've got to get out of here." I went back to Saigon.

The next day everybody in that tank I had been riding on died in a rocket attack. I told the bureau chief that I'd had enough. That was it.

I look back at Vietnam as the most exciting thing that I'd ever been involved in. Of course, I came back with all my limbs intact, and a potentially great career ahead of me. So it's easy for me to say. I did go back on two occasions, for brief periods of time. But I never felt the pull that a lot of people did. Most of those who had that pull died.

*What kind of pull?*

Vietnam was extremely addictive to a lot of people. They found that anything else was very boring. I can name a number of them, and most of them are dead:

Dana Stone, Kyoichi Sawada, Sean Flynn, Larry Burrows, Henri Huet. The list goes on.

I have a lot of respect for those people who were there. They were gambling with the most significant thing they had to gamble. When I went to Vietnam, there were 20 of us who were not there as adventurers but went out on a daily basis to make images. We all knew who was real and who wasn't.

*Did you feel that you were gambling with your life?*

I felt pretty invincible.

*What did you do when you came back to the United States?*

One of the first assignments I had was to photograph life in an Oregon commune. The juxtaposition of those two subjects was like night and day.

*Which was night? Which was day?*

I don't know. The wonderful thing about being a journalist is that you don't really have to take a side. You can just record. It was hard to be in Vietnam and not be supportive of the G.I.s. But I didn't take any strong position on the peace movement. I was an observer and a recorder during my time as a journalist. That's how I moved about.

*Without coming in emotional contact with the subject?*

Without having to decide what's right and what's wrong. Leaving that to a third party.

*What were you looking for when you took pictures?*

The moment. Putting on film an honest representation of what the particular issue was. In the commune a number of adults had chosen a lifestyle, and what I did is record what that lifestyle was.

*You photographed a couple reading to their children. Is that something that just happened?*

To expose the film correctly, I put a strobe light into the tent in such a way that the picture looked as if it were lit by a little fire they had there. I had to use lights, but the lighting wasn't something that I did because it would look good. There's always a risk in the process of putting something on film that the photographic event becomes the main event, and the subjects act differently than they would if the process of taking the picture weren't noticed. The ideal photographer is an invisible man.

But part of the responsibility of the photographer is to go out and to make some determinations of what the key issues are and to put them on film. In this case there was the fact of these parents having to teach their children because they weren't sending them to school. But there are a number of other things in that photograph as well. They all look unkempt. I'm sure it was an extremely shocking image for the "silent majority" to see.

When I went to work at *Life* at the age of 21, I was the youngest photographer on the staff (by many years), so I got all the drug stories. All the dissidents stories. All the rock-'n'-roll stories. Rock stars were horrible assignments. They

Oregon commune. 1969
*The juxtaposition was
like night and day.*

original in color 7/18/69

The Jacksons.
Encino, Calif. 1971
*A wonderful little family that
looked as if they were all having
a great old time together.*

original in color 9/24/71

Frank Zappa
and parents.
Los Angeles. 1971
*They wanted
to act like
human beings
in front of
their parents.*

original in color 9/24/71

had a negative attitude about the whole process, and it was something I really didn't look forward to.

But the story on rock stars with their parents was a natural. A number of the same stars I'd found very distasteful and uncooperative were very cooperative around their parents. They were all scared of them—or at least wanted to act like human beings—in front of their parents.

Frank Zappa arrived at his home at nine o'clock in the morning, and no rock star gets up at nine o'clock in the morning. Not only was he up, he was polite. He was professional. Still, the assignment took 13 months to do. The first person we shot was Grace Slick in her parents' home in Southern California. Her father was a banker, and he wouldn't pose with her. She was eight months pregnant, and by the time we'd finished the story, she had a 10-month-old child. So we went back and photographed her again. Michael Jackson was this little elf. The Jackson Five was a wonderful little family that looked as if they were all having a great old time together. I shot Eric Clapton at his grandmother's house. I got there before Eric arrived. His grandmother had a parrot. I looked in the cage, and the parrot looked at me and said, "Fuck you."

I brought my assistant over, and I said, "Listen to this."

The parrot said, "Fuck you."

A few minutes later, Clapton's grandmother came back into the room, and I said, "What's the parrot saying?"

"He's saying, 'Gobble-gobble,' " she said.

She left, and the parrot said, "Fuck you," again.

An hour later, Eric came. I walked him over to the parrot and said, "What's that parrot saying?"

"I know, I know," he said. "Bonnie and Delaney stayed here for a month, and they taught him that, but my grandmother won't admit it."

When I came to *Life*, I really came as just a candid photojournalist. After I got to *Life*, I had the opportunity to start to develop other skills. And that was an ongoing process that, in fact, is still evolving. I wasn't on the staff a long time. I felt I needed to move on. I've spent 20 years being in business for myself. There have been ups and downs, but I would never want to have worked for anyone but myself. I do a lot of corporate photography. It's very commercial, but it allows me to draw from a number of different areas that I've worked in. Now I'm content. And not until recently have I ever been content in my career. Is that getting old?

On the *Life* staff 1969-71
Interviewed in New York City on October 29, 1993

# I kept watching the commissioner of correction. He had made a mistake

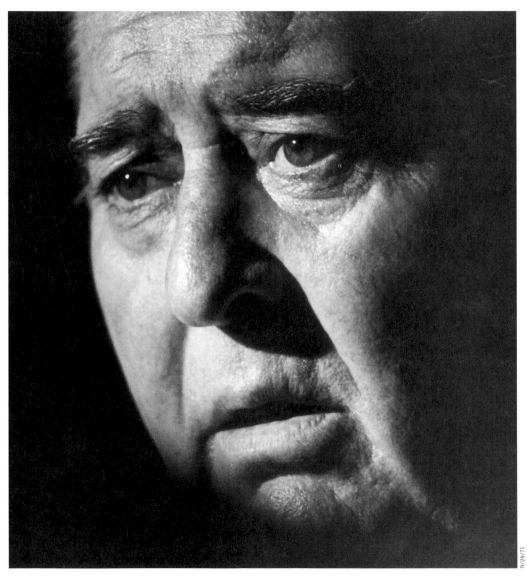

9/24/71

Russell Oswald, Attica Prison. Attica, N.Y. 1971

# JOHN SHEARER

**J**OHN SHEARER: I fell in love with photography at 11, when a lot of us did. I was lucky that my father had a very good friend named Gordon Parks, who lived down the street in White Plains. I was attracted to Gordon because he had a Jaguar XK-150, and he went to a lot of interesting places. He was in the same men's club as my dad, and he had a lot of stories to tell. I remember one day showing my pictures to Gordon. He ripped into all but one. I came home kind of teary-eyed, and my dad said, "That's good for you. You have to learn to edit your own work."

My dad was a painter. Years later he had a cartoon strip called *Quincy,* but when he was a boy he did a comic strip called *Next Door,* which he started when he was 17 and which ran in the *Amsterdam News* and papers of that ilk.

I was the editor of the school paper and started to take pictures professionally during high school. They had the Scholastic Photography Awards, sponsored by Kodak, and every year, all through high school, I won first, second or third in all the different categories. I did my first assignments for *Newsweek* and some other places, and right after high school I went on the staff of *Look* magazine. I was 17.

I had a boss at *Look* named Arthur Rothstein, who was a very wise man. The Vietnam War was raging. "Young man," he said, "it's the Army, or think about going to college." I went to Rochester Institute of Technology. It was the best thing that ever happened to me. Arthur worked it out so that I could work full time and go to school. I'd fly back and forth.

*John Loengard: What kind of stories were you doing for* Look*?*

I covered the civil rights movement, and because I was a kid, I covered rock

music. It was great training; learning to become invisible was the whole deal. Photographers today walk in the door with eight assistants and 15 cases, mostly full of lighting equipment. That wasn't our shtick. We went out to do a story, and we thought of it as a story.

*What's so good about doing picture stories?*

They have an intimacy. Human gesture and expression are the essence of photography. It's not about lights or fast lenses and fast film. It's the ability to capture a moment in time. To capture the spirit of someone in that magic box is wonderful. It's what I fell in love with as a kid.

At *Life* I spent six weeks with a street gang called the Reapers, in the South Bronx. I slept on their couch. I don't know if it was my best story or my worst story, but obviously, because of my relationship with Gordon, it was a very important story for me. It was like becoming a man in a way. Gordon did his first piece for *Life* on a gang leader, Red Jackson, and now I was doing a story on street gangs. It was important to me to do the story in color, because Gordon's had been in black and white. But then color was slow, and I couldn't increase its speed much by developing it longer, because at a certain point the material became monochromatic. However, the strength of the picture I took of the gang meeting late at night was partly *because* it was monochromatic. Here were 300 guys in a schoolyard under a street lamp having a meeting, and people were surprised when they saw that. It had a certain impact. It told a story, and that's what we were about. I wasn't just making pretty pictures.

*Was it hard getting along with them?*

I'd been shy as a person at times. And when I was a young man, the camera helped me get over my shyness. I didn't like to talk a lot, and the camera was my crutch. But after having said that, I loved people, and I still do. And there was a trick. You'd go around with no film in your camera and warm people up to the idea that you're shooting, but you're not wasting a lot of film.

*Photographers say they do that, but did you really do so?*

Maybe for a day. And then I couldn't resist shooting real film. It's crazy, you know. You miss so many pictures anyhow, and a picture might never happen again, and you were just pretending—

*How did you feel when they did something against the law?*

They went after a young man who had stolen a car from one of the gang members. They went looking for him, and found him at home, and dragged him out into a hallway and had their way with him. I don't know that I could have stopped it, honestly. You're talking about some big guys, and I certainly wasn't going to stand in the middle of it. But, also, my job was to document what happened. I never thought about trying to stop it.

*Did Eddie Cuevas, the gang leader, get out of the South Bronx?*

I'm not sure. He had a strong interest in art, and it was clear that he had a flair for it. The last time I saw him he was doing set painting at the Metropolitan

Opera, but unfortunately I have lost track. One of the things that's been nice for me as a black man is that occasionally I can be, by virtue of that fact, a role model in some way to other folks. "Hey, he did it, and he's not that smart, you know. Maybe I can do it too." I think it's important.

*You covered the prison riots at Attica, New York, in 1971.*

I went up there with the rest of the American press corps, because those were the kinds of things I tended to cover—

*Those being black—*

Well, Black Panthers and Attica, you know, right.

*Did you feel you were being typed as a—*

Life is about being typed, John. Yes, I resented it sometimes. But I had a story to tell, and it was important to me to cover that story. It's interesting, working for the white press as a black fellow. Sometimes I had more freedom to tell our story because I was the one telling it. *Life* told the story about the Black Panthers before a lot of the black press would tell it.

Obviously, those were the kinds of stories that I tended to be involved in. Vietnam was important to John Olson; the civil rights movement had that same importance to me. Covering Attica was important to me because George Jackson had just been killed in San Quentin. They said he tried to escape, and that was nonsense. I had gone out to the funeral, and it was the catalyst for Attica, you know. It wasn't the only reason. Conjugal visits were a big part of it too. They wanted to be treated with respect, and they should be. You want to be able to take a shower. You want to be able to have soap when you take a shower. Those were the issues that caused Attica. I think one of the best pictures I ever made was of Russell Oswald, New York commissioner of correction. Oswald was getting ready to make a statement, and I kept watching him. He realized he had made a mistake. It was luck to see him standing by himself and to have the TV guy in the press pool check his light to see if it worked and incidentally put light on that scene. Otherwise, it was hard to see him in the darkness; but we train to be lucky. And yet you've got to be prepared because you can be the luckiest guy in the world, but if you don't have the craft, luck doesn't matter.

When the weekly *Life* stopped, a year later, it felt like I had been fighting for the heavyweight championship. I'd practiced, and I'd sparred, and I got ready, and I fought the big fight. And then there was no place to go. I had job offers, but it wasn't the same. There was nothing like it. I've been very involved in the production of magazines and the creation of magazines. I do that for a living, but there was nothing like *Life* magazine. We all were spoiled. Where else in the world would photographers be the most important part of an organization?

On the *Life* staff 1970-72
Interviewed in New York City on October 20, 1993

I'm an observer.
Everything was implied in these
two kids' expressions.
That was absolutely my
favorite picture that ever got in a magazine

Cedarburg, Wis. 1969

# MICHAEL MAUNEY

**M**ICHAEL MAUNEY: My *Life* story was very brief. I was real easy on my expense account, so it was not my fault that the magazine went out of business. I had just been asked to be the photographer in London, and I was more upset about not getting to take my family there for two or three years than I was about the magazine folding. I was upset about the wrong thing.

As a photographer, I'm an observer. What I'm looking for is for people to react. I did a story on a battle against sex education in the town of Cedarburg, Wisconsin. I ended up at a Sunday night vespers service for teenagers. The light was bad, and there were only 12 teenagers in this church. The minister was saying, "You've got to decide what's right and what's wrong. The church says, 'This is what's right,' but you have to decide." I walked around behind him and started shooting the teenagers' faces, and there's one nice frame of a guy—he looks like a high school ballplayer—looking at his girlfriend. She's looking at him. The moment just says that in the end people have to decide for themselves. The teenagers of Cedarburg, in their wisdom, are working it out in their own way. Everything was implied in these two kids' expressions, and it was really a sweet, gentle picture. And it was wonderfully used, spread over two pages. That was absolutely my favorite picture that ever got in a magazine. Do you remember the picture? Go look it up, and tell me if I overplayed it. I think you'll find it's just exactly what I said.

On the *Life* staff 1971-72
Interviewed in New York City on October 26, 1993

It was 3 in the morning.
*I Want to Hold Your Hand* was number one.
They were coming to America

The Beatles. Paris. 1964

# HARRY BENSON

**H**ARRY BENSON: The phone is ringing this morning because of the cover on Elizabeth Taylor.* Some people read in the paper that *Life* had retouched it, and that's not true. I used a lens I got from a French fashion photographer. It softens the image without putting it out of focus and getting a mushy look.

I was the first person to photograph Elizabeth as Cleopatra in 1961. They were doing a costume test at Pinewood Studios in London. I slipped onto the set at four o'clock in the morning and hid in a palm tree until 5 in the afternoon. I thought she was never coming, but then the lights went up. I couldn't see her, but I heard Walter Wanger, the producer, telling her, "You look terrific, Elizabeth." Then she walked down the stairs—once. How they ever thought they could make a Roman-Egyptian epic in London in February, I don't know. Even my dog could figure that one out.

I was working for the London *Daily Express*. I had started off in Scotland, where unless you can do French, Latin and Greek by the time you're 13, you're not going anywhere. Basically, I wanted to play professional soccer. That was my ambition. It still is.

After I came out of the RAF, I started doing Saturday morning weddings in Glasgow. I would photograph and run home with the film, develop it and take back a bunch of wet prints, in towels, and try to sell them. My first big job was the Hamilton *Advertiser*. It's still the largest weekly in Scotland. It's the newspaper to which David Livingstone, the Scottish missionary, sent his letters back from Africa. I used to cover everything from Masonic dances to women's-guild church

* February 1992 issue.

meetings. I would do 10 jobs a day, which I think is the only way you can learn the business. I learned I've got to come back with a picture.

From there I started working for the *Daily Sketch*, and they brought me to London. In London there was a party that Lord Beaverbrook's son, Sir Max Aitken of the *Daily Express,* was giving. People were talking about the party, so I really wanted to get in. I'm the only photographer there, and I've just started taking photographs. Suddenly, there's a hand on my shoulder. Somebody mutters to me, "Max Aitken would like to speak to you." He offered me a job on the *Daily Express.*

*John Loengard: He offered you a job because he liked your looks?*

No, he liked it because I had just gate-crashed his party. That was the interesting thing about the Beaverbrooks. Lord Beaverbrook was the closest man to Winston Churchill during the war, and knew a lot of people. But if someone had complaints about his staff, which were abundant, he would just say, "Yeah, that's my boys doing their job," and he would have a laugh. He enjoyed the stories about one of his rich friends in an embarrassing situation. He didn't protect them one bit.

*Do you draw the line at anything?*

Yes, on children. Because children are innocent. I feel sad when I see them in a compromising position. But draw the line? No, my position is not to be an editor. My job is bring back what I can. If I'm going to trespass, I do not tell my editors, because I'm not going to make them party to it, but I'll certainly tell them afterwards, "This is how I got these photographs. Now you know the facts, so don't get carried away with the pictures. You might not be able to use them." They've got lawyers that get paid much more than I do for figuring this out. Let them figure it.

Do I draw the line? No. Every time I've tried to be a sport, I've made a mistake. I remember Audrey Hepburn once in Sardinia. She was in some divorce or some other drama, and she arrived one evening about five o'clock. She saw me, and she said, "Oh, please, don't take my picture. Tomorrow I'll give you all the pictures you want." Well, she spent the early morning being photographed by Antony Armstrong-Jones, and then she just flew off. The editor of the *Daily Express* wanted to know if Benson had gone off his head. I should just have taken the photograph and said, "Fine. I can take a better one tomorrow." A photojournalist's job is to bring back pictures.

The technical part of photography has always bored me. It's the content you're looking for. I don't like things to be too photographer-ish. You know, "Oh, *look* at that!" To me, it's the content. Always has been. Take the picture first, then focus.

The thing I used to hear a lot in Fleet Street, when I'd think I took a great picture, they would say, "But what does it mean?" The picture had to mean something. You'd almost pull your hair out. "But what does this picture mean?"

To me a good picture is a picture that you'll stop and look at, and you'll turn the page back and look at it again. Everything seems to be moving in it. It's not contrived. It's not pushed.

*Do you use automatic-exposure cameras?*

Yes, I do. Because when I would do it myself, half the exposures on a roll were right. But when I'd do it on automatic, it is 99 to 100%. And automatic focus, for certain things, yes. It is a major breakthrough on photographers' eyes going—and their eyes do go.

*How do you get people to lower their guard?*

It seems so self-serving, John, what I'm talking about. I'm quick. I'm not the main event—the subject is the main event. Usually they're intelligent people, and no one wants to pass this way unnoticed. If you're carrying *Life* magazine's name in your back pocket, you've got some weight as well.

I was always aware of the power of *Life* magazine, because on Fleet Street I'd be out in the cold. I remember once, at some party President John F. Kennedy had at Claridge's, Alfred Eisenstaedt was ushered in where we were pushed back over to the other side of the street in the wet. I knew I was going to get away from that type of journalism by hook or by crook.

Don't get me wrong. I enjoyed being a bit loathsome, but I always knew that I would move on. I always thought when I could get inside the room, like the one where Eisenstaedt was—God! What I would do! I wanted to get to the inner sanctum, to get to the bedroom, to get as near as I can to these individuals. That's never left me. It's predatory. I go as close as I can. Some photographers, when people are nice with them, they get softer. I get harder. Whoever said I was their friend? Some people like the pictures. Some don't. Some people say, "Thank you, Harry. That was a lovely picture you took of me. You can photograph me anytime." But I always think to myself, "The other picture they might have used was not so flattering. It could have gone either way." I don't go out to hurt people. I really don't. But who ever said I was a friend?

*Were you friends with the Beatles?*

Not really. I covered the Beatles well. On certain days, nobody beat me. I do think my pillow-fight-in-Paris picture is one of the best pictures taken of them, because it's got movement and action in it. That's a difficult thing to do in portraits. During their tour in France, they were shut away in these hotel rooms, and they had had pillow fights. So I asked them to have another. It was 3 in the morning, after Brian Epstein had told them that *I Want to Hold Your Hand* was number one in America. They were feeling like fun—it meant they were coming to America. I came with them on the same plane. I always knew that I would stay in America. I always wanted to work for a magazine like *Life*, but I never thought I was up to that standard. *Life* was very élitist.

*Do you mean that the people who worked for* Life *were snobbish?*

Yes, they were. I would meet them in Africa. They always seemed to have the

best equipment. I'd be looking for a screw for my Rolleiflex. They didn't have this problem. They would have four or five Rolleis. I mean, they were very nice, but certainly they were condescending. I envied them. I wanted to beat the bastards.

I went over to *Life* in 1964 with my portfolio, and David E. Scherman was sitting in for the picture editor. He gave me my first job, on an artist called R. Crumb, who drew underground comics. It never ran, but they liked it, and I was always available for them. I would drop everything, even if it was Christmas—because just to say to people that I worked for *Life* magazine was a tremendous honor. It still is.

*You were about to join the staff when the weekly* Life *stopped?*

I was hoping you would avoid asking that. It's embarrassing. Ronald Bailey, who became director of photography in 1972, asked me to join the staff in November 1972. A few weeks later, I was covering Henry Kissinger's Vietnam peace talks in Paris. Kissinger himself phoned me at 6:30 one morning and told me, "Get over here quick." So I went over to the American embassy, and he let me take pictures of him having breakfast in his room. It was a really good exclusive. I came back to *Life's* office in Paris very happy with what I'd got. I'm jumping about, a happy little fellow, but as I walked into the office, I heard them saying, "Oh, my God." I did not have to ask them what it was. I just went downstairs and had a coffee, round the corner. When I went back up, they told me what I knew—that *Life* had folded. So, there—that's me coming on the masthead of *Life*.

People try to limit what I can photograph all the time. "You can't go here and you can't go there" or "You can't do it in this room. You've got to do it over there." We've got to fight this. A lot of journalists (and I don't just mean photojournalists) coming into the business think this is the way that it's done, with flacks—public relations people—telling us what to do. I'll hear them on Channel 13 saying, "We're real journalists. We've got freedom of the press." That's bullshit. It's being taken away by little fascists. On numerous occasions I know a magazine hasn't given the subject any approval of the pictures, but the photographer's giving them approval and showing them the pictures. And the writer is showing them the words. It's just appalling. Nobody is bothering to say, "Stop! This isn't how we do things."

*How do you get around it yourself?*

I just say, "Yes, that sounds fine," and then do what I want to do. Unless, of course, there's something they want me to sign. I don't sign anything. But I've always got on with people where there's a difficult side. Like the chess player Bobby Fischer, or Joe Namath, who wouldn't speak. It's because I will it. I want it.

*Joe Namath wouldn't speak?*

He wouldn't speak to anybody. He was very big-headed. It's so stupid.

*Do you have a plan ahead of time?*

Oh, absolutely. You've got to, dealing with clever people. You've got to be aware of what they're up to and how they are putting you in your place. For

example, if I wanted to know what the Nixons thought of me, I didn't look at Mrs. Nixon or the President. I would look at the Secret Service. Their faces would tell me I'm either in or out. You know, it's just like a secretary. She's not as clever as the boss, but she's certainly giving you the wavelengths—that you're in or not in. Just by her attitude.

It always amazed me that American photographers—except Eisenstaedt or Carl Mydans and some of the others—always dress so badly. At the White House they dressed like TV cameramen. Why the photographers don't dress like Dan Rather, I don't understand. You can be just as tough or loathsome in a suit as you can be in a pair of dungarees. I dress properly because that's just the way I am. But, also, if you worked for Lord Beaverbrook, there was no way that you were going to go out in a pair of blue jeans. I don't think this is a hang-loose business. I think this is a tough business. You've got to adapt.

When I'm going to photograph the President, they'll say, "You've got half an hour." I know full well I'll be lucky if I get four minutes, and I know, while in the room waiting for the President, someone's going to come in and say, "You could not have picked a worse morning." All we've got is 15 minutes. Then they'll come in again and say, "Oh, we don't know if we can do it or not." Now, all this is putting you right on edge, but I know this will happen. I'm ready for four minutes. I did the Reagans dancing and kissing in six minutes for *Vanity Fair* magazine. The thing I learned when I went to Fleet Street—there was this very clever old photographer, David Johnstone, and he said, "When you get to a job, Harry, always photograph everything you see, quickly." That advice has never, never left me.

*When you're going to photograph somebody, do you have any tricks?*

Every photographer's got little ways he can fall back on. I have photographed a lot of people at the window. I did that with Jimmy Carter in the Oval Office. There's a loneliness apparent when they stare out. They're apt to go into a little bit of a trance, even though they know you're there. It's quite interesting what happens. With Jane Pauley I was trying to make an uptight person who watches everything she does seem relaxed.

If you come in with nothing in your head, you could come back with nothing. I ad-lib much of it, but something wonderful is going to happen when I've got ideas. With TV evangelists Jim and Tammy Faye Bakker, it was my idea to get them into the water, because there's something about religious people and water that appealed to me, and their house was only about 20 yards from the ocean. I had a reporter with me, and he saw me bringing them to the water. He kept shouting, "Oh, they'll get their feet wet! They'll get their feet wet!" So I told Jon Delano, who works with me, to go and tell him to shut his F-ing mouth. I wanted this white water coming round them. I had that picture in mind before I left New York to go to California.

*Did you tell them about it?*

Oh, no, no. Why should I hand over the crown jewels? I don't tell anybody

Elizabeth Taylor. 1992   *I hid in a palm tree.*

Jim and Tammy Faye Bakker. 1987
*I've always taken photography as a war.*

Presidents' children. Boston. 1984
*The picture on the cover of*
Life *changed Caroline.*

what I'm going to do. In fact, I don't even tell myself, if you know what I mean. I'm not even thinking about it that hard. It's in the back of my mind.

*How did you lead them to the water?*

"Just come down a bit closer. A bit closer. It's all right. You won't get wet." *Splash.* [*Laughs*] They get wet, and it's wonderful. It's very touching. This is really very touching. What was I to tell them beforehand on the phone: "You'll get water in your shoes and your good dress all wet"? I mean, *really*—they'd say, "Is he daft? Has he gone mad?" You know that doesn't work.

I've always taken photography as a war. And on every story that's any good, I always have a downtime where it's depressing. And if my pictures don't come out fine, I just want to forget about it, not try to improve things, because I don't want to consolidate a disaster.

*You photographed John-John and Caroline Kennedy in 1984. It was the first time they had posed for a publication since they left the White House.*

That's not a *great* picture. It's a fine picture. They had never been photographed, and I had to tell them what to do. Actually, they were fun to photograph for that reason. It was nice to be the first one.

*Did you talk to them afterwards about their reaction?*

They loved it. Oh, yes. That's interesting because Caroline's mother told me that the picture on the cover of *Life* changed Caroline, who didn't really think that much about her looks (which is wrong because she is a pretty woman). "After the picture appeared," Mrs. Onassis said, "people started telling her how pretty she was." The pictures had some effect on her in how—now, I want to get it absolutely right—in how she started to believe more that she was an attractive person. And then she met her husband-to-be. So some good came out of that.

*Did you photograph Mrs. Onassis?*

Yes, but that would come into the original Elizabeth Taylor category. I was there at her wedding to Aristotle. And other things. Skiing. In London too. It's in my book.

*You never posed her?*

No, I never posed her.

I photographed Bobby Kennedy a lot. The thing about Bobby was, he was one of these people that you left wagging your tail because you got some pictures. In the campaign he would make you one of them, part of the entourage. There's no question that's manipulative, but I was getting photographs. And then I was beside Bobby when he was shot. He had left the podium. I was going to go another way, and then I said, "No, I'll follow the candidate out," because the candidate is going to get out, *phwwt*, right through the kitchen. I was only about two-and-a-half yards behind him. Then I turned to go another way out, because they were going to some elevator to take him upstairs. I was turning to the left. A girl with one of those "Kennedy for President" boaters screamed, and I didn't have to know. I said, "This is it." I knew. I turned around, and Bobby's going

over, in slow motion. Just like slow motion. He was falling over. Then the room seemed to move. The screaming I remember.

I wake up at night—I don't mean having nightmares, but I can go through the whole event. I just kept on saying, "This is for history, this is for history."

I remember, I got on top of a hot plate, looking down on Bobby, and Jesse Unruh, a Democratic politician in Los Angeles, threw me right off it. And then getting up, I was only about a yard from Bobby's head. And Ethel was bending down to him. She said to him, "I'm with you, my baby. I'm with you." And Bobby was slipping fast. I could tell he was out of it. And I went back up to the hot plate again. I was the last person to leave the kitchen. I photographed everything.

I never bothered about Sirhan. I saw some commotion going on to my left. But I wanted to stay at the center. To me, Bobby was the center. When I was down, I looked around and I discovered other people had been shot, all around me. There was a person with blood all over his face, and there was this woman with blood all over her. It dawned on me that it involved other people. I was taking the film out of my camera and putting it into my sock, because I didn't want to be caught with this film on me. Somebody with a gun says to me, "Give me your film." You know, you want to photograph for *Life*. You don't want to die for it.

That's about it. I covered it like a dreadful event. But that's what I was in the business for. I've got to come through in these times. I kept saying to myself, "Don't fail. Don't fail now. This is it. Fail tomorrow. Not now."

*Those pictures were for the* Daily Express? *And* Life *used one?*

Yes. Not many photographers took pictures that night. Bill Eppridge and somebody from United Press International. Yet, in the hall, there were dozens of photographers, and some photographer said to me afterwards, "How could you do it?" They respected Bobby too much. To this day they still say this, but, you know, when I eventually see Bobby, I'll explain it to him. I'm sure he'll understand that I was recording a historic moment.

*You've put a different picture of Colonel Oliver North in your book* People *than was used in* Life *magazine.*

*Life* wouldn't use that picture of him winking. They thought it wasn't fair. I mean, *really*. But that's their business. I don't lose any sleep over it. The self-righteousness of Oliver North intrigued me—thinking that he knew what was good for everybody. I wanted the photograph to look like the Hitler propaganda pictures, with the flag and the eagles—sort of the storm trooper.

*You had a backdrop painted for the picture?*

Yes. Tony Armstrong-Jones' backdrops were always better than mine, and I found out from his assistant where Tony got them. From then on, this man's been painting them for me. I can tell him over the phone, "I want thunder, lightning, clouds, and put the thunder and lightning to one side, and put the sunset over here, or give me a bit of a Gainsborough or Italian Renaissance." He can

Ethel Kennedy. Los Angeles. 1968
*A girl with one of those "Kennedy for*
*President" boaters screamed.*

King Juan Carlos of Spain. 1985
*The King looked at me, as if to*
*say, "You know, you are a fool."*

Alexander Solzhenitsyn. Cavendish, Vt. 1982
*He looked like the lion in* The Wizard of Oz, *with his mop of hair and red beard.*

do them in a couple of hours, and they're terrific.

*When you started out in photography, it was a little bit up from being a mail carrier, but photography has now become regarded as art. Does that make it easier for you?*

On magazines or newspapers, photographers are still the second-class citizens. Maybe it's an art now because the newspapers have got an extra few pages to fill on a Sunday, but I'm sure that if they only had eight pages instead of 12, the photography section would go out the window. If you want to call it an art, great. Some pictures look nice on walls, and some look dreadful. I certainly don't go out looking to take pictures for a museum.

*Do you know many photographers?*

Not really.

*Do you respect many?*

Yes. Alfred Eisenstaedt, for what he's done. I respect Co Rentmeester and Harald Sund and Brian Lanker. See, when I look at a picture, I look at it to see if I could beat it; and when I don't think I can beat it, I have respect for them. Where I get annoyed with photographers is where they've been given this wonderful opportunity to, say, photograph the Queen of England, or the Pope, or anybody, and they just haven't moved that bit closer. I can tell when a photographer has laid back and just done his picture because he's respected the subject too much. I mean, if he can get them *here*, why did he not get them *there*?

*What do you mean by closer? A close-up? Inches from your subject?*

I mean getting more intimate, unusual pictures, because that's basically what photography—*Life* magazine—is about: taking unusual pictures. What makes the pictures interesting? Putting a camera in an interesting position—a position you don't expect. When I see photographers not moving in, not being predatory, I get a bit angry with them.

*Where did you push Willie Nelson?*

Into the bath. I was photographing him, and my assistant said to me, "You know, Willie could do with a bath." I thought, "Not bad . . ." So I started to work on the idea. I said to Nelson's wife, "How about a nice picture of you and Willie in a bubble bath together?" She thought that was the greatest idea. She wanted to show their intimacy in the picture.

*How did you push the Shah of Iran?*

When I saw him five years earlier, he was very grand. Very putting you in your place. Very royal. When I saw him again in 1978 for the first issue of the monthly *Life*, I could see things were starting to disintegrate a bit. He had things on his mind. Maybe he wanted to get a nice, friendly message over to the American people through *Life* magazine. I was fortunate to be there to take advantage of this state of melancholy. He was up for ideas. Swimming, water skiing, this or that. I called him "Your Royal Highness," but after you say that twice, it's difficult. Like calling a woman "Duchess." It sounds as if it's a barroom woman you're talking to. With the Queen of Jordan, every time I spoke to her,

I had to say "Your Royal Highness," or she wouldn't acknowledge I was there. [*Laughs*] I mean, this was some girl from Princeton. It was really outrageous.

I liked the King of Spain. He's the way that royalty should be. Not at all like the British royal family. I've stood in the British royal yacht for hours on end, and nobody's ever given me a drink of water. The King of Spain came over and gave me his Sherry. And he came over again and gave me another Sherry. Could you imagine Prince Philip or the Queen or Prince Charles doing that? No way.

I was packing up, and King Juan Carlos' dogs were running around the garden. A bunch of puppies. He is gathering one, gathering another, by the scruff of the neck, and putting them in a pen. I thought, "God, that's a good picture." So what I did was, I ran down there, went into the pen and left the pen door open. All the dogs went back out again. [*Laughs*] The King looked at me, as if to say, "You know, you are a fool."

I said, "Oh, I'm sorry, Your Royal Highness. Is there a way you could get the dogs again?" And I got my picture.

Growing up in Glasgow during the war, and listening to his speeches, I'm sure Winston Churchill had more to do with me being a journalist than anybody else. Wanting to be there for the drama of the event. I had the privilege of photographing Churchill in London on numerous occasions. I even had a picture of myself with him, and I'd love to have that picture now, but it's lost. When you work for a newspaper, your thought is not to do your memoirs but to stay on the payroll to the end of the week. You get judged daily.

*How many good pictures have you taken?*

Probably 10. I have to put Churchill in there—his last time going back to his old school at Harrow, a month before he died. The students sang, "Churchill's name shall win acclaim through each new generation." I mean, I still get goose bumps thinking about it. He was crying.

Then there's the Beatles' pillow fight—this gets difficult. Pictures have to have a historic meaning. Nixon's resignation I like because it's such a moment. Good pictures give information. When photographers start controlling pictures and making people into what they think they are, they're making a mistake.

*Do you work with reporters often?*

Sometimes. They're a cross we have to bear. I'm the cross they have to bear. There's a problem because nobody tells a reporter how to be a reporter. They just assume that they know how to speak to people, and they don't. I cannot discuss anything with reporters, because they will tell my victim—my subject—what my plans are. I don't like to tell the office exactly what my pictures are, even after I've done them, because I don't want any kind of stupid thing said like, "Well, if you got Willie Nelson in the bath, why don't you get him jumping into the swimming pool naked?" Reporters have got a habit of giving the editors a blow-by-blow, making themselves sound important. Oh, no, they're little creeps.

So, anyway, I have a deal with them. I say, "You don't discuss my pictures,

and I won't discuss your quotes." They don't like their quotes being discussed, either. So it's fair. I defy anybody to remember a great piece written in *Life*, unless it was written by Churchill or Khrushchev or. . . I hope I'm sounding off well enough. I wonder if I've got rid of enough venom? [*Laughs*]

*You said young reporters don't know how to speak to people. What does that mean?*

They're telling the subject too much about what we've got to do.

*Well, how do you ingratiate yourself? Do you ask questions?*

Sure. I must do that. I can't walk in there like a zombie. But I don't become the main event. If I have to do it with an assistant, I go in with one. I don't go in with three or four, as some photographers do, and they've got a bunch of, you know, trendy little fellows jumping about. That can make people like General Colin Powell or General Norman Schwarzkopf a bit uptight. You're not going to go anywhere with these people, with this event going on, in front of them.

*You photographed Schwarzkopf during the Gulf War buildup.*

Yes.

*There were a thousand press people there it seemed, but he treated you differently. Why?*

I wanted him. This was a leader of the first order. The first impression from 20 yards is that he looks a bit like some gung-ho Marine and not that bright. But you're wrong. That's why when people tell me, "So-and-so is a wonderful human being, you'll love him. He's a great person. You'll have a great time with him," I go for my revolver. I know there's a problem. I know that what I've got is a manipulating individual. But when somebody is supposedly difficult, I'm getting myself ready for this person. I'm prepared for him. I'm taking nothing for granted. I'm not assuming anything. I want them. I want to get close. I look at their eyes. The eyes tell me everything. When. What. How. Then like a cobra, I strike very quick.

*Out of a pack of press, how can Schwarzkopf tell that you're different?*

The thing about it is: they dress so dreadfully. They want to look like maintenance people. That's their problem. I don't want whoever is handling this to think I'm one of them. If I'm in the pack, I'm going to be treated with the pack. If the press is standing over there, waiting for something, I'm going to stand over there waiting for something else. Sometimes it's just a question of aloofness in yourself. Who you represent and what you're doing deserves some special attention. This is *Life* magazine, and we've got to be treated the same way that Diane Sawyer, with all her hairdressers, has got to be treated.

They'll give you attention too if you go about it in the proper way. It's when the reporter comes in and says, "I think it's better if we go in this bus with them."

"I don't want the bus," I say. "You go in the bus." I let it be known to whoever that I'm not doing it that way, and then they'll send a car out for me. I say, "Now we're talking. Now we're getting things going a little bit."

*Did anybody sit you down and tell you the rules?*

Well, I was very fortunate. When I started out in Fleet Street, I started out

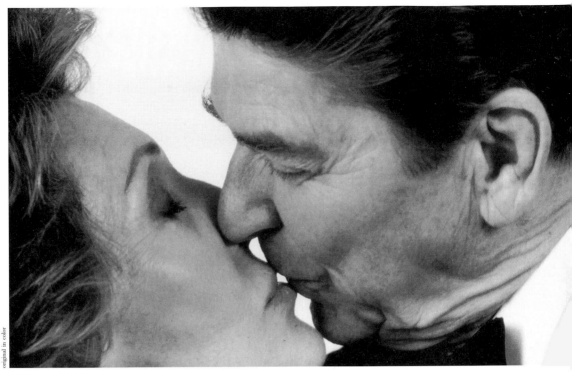

The Reagans kiss. 1985   *People try to limit what I can photograph all the time.*

Norman Schwarzkopf and Melissa Rathbun Nealy. 1991   *She said, laughing-crying, "I don't mind."*

with very intelligent people. Great reporters. Beaverbrook reporters. Ones who had been at Munich, you know, with Hitler. Covered Algiers and were politically very savvy and clever men and women.

But they knew they weren't going an inch unless we got pictures as well. And so did Lord Beaverbrook. It's not like that now. The first thing we think about in a magazine, now, is the words. And then . . . Oh, don't get me bitter. I don't care.

*General Schwarzkopf demolished the Iraqis on, say, Tuesday. Wednesday, you called him up and said, "I want an exclusive"?*

No, I saw him at his press conference on his big victory. The war would be over in the next couple of days, and he was just explaining it. I had photographed him earlier in the year, during the buildup. At the time, he gave me a decent picture. So he was laughing. He was very friendly.

I went up to where he signed the peace in Iraq, and the following day I photographed him for a *Life* interview. He said to me, "Where were you yesterday? I wanted you to fly back with me. I was looking for you."

Jokingly, I said, "You always say that." The following day he calls me. He tells me to come with him. He was going to Bahrain to pick up the prisoners of war who had flown in to a hospital ship early that morning. It's only me. There's different degrees of exclusive, you know. Some people say they've got an exclusive, but it's Madonna's first interview for the recording, or Michael Jackson with his chimpanzees. But this is a real one.

He goes into the room with all the P.O.W.s on this hospital ship. I mean, they're British, American, Italian, French pilots, all shot down. The one I was looking for was a woman, Melissa Rathbun Nealy, the first American woman G.I. ever to be taken prisoner. I saw her, and she was standing kind of with a bunch of people, off to the right but separated from them slightly by a yard or two. She was my main one. I didn't want to run out of film. I didn't want to get to #34, #35, #36, *bang*, I've got to change film when the general gets to her. I'm even putting new batteries in, and I'm just making sure that my flash and everything worked. He comes over to her. She's sort of laughing-crying, and so is he. If I remember right, he said to her, "I thought about you every night. I said a prayer for you. Just like my own daughters, and there's something I would like to do. And I hope you don't mind. I'd like to give you a big hug."

She said, laughing-crying, "I don't mind." He bent over. And I took a picture from the back and another from the front.

What was nice was that he asked permission to hug her. He just wasn't like the big general who can go up and hug any of his soldiers. It was very touching. The doctors liked him doing that. They were watching her because of what she had probably gone through.

I transmitted the pictures back to New York through Saudi Arabia, where Neil Leifer did a great editing job. He saw these pictures and phoned me up and told me these are very good. What amazed me was that New York never called

me to find out what was said. I was the only press on the hospital ship. I've got eyes, and I can think and I can talk. I could have explained to them what the general was saying to different individuals, and his feelings. If that was the London *Daily Express,* someone would have been on the phone to me right away.

It was the front cover and the back cover, and eight pages inside. It was a great show. A week later television got prisoners welcomed back, coming back off of planes. We were way, way ahead of them. That's what we're in the business for. This was an exclusive.

*Did you want to go to Vietnam?*

Yes, I regret not having gone there. But maybe I was meant, by somebody up there, not to go there at all. I'm superstitious in these things. I'd like to have gone. Just to say, "I was in Vietnam, and it was like this."

*What do you take pictures for?*

To feed the dog. To feed my family. Because I love photography. It's got a lot of energy, and it's fun. Television goes too quick. It's forgotten. Photography is forever. It's for the archives. It's for history. The first time I saw Alexander Solzhenitsyn, the dissident Russian writer living in exile in America, I thought he looked like the lion in *The Wizard of Oz,* with his mop of hair and red beard. He was not a particularly pleasant man. Like President Jimmy Carter, he thinks he could be doing more important things than being photographed. There are people like that, who genuinely think it's a waste of time. He was one of them.

It's not a waste of time with me. I've got to pull out all my strongest artillery. Anything at all I've got. Stones. Sticks. Anything. Or just charm. Anything to get them to do something. If I can get him to walk 10 yards from his house, I'm going to get him to walk 10 yards back. Now I've doubled it. Do you understand? If I can take him away from his little nest, where he's got all his books and papers, now I've got a chance. And I did. I took him down toward the woods, a little bit. And I said to him, "This lovely air up here. It's free."

"Yes," he said, "it's free," and took a deep breath. That was a shot.

*Are there any pictures you missed?*

Oh, absolutely. All the time. The worst thing about my job is when you have an inspiration flying into Kennedy Airport. God, why did I not think of that? It's usually obvious and simple. It's just like when I'm photographing and something happens; I've taught my assistant, or any reporter that's with me, not to interfere. If the person falls, let them fall. If something happens, let it happen. Don't run and help them. Elegance is not my concern.

*If somebody has set himself on fire, and you are the only person around, do you put out the fire or take a picture?*

I would save them. Of course, I would. And no question about it. Of course.

Interviewed in New York City on January 10, 1992

# GALLERY

Harry Benson. ca. 1972

Jack Birns. 1948

8/2/48

Myron Davis. 1941

Edward Clark. 1945

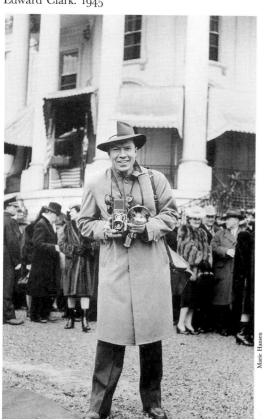

Marie Hansen

Bernard Clayton 9/15/41

Horace Bristol. 1989

Loomis Dean. 1946

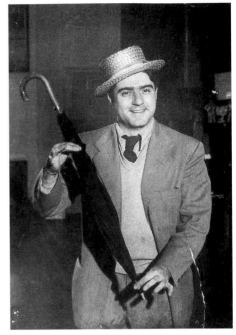

Cornell Capa. 1949

John Dominis 1966

Alfred Eisenstaedt. 1981

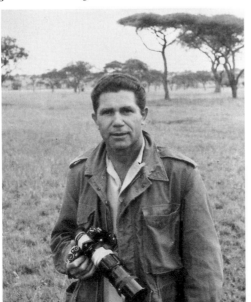

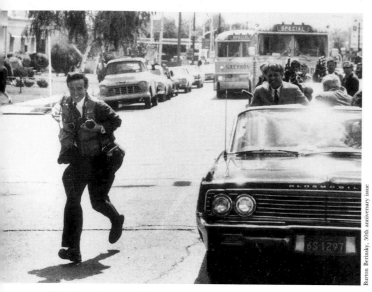

Bill Eppridge. 1968

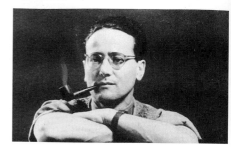

Andreas Feininger. 1945

Rex Hardy. 1937

Henry Groskinsky. 1966

Martha Holmes.

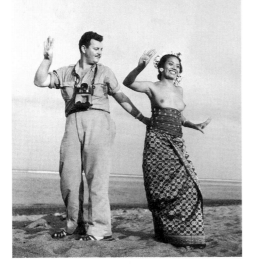

John Florea. 1946

Allan Grant. ca. 1947

Mark Kauffman. ca. 1955

Yale Joel. ca. 1953

Walter B. Lane. 1941

Dmitri Kessel. 1953

Nina Leen. ca. 1950

Anthony Linck. 1945

Hansel Mieth. ca. 1937

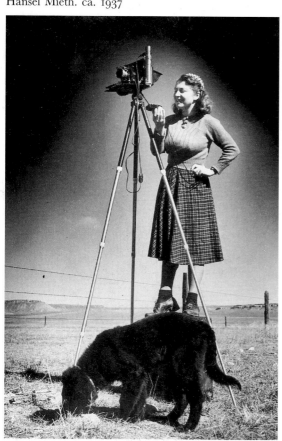

Ralph Morse. 1940

John Loengard. 1969

Michael Mauney. 1970

Vernon Merritt. 1969

Shelley & Carl Mydans. 1945

John Olson. 1968

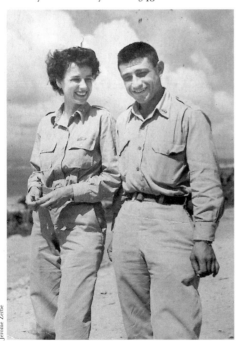

Gordon Parks. 1952

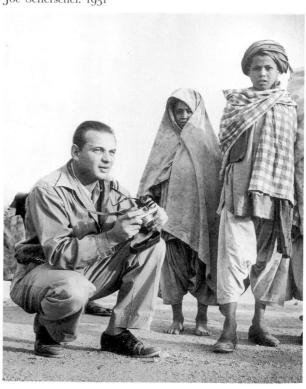

John Phillips. ca. 1940

Co Rentmeester. 1968

Joe Scherschel. 1951

David E. Scherman. 1939

Hart Preston. 1940

Bill Ray. 1966

George Silk. 1944

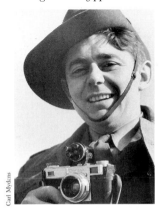

John Shearer. 1971

Howard Sochurek. 1955

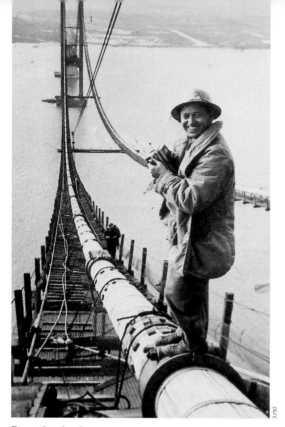

Charles Steinheimer. 1946

William J. Sumits. 1950

Peter Stackpole. 1952

Grey Villet. ca. 1970

Hank Walker. 1956

## LIFE STAFF PHOTOGRAPHERS 1936-98

Dates on staff, name, place of birth, personal dates.

1964–71 Bavagnoli, Carlo (Italy), 1932
——— Benson, Harry (Scotland), 1929*
1947–51 Birns, Jack (USA), 1919
1951–69 Bourke-White, Margaret (USA), 1904–71
1937–38 Bristol, Horace (USA), 1908–97
1951–64 Burke, James (China), 1915–64
1961–71 Burrows, Larry (England), 1926–71
1946–54 Capa, Cornell (Hungary), 1918
1944–46 Capa, Robert (Hungary), 1913–54
1944–61 Clark, Edward (USA), 1911
1951–72 Crane, Ralph (Germany), 1913–88
1942–46 Davis, Myron (USA), 1919
1947–61 Dean, Loomis (USA), 1917
1950–72 Dominis, John (USA), 1921
1936–38 Dorsey, Paul (USA), ca. 1902–n.d.
1946–56 Duncan, David Douglas (USA), 1916
1951–64 Eisenstaedt, Alfred (Germany), 1898–1995
1942–64 Elisofon, Eliot (USA), 1911–73
1964–72 Eppridge, Bill (Argentina), 1938
1942–61 Eyerman, J.R. (USA), 1906–85
1946–61 Farbman, N.R. (Poland), 1907–88
1943–62 Feininger, Andreas (France), 1906
1946–61 Fenn, Al (USA), 1912–95
1943–49 Florea, John (USA), 1916
1944–50 Gehr, Herbert (Germany), 1910–83
1944–66 Goro, Fritz (Germany), 1901–86
1947–62 Grant, Allan (USA), 1920
1937–39 Griffin, A., n.d.
1965–72 Groskinsky, Henry (USA), 1934
1942–46 Hansen, Marie, ca. 1918–69
1936–39 Hardy, Rex (USA), 1915
1936–51 Hoffman, Bernard (USA), 1913–79
——— Holmes, Martha (USA),**
1941 Jarché, James (England), 1891–1965
1947–72 Joel, Yale (USA), 1919
1940 Jones, Stedman, n.d.
1945–60 Kauffman, Mark (USA), 1921–94
1952–66 Kelley, Robert W. (USA), 1920–91
1944–67 Kessel, Dmitri (Ukraine), 1902–95
1942–56 Kirkland, Wallace (Jamaica), 1891–1979
1945–46 Lacks, George (USA), 1910–n.d.
1941–47 Landry, Bob (USA), 1913–ca. 1960
1945–47 Lane Walter B. (USA), 1913–96
——— Leen, Nina (Russia), ca. 1914–95*
1988-90 Leifer, Neil (USA), 1942***
1946–49 Linck, Anthony (USA), 1919
1961–72 Loengard, John (USA), 1934

1971–72 Mauney, Michael (USA), 1937
1937–60 McAvoy, Thomas (USA), 1905–66
1956–72 McCombe, Leonard (Isle of Man), 1923
1994–98 McNally, Joe (USA), 1952
1968–72 Merritt, Vernon (USA), 1940
1937–44 Mieth, Hansel (Germany), 1909-98
1947–68 Miller, Francis (USA), 1905–73
1942–72 Morse, Ralph (USA), 1918
1937–72 Mydans, Carl (USA), 1907
1969–71 Olson, John (USA), 1947
1949–60 Parks, Gordon (USA), 1912
1940 Paschkoff, Boris, n.d.
1968–70 Phillips, Charles (USA), n.d.
1936–50 Phillips, John (Algeria), 1914–96
1940–43 Preston, Hart (USA), 1910
1963–72 Ray, Bill (USA), 1936
1966–72 Rentmeester, Co (Holland), 1936
1961–71 Rickerby, Arthur (USA), 1921–72
1942–47 Rodger, George (England), 1908–95
1947–71 Rougier, Michael (Canada), 1925
1944–61 Sanders, Walter (Germany), 1897–1985
1947 Schaal, Eric (Germany), 1905–94
1939–47 Scherman, David E. (USA), 1916–97
1942–61 Scherschel, Frank (USA), 1907–81
1948–61 Scherschel, Joe (USA), 1921
1956–67 Schutzer, Paul (USA), 1930–67
1970–72 Shearer, John (USA), 1947
1945–47 Shere, Sam (Russia), 1904–82
1940–46 Shrout, William C. (USA), n.d.
1943–72 Silk, George (New Zealand), 1916
1944–56 Skadding, George, ca. 1905–n.d.
1945–46 Smith, Ian (Scotland), n.d.–ca. 1987
1944–51 Smith, W. Eugene (USA), 1918–78
1950 63 Sochurek, Howard (USA), 1924–94
1936–60 Stackpole, Peter (USA), 1913–97
1946–50 Steinheimer, Charles (USA), 1914–96
1940–44 Strock, George (USA), 1911–77
1947–50 Sumits, William J. (USA), 1914
1936–46 Vandivert, William (USA), 1912–90
1955–72 Villet, Grey (South Africa), 1927
1950–62 Walker, Hank (Canada), 1922–96
1957–72 Wayman, Stan (USA), 1927–73
1957–62 Whitmore, James (USA), 1926–ca. 1966
1940–47 Wild, Hans (England), 1914–69
1944–46 Wilkes, Jack (USA), ca. 1915–n.d.

*Benson and Leen were never actually on the staff (see introduction). **Holmes' dates are omitted at her request. ***Life paid half the salary of Leifer, a Time magazine staff photographer.

# SELECTED READING

GENERAL

*BEST OF LIFE, THE*, ed. David E. Scherman, New York: Time-Life Books, 1972.

*GREAT ESSAYS FROM LIFE*, ed. Maitland Edey, Boston: New York Graphic Society, Little, Brown and Company, 1978.

**Hicks, Wilson:** *Words and Pictures*, New York: Harper & Brothers, 1952.

*LIFE: THE FIRST DECADE 1936-1945*, ed. Doris C. O'Neil and Robert Littman, Boston: New York Graphic Society, Little, Brown and Company, 1979.

*LIFE: THE FIRST 50 YEARS*, ed. Philip B. Kunhardt Jr., Boston: Little, Brown and Company, 1986.

*LIFE: THE SECOND DECADE, 1946-1955*, ed. Doris C. O'Neil, Boston: New York Graphic Society, Little, Brown and Company, 1984.

*LIFE: THE '60S*, ed. Doris C. O'Neil, Boston: Bulfinch Press, Little, Brown and Company, 1989.

*MEMORABLE LIFE PHOTOGRAPHS*, ed. Edward Steichen, New York: Museum of Modern Art, 1951.

**Rayfield, Stanley:** *How LIFE Gets the Story*, New York: Doubleday & Company, 1955; *LIFE Photographers, Their Careers and Favorite Pictures*, New York: Doubleday & Company, 1957.

INDIVIDUALS

**Benson, Harry:** *On Photojournalism*, New York: Crown Publishers, Inc., 1982; *People*, San Francisco: Chronicle Books, 1990; *The Beatles: In the Beginning*, New York: Universe Publishing, 1993; *First Families*, Boston: Bulfinch Press, Little, Brown and Company, 1997.

**Bristol, Horace:** *Horace Bristol, An American View*, by Ken Conner and Debra Heimerdinger, San Francisco: Chronicle Books, 1996.

**Capa, Cornell** (selected titles): *Let Us Begin: The First 100 Days of the Kennedy Administration*, New York: Simon & Schuster, 1961; *The Concerned Photographer*, New York: Grossman Publishers, 1968; *The Concerned Photographer 2*, New York: Grossman Publishers, 1972; *Margin of Life*, text by J. Mayone Stycos, New York: Grossman Publishers, 1974; *Cornell Capa*, eds. Cornell Capa and Richard Whelan, Boston: Bulfinch Press, Little, Brown and Company, 1992.

**Clark, Edward:** *Decades: A Photographic Retrospective, 1930-60*, text by Frank ("Tico") Herrera, Yardley, Pa.: The Publishers at Yardleyville, ca. 1993.

**Dean, Loomis:** *Hemingway's Spain*, by Loomis Dean and Barnaby Conrad, San Francisco: Chronicle Books, 1989.

**Dominis, John:** *The Cats of Africa*, text by Maitland Edey, New York: Time-Life Books, 1968; *Foods of Tuscany*, by Giuliano Bigialli and John Dominis, New York: Stewart, Tabori and Chang/Workman, 1992.

**Eisenstaedt, Alfred** (selected titles): *Witness to Our Times*, New York: Viking Press, 1966; *The Eye of Eisenstaedt*, as told to Arthur Goldsmith, New York: Viking Press, 1969; *People*, New York: Viking Press, 1973; *Eisenstaedt: Germany*, New York: Harry N. Abrams, 1980; *Eisenstaedt on Eisenstaedt*, New York: Abbeville Press, 1985; *Eisenstaedt Remembrances*, ed. Doris C. O'Neil, Boston: Bulfinch Press, Little, Brown and Company, 1990.

**Eppridge, Bill:** *Robert F. Kennedy: The Last Campaign*, text by Hays Gorey, New York: Harcourt Brace, 1993; *Jake*, New York: Farrar Straus Giroux, 1995; *Upland*, New York: Farrar Straus Giroux, 1995.

**Feininger, Andreas** (selected titles): *Feininger on Photography,* New York: Ziff-Davis, 1949; *The Anatomy of Nature,* New York: Dover Publications, Inc., 1956; *The Complete Photographer,* New York: Crown, 1961; *New York in the Forties,* text by John von Hartz, New York: Dover Publications Inc., 1978; *Experimental Work,* Garden City, N.Y.: Amphoto, 1978; *Feininger's Chicago,* New York: Dover Publications, Inc., 1980; *Industrial America 1940-1960,* New York: Dover Publications, Inc., 1981; *Andreas Feininger Photographer,* New York: Harry N. Abrams, 1986; *In a Grain of Sand,* San Francisco: Sierra Club, 1986.

**Hardy, Rex:** *Callback: NASA's Aviation Safety Reporting System,* Washington, D.C.: Smithsonian Institution Press, 1990.

**Kessel, Dmitri:** *Splendors of Christendom,* Lausanne: Edita Lausanne, 1964; *On Assignment: Dmitri Kessel, LIFE Photographer,* New York: Harry N. Abrams, 1985.

**Leen, Nina** (selected titles): *The World of Bats,* text by Alvin Novick, New York: Holt, Rinehart and Winston, 1969; *Love, Sunrise and Elevated Apes,* New York: W.W. Norton & Company, 1974; *Women, Heroes and a Frog,* New York: W.W. Norton & Company, 1974; *Images of Sound,* New York: W.W. Norton & Company, 1977; *Snakes,* New York: Holt, Rinehart and Winston, 1978.

**Loengard, John:** *Pictures Under Discussion,* New York: Amphoto, 1987; *LIFE Faces, Commentary by John Loengard,* New York: Macmillan & Company, 1991; *Celebrating the Negative,* New York: Arcade Publishing, 1994; *Georgia O'Keeffe at Ghost Ranch,* New York: Stewart, Tabori and Chang, 1995; *LIFE Classic Photographs: A Personal Interpretation by John Loengard* (enlarged and updated), Boston: Bulfinch Press, Little, Brown and Company, 1996.

**Mieth, Hansel:** *Simple Life, Photographs from America, 1929-1971,* Stuttgart: Schmetterling Verlag, 1991.

**Mydans, Carl** (selected titles): *More Than Meets the Eye,* New York: Harper & Brothers, 1959; *Carl Mydans, Photojournalist,* New York: Harry N. Abrams, 1985.

**Mydans, Shelley Smith** (selected titles): *The Open City,* Garden City, N.Y.: Doubleday, Doran & Company, Inc., 1945; *Thomas: A Novel of the Life, Passion and Miracles of Becket,* Garden City, N.Y.: Doubleday & Company, 1965; *The Vermilion Bridge,* Garden City, N.Y.: Doubleday & Company, 1980.

**Parks, Gordon** (selected titles): *The Learning Tree,* New York: Harper & Row, 1963; *A Choice of Weapons,* New York: Harper & Row, 1966; *Moments Without Proper Names,* New York: Viking, 1975; *Flavio,* New York: W.W. Norton and Company, 1978; Martin H. Bush, *The Photographs of Gordon Parks,* Wichita, Kans.: Edwin A. Ulrich Museum of Art, Wichita State University, 1983; *Arias in Silence,* Boston: Bulfinch Press, Little, Brown and Company, 1994; *Half Past Autumn,* Boston: Bulfinch Press, Little, Brown and Company, 1997.

**Phillips, John:** *Odd World,* New York: Simon & Schuster, 1959; *Italian Profiles,* London: Hamish Hamilton, 1965; *A Will to Survive,* New York: The Dial Press/James Wade, 1976; *It Happened in Our Lifetime,* Boston: Little, Brown and Company, 1985; *Poet and Pilot, Antoine de Saint-Exupéry,* Zurich: Scalo, 1994; *Free Spirit in a Troubled World,* Zurich: Scalo, 1996.

**Ray, Bill:** *The Art of Invention: Patent Models and Their Makers,* by William & Marlys Ray, Princeton, N.J.: Pyne Press, 1974.

**Rentmeester, Co:** *Three Faces of Indonesia,* Lausanne: Elsevier Publishing, 1974.

**Scherman, David E.:** *Literary England,* text by Richard Wilcox, New York: Random House, 1943; *Literary America,* by David E. Scherman and Rosemarie Redlich, New York: Dodd, Mead, 1952.

**Sochurek, Howard:** *Medicine's New Vision,* Easton, Pa.: Mack Publishing, 1988.

**Stackpole, Peter:** *The Bridge Builders,* Corte Madera, Calif.: Pomegranate Artbooks, 1984; *Life in Hollywood,* Livingston, Mont.: Clark City Press, 1992.

**Villet, Grey:** *Those Whom God Chooses,* by Barbara and Grey Villet, New York: Viking Press, 1966; *Blood River,* by Barbara and Grey Villet, New York: Everest House, 1982.

# INDEX

Page numbers in bold italics indicate photographs.